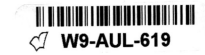
American Women Artists 1830-1930

Introductory essays by Gail Levin, Alessandra Comini & Wanda M. Corn

Eleanor Tufts

American Women Artists 1830⁄1930

International Exhibitions Foundation for The National Museum of Women in the Arts, 1987

Exhibition and catalogue made possible by United Technologies Corporation

Participating Museums

The National Museum of Women in the Arts, Washington, D.C.
10 April–14 June 1987

The Minneapolis Institute of Arts, Minneapolis, Minnesota
5 July–30 August 1987

The Wadsworth Atheneum, Hartford, Connecticut
19 September–15 November 1987

San Diego Museum of Art, San Diego, California
5 December–31 January 1988

Meadows Museum, Southern Methodist University, Dallas, Texas
20 February–17 April 1988

This exhibition is organized by The National Museum of
Women in the Arts in cooperation with the International
Exhibitions Foundation, Washington, D.C.

The exhibition and catalogue are made possible by a grant from
United Technologies Corporation.

Designed and produced by Derek Birdsall RDI
Production supervised by Martin Lee/Omnific Studios

Typeset in Poliphilus with *Blado Italic*
and printed on Parilux matt cream
by Balding + Mansell International Limited, Wisbech, England

Cover illustration: Detail from Constance Coleman Richardson,
Street Light, 1930. Indianapolis Museum of Art,
Gift of Mrs. James W. Fesler. Catalogue no. 78.

Contents

Acknowledgments

It has been a great pleasure and privilege for the International Exhibitions Foundation to join The National Museum of Women in the Arts in organizing its inaugural exhibition of "American Women Artists, 1830–1930." We are extremely grateful to Wilhelmina Cole Holladay, the founder and president of the new museum, for inviting us to coordinate preparations for this premier exhibition and to oversee the subsequent four-museum national tour. The ninety-nine paintings and twenty-five sculptures seen here include several works that have never before been shown in public exhibition as well as many by such renowned artists as Sarah Peale, Mary Cassatt, and Georgia O'Keeffe. This is also the first major traveling exhibition to feature sculpture by women artists such as Harriet Hosmer, Anne Whitney, and Malvina Hoffman. An exhibition of this magnitude could not have been assembled without the generous cooperation of the many public and private lenders from across the country, and to each of them we extend our most sincere thanks.

I would like to express my personal respect and admiration for Mrs. Holladay, who has worked tirelessly to establish this first national museum dedicated to the advancement of the creative excellence of women artists. She has brought together the resources necessary for the purchase and renovation of an impressive landmark building in downtown Washington, D.C., and has engaged a superb museum staff led by Dr. Anne-Imelda Radice, director. She has also marshaled tremendous corporate support and an astonishing nationwide membership of over 55,000. As a member of the NMWA advisory board, I am honored that IEF could be associated with this bold and distinguished venture.

Mrs. Holladay's commitment to presenting fine art exhibitions and scholarship of the highest quality is reflected in her choice of Dr. Eleanor Tufts of Southern Methodist University as the guest curator for the exhibition. Dr. Tufts, after many years of research in the field of women's art, has spent countless hours identifying and contacting potential lenders to the exhibition. She made the final selection of this remarkable group of paintings and sculptures to illustrate the accomplishments of a wide range of American women artists working between 1830 and 1930. She has written the introduction to the catalogue as well as scholarly entries on each artist and each work of art included in the show. We have been continually impressed by her enthusiasm and energy and would like to thank her particularly for the extraordinary amount of research she has devoted to the project. We are also grateful to Dr. Alessandra Comini, Dr. Wanda M. Corn, and Dr. Gail Levin for contributing the excellent introductory essays, which further enhance the scholarship of the catalogue.

We are deeply indebted to United Technologies Corporation, whose most generous grant has made possible the national tour of the exhibition and the publication of the fully illustrated catalogue.

We would like to express our special gratitude to Raymond D'Argenio, Senior Vice President-Communications; Gordon Bowman, Director of Corporate Creative Programs; Carin Quinn, Manager of Cultural Programs; and Carol F. Palm, Cultural Programs Coordinator, for their crucial support of this historic exhibition and the accompanying catalogue.

We wish to thank The Andrew W. Mellon Foundation, notably David Saltonstall, Program Director, for their continued funding of our catalogue program.

It has been a delight to collaborate once again with Derek Birdsall on the production of this catalogue. His brilliant design talents, along with his wit, intelligence, and sensitivity, make him a formidable partner in a project such as this. Martin Lee has overseen the complex job of production with great skill. It is always a pleasure to know that the printing of a catalogue will be in the able hands of Balding + Mansell International Limited.

The directors of the museums on the national tour of the exhibition have been especially encouraging and cooperative. Our warm thanks go to Dr. Anne-Imelda Radice, Director of The National Museum of Women in the Arts; Alan Shestack, Director of The Minneapolis Institute of Arts; Tracy Atkinson, Director of The Wadsworth Atheneum in Hartford, Connecticut; Steven Brezzo, Director of the San Diego Museum of Art; and Donald E. Knaub, Director of the Meadows Museum at Southern Methodist University in Dallas, Texas. Their early support of this project ensured its successful development.

Finally, I would like to thank the staff of the International Exhibitions Foundation: Gregory Allgire Smith, Vice-President; Lynn Kahler Berg, Registrar; Linda Bell, Exhibitions Coordinator; and Tam Curry, Editor. Other members of the staff have lent their many skills to preparations for this exhibition and catalogue, and I would like to recognize their assistance: Sarah Tanguy, Bridget Goodbody, Diane Stewart, S. Stanley Dawson, Ingeborg A. Schweiger, Joseph Saunders, Mimi Holland, and Ana Lim.

Annemarie H. Pope
President
International Exhibitions Foundation

The National Museum of Women in the Arts is honored to present "American Women Artists, 1830–1930," as the inaugural exhibition in its permanent building. To our knowledge, it is an exhibition theme never before fully explored. The range and depth of the show is a tribute to the scholarship of guest curator Dr. Eleanor Tufts.

On behalf of the Board of Directors and staff of the Museum, I would like to thank the International Exhibitions Foundation and the many museums and collectors across the country who have cooperated with us to make the opening show possible. We hope it will be the first of many wonderful exhibitions celebrating the achievements of women in the arts throughout the ages. I would also like to thank United Technologies for their generosity in funding both the exhibition and the companion catalogue.

As we anticipate the opening of this unique exhibition, we realize that The National Museum of Women in the Arts is taking its first major public step into an area of art that is largely unknown and uncharted. Because viewers tend to prefer that which is familiar, and many visitors will not have previously seen the pieces included in this and in future shows, it may take some time before the artists are fully appreciated. Yet we are confident that the introduction to these works by women artists will ultimately prove to be as aesthetically rewarding and thought provoking for our visitors as it has been for all of us who have worked to establish the Museum.

Wilhelmina Cole Holladay
President
The National Museum of Women in the Arts

This exhibition of "American Women Artists, 1830–1930," celebrates the opening of The National Museum of Women in the Arts. The breadth of scholarship, beauty, and history presented in the exhibition are the result of hard work, vision, and the commitment of many. Dr. Eleanor Tufts, United Technologies Corporation, the International Exhibitions Foundation, and the president of the Museum, Wilhelmina Cole Holladay, deserve our special recognition and gratitude.

Anne-Imelda Marino Radice
Director
The National Museum of Women in the Arts

Although United Technologies has over the past decade supported many important exhibitions and museums, worldwide, I believe our sponsorship of *American Women Artists, 1830-1930*, and our support of the glorious new Museum of Women in the Arts may be one of the corporation's most significant undertakings.

We wish the new museum every success, and hope the opening exhibition as well as this companion catalog will help bring new understanding of the role of the woman artist.

Robert F. Daniell
Chairman and Chief Executive Officer
United Technologies Corporation

Introduction

"American Women Artists, 1830 to 1930," is both the inaugural exhibition for the first museum in the world devoted solely to women artists and the first major traveling exhibition of American women artists. It seems appropriate in opening this National Museum of Women in the Arts to show one hundred years of painting and sculpture by professional women artists. The span 1830 to 1930 has been chosen in order to commence with and feature that leading family of early nineteenth century artists, the Peales of Philadelphia, and to include the first signs of abstraction in the paintings of Katherine Dreier and Agnes Pelton in the 1920s.

How many American women artists does the public know? Certainly Mary Cassatt and Georgia O'Keeffe have enjoyed great name recognition. The striking fact, however, is that there has been an amazing number of excellent women artists whose names do not spring so readily to the public mind. Thus, with this exhibition, we embark on a voyage of discovery.

Instead of being arranged chronologically, this exhibition has been organized into five categories: portraiture, genre and history, landscape, still life, and sculpture. This system has been adopted in the realization that women's contributions to all these areas have been not only interesting and substantial but of a variety that merits the pleasure of contrast and comparison. The works within each category are ordered chronologically to reflect general developments in the history of style.

Many are familiar with women's long history of impressive accomplishments in portraiture and still life, and this exhibition illustrates the continuation of this tradition into the nineteenth and early twentieth centuries. The fifty examples presented here are of course only a taste of the great wealth of material available. A representative selection of miniatures has been included within the portraiture section, because in the nineteenth century women especially excelled in this medium.

Not surprisingly, women artists have also been adept and prolific at genre painting. Depiction of everyday life has been a material outlet for these artistic keepers of the hearth. This exhibition features twenty-two genre scenes by such artists as Lilly Martin Spencer, Lilla Cabot Perry, and Alice Barber Stephens. Compositions range from domestic interiors and beckoning outdoor settings to busy salesclerks at Wanamaker's and laundresses around a tub, to children in church, chamber music at home, and high-spirited bedlam on the beach. History painting by women is a little scarcer, but several examples are included in this show: two nineteenth-century biblical subjects, and a Kansas massacre scene for a WPA mural. The monumental painting by Cornelia Fassett of the *Electoral Commission of 1877* (1879, cat. no. 40) records the occasion when the Hayes-Tilden presidential election was referred to an electoral commission for a final decision after ending in a tie.

Landscapes by women abound, and this exhibition extends from the early painting of *Harper's Ferry* by Henrietta McKenney (1841, cat. no. 62) to Jane Peterson's colorful New England coastal scenes (1916 and c. 1923, cat. nos. 72 and 73). The intriguing discovery is the breadth of travel undertaken by women. Not only did many study in Paris in the nineteenth century but they traveled far beyond Europe at the turn of the century, venturing into North Africa, the Near East, and the Orient, carrying their paintbrushes with them and recording the new sights. Marguerite Zorach's *Market Outside Damascus Gate, Jerusalem*, and *Village in India* (both 1911, cat. nos. 67 and 68), Alice Schille's *Tunisian Market* (c. 1922, cat. no. 69), Rosina Emmet Sherwood's *San Pedro, Manila* (1922, cat. no. 70), and Emma MacRae's *St. Mark's Square* (c. 1929, cat. no. 71), can only serve as tokens of this extensive travel.

What women artists did not do is rival their male counterparts with large panoramic vistas, since so often the women were not addressing the commercial market. Mary Moran's landscapes of the West are much smaller than those of her husband, and her work is being reserved for the first etching exhibition at The National Museum of Women in the Arts. The small paintings of the Catskills by Sarah Cole, another artist not included in the present exhibition, demonstrate a skill comparable to that of her brother Thomas. Julia Kempson (1835-1912) was one of the earliest artists to specialize in landscapes. A fine example of her work is the luminous *Landscape with Cows* (private collection). The California painter Marion Wachtel (1876-1954) did not want to compete with her landscapist husband when they painted western views side by side, so she worked in watercolors while he lived. Only after his death in 1929 did she turn to oil painting. Her spectacular painting *Mt. Moran—Teton National Park* (Gardena High School, California) must therefore have been done after the period covered in our exhibition. We are fortunate, however, to be able to include a breathtaking *Grand Canyon* (1930, cat. no. 75) by the productive but unknown western painter Abby Hill and powerful urban scenes by Georgia O'Keeffe, Molly Luce, and Constance Richardson, who is being rediscovered with this exhibition.

Although the chain of women *painters* extends back to the fifteenth century, the earliest breakthrough in sculpture occurred when American women went to Rome in the nineteenth century to work in marble. This group included Harriet Hosmer, Margaret Foley, Edmonia Lewis, Emma Stebbins, Florence Freeman, and Anne Whitney. While in Europe, a few of these artists also learned how to cast in bronze, and Whitney used this particular medium for some expressive, realistic works that broke away from the neo-classical style and "ideal" subject matter popular with the American male sculptors. Alessandra Comini has contributed an essay that concentrates on two of these pioneer sculptors, Harriet Hosmer and Elisabet Ney, whose lives had several points of conjunction and whose struggle to overcome prejudices was taken up by their contemporary sisters.

In some instances individual paintings and sculptures in this show could by felicitously coupled. For example, Marion Boyd Allen's painted portrait of Anna Hyatt Huntington (1915, cat. no. 21) shows Huntington sculpting a small model of *Joan of Arc*, while this very sculpture is represented in this exhibition by a medium-sized, finished bronze casting (1915, cat. no. 120). Anne Whitney's early portrait bust of Laura Brown (1859, cat. no. 109), modeled in the Browns' home in Brooklyn, depicts the same little girl shown in Fidelia Bridges's painting of *Laura Brown in a Wing Chair* (1867, cat. no. 38), which shows the interior of this same Brooklyn home.

Previous occasions when the works of nineteenth-century American women painters and sculptors were exhibited together were the Philadelphia Centennial of 1876 and the Columbian Exposition of 1893. Wanda Corn writes in her essay of the connection between the women's buildings at these two international expositions and the new National Museum of Women in the Arts, and she points out that at the Woman's Building in Chicago Mary Cassatt and Mary MacMonnies were given the most important public commissions of their careers. We are fortunate to have the generous loans of several first-class paintings by Mary Cassatt. As for MacMonnies, her paintings are not readily available for loan in America; some are dispersed in family hands and a few are in the Musée des Beaux-Arts in Rouen. In 1942 the St. Louis Museum of Art de-accessioned its holdings of her work. Her *Between Neighbors* (1891) today in the Sheldon Swope Gallery, Terre Haute, is unfortunately too big to move without exorbitant restoration expense. MacMonnies's *Self-Portrait* (at the National Academy of Design) along with the self-portraits of other women artists would make a fascinating exhibition for the future.

The one-hundred-year span of American women artists covered in this exhibition ends in the 1930s with the realistic paintings of the Depression era—for example, Ethel Magafan's study for a Federal Art Project mural—and includes the advent of modernism with artists like Katherine Dreier, Kathleen McEnery, Agnes Pelton, and Marguerite Zorach, all of whom exhibited at the Armory Show of 1913. Gail Levin's essay summarizes well the situation in the first third of the twentieth century.

This exhibition quite naturally reflects the historical demographic development of the United States. Initially one sees a preponderance of artists from Philadelphia, Boston, and New York. This is followed by representatives of the westward and southward expansion. Artistic training was available first on the Atlantic seaboard, but at the turn of the century aspiring female students were also accepted at the art schools in Chicago and Cincinnati. Many Nashville artists, for example, went to Cincinnati for their training, although Helen Turner from Kentucky and Kate Freeman Clark from Mississippi still traveled to New York to enroll at the Art Students League. Recent California scholarship has produced several excellent books on western landscape painting, which reveal that women artists were among the earliest to paint California's missions, mountains, seacoast, and eucalyptus trees.

The works included in this exhibition have been produced by artists from all across America, but they are not necessarily regionalist in subject matter, because the artists moved around. Abby Williams Hill, famous for her series of landscapes of the Cascade Range in Washington state (commissioned by the Great Northern and the Northern Pacific Railway Companies), was actually born in Iowa. The San Franciscan Anna Klumpke and Cincinnati-born Elizabeth Nourse spent most of their creative years in France.

I also wanted to include artists who were less well known but whose technique was superb. Visually one can appreciate the virtuosity of Anna Lownes's and Kathleen McEnery's still lifes, but the biographical data on these two painters remains slim and awaits research.

A select bibliography has been included in this catalogue to acknowledge some of the especially helpful, pertinent books. In preparing this exhibition, I have been delighted to expand my own horizon and find so many women artists unknown to me that my previous attempt to address this rich field, *American Women Artists, Past and Present, A Selected Bibliographical Guide* (1984), will surely have to be updated.

Several observations can be made in closing. First, a great number of women artists from the period 1830 to 1930 who were not included in this exhibition are certainly worthy of more attention. Second, many women practiced their art solely for the sake of creativity and not for financial remuneration. Some women, of course, did support themselves by their art—beginning with Sarah Peale and continuing through Ellen Robbins, Harriet Hosmer, and Fidelia Bridges—and some, like Lilly Martin Spencer, supported their entire families. Third, there is no discernible difference in technique between men and women artists. And fourth, if many of the artists in this exhibition seem new to the public, the question might be asked, "How many American male artists were generally known from the period 1830 to 1930—before the recent spate of scholarly resuscitations and exhibitions calling national attention to our indigenous artists?" Our cultural orientation has been so focused on Europe that until very recently we have been myopic about our own gifted artists. As the twentieth century draws to a close and the history of the New World lengthens, perhaps we will develop a deeper appreciation of the achievements of *both* the female and the male artists nurtured between the Atlantic and Pacific coasts.

Eleanor Tufts
Professor of Art History
Southern Methodist University

Author's Acknowledgments

I am grateful to Dr. Anne-Imelda Radice, director of The National Museum of Women in the Arts (NMWA), and Wilhelmina Cole Holladay, founder and president of this first museum for women artists, for entrusting me with their inaugural exhibition. It has been a rewarding experience, after two decades of research in this field, and lecturing across the country, to select the paintings and sculpture for this exhibition and to discover in the process talented women artists once celebrated but later lost from sight. The whole staff of the NMWA has labored enthusiastically to make the dream of this museum become a reality, and each member of the staff has been very supportive of this first exhibition.

My writing of the catalogue would not have been possible without the cooperation of librarians, such as Krystyna Wasserman at the NMWA and Athena Sax, Marilyn Duncan, Anne Bailey, and others at Southern Methodist University. Also, I am grateful to colleagues and students at SMU for generous consultation: professors Elizabeth Garrity Ellis, Alessandra Comini, and Gerald Carr, my graduate assistant Anne Edwards, and the students in my women artists course in the fall of 1985.

My special thanks go to Dean Eugene Bonelli and Professor Karl Kilinski of SMU for granting me a leave of absence in the spring of 1986 to work on this exhibition. A prior SMU Faculty Research Grant and a National Endowment for the Humanities summer travel grant enabled me to do research in the Anne Whitney archive at Wellesley College. I greatly appreciate the help of Ann Knight Bower, who patiently read and critiqued the manuscript for all of the 124 catalogue entries.

There are many scholars and collectors across the country to whom I am indebted for help on individual artists, and I would like to thank publicly the following: Mary Raymond Alenstein, Dr. Heather Anderson, Barbara Buff, Dr. Susan P. Casteras, Ronald Christ, Janis C. Connor, Sandra and Bram Dijkstra, Dr. William H. Gerdts, Charles A. Gilday, Leslie Greenbaum, David Henry, Sam Klein, Dr. A. Everette James, Jr., Richard H. Love, Merl M. Moore, Angela Noel, Chris Petteys, Beatrice Gilman Proske, Lewis Hoyer Rabbage, Charlotte Streifer Rubinstein, Roger Saunders, Tara Tappert, Charles B. Tyler, and Lisa Ward.

One of the joys of organizing this exhibition has been to experience the warm cooperation of lenders. Dr. Charles C. Eldredge, director of the National Museum of American Art, and Linda Bantel, director of the museum at the Pennsylvania Academy of the Fine Arts, both responded with alacrity to my requests. Sigrid Reddy and the Trustees of the Watertown, Massachusetts, Free Public Library wanted to share with the rest of America their treasured possession, Anne Whitney's prize-winning model for the statue of Senator Sumner. The national officers of the Woman's Christian Temperance Union for similar

reasons voted to lend Whitney's superb portrait of their founder, Frances E. Willard, which usually graces their national headquarters in Evanston, Illinois. Jonathan Joseph of Boston graciously showed me his vast collection of Jane Peterson paintings, and Professor Leon Edel agreed to lend Ellen Emmet's portrait of Henry James, which used to hang in James's dining room and has never been publicly exhibited before. Many descendants of artists gave generously of their time in showing me their mother's, their grandmother's, or their great-aunt's paintings. Joan Cunningham Williams, a painter herself, has her mother's artistic legacy beautifully displayed in a spacious house in Madison Mills, Virginia; and not far away Nancy Hale Bowers, the writer, also kindly showed me her mother's paintings. Elsie Grew Lyon devoted a day in Hancock, New Hampshire, to guiding me around the studio and house of her grandmother, Lilla Cabot Perry. And in southeastern New Hampshire, Miriam Gardner Dunnam and Cecilia Drinker Saltonstall genially shared information on their great-aunts with me. Even the Bouguereau descendants in Paris courteously showed me where Elizabeth and William lived and painted.

Others, unrelated to the artists, have cooperated in letting me examine loans for the exhibition and photograph works for my teaching and study. President Matina S. Horner of Radcliffe College hospitably lingered to chat about women's accomplishments when I invaded her office to photograph the large Cecilia Beaux portrait that hangs near her desk. The master of Currier House, Dr. Georgene Herschbach, herself photographed the Lilla Cabot Perry on loan from the Fogg Art Museum and now in our exhibition. And in my pursuit of Anne Whitney's sculpture, Tom Bower, assistant registrar at the National Museum of American Art, escorted me to the Smithsonian storage building in Suitland, Maryland, where I photographed Whitney's colossal statue of *Leif Ericson*; what could be more appropriate for this exhibition than Whitney's optimistic figure sighting the New World!

I am especially grateful to the three essayists, Dr. Alessandra Comini, Dr. Wanda Corn, and Dr. Gail Levin, for their scholarly contributions to the catalogue, and would like to express my thanks to the International Exhibitions Foundation staff, in particular to Tam Curry, editor, Lynn Berg, registrar, and Linda Bell, exhibitions coordinator, for their invaluable assistance.

Eleanor Tufts
Curator of the Exhibition

The Changing Status of American Women Artists, 1900-1930

Gail Levin

Any retrospective study of American women artists must take into account the attitudes they had to face among critics, dealers, museums, and their male counterparts. These were some of the factors that helped to shape their careers and determine their fate. Major societal and aesthetic developments in the early twentieth century, such as radical politics and the arrival of modernism, altered exhibition opportunities for both men and women artists. Feminism also contributed to the changing situation for women.

About 1908 progressive male artists, like the group who formed "The Eight," began to rebel against the conservative forces in the art establishment and withdrew from such august organizations as the National Academy of Design. This ultra-conservative institution did not permit women to attend anatomy lectures until 1914 and from 1825 to 1953 offered membership and associate membership to only seventy-five women in a total membership of 1,300. Once male artists were separated from the closed system of juried exhibitions of the official art establishment, their attitudes toward women artists also began to change.

The very concept of an independent non-juried exhibition, like the Exhibition of Independent Artists organized by Robert Henri, John Sloan, and others in New York in 1910, encouraged the participation of everyone—including women. And given the opportunity, women were eager to exhibit their work alongside that of male colleagues. For a fee of $10 per entry, anyone could display his or her work, thus many women participated in this landmark exhibition. In fact, the only three items that sold on opening night included a drawing by Henri and two works by women: a sketch by Edith Haworth, and a painting by Clara Tice.[1]

Other exhibitions at this time featured work by only women artists, for instance, the Exhibition of Paintings by Women Artists held at the Knoedler Galleries in New York in April 1908.[2] Single-sex women's shows raised problems for some critics, among them Mary Fanton Roberts, who wrote under the male pseudonym "Giles Edgerton." She insisted that women's exhibitions were something out of the past, "Eighteen-Thirty in expression," and belonging "to the helpless days of crinoline when ladies fainted if they were spoken to with undue harshness. . . ."[3]

A close friend of Henri, Roberts was the wife of William Carman Roberts, editor of the *Literary Digest*. Her motivation in choosing a pseudonym, however, was not just to distinguish her name from her husband's, for she need not have selected a man's name. As an editor of Gustav Stickley's magazine, *The Craftsman*, Mary Fanton Roberts found an especially encouraging attitude toward women. Yet she must have been acutely aware that this openness did not extend to the society at large: "As long as society decrees this radical sex difference in the attitude of men and women toward the world and of the world to them, there must follow along the same lines exactly a corresponding difference in the art expression of men and women. . . . Each may be progressive and each great in achievement, but under present social conditions there must be the fundamental difference."[4] But Roberts judged women artists harshly, lamenting: "It is not once in a generation that a woman so subverts her essentially characteristic outlook on life to her work that her art impulse becomes universal, as that of the greatest men often is."[5] A supporter of the radical all-male group "The Eight," Roberts was willing to admit that Cecilia Beaux's portraits had that "universal" appeal.

A more liberal environment was available to the many women who studied with Henri and William Merritt Chase at the New

York School of Art and later at the Art Students League. Between 1912 and 1918, some of these women joined their male counterparts in contributing to the radical Socialist magazine *The Masses*, which promoted women's causes from birth control to suffrage. Among the women whose art was published in *The Masses* were Cornelia Barnes, Alice Beach Winter, and Josephine Verstille Nivison. In the July 1914 issue a charming drawing by Nivison of a group of children accompanied an article, "Happy Valley," by journalist and political activist John Reed. Nivison later married the politically conservative painter Edward Hopper, however, and did not remain in radical circles. In March 1915 Barnes had a drawing published that showed one young woman exclaiming to another, "My Dear, I'll be economically independent if I have to borrow every cent," a poignant expression of what was certainly a major obstacle for women artists.

These feminist issues also captured the attention and imagination of women artists who were not in the radical circle of *The Masses*. For example, realist painter Theresa Bernstein depicted such subject matter in her *Suffragette Parade* of 1916 and in *Waiting Room— Employment Office* of 1917. In the latter picture, the room is filled with women seeking work, whose faces express a wide range of emotions, from resignation to hope. Bernstein showed her work in various venues, as well as with the National Association of Women Painters and Sculptors.[6]

It was not only the politically radical men but also the aesthetically radical circle that gave women artists a chance to promote their work as equals. In New York this meant the coterie around photographer Alfred Stieglitz, whose Little Galleries of the Photo-Secession, known as "291," for its address on Fifth Avenue, showed the most modern art of the day. The first nonphotographic art exhibited at "291," in January 1907, was by a woman—Pamela Colman Smith, an American-born painter and illustrator who had been living in London.

Stieglitz also showed a number of other women at "291," including photographers Gertrude Käsebier and Alice Boughton and painters Marion H. Beckett, Katharine N. Rhoades, and Georgia O'Keeffe (see cat. nos. 81, 82, 83, and 99).[7] His promotion of O'Keeffe and their subsequent marriage have become legendary. Yet his exclamation, "finally a woman on paper,"[8] upon discovering her work, which he exhibited without her knowledge in spring 1916, suggests his lack of enthusiasm for the drawings of Pamela Colman Smith that he had shown in several earlier exhibitions. O'Keeffe was especially fortunate in having her talent recognized and championed by such an influential figure as Stieglitz.

Stieglitz was one of the six members of the all-male organizational committee of The Forum Exhibition of Modern American Painters in 1916, a landmark exhibition featuring the work of seventeen leading American modernist painters. Only one woman, Marguerite Zorach (see cat. nos. 67 and 68), was included in this important show, and only she, of all the artists, was excluded from the catalogue, which featured essays and reproductions of one work by each of the other artists in the exhibition. Evidently the organizers

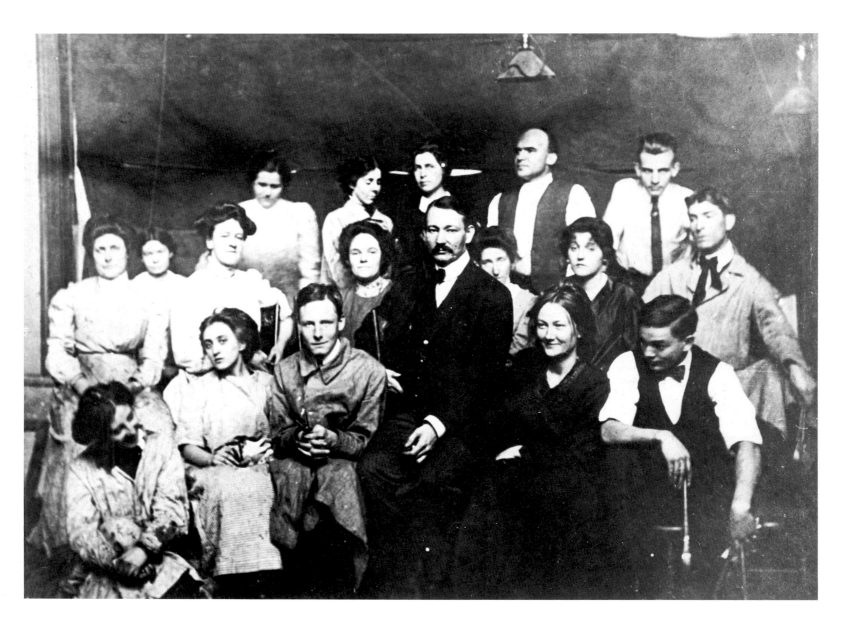

felt that Marguerite Zorach was sufficiently represented by her husband's essay and a reproduction of his work. More than likely, William Zorach had insisted on the inclusion of his wife, for although they worked separately, they appear almost as one—as "Wm. and Marguerite Zorach"—in the catalogue's list of artists.[9] Jo Nivison Hopper recalled that William Zorach, unlike her husband, went to great efforts to promote his wife's art.[10]

William Zorach's relatively enlightened and supportive attitude toward his wife's work was also indicated by the company they kept. During the summer of 1916 in Provincetown on Cape Cod, the Zorachs designed and painted scenery for the Provincetown Players, a group of Greenwich Villagers of radical political and feminist philosophies that included Susan Glaspell, Floyd Dell, John Reed, Louise Bryant, George Cram Cook, and Eugene O'Neill.[11]

Among the other visual artists in Provincetown over the summer of 1916 was the painter Marsden Hartley, the house guest of John Reed. Also a poet and essayist, Hartley devoted one chapter in his 1921 book, *Adventures in the Arts*, to "Some Women Artists in Modern Painting." Citing "feminine perceptions and feminine powers of expression," Hartley discussed only Sonia Delaunay, Marie Laurencin, and Georgia O'Keeffe, a friend and the wife of his dealer, Alfred Stieglitz.[12] Hartley concluded by claiming, "If there are other significant women in modern art I am not as yet familiarized with them."[13]

Hartley, who was very attuned to sexual issues, described O'Keeffe as seeing "the world of a woman turned inside out and

Left
Robert Henri's class at the New York School of Art, before 1906. George Bellows is seated on Henri's right among some of the many women students.

Below
Theresa Bernstein's *Waiting Room—Employment Office*, 1917 (photograph courtesy Smith-Girard, Stamford, Connecticut).

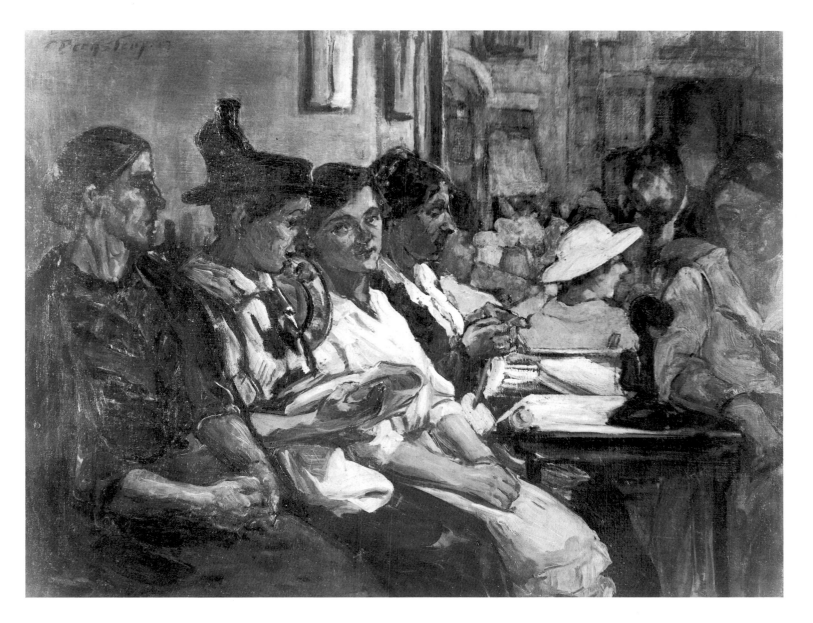

gaping with deep open eyes and fixed mouth at the rather trivial world of living people."[14] He continued: "Whatever the wish may be in point of dismissing the idea of sex in painting, there has so often been felt among many women engaging to express themselves in it, the need to shake off marked signs of masculinity and even brutishness of attack, as denoting, and it must be said here, a factitious notion of power."[15] Hartley, who was a homosexual, noted, "Power in painting does not come from muscularity of arm; it comes naturally from the intellect."[16]

Hartley's enthusiasm for O'Keeffe's work was noted and shared by others. Henry McBride, the influential critic for the *New York Herald*, praised O'Keeffe's 1923 exhibition at the Bourgeois Galleries, exclaiming that she "advances the cause of art in her country."[17] The Modernist critic Paul Rosenfeld also stressed O'Keeffe's sexuality when he insisted, "No man could feel as Georgia O'Keeffe and utter himself in precisely such curves and colors; for in those curves and spots and prismatic color there is the woman referring the universe to her own frame, her own balance; and rendering in her picture of things her body's subconscious knowledge of itself."[18]

During this period, although not working specifically for the cause of women artists, several women artists sought to remedy the lack of exhibition opportunities for modern or American artists. Sculptor Gertrude Vanderbilt Whitney founded the Whitney Studio Club in 1918, with Juliana Force as its director. Women artists participated in group shows at this Greenwich Village center, and among the artists given one-person exhibitions there were Florence Lucius, Grace Mott Johnson, Malvina Hoffmann (see cat. nos. 122, 123, 124), Jeanne Poupelet, Edith Dimock Glackens, and Dorothy Varian, as well as Gertrude Whitney herself.

Katherine Dreier, a painter (cat. no. 26), championed the cause of modernism in America when, together with Marcel Duchamp and Man Ray, she founded the Société Anonyme in 1920. One year later Dreier's cofounders departed for Europe, leaving her to shape the programs of this avant-garde enterprise. Among the early members of the Société Anonyme were the Stettheimer sisters: Florine, a painter (cat. no. 74); Carrie, who built an elaborate doll's house with its own authentic art collection in miniature made by avant-garde artist friends; and Ettie, a William James scholar.

In 1926 Dreier organized a large show, the International Exhibition of Modern Art, which took place at the Brooklyn Museum. Although very few American women artists were included among the 106 artists represented, Dreier, O'Keeffe, and Zorach exhibited there, and a nineteenth-century bedspread by a Mrs. H.E.B. Bronson was shown. A number of European women also participated in this exhibition: Marcelle Cahn, Franciska Clausen, Suzanne Duchamp, Alice Halicka, Erika Klien, Gabriele Münter, Suzanne Phocas, and Kate Steinitz.

Other women artists, working independently, produced art that can be identified with the vanguard movements of this period. Alice Schille, who studied first with William Merritt Chase and then in Paris, painted watercolors with a bright Post-Impressionist palette and paint application (see cat. no. 69). Schille taught art in her native Columbus, Ohio, and was encouraged by her neighbor, Fernand Howald, an avid collector of avant-garde art. The German-born Agnes Pelton, like O'Keeffe a former student of Arthur Wesley Dow, pursued very personal abstractions, which she painted from her own mystical orientation. With biomorphic shapes and translucent colors, she created evocative paintings that were eventually recognized by her male contemporaries (see cat. no. 80). Pelton became a founding member of the Transcendental Painting Group in New Mexico in 1938.

The period from 1900 to 1930 was a time of significant change for all artists in America. The arrival of modernist styles, the waning authority of the National Academy of Design, and the evolution of new exhibition places and policies affected all artists. For women artists, these developments suggested a chance for equal recognition. Today, however, it is clear that the door to equality was opened only a crack and, despite progress, much remains to be achieved.

[1] See Bruce St. John, *The Fiftieth Anniversary of the Exhibition of Independent Artists* (Wilmington, Del., 1960), 12.

[2] This exhibition included work by Charlotte Coman, Alice Schille, Rhoda Holmes Nicholls, Ellen Emmet, Lydia Field Emmet, Ella Condie Lamb, and others.

[3] Giles Edgerton, "Is There a Sex Distinction in Art? The Attitude of the Critic Toward Women's Exhibits," *The Craftsman*, XIV (June 1908), reprinted in Barry Sanders, ed., *The Craftsman: An Anthology* (Santa Barbara and Salt Lake City, 1978), 205.

[4] Ibid., 205.

[5] Ibid., 205.

[6] For a description of the evolution of this organization and its programs, see Julie Graham, "American Women Artists' Groups: 1867-1930," *Woman's Art Journal* 1 (Spring/Summer 1980), 10.

[7] For an account and a listing of the exhibitions at "291," see William Innes Homer, *Alfred Stieglitz and the American Avant-Garde* (Boston, 1977).

[8] See Anita Pollitzer, "That's Georgia," *Saturday Review of Literature* 33 (4 November 1950), 42.

[9] See *The Forum Exhibition of Modern American Painters* (New York, 1916).

[10] Edward and Jo Hopper interviewed by Arlene Jacobowitz, The Brooklyn Museum, 29 April 1966. Jo's bitterness about Edward's failure to help her in promoting her work is especially poignant given the invaluable assistance she gave him before he was famous. See Gail Levin, "Josephine Verstille Nivison Hopper," *Woman's Art Journal* 1 (Spring/Summer 1980), 28-32.

[11] For a discussion of the attitudes toward feminism in this circle, see June Sochen, *The New Woman in Greenwich Village, 1910-1920* (New York, 1972), 85-92.

[12] Marsden Hartley, *Adventures in the Arts* (New York, 1921), 112-19. Reprinted by Hacker Art Books, Inc., 1972.

[13] Ibid., 119.

[14] Ibid., 116. Hartley wrote about O'Keeffe again in 1936. See Gail R. Scott, ed., *On Art by Marsden Hartley* (New Haven, 1982), 102-108.

[15] Ibid., 112.

[16] Ibid., 112.

[17] Daniel Catton Rich, ed., *The Flow of Art: Essays and Criticisms of Henry McBride* (New York, 1975), 166-69, reprinted from *The New York Herald*, 4 February 1923.

[18] Paul Rosenfeld, *Port of New York* (New York, 1924), 205.

Who Ever Heard of a Woman Sculptor? Harriet Hosmer, Elisabet Ney, and the Nineteenth-Century Dialogue with the Three-Dimensional

Alessandra Comini

Who ever heard of a woman sculptor? Neither Harriet Hosmer nor Elisabet Ney ever asked such a question. The two sculptors were professional rivals who never met but who heard of each other all their working lives. They were almost exact contemporaries: Hosmer was born in Watertown, Massachusetts, on 9 October 1830 and died there at the age of seventy-seven on 21 February 1908; Ney was born in Münster, Germany, on 26 January 1833 and died a naturalized American citizen in Austin, Texas, on 29 June 1907 at the age of seventy-four. Both were, from childhood, inexorably drawn to the special realm of three-dimensional art. "Early in life," recalled a still-energetic and spirited Hosmer at the age of fifty-eight, "I was animated by a passion for sculpture. In a clay-pit near father's house I used to spend hours making clay models. Other children near by made mud pies."[1] At the age of seventeen, the tall, red-haired Elisabeth Ney (she had not yet pared the 'h' off her first name for dramatic effect) embarked upon a drastic six-day hunger strike, announcing to her horrified parents that if she was not allowed to study sculpture in Berlin she would starve herself to death. Her father, a prosperous stonemason and marble cutter who had previously enjoyed his daughter's industrious presence in his studio, could not comprehend her desire to become an artist. But she was committed to the calling. She had been captivated as a child by the story of Sabine von Steinbach, the legendary fourteenth-century sculptor who completed the carvings on Strasbourg Cathedral after her father Erwin, the building's architect and sculptor, had died.

Hosmer, the daughter of a physician with advanced ideas on the education of girls, encountered no such resistance. She was encouraged to develop an independent mind and a rugged physical constitution—Hiram Hosmer did not want to lose his one remaining child to the tuberculosis that had claimed his wife and three other children. The role models admired by young Harriet did not date back to the fourteenth century but were the real, live, modern-day actresses Fanny Kemble (1809-1893) and Charlotte Cushman (1816-1876). Cushman visited Hosmer's school in Lenox and by example and kindly advice inspired her to turn her talent and love for clay modeling into a vocation.

Hosmer and Ney could both have been described as "tomboys" in their youth, an epithet that in those days, as fellow sculptor Emma Stebbins later explained, was "applied to all little girls who showed the least tendency toward thinking and acting for themselves."[2] "Tomboys" in the nineteenth century often grew up to choose professions such as nursing, teaching, writing, singing, and acting; but to earn one's living as an artist was a novel and, to many, a foolish concept. Who ever heard of a woman artist? One who actually supported herself?

But Hosmer and Ney did not think of themselves primarily as "women artists." They conceived of themselves as artists who were female by "accident of sex." And as active participants in the late nineteenth-century flowering of the sculptural arts—especially in America, where the profession was new for men as well as women—they can be singled out and examined for the insight their careers yield into the circumstances affecting those artists of either sex whose "passion for sculpture" led them into a lifelong dialogue with the three-dimensional.

Once exposed to the marble dust bacillus, the mid-nineteenth-century American sensibility was prone to irreversible marmorean infection. Here is the feverish Harriet Hosmer, just twenty-one years old and very wise, reacting to her Friday afternoon visits to Boston's Athenaeum art gallery:

Such thoughts, assigning primacy to sculpture over painting, were echoed eight years later by another New Englander, Nathaniel Hawthorne (1804-1864), who traveled to Rome and saw Hosmer there in all her untrammeled glory, already cheerfully established as a self-supporting and sought-after sculptor of "ideal" pieces such as the *Puck* in our exhibition (see cat. no. 101). Hawthorne in fact modeled the character of Miriam, the mysterious, dark-eyed woman artist in *The Marble Faun* (written 1859, published 1860), partly on the free-spirited example of Hosmer.[4] He paid tribute to her by name in his preface to the novel[5] and by admiring text reference to her *Clasped Hands of the Brownings*, also in the present exhibition (cat. no. 100).[6] Concerning the *Marble Faun* of Praxiteles, which the novel's four young protagonists are studying in the opening scene, Hawthorne has Miriam say: "The portraiture is perfect in character, sentiment and feature. If it were a picture, the resemblance might be half illusive and imaginary; but here, in this Pentelic marble, it is a substantial fact, and may be tested by absolute touch and measurement."[7]

Apart from the substantiality of sculpture, it was the ever-present examples of the great statues of Greek and Roman antiquity that lent such luster and authority to the practice of the three-dimensional art in the nineteenth century. Their noble qualities appealed to the idealistic underpinnings of the neoclassical revival. And Rome, with its thousands of specimens of classical statuary, was a powerful magnet for sculptors of all nationalities. Antonio Canova (1757-1822) first came down from Venice in 1779, and worked in Rome for the rest of his life. The genial Dane Bertel Thorvaldsen (1770-1844) arrived in Rome as a student in 1797 and remained until 1838. Germany's two greatest sculptors, Johann Gottfried Schadow (1764-1850) and his pupil—Ney's teacher—Christian Daniel Rauch (1777-1857), both enjoyed important Roman sojourns: Schadow from 1785 to 1787; Rauch during three separate residences from 1805 to 1818. John Gibson (1791-1866), England's most renowned sculptor—and Hosmer's teacher for seven years—arrived in Rome in 1817 to study with Canova and Thorvaldsen and spent the rest of his life there.

Notable among the many male American artists who made Rome their marble mecca at this time were: Horatio Greenough (1805-1852), Hiram Powers (1805-1873), Thomas Crawford (1813-1857), William Wetmore Story (1819-1895), Paul Akers (1825-1861), and Randolph Rogers (1825-1892)—the last three all eulogized, along with Hosmer, by Hawthorne in the preface to *The Marble Faun*. Among the American women artists who descended upon Rome's hills were, in order of arrival: Harriet Hosmer in 1852; Louisa Lander (1826-1923) in 1855 to work with Thomas Crawford; Emma Stebbins (1815-1882) in 1857 to study with Paul Akers; Margaret Foley (1827-1877) in 1860; Florence Freeman (1825-1876) in 1861; Edmonia Lewis (1844-c. 1911) in 1865; Anne Whitney (1821-1915) in 1867; and Vinnie Ream Hoxie (1847-1914) in 1869. For awhile it seemed as if female American sculptors outnumbered male American sculptors in Rome, and this may account for Henry James's somewhat acid identification of Hosmer as "the most eminent member of that strange sisterhood of American 'lady sculptors' who at one time settled upon the seven hills in a white, marmorean flock."[8] Actually, the flock had a healthy mix of rams and ewes, but it was the "odd phenomenon" of the sisterhood's "practically simultaneous appearance" that intrigued James, commenting in 1903.

James also quoted a rather peevish letter from William Wetmore Story, then a novice sculptor who had settled in Rome to model a statue of his father, Supreme Court Judge Joseph Story. Young Story was describing Harriet Hosmer, one of the "emancipated females" clustered around Charlotte Cushman's residence in Rome at No. 28 on the Corso. Hosmer had arrived with her father and Miss Cushman on 12 November 1852 and by the time of Story's letter was ensconced in a little studio once belonging to Canova as personal apprentice to old John Gibson. Here are Story's remarks on his precocious rival, five feet two inches tall and eleven years his junior: "Miss Hosmer is also, to say the word, very wilful, and too independent by half. . . . She is doing very well and shows a capital spirit, and I have no doubt will succeed. But it is one thing to copy [after the antique] and another to create. She may or may not have inventive powers as an artist, but if she have will she not be the first woman?"[9] Story emphasized Hosmer's exasperating tomboy traits: "Hatty takes a high hand here with Rome, and would have the Romans know that a Yankee girl can do anything she pleases, walk alone, ride her horse alone, and laugh at their rules."[10]

Hawthorne, also struck by the unfettered life of American women artists working in Rome, viewed the situation with greater sanguinity, even drawing some proto-feminist conclusions. In *The Marble Faun* he describes Hilda, the artist from New England, as "an example of the freedom of life which it is possible for a female artist to enjoy at Rome. . . . The customs of artist life bestow such liberty upon the sex, which is elsewhere restricted within so much narrower limits; and it is perhaps an indication that, whenever we admit women to a wider scope of pursuits and professions, we must also remove the shackles of our present conventional rules, which would then become an insufferable restraint on either maid or wife."[11] Hawthorne, whose wife Sophia was an amateur artist, certainly *had* heard of women sculptors by the time he returned to America.

Hosmer herself, in exuberant letters home during the 1850s, describes something of what it was like to be an aspiring young sculptor in Rome—one who had found her niche:

(22 April 1853) I am as busy as a hornet . . . making some designs for bassi-relievi. I reign like a queen in my little room in Mr. Gibson's studio, and I love my master dearly. He is as kind to me as it is possible for you to imagine, and he is, after Rauch, the first sculptor of the age.

(2 March 1854) Mr. Gibson . . . seems to interest himself in my progress, and wishes, to use his own words, "to teach me all he knows himself." I am more and more delighted with the path I have chosen, and daily am more firmly resolved to realize the hopes of my friends.

Left
Harriet Hosmer at work on her statue of Senator Thomas Hart Benton, Rome, c. 1861

Below
Harriet Hosmer with her Italian workmen, Rome, c. 1867.

(22 April 1854) Here am I as merry as a cricket and as happy as a clam. . . . I suppose it is, as Mr. Gibson says, because I have always been occupied; but there is something in the air of Italy. . . . In America I never had that sense of quiet, settled content such as I now have from sunrise to sunset. . . . I wish you could walk into my cosey [sic] little room in the studio, where all my days are spent, with the exception of the picnics. . . . Now that I am supporting myself I feel so frightfully womanly that I cannot describe my venerable sensations.[12]

It was in connection with "the picnics" in the Campagna—that great Roman pastime of the mid-nineteenth century—that Elizabeth Barrett Browning had written so affectionately about Hosmer as a "pet of mine and of Robert's."[13]

In other letters written during the early years of apprenticeship in Rome, Hosmer discussed the difficulties of mastering her art with her St. Louis patron Wayman Crow:

(17 June 1854) One must have perfect command over the clay to make it express what one desires, and the fingers work but slowly, however energetic the brain may be. . . . The only remedy I know is patience with perseverance, and these are always sure, with a real honest love for art, to produce something.

(12 October 1854) Some seem to think that statues can be made like rail-fences. I do not agree with them. It is work, work, work, and if they would try their hands at it, they would become aware of the length of time one must study, before one can hope to do anything. . . . Why it is not three years yet and what is that for learning so difficult an art in, an art which requires years and years to master? And when we consider that the first year I was kept copying the antique. . . . My master is the one to know if I have made progress, and he is satisfied with me, and is not one easily satisfied either.[14]

Gibson was indeed eminently satisfied with his young American protegée. He had even boasted of her works to a most important visitor, as he glowingly explained in a letter to Dr. Hosmer:

We have here now, the greatest sculptor of the age, Rauch of Berlin, seventy-seven years of age. He came to my studio and staid a considerable time. Your daughter was absent, but I showed him all she had done, including a small sketch-model for a statue life size. Rauch was much struck and pleased with her works, and expressed his opinion that she would become a clever sculptor. He inquired her age, and wrote her name in his pocket-book. So now you have the opinion of the greatest living sculptor concerning your daughter's merit.[15]

It was about the "prodigious" work of twenty-two-year-old Hosmer that the silver-haired, blue-eyed Rauch promptly spoke when a Fräulein Ney was presented to him a few weeks later at an artists' party in Munich in June 1854. The venerable sculptor, on his way back to Berlin, could not have known that the young German girl had dreamed of working with him since a hunger strike of four years earlier. She had not straightaway triumphed over her parents' objections to her studying sculpture in Berlin. With the aid of Münster's bishop, they had convinced her to spend one more year at home "maturing," and then she could go—not to Berlin, that hothouse of liberals and Protestantism, but to Munich, which had an excellent art academy and was securely Catholic. In September 1852 Ney made application to Munich's all-male academy. It took two months of persistent campaigning before she was admitted, but on 12 November 1852—the very day of Hosmer's arrival in Rome—Ney became the academy's first female student of sculpture, on a probationary basis that included being chaperoned to and from class.

Ney's sculpture professor at the academy was Max Widnmann (1812-1895), a former student of Thorvaldsen in Rome, as was Hosmer's teacher Gibson; and like Gibson, he was a dedicated classicist. Under Widnmann's rigorous instruction, Ney was obliged to study all the stages in transforming an original small clay model into an armature-supported plaster cast from which marble replicas would be carved—tasks traditionally left to artisans (and which Ney had first learned as an eager assistant in her father's stonemasonry studio). By 20 July 1854, a few weeks after meeting her idol Rauch, Ney had a diploma from Munich's art academy; and on the strength of this piece of Royal Bavarian paper and Widnmann's earnest recommendation, she was granted a scholarship to the Berlin academy. This included the privilege of studying under Rauch in his large atelier known as the Lagerhaus.[16] Her prayers that Rauch might be kept alive until she could get to Berlin had been answered.

The twenty-one-year-old Ney made rapid progress under Rauch, especially in portraiture, for which she had a fine natural bent, and in modeling the human figure. And she also achieved quick entry into Berlin's intellectual circles, particularly after she stopped correcting the impression that she was a "grand-niece" of Napoleon's Marshal Ney (she was, in fact, a distant relative). During the next five years she met—and created portrait busts of—some of Germany's most prominent (and most geriatric) cultural elite. In 1858 she modeled the diplomat-writer Karl August Varnhagen von Ense (1785-1858), widower of the fabled salon giver Rahel, née Levin (1771-1833; from whose example of dropping a letter from her name—originally "Rachel"—Ney arrived at the eye-catching "Elisabet"). The same year she also fashioned the likeness of Jacob Grimm (1785-1863), the great philologist and, with his brother Wilhelm, collector of German fairy stories. Then in 1859 she met Franz Liszt at the wedding of his daughter Cosima to the conductor-composer Hans von Bülow and produced a striking portrait medallion of the hawk-nosed Cosima (1837-1930).

Later in 1859 Ney snagged two extraordinary portrait bust commissions. She won the first by surprise frontal attack on Frankfurt's misogynist hermit philosopher, Arthur Schopenhauer (1788-1860)—she simply invaded his apartment unannounced and cajoled him into sitting for a bust that would correct the mistaken impressions all painted portraits had conveyed of him.[17] Ney gained the other commission by royal command from blind King George V of Hanover (1819-1878). Then early the following year, at the request of the Hanoverian monarch, she modeled a bust of the violinist-composer Joseph Joachim (1831-1907), a close friend of Brahms and Clara Schumann. Thus at the age of twenty-six, Ney was well on her way to acceptance and fame. A description of her at this time, her hair cut to a practical short length and attractively bobbed, touches upon the inflexible will just experienced at first hand by the author of *The World as Will and Idea*: "One is struck first by her beauty, and then by her aggressiveness. Hers is a will not easily aroused, but sure and energetic when it meets opposition and challenges her well-being."[18]

If "the Ney's" will was unfetterable, her heart was subject to the invisible chains of love. She had met her soul-mate, Edmund Montgomery, at Heidelberg in September 1853. He was a Scottish-born, German-educated student of medicine, two years younger than Elisabet (who immediately declared that her birth year was the

same as his). But the two lovers spent most of the next ten years apart, while she pursued her sculpture studies and commissions and he continued his medical work in various European cities. She did not speak of marriage, although he would have liked to marry her. They were both "rebels" and did not need the conventions of society to confirm their "ideal love," she said. They would always be simply "best friends" and in front of other persons address each other as "Dr. Montgomery" and "Miss Ney" (Schopenhauer had suggested the exotic English form to an enchanted Ney).

Not until 7 November 1863 did Dr. Montgomery persuade Miss Ney to marry him, and this under most unusual circumstances. He had sailed to the Portuguese island of Madeira in the early fall of 1863 for health reasons and was there asked to treat a young Englishman, Lord Brownlow, who was dying of tuberculosis. When Montgomery learned that his patient's anxious mother was Lady Marian Alford, he wrote his "best friend" the news, sure that it would interest her enough to make her join him in Funchal. Indeed, Ney instantly recognized the name. Lady Marian was an extravagant collector of modern sculpture and patron of her countryman John Gibson, through whom she had met Harriet Hosmer; she had recently ordered a large fountain from Hosmer (*The Fountain of the Siren*, 1861-62) for the conservatory of her London house. Within weeks of receiving Montgomery's letter, Ney sailed for Madeira. Exercising the magnetism of her irresistible "will," she soon was a regular visitor in Lady Marian's luxurious villa, modeling a statuette of Lord Brownlow and a miniature portrait bust of his mother. Coincidentally, in order not to compromise Dr. Montgomery's professional position in the small gossip-prone island community, she married him in a civil service conducted by the British consul in Funchal.[19] The terms of their marriage, agreed upon in private, included a promise *not* to admit publicly that they were married, to continue to address each other in front of others, even intimate friends, as "Miss Ney" and "Dr. Montgomery," and to be free each to go wherever their professional interests might take them.

In this strange convergence of the histories of Harriet Hosmer and Elisabet Ney in the person of their mutual patron Lady Marian Alford, we are now confronted with the fascinating phenomenon of one woman sculptor who refused to marry—Hosmer—and one who refused to *admit* that she was married—Ney. As early as August 1854 Hosmer too had made a very definite statement on marriage, in a letter to her fatherly patron Wayman Crow:

I am the only faithful worshipper of Celibacy, and her service becomes more fascinating the longer I remain in it. Even if so inclined, an artist has no business to marry. For a man, it may be well enough, but for a woman, on whom matrimonial duties and cares weigh more heavily, it is a moral wrong, I think, for she must either neglect her profession or her family, becoming neither a good wife and mother nor a good artist. My ambition is to become the latter, so I wage eternal feud with the consolidating knot.[20]

Apparently this "either/or" conundrum also worried the other women sculptors in Rome at this time, for of those mentioned above—Lander, Stebbins, Foley, Freeman, Lewis, Whitney, and Ream—only one, Vinnie Ream Hoxie, married, exchanging at her husband's request the role of artist for that of hostess in their Washington, D.C., Farragut Square home.[21]

At first Ney did not find marriage and the practice of her profession incompatible. She wooed Lady Marian, whose sculpture-collecting interests she firmly hoped to deflect from

Hosmer to herself, while Montgomery continued to treat the invalid Lord Brownlow. Staying for a full year on Madeira, with its limpid southern light (a feature Ney would appreciate again in Texas), Montgomery's health visibly improved and Ney completed a portrait bust of him and began one of herself. Ney's English was also improving under Lady Marian's non-stop barrage of chatter, although she could not have enjoyed what Lady Marian had to say: "Why *do* you do portraits? Even I, a mere amateur, can model perfect likenesses. . . . Dear Harriet is of course too good an artist to do portraits. She has commissions for ideals which will keep her busy for years. . . . Have you ever had a studio? You must see the studio of the Hosmer in Rome. . . . Who did you say your teacher was? Oh, Rauch. I believe I've heard of him. With such a teacher as John Gibson . . . my Harriet Hosmer had to be a great artist."[22] Small wonder that at the end of their sojourn on Madeira the ambitious Ney soberly announced to Lady Marian that she would soon be leaving for Rome to open a studio.

Ney arrived in Hosmer's Rome in the spring of 1865 and took the obligatory studio near the Spanish Steps, but she waited in vain for clients. Although she was celebrated in several German capitals, she was an unknown in the papal city. If Ney saw Hosmer's studio at all, it could only have been from the outside, for the American sculptor, flush with success, was just (at the end of May) putting the finishing touches on a new studio at 5 Via Margutta, a new apartment in the Palazzetto Barberini, and a new stable for her horses (she and Charlotte Cushman had helped to found a fox hunting club) before leaving for a tour of France and Switzerland with the Crow family. Hosmer was away from Rome through September. In the meantime, her twenty-four Italian marble cutters were kept busy filling orders for copies of her majestic *Zenobia in Chains* (cat. no. 102) and her entrancing new *Sleeping Faun* (cat. no. 103). Ironically, the best way for an American sculptor to establish a reputation in mid-century America was to live and work in Rome.

Rome brought nothing to Ney, however, and in May she determined to corner another famous lion in his den. This time she shrewdly chose Italy's great freedom fighter, Giuseppi Garibaldi (1807-1882). She sailed first to Sardinia, then by smaller boat to Caprera, the six-square-mile island off the northeast coast of Sardinia that Garibaldi had bought and where he was now living in temporary retirement. Two weeks later, after urging Garibaldi to let her know if ever she could be of assistance to his cause,[23] Ney returned to Rome with a life-size bust and a statuette (modeled in secret for herself) of the man whom all Italy, with the exception of Pio Nono, worshiped. By the time Montgomery joined her in Rome, the bust had been copied in marble and the statuette cast in bronze.

Within the year Ney's offer to be of service to Garibaldi was taken up. In April 1866 the Seven Weeks' War between Austria and Prussia broke out, and Garibaldi led his Italian red-shirts against Austria, hoping to secure the Austrian-held Venetia for Italy. At his express request, Ney and Montgomery spent this crucial period at an old castle lookout in the Austrian Alps near Innsbruck and the Bavarian border conveying information on troop movements to Italian agents. So well did they do their job that Garibaldi recommended Ney to the victorious Bismarck (who did award Italy the Venetia) as not only a sculptor of merit but also a reliable secret agent. Bismarck therefore acted on behalf of politics as well as art when in February 1867 he counseled Wilhelm I to invite "the Ney" to Berlin.

As far as Ney knew, the reason for the royal invitation was the

very welcome and prestigious commission of modeling a bust of the minister-president of the German Confederation, Count Otto von Bismarck (1815-1898). This she did with her usual dispatch, hardly noting the questions her sitter asked concerning her "services" for Garibaldi. Both were pleased with the results: Bismarck concluded that Ney, in her "guise" as sculptor, would be an ideal agent to send down to the as yet unsecured Bavarian court (bound to Prussia by treaty but not by political sympathies); and Ney sent a plaster copy of her portrait bust of Europe's man of the hour to the International Art Exposition to be held in Paris that summer.

In another historical conjunction, both Hosmer and Ney turned up at the Paris exposition in the early summer of 1867 to see how their works had been installed. Hosmer celebrated the fourth of July by writing Wayman Crow from Paris that her *Sleeping Faun* could not have been placed better had she done it herself.[24] And strolling through the different salons of the exposition, Hosmer surely recognized the original sitters for two of Ney's entries: a bronze statuette of Lord Brownlow (who had just died), and the miniature marble bust of Lady Marian Alford. Other Ney pieces in the show were: in marble, a genii group (two young boys modeled in Madeira, later called *Sursum* by the artist), the bust of Dr. Montgomery (unidentified in the catalogue), and the head of Garibaldi; and in plaster, the just-executed portrait bust of Bismarck. At the height of their European fame, then, the thirty-six-year-old Hosmer was represented in this exposition by an ideal piece—in which vein she would always be most appreciated in

America—and the thirty-four-year-old Ney by her realistic portrait busts—the genre that would secure her second reputation as an "American" sculptor in the New World.

One final assignment awaited Ney in the Old World, however. It was a commission of such luster that any sculptor would have leapt at it, and it was an undertaking that brought an unexpected and abrupt end to Ney's European career. At the end of the year, 1867, Ney was summoned to Munich by Bismarck's newly appointed Prussian ambassador to Bavaria and told that her presence there was desired by none other than the young art-loving King Ludwig II (1845-1886). Bismarck had raved to him about her work. What she was *not* told was that she was to be the unwitting instrument of Prussian intelligence. As sculptor to the king, who had been persuaded to pose for her, she would be in a unique position of intimacy and trust, able to transmit desired data (given to her by the Prussian ambassador) to and about the king. The impressionable young monarch, who had already provided his personal composer Wagner with a house and planned an opera house for him, now offered to build a studio-villa for his personal sculptor. Dazzled, she accepted. For the next three years Ney and Montgomery lived in splendor in their Schwabing state-supplied villa (snubbed by Cosima von Bülow, now also in Munich, for openly living together in what she believed was an unmarried state, while Cosima began to give birth to a succession of daughters sired by Wagner and passed off as Bülow's). Montgomery pursued his scientific studies; and Ney pursued the king, whose mercurial changes of mood and unpredictable lengthy absences from Munich to supervise the building of his fantasy castles in the Bavarian countryside often left the sculptor without a sitter. Only with much persistence and by resorting to dramatic devices as colorful as the king's own inner romantic reveries did she at last gain enough sittings to fashion an elegantly garbed standing figure (*King Ludwig II as a Knight of the Order of Saint Hubert*) and to model a dreamy portrait head (cat. no. 114). Ney would have agreed with Hosmer's description of her elusive subject: "Having seen the young king, I associate him always with the verses of the folk-lore . . . he loved so well. . . . Clothe him in the shining garb of a Lohengrin, and without further metamorphosis we have the ideal hero of romance."[25]

Ney was much taken with the fragile psyche of her royal model—too taken by early 1870 to pass on his confidences any longer to the Prussian ambassador. Then in July 1870 the very thing Ludwig had most dreaded occurred: Bismarck provoked France into declaring war on Prussia; and Bavaria, by virtue of its treaty with the larger German state, would soon be dragged into the conflict. Pressure on Ney to influence the king doubled. But in December she discovered she was pregnant and instantly decided she did not want to give birth to a child in a war-torn Europe. Montgomery agreed. Impulsively, Ney addressed a letter to Ludwig telling him of their decision to leave, but the letter was intercepted and a curt note from the king's secretary—another Bismarck agent—accused Ney of being a traitor. She was ordered to appear at the Prussian embassy later that day. Ney never showed up. Instead, she and Montgomery crated their belongings, boarded up the villa, and secretly fled Munich. They had had enough of temperamental kings, war, and politics. On 14 January 1871 they boarded a North German Lloyd ship in Bremen bound for New York. When they debarked two weeks later, American newspapers were full of the news that Paris had surrendered and a new German Empire including Alsace and Lorraine had been proclaimed at Versailles with Wilhelm I of

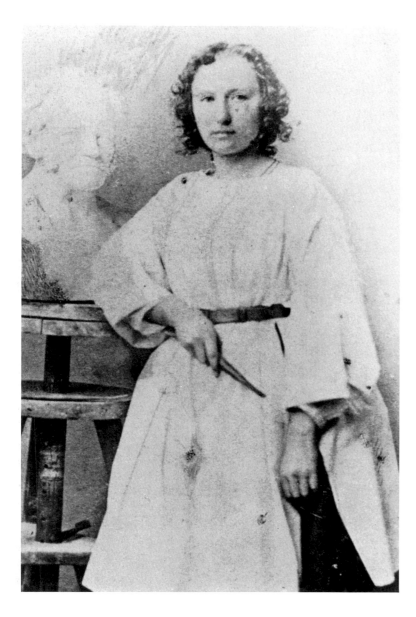

Prussia as emperor. "We are all bowled over by the news of the capitulation of Paris. . . . Prussia is now cock of the walk, the arbiter of Europe," wrote Hosmer in amazement from Rome.[26]

Ney did not allow the fate of the Old World to occupy her thoughts. Searching for a utopian southland that would remind them of Madeira, she and Montgomery first settled in Georgia, where their son, named Arthur in honor of Schopenhauer, was born. After the birth of a second son, Lorne, in 1872, they moved to Texas, purchasing a run-down plantation, "Liendo," in the Brazos Valley, five miles southeast of the small town of Hempstead and some 120 miles from the state capital Austin. All work on sculpture was suspended while "Miss Ney," as she was still called by Dr. Montgomery, to the bewilderment of all their acquaintances, concentrated on molding the character of her children and making a financial success of the plantation (Montgomery left both tasks to her, preferring to devote himself to scientific research in his laboratory). But Ney was not to have the same satisfaction or success as a mother that she had achieved as an artist. Her first son died of diphtheria before he was two, and Lorne, increasingly mortified by parents who refused to confirm that they were married, spent his adult life in a rampage of revenge. Later, unable to overcome her hurt, Ney would deny that she had a son.

Ney created no sculpture during the 1870s[27] and only five portrait busts in the 1880s[28]—the years of her prime. Even if she had wanted to renew her career (and slowly she began to ache for it), she had buried herself in a part of America where the question was not "who

Left
Elisabet Ney standing next to her bust of Arthur Schopenhauer, 1860. (Texas Collection, Baylor University)

Below
Elisabet Ney in her Austin, Texas, studio, "Formosa," with her portrait bust of *William Jennings Bryan*; plaster of the standing figure of *Stephen F. Austin* to the left, and covered plaster figure of *Lady Macbeth* to the right; c. 1900.

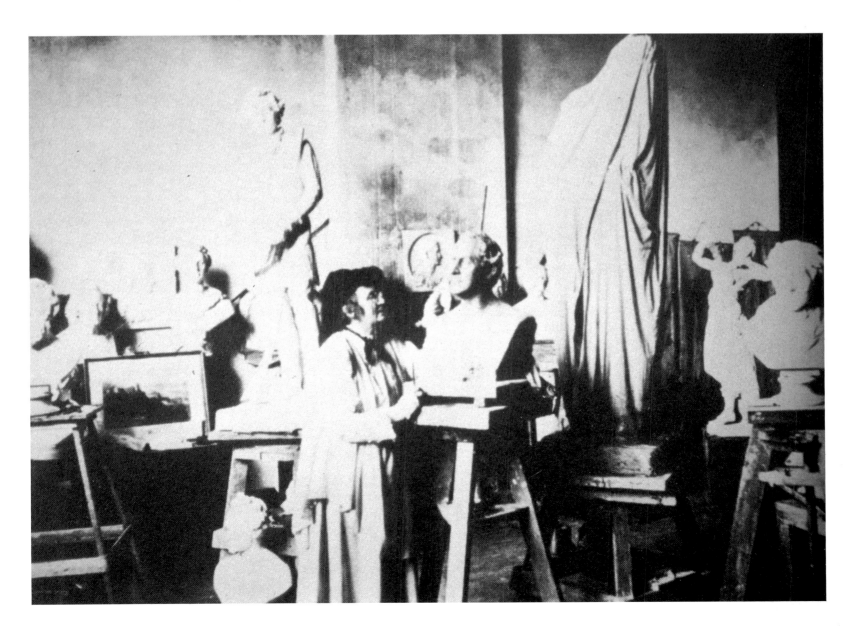

ever heard of a woman sculptor," but "who ever heard of a *sculptor?*" At last, by chance in 1878 she met Judge Oran M. Roberts, a cultivated, art-minded individual soon to be elected governor of Texas. Through his efforts—both as governor and afterward as professor of law at the newly created University of Texas at Austin—Ney was invited in October 1890 to consult with the committee in charge of planning an exhibition for the Texas Pavilion at the World's Columbian Exposition to be held in Chicago in 1893. It was agreed that companion statues of Texas's two greatest pioneer heroes, Stephen F. Austin (1793-1836) and Sam Houston (1793-1863), would be an impressive and appropriate representation. Ney was commissioned to execute in plaster two standing statues of heroic size.

Rising to the challenge with all the enthusiasm and vigor of her student days in Munich and Berlin, Ney moved to Austin and bought a plot of land, living on it in a tent while she supervised the construction of a permanent studio (today the Elisabet Ney Museum). Exhilarated, she saw herself as a new Prometheus (the subject of one of her European works), bringing art to the American frontier. With the thoroughness of a scholar, she interviewed relatives of the two men, read their correspondence, and steeped herself in Texas history. Finally, she determined how she would portray these two frontiersmen. Both would be dressed in buckskin: Austin with a long musket and a map of the Texas territory to which he led the first Anglo-American colonists in 1821; the six foot two inch General Houston—hero of the 1836 San Jacinto battle against Santa Anna—with a woolen blanket, high boots, and a saber at his side. Imagining the general when he was later president of the Republic of Texas, Ney also modeled an ideal bust of the older *Sam Houston* (cat. no. 115). Only the standing figure of *Sam Houston* was completed in time for the Chicago opening.[29] There, surrounded by other "representatives" of the Lone Star State such as steer horns and rattlesnake rattles, it silently announced to astonished visitors that Texas harbored a sculptor of the first rank.

Certainly Harriet Hosmer would have agreed, although as a judge for the art submitted to the exposition, and as an even stauncher classicist than Ney, she might not have approved so much of the buckskin coat with its fringes (she described the costumed public statuary she saw during her trip to California the following year as "outrageous" and "uncouth"[30]). Hosmer's own colossal plaster of *Queen Isabella*, commissioned by the city of San Francisco in 1891, was also on display, in the California Building in front of a pampas grass palace. Indeed, at this great exhibition celebrating the four-hundredth anniversary of Columbus's discovery of America, examples of statues by women sculptors could be seen in the individual state pavilions, in the Fine Arts Building, and in a specially constructed Woman's Building. And in supervising the vast amount of decorative statuary to be scaled up for temporary exposition edifices like the Horticultural Building, the young Chicago sculptor Lorado Taft (1860-1936) had hired no fewer than six women artists as paid assistants,[31] including his sister. Known as the "white rabbits," these young women may be thought of as repeating the scene witnessed in Rome of the 1850s and 1860s when the "white marmorean flock" was in abundance.

Taft was the first to assemble a serious history of American sculpture—published in 1903, the same year as James's portrait of William Wetmore Story—and he not only began with a woman sculptor[32] but devoted an entire chapter to "Harriet Hosmer and the Early Women Sculptors." The chapter accorded seven pondering

pages and two illustrations to Hosmer as a product of the "old-time Roman school," and concluded with two mostly admiring pages on Ney, whom Taft had recently made a point of visiting: "Secluded from the world in her little studio of stone, which nestles among the trees on the outskirts of Austin, Texas, still dwells and toils Elizabet [sic] Ney, one of the most interesting of characters as she is one of the best equipped of women sculptors."[33] At the end of his sketch, Taft mentioned a work in progress, *Lady Macbeth*, and called it "one of the most expressive and eminently sculptural conceptions among recent American ideals."

Both Hosmer and Ney chose to model images of women as their final completed major works. Hosmer had portrayed women before, but as tragic or ill-fated figures—*Beatrice Cenci* (1856-57) and *Zenobia in Chains* (1858-59). Now, in her early sixties, she elected with her *Queen Isabella* to expend her energies on sculpting a woman of power and authority. The queen of Castile is shown at the moment she changed history by offering her own jewels to sponsor Columbus's voyage of discovery. After the completion of her *Victrix Isabella*, Hosmer was heard from no more as a sculptor. Disenchanted by the changes in post-Unification Rome, she began making extended visits to the homes of her doting English admirers. In 1900 she returned to her native Watertown, Massachusetts, where she, the Perpetual Puck, became absorbed in trying to perfect a perpetual motion machine. She clung to her "old-time" Roman ideals for sculpture, deriding the "bronze photographs" produced at the end of the century.[34] Late in life she wrote this confirmation of allegiance to her early training: "But scoff as we may, what is known as the classic school has proved the true and lasting fount of inspiration of all great art. . . . Schools will arise in which grotesqueness will be called 'originality' and caricature 'nature.' But after all these schools have completed their little cycles, lovers of all that is beautiful and true in nature will seek their inspiration from the profounder and serener depths of classic art."[35]

No serenity illuminates the last work of Hosmer's sister-in-arms, Elisabet Ney. Although her sculpture career had been triumphantly launched again—after a hiatus of nearly a quarter of a century—one cannot help but see Ney's own suffering in the tall, gaunt *Lady Macbeth*, wringing her hands in agony and remorse. First conceived in 1852 while Ney was still a student in Munich,[36] it was not until the early winter of 1904, when Ney was seventy-one and subject to light heart attacks, that she traveled to the quarries at Michelangelo's Seravezza to select the pure white marble for her lady. It is doubtful whether Ney, whose ever-proud will would admit of no defeat, was aware of the personal tragedy entrapped in her marble monument to ambition and anguish. What is sure is that with the prolonged, loving completion of *Lady Macbeth* back in her Austin studio in 1905, Ney released much of the frustration of her long absence from her life's calling.

The attraction of the three-dimensional for Harriet Hosmer and Elisabet Ney was ineluctably preordained by their family backgrounds, natural talents, and psychological propensities. Their separate destinies as women sculptors converged historically and geographically at several junctures as they shaped their auspicious careers. Perhaps they would both have nodded in sage assent to Miriam's philosophical musing in *The Marble Faun*: "As these busts [exist] in the block of marble, so does our individual fate exist in the limestone of time. We fancy that we carve it out; but its ultimate shape is prior to all our action."[37]

1 Interview in the *Saint Louis Daily Globe-Democrat*, 13 December 1888, Harriet Hosmer Archive, The Schlesinger Library, Radcliffe College, Cambridge, Massachusetts.

2 Emma Stebbins, *Charlotte Cushman: Her Letters and Memories of Her Life* (Boston, 1878), 12, with regard to Charlotte Cushman's proud pronouncement "I was born a tomboy."

3 Cornelia (Crow) Carr, ed., *Harriet Hosmer Letters and Memories* (London, 1913), letter to her St. Louis schoolmate Cornelia Crow, Watertown, November 1851, pp. 14-15.

4 Hawthorne also had in mind the sculptor Louisa Lander, born, as he was, in Salem, Massachusetts, and working in Rome at the time of his visit there. She modeled an oversize portrait bust of him (Essex Institute, Salem, Massachusetts). Another American woman sculptor, Florence Freeman, who arrived in Rome in 1861 with her fellow Bostonian Charlotte Cushman, was sometimes called "Hilda" by the Anglo-American community in honor of the other independent female artist depicted in *The Marble Faun*, Hilda, identified as being from New England.

Hosmer's friend Sir Henry Layard, writing from London, simply assumed that the mysterious Miriam was Hosmer: "I have recently been reading Transformation [*The Marble Faun*], so you may easily fancy that you have been very constantly in my thoughts. I of course concluded that you were the heroine." (Carr, *Harriet Hosmer Letters*, 27 June 1860, p. 159). For Hosmer's own high opinion of Hawthorne's new novel, see her letter of 20 May 1860, to Wayman Crow (Cornelia Carr's father), 156.

5 Referring specifically to art works by American sculptors in Rome "purloined" for use and description in *The Marble Faun*, Hawthorne gallantly concludes: "Were [the author] capable of stealing from a lady, he would certainly have made free with Miss Hosmer's admirable statue of Zenobia" (Nathaniel Hawthorne, *The Marble Faun* [New York (1860), 1961], vii).

6 Ibid., 93.

7 Ibid., 14.

8 Henry James, *William Wetmore Story and His Friends: From Letters, Diaries, and Recollections*, 2 vols. (Boston, 1903), I, 257.

9 Ibid., letter to Story's former Harvard classmate James Russell Lowell, dated Rome, 11 February 1853, pp. 256-57.

10 Ibid., 255. Later Story and his wife Emelyn would become good and loyal friends of Hosmer's, accepting her idiosyncrasies of dress and conduct as part of the likeable whole of their fellow Massachusetts Yankee in Pope Pius IX's court.

11 Hawthorne, *The Marble Faun*, 47.

12 Carr, *Harriet Hosmer Letters*, 27, 30, and 32.

13 Frederic G. Kenyon, ed., *Letters of Elizabeth Barrett Browning*, 2 vols. (London, 1897), II, 166.

14 Carr, *Harriet Hosmer Letters*, 34, 38.

15 Ibid., 24-25. Hosmer's editor supplies the year of this undated letter as 1853, but Rauch chronology has him in Italy in 1854.

16 Rauch had accepted one other female student prior to Ney. From 1827, for seven years, he taught Goethe's young protegée from Weimar, Angelika Facius (1806-1887), who had returned to Weimar in 1834.

17 For more on this exceptional coup, see Vernon Loggins, *Two Romantics and Their Ideal Life* (New York, 1946), 76-82, 84, 85, 88-93; and my article, "In Praise of Creative Misinterpretation, or 'How a Little Bit of Schopenhauer Changed My Life,'" *Arts Magazine* (March 1978), 118-23. Schopenhauer described Ney as "incomparable," "talented," "very beautiful," and warned that "when you meet [her] you'll feel like tearing youself to pieces for her" (all this from the confirmed woman hater!) (Loggins, *Two Romantics*, 82).

18 Description given by Ney's friend from Münster, Herman Hüffer, three years older than she and hopelessly in love with the unresponsive artist (quoted in Loggins, *Two Romantics*, 98).

19 A copy (1887) of the document recording this civil union (in which Ney left her profession blank and entered her birthdate as "1835" to match that of her husband) is reproduced in Bride Neill Taylor, *Elisabet Ney Sculptor* (Austin, 1938), opp. p. 30.

20 Carr, *Harriet Hosmer Letters*, 35. Hosmer's mentor Gibson had never married, nor had Ney's teacher Rauch. See Hawthorne, *The Marble Faun*, 94, for a similar manifesto from Miriam. Although marriage was not for Hosmer, she was enthusiastic godmother to Cornelia Crow Carr's daughter, who was named after her.

21 Only in her later years did Vinnie Ream Hoxie take up the profession of sculpture again, responding to major commissions from the states of Iowa and Oklahoma.

22 I have quoted this paraphrasing of Lady Marian exactly as it is projected with poetic license in Loggins, *Two Romantics*, 111. Loggins's sources include Ney's private notebooks and letters in the Elisabet Ney Archives of the Texas Fine Arts Association in Austin (pp. 353, 360).

23 To record this momentous event, conducted in English, Ney put together a diary (possibly at a later date) entitled "My Time with General Garibaldi" and written in a charming combination of English and German. This journal is in the Barker Texas History Center of the University of Texas at Austin. Hosmer also met Garibaldi, deemed him courteous and gallant, but not especially interesting as a conversationalist (interview in unidentified newspaper clipping entitled "People Miss Hosmer Met" [Chicago, 1890?] in the Harriet Hosmer Archive, The Schlesinger Library, Radcliffe College, Cambridge, Massachusetts).

24 Carr, *Harriet Hosmer Letters*, 226-27.

25 Ibid., 273, from a reminiscence of the three Bavarian kings Hosmer had known, written after 1886.

26 Ibid., 289-90, letter to Wayman Crow of 30 December 1870.

27 With the exception of a model of her dead infant son, a tragic memento which she kept locked in a trunk by her bed and which was destroyed by her son Lorne after her death.

28 Plaster portraits of Governor Oran M. Roberts (1882), Francis R. Lubbock (1882), her son Lorne at the age of fifteen (1886-87; identified by Ney only as "A Young Violinist"), Julius Runge (German Consul at Galveston) and his wife, Johanna Runge (both 1887).

29 Two other pieces by Ney, shipped over from Germany for the occasion, were shown anonymously in the Woman's Building: the plaster model of *King Ludwig II as a Knight of the Order of Saint Hubert* and the marble *Sursum*.

30 Carr, *Harriet Hosmer Letters*, 331-32.

31 Five of them became successful sculptors in the generation that followed Hosmer and Ney: Janet Scudder, Bessie Potter Vonnoh, Enid Yandell, Julia Bracken (Wendt), and Caroline Brooks (MacNeil) (see Charlotte Streifer Rubinstein, *American Women Artists from Early Indian Times to the Present* [Boston, 1982], 94-95).

32 Lorado Taft, *The History of American Sculpture* (New York, 1903; reprinted with a supplementary chapter, 1923), 15: "The earliest sculptural expression of which we find record in the American colonies is the work of Mrs. Patience Wright of Bordentown, New Jersey. Her miniature heads in wax were celebrated."

33 The misspelling of her name only added to Ney's irritation at Taft's characterization of her work. "Do you read between the lines of Taft?" she wrote to Bride Neill Taylor. "Between the lines stands this: 'You people of Texas, if you have any more *standing men* to make, give them to me!'" (quoted in Loggins, *Two Romantics*, 327). Taft, although complimentary on the whole, had tossed off this patent putdown: "her standing figures of men are as unmasculine as such interpretations by women always have been" (Taft, *The History of American Sculpture*, 214).

34 Carr, *Harriet Hosmer Letters*, 332.

35 Ibid., 334.

36 Ney returned to the idea in Rome in 1865, when she was thirty-two, and was stimulated anew when she saw a performance of Hosmer's friend Charlotte Cushman as Lady Macbeth in New Orleans in January 1873.

37 Hawthorne, *The Marble Faun*, 90.

Women Building History
Wanda M. Corn

During the century encompassed by this exhibition, 1830 to 1930, growing numbers of women left the ranks of amateur artists to become professionals. The move was always a big one, for American culture sanctioned the lady amateur in art but offered little encouragement to women artists aspiring to professional careers. In the earlier part of this period, women like Anna Claypoole Peale and Sarah Miriam Peale succeeded as income-producing artists because they came from an extraordinary artistic family, or like Lilly Martin Spencer, because she had the strength of temperament to flout prevailing cultural mores and expectations. But during the last decades of the nineteenth century institutional support for women artists began to develop, and it became possible for ordinary women with artistic aspirations to dream of careers in art. Pressed by sympathetic teachers and demanding women students, art schools increasingly opened the full range of their curricula to men and women alike. For the first time in modern history, women in growing numbers began to receive instruction in drawing or painting the nude model and to exhibit, receive prizes, and work as professionals. A few, such as Catherine Drinker, Cecilia Beaux, Violet Oakley, and Emily Sartain, even began to teach.[1]

It was not only in the art schools and official exhibition halls that women artists found new support. They also received encouragement from other women, particularly from those women's organizations in the late nineteenth century dedicated to promoting new opportunities for their sex. In 1876 community-minded women initiated a Women's Pavilion at the Philadelphia Centennial Exposition where they showed women's art as part of a general survey of modern-day female accomplishments. Novel at the time, this kind of exposition building, given over exclusively to art and artifacts made by women, became common practice at subsequent fairs.[2] The greatest such presentation was the Woman's Building in Chicago at the World's Columbian Exposition of 1893, where all key posts and exhibition spaces were given to women artists, providing some, such as Mary Cassatt and Mary MacMonnies, with the most important public commissions of their careers. In Chicago, women designed the building, created all the sculptural and painted decorations, and made up the entire exhibition of prints, paintings, and sculpture that commanded the main exhibition space.

Now, nearly a century later, we have good reason to recall these early crusades on behalf of women's art and the women involved in them. We recognize that the women's buildings, though they were temporary and their contents lost or dispersed, were significant events in the history of women's art. In no other period, excepting our own, have community women taken such an interest in women artists. The 1876 Women's Pavilion pioneered the concept of the all-female exhibition and the 1893 Woman's Building offered female artists— many of them represented in the present exhibition—the challenge of a major sculpture or painting commission.

The two nineteenth-century women's buildings should also be remembered as the rightful predecessors of the new National Museum of Women in the Arts. The older buildings were temporary and all-inclusive in their exhibitions, whereas the new museum is permanent and dedicated to art, but despite the obvious differences, they belong to the same family tree. All were founded as all-female or separatist exhibition spaces by public-spirited women who wanted to educate people as to the full range of women's talents and to inspire women to raise their sights. The nineteenth-century women's buildings, along with their founders, set historical precedents and guidelines that govern practices and expectations at

the new museum today. They also generated controversies, which continue to greet every all-women art exhibition.

Each of the women's buildings was administered by a skillful organizer who presided over a nationwide network of volunteer committees. In 1876 it fell to Elizabeth Duane Gillespie, an experienced community leader and the great-granddaughter of Benjamin Franklin, to administer the Women's Pavilion at the Philadelphia Centennial Exposition, a building that came about through a broken promise. When Mrs. Gillespie was asked by the financially troubled, all-male Centennial Board of Finance to head up a Women's Centennial Executive Committee to raise money for the fair, she extracted a promise that in exchange for national fund raising activities, she could offer her volunteer women a space in the main exhibition hall to show off the work of their sex. But the men let her down. After two years of fund raising netted some $125,000, Mrs. Gillespie learned there was no room for a women's exhibition in the main building. The space had all been assigned. Instead she was offered a compromise. She could have an entirely separate building if her national committee raised an additional $30,000 within a few weeks to pay for it. As one wag put it, this was tantamount to saying "get up a side show for yourselves, pay for it yourselves and be—happy."[3]

Mrs. Gillespie was hurt and disappointed. Yet with less than a year to the fair's opening day, she called upon her committees to raise the money for a separate building. Not thinking to look for a woman architect—"our first *great* mistake," Mrs. Gillespie later recalled—she called upon H.J. Schwarzmann, the fair's architect, to design a building.[4] The structure covered an acre of land and was big enough to house some six hundred different exhibitions organized by state and foreign women's committees and by women's schools and clubs. These displays of artifacts designed or made by women were extremely diverse, including new forms of female underdress, household gadgets and furniture for the home, case after case of embroidery and fancy work, and an index created especially for the fair of the 822 charities that women ran and contributed to throughout the world. Queen Victoria sent handmade napkins and etchings of her family, while the Canadian committee provided models of convents and hospitals designed by nuns. A young Canadian engineer, Emma Allison, provided a living display, running the building's steam engine, which powered six looms and a printing press, thus demonstrating that a woman could do a man's work. The press was used to publish a newspaper, *The New Century for Woman*, which featured articles about women and women's issues. Though small, there was also an art exhibition of paintings, sculpture, photography, and engravings by women, many provided by women's schools in design and decorative arts. The art work that attracted the most publicity, however, was a relief sculpture of the romantic Iolanthe—a blind princess—carved not in wood or marble but in butter, a sculpture form popular among women in the nineteenth century. "A liberal supply of ice placed in the tin frame beneath" kept the butter firm, explained a guidebook.[5]

The problems of maintaining quality in such a potpourri would plague all nineteenth-century women's buildings and will remain a challenge for the new museum. It was not the Victorian eclecticism of the displays that was problematic; late nineteenth century fairs in general were sweeping, often sentimental inventories of human accomplishments. Rather, the problem lay in the unevenness of the exhibitions. Quality was bound to suffer when anything done by a woman was deemed suitable for exhibition and when there was no

Mrs. E.D. Gillespie, President of the Women's Centennial Executive Committee. Wood engraving from *Frank Leslie's Historical Register of the United States Centennial Exposition, 1876* (New York, 1877).

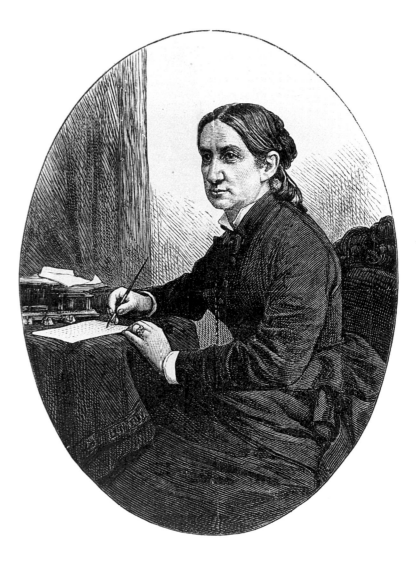

mechanism to refuse an aspiring exhibitor. Women of amateur and professional ambitions, and of minor and major talents, were displayed side-by-side. This was particularly troubling to some professional women artists who feared their work would not be taken seriously if viewed in such a context. Some in 1876, even though they sympathized with women's causes, elected to exhibit only in the official and international fine arts exhibition where all work had passed the rigors of a jury and was deemed of quality. Others, however, such as Emily Sartain, Eliza Greatorex, and Margaret Foley, resolved the dilemma by exhibiting in both halls. Emily Sartain, for example, showed a large prize-winning painting in Memorial Hall, and contributed smaller works to the Women's Pavilion.

For women whose political stand was more radical than that of the organizers, the exhibitions caused further difficulties. Suffragists had serious ideological and political concerns about the Women's Pavilion. They objected to the soft and conciliatory image of woman projected by these highly visible displays, which ignored the work of the poor and of the working classes while featuring the handiwork and charitable benevolence of the affluent. For radical feminists, the building was too genteel and did too little to advance equal rights. "The Pavilion was no true exhibit of woman's art," Elizabeth Cady Stanton complained. It showed none of the products made by women in factories nor did its exhibits point up woman's "political slavery."[6] And the building's organizers did not participate in the most significant feminist protest at the fair—the presentation and

reading on 4 July 1876, of the Declaration of Rights for Women. On that occasion Elizabeth Cady Stanton, Susan B. Anthony, and other early feminists interrupted the official Independence Day program at the fairgrounds to present their radical document.

Suffragist criticism of the Woman's Building of 1893 was more muted than it had been in 1876.[7] This was in good part due to the fact that the building and its activities were more sophisticated, better planned, and accommodated a wider spectrum of viewpoints. There was something for almost everyone, including a week-long congress devoted to suffrage. Furthermore, given the large number and broad range of women who participated in the 1893 building, it seems clear that women holding widely differing political positions found it possible to join hands in the common cause of celebrating themselves, their talents, and their desire to better their lot. By the 1890s women possessed a group identity they had not had twenty years earlier. Suffragists had become more tolerant of non-radical women who, in turn, were becoming sensitized and increasingly sympathetic to a broad range of women's issues. Large numbers of middle class and upper class American women had been affected by the debates around "The Woman Question" and were beginning to experience ambitions and injustices they had not felt earlier. They were not ready to claim equality with men—their respect for ladyhood and the ideology of separate spheres was too strong—but in their clubs and organizations, they were prepared to add women's causes to their efforts on behalf of temperance, urban reform, and settlement house work. They were also prepared, as never before, to

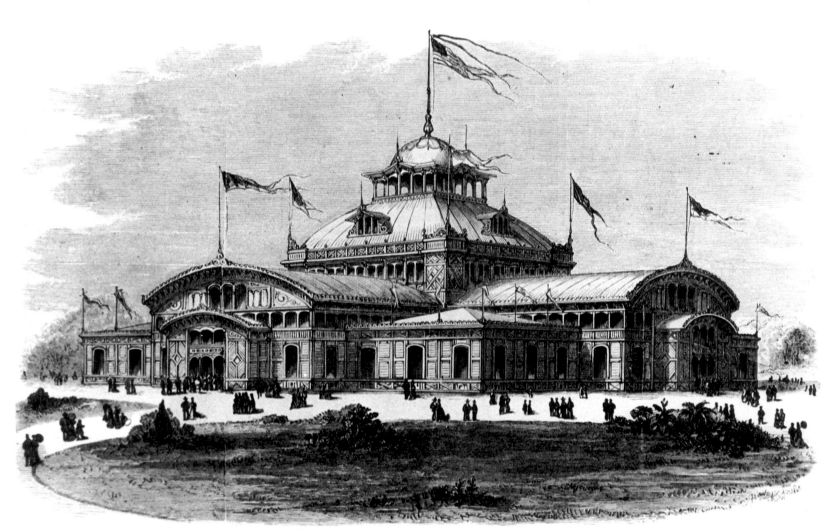

WOMEN'S PAVILION, ON BELMONT AVENUE, NEAR THE HORTICULTURAL GROUNDS.

fight for better educational opportunities for women, for better wages and working conditions for female laborers, and for the privilege of women to become professional artists, social workers, scientists, and teachers.

These goals were forcefully presented by Bertha Palmer in her speeches about the 1893 Chicago Woman's Building.[8] The wife of Potter Palmer, one of Chicago's richest men, Bertha Palmer was the elected president of a large and cumbersome 117-member Board of Lady Managers formed to run the women's building. Like the majority of her board, she had been active in clubs and philanthropic causes but had never held a job nor a major administrative post. To some suffragists, she and her board were simply society leaders whose "instincts are to help women by being charitable to them instead of by giving them opportunities to work for what they want."[9] But to many more observers, Bertha Palmer proved to be a remarkably able and diplomatic administrator, who went out of her way to accommodate women whose views were more radical than her own. Though she herself did not advocate equal rights, she did believe that women suffered from demeaning stereotypes and deserved more respect and better treatment than they were generally accorded. Convinced that the suffrage question divided and threatened both men and women, she steered a course of moderation and staunchly refused to let the building be overshadowed by politics. This allowed her, she believed, to win over conservative women "opposed to any extreme views"[10] while at the same time to appease the radicals who were "strongly drawn" to a project endorsed by government that

Left
Women's Pavilion. Wood engraving from *Frank Leslie's Historical Register of the United States Centennial Exposition, 1876* (New York, 1877).

Below
The Art Department in the Women's Pavilion. Wood engraving from *Frank Leslie's Historical Register of the United States Centennial Exposition, 1876* (New York, 1877).

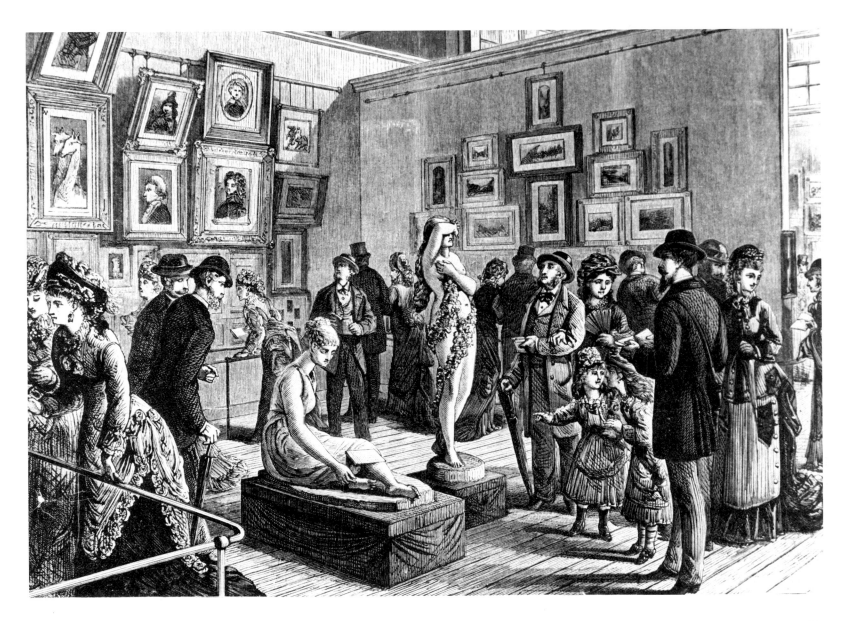

would "carry our sex another step forward."[11] The Woman's Building was to be for every woman and all voices would be heard. "Abroad as at home," she told her Board, "all the elements that are contributing to carry forward the cause of women, no matter whether they are seeking to attain equal political rights or equal educational or industrial advantages, are blending into a strong and beautiful union, to aid us in the work we are trying to do."[12]

Bertha Palmer's leadership colored every detail of the building and its programs. She and her helpers were determined to do better by women than time and budget had allowed their "Centennial sisters" in 1876. Their ambitions seemed without boundaries. At the early fair, there had been a kindergarten annex to the Women's Pavilion where Frederick Froebel's progressive methods of teaching young children were demonstrated. In Chicago there was an entire Children's Building behind the Woman's Building in which demonstrations were held and children of all ages cared for using the most progressive methods of the day. Just as in a modern day-care center, parents left their children with women professionals who tended babies in a modern nursery, instructed preschoolers in a kindergarten, and supervised the older boys and girls in using the library, gymnasium, and workshops for woodcarving and clay modeling. There were also international exhibits of toys and games, children's art, demonstrations of classes in lip-reading for the deaf, and lectures for older children on foreign countries to prepare them for seeing exhibitions at the fair.

The exhibits in the Chicago Woman's Building were also far more comprehensive and inclusive than they had been in 1876. Taking the progress of women as their building's theme, the Board of Lady Managers called upon women's committees in individual states and in countries around the world to submit both historical and contemporary artifacts. Their aim, they wrote in a "Preliminary Prospectus," was to demonstrate that women "were the originators of most of the industrial arts," having been the first makers of baskets, pots, blankets, and clothes—and that modern women were now active in every field of industry, education, science, and the arts. "The footsteps of women," the prospectus stated, "will be traced from prehistoric times to the present and their intimate connection shown with all that has tended to promote the development of the race, even though they have worked under the most disadvantageous conditions."[13]

With such a mandate, displays poured in from around the world to chronicle women's work, past and present. The Smithsonian Institution provided ethnographic exhibitions documenting the work of women from American Indian, Eskimo, Polynesian, and African tribes. The inventions room displayed women's patents ranging from household aids to a night signal system adopted by Western governments for use at sea. Pennsylvania submitted an exhibition on women in the shearing industry, while Utah presented one on women raising silkworms. Indeed, the variety and scope of exhibits was extraordinary: Iceland sent hand-spun, knitted woolen goods; Scotland sent tartan hose; Italy and Ireland sent embroidery and laces; Russia sent displays of women in medicine and surgery as

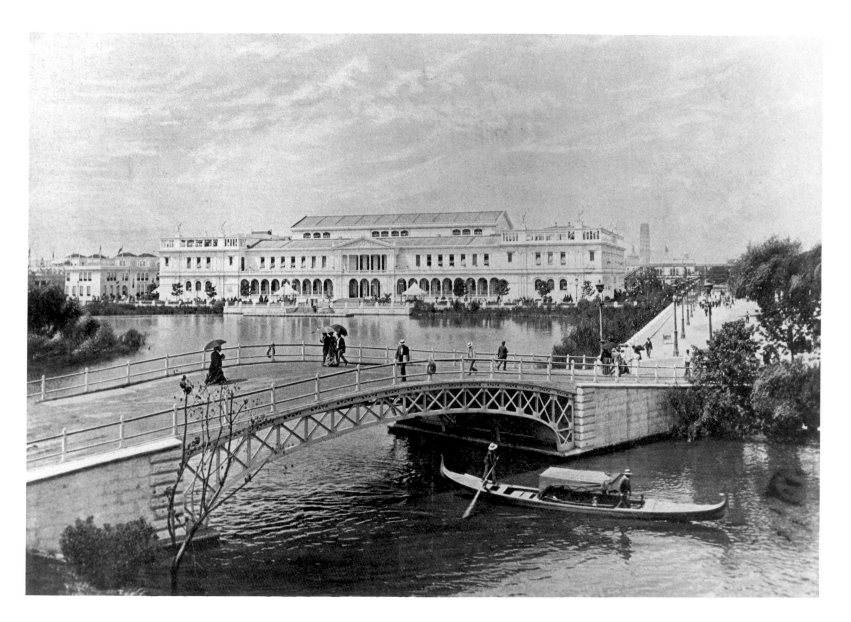

well as peasant and court costumes; Japan organized a historical exhibition of woman's toiletries and finery; France offered numerous displays, including a glass case of dolls dressed in costumes through the ages; Ceylon reconstructed a tea house; and England sent an exhibit of photographs and reports on women in education. Elsewhere there was a model kitchen furnished with the latest in equipment and utensils, and a Woman's Library organized by the women of New York to include 7,000 volumes written by women from around the world. In Mrs. Palmer's office, fishnets made by women draped the ceilings and pictures of women in the fishing industry decorated the walls.[14]

While Mrs. Palmer took a special interest in seeing that the skills of women in the labor force were clearly demonstrated, she also made it something of a personal campaign to see that women artists were well represented throughout the building. Of all the Lady Managers, she had the most experience and the best contacts in the fine arts. She and her husband had just put together an art collection for their new mansion in Chicago, a collection made up of avant-garde French Impressionist paintings as well as works by more traditional artists. So she had access to artists, particularly to those Americans working abroad. From the very beginning, she was convinced that women should do all the work on the building's designs and decorations. She ran juried competitions for the architecture and sculpture of the building, resulting in a commission going to the young architect Sophia Hayden, a recent graduate of the Massachusetts Institute of Technology, to design the building and to Enid Yandell and Alice Rideout to sculpt figures for the building's exterior. She then engaged eight other women to paint large wall decorations for the building's foyer and central hall, the so-called Gallery of Honor. The most extraordinary of these commissions went to Mary Cassatt and Mary MacMonnies for two monumental murals, each 58 by 14 feet, installed high on the walls at either end of the great central gallery. For these two artists, Palmer's commissions provided the first (and last) opportunity to work on a monumental scale heretofore reserved for men.[15]

In keeping with the building's theme of progress, Bertha Palmer also wanted to show a historical survey of women in fine arts, representing the excellence "reached by woman in past times" as well as in the present.[16] To that end she wrote to the director of The Metropolitan Museum of Art in New York requesting "screens with Egyptian textures and embroideries, which would be of the utmost value as to illustrating the primitive industries of women," two flower paintings by early Dutch women artists, and Rosa Bonheur's *The Horse Fair*.[17] Though the Metropolitan turned her down, Frederick Keppel, a well-known print dealer, agreed to her request for an exhibition of women printmakers. Keppel was very cooperative and put together one of the most historically coherent exhibitions in the entire building. Borrowing some 138 prints from private collections and contemporary artists, he presented a survey of European and American women etchers and engravers from the late Renaissance to the present. Probably the first woman's art survey of its type, the exhibition included works by Marie de Medici, Angelica Kauffman, Caroline Watson, Marie Bracquemond, Rosa Bonheur, Anna Lee Merritt, and Mary Cassatt.[18]

Mrs. Palmer also called upon every country to submit fine arts by their most accomplished women. Envisioning the Gallery of Honor filled with works "of rare merit and value,"[19] she ignored those like Sara Hallowell, her friend and art adviser, who worried that there were "too few fine women artists to warrant their making a *collective*

Left
Woman's Building, World's Columbian Exposition at Chicago, 1893. Photograph from Hubert Howe Bancroft, *The Book of the Fair* (Chicago, 1893).

Below
Mrs. Potter Palmer. Photograph from *Addresses and Reports of Mrs. Potter Palmer* (Chicago, 1894).

exhibition worthy to compete with their brothers."[20] And she underestimated the resistance many professional women had to showing their work alongside amateurs in a building that exhibited everything from household goods to embroidery. Regardless of their sympathies for women's causes, many women artists aspired to show exclusively in the Fine Arts Building where they competed with men for coveted positions. Mrs. Palmer was also unprepared for the scores of mediocre paintings and sculpture submitted by foreign and state committees, which she could not refuse. She had to display Queen Victoria's paintings of pug dogs, dozens of paintings on porcelain and china, and scores of amateur still life and landscape paintings. Although many of these works were hung in the state rooms, or in the displays of foreign countries, the fine arts exhibition in the Gallery of Honor was still a disappointment. There was an occasional painting by a respected artist such as Cecilia Beaux and sculptures by professionals such as Vinnie Ream Hoxie, Adelaide Johnson, Edmonia Lewis, and Anne Whitney, but the exhibition as a whole, wrote one critic, was "a gorgeous wealth of mediocrity." Echoing sentiments that had been first voiced in 1876, the critic went on to say that this was to be "expected in art contributions where femininity was the first requisite and merit a secondary consideration."[21]

Despite the mixed quality of the art, the building as a whole offered such a dazzling display of women's contributions that historian Hubert Howe Bancroft, one of the fair's most perceptive commentators, predicted women would never again "be excluded on the ground of mental inferiority."[22] The building had presented too fine "a case of what women have done and are doing in the cause of their sex, in the cause of home, of education, charity, science, art, and in every branch of human endeavor."[23] The best of the exhibitions, he urged, should be preserved and placed in a permanent women's building.

That indeed had become the dream of Mrs. Palmer and her board ever since the building had opened. So excited were they by their success that they immediately began to raise money for a permanent Woman's Memorial Building in Chicago. Mr. Palmer donated $200,000 to the project, and many of the exhibits and commissioned decorations of the Woman's Building were stored pending the creation of a permanent home. For reasons that are not entirely clear, construction of the Woman's Memorial Building was never realized. The fate of the decorations and exhibits placed in storage is likewise still a mystery.[24]

Yet some part of Bertha Potter's dream is now being fulfilled by the opening of The National Museum of Women in the Arts (NMWA). Although the new museum has no direct bloodlines to the Woman's Building of the last century, the resemblances are remarkable. In 1893 women had envisioned a large public building housing a museum, an auditorium, and a library dedicated to women's issues; and these very facilities are to be found in the NMWA today. Like its earlier prototypes, which had rooms furnished by state committees, the founders of the new museum have designated one gallery to house changing exhibitions selected by state

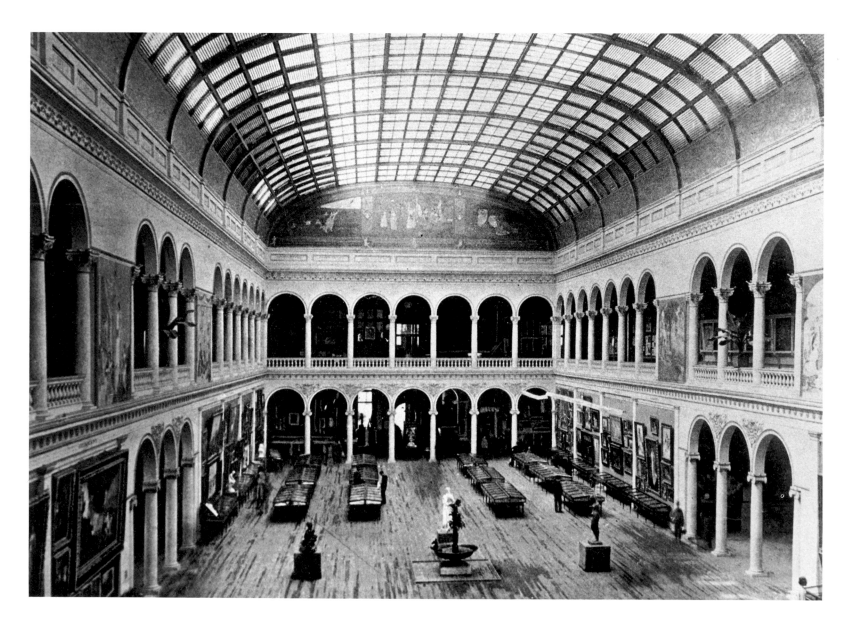

committees. And just as the Chicago Woman's Building opened its doors with performances of woman's music and poetry, NMWA will open with the National Symphony giving the premiere performance of a composition commissioned from Ellen Taaffe Zwilich, the first woman composer to win a Pulitzer Prize.

Even the founder of NMWA bears striking resemblance to her counterparts of a hundred years ago. Wilhelmina Holladay, president of NMWA, is, like Bertha Palmer and Elizabeth Gillespie before her, a public-spirited woman with drive and considerable organizational skills. Herself a collector of women's art, she has marshaled the wealth and influence needed to buy and refurbish a landmark building in downtown Washington, D.C., and establish a new museum. In projecting her goals as educational and inspirational, she speaks a similar rhetoric to that of her ancestors. In 1876 Elizabeth Gillespie spoke of the Women's Pavilion as teaching women how to advance themselves economically. "We sought to show our more timid sisters that some women had outstripped them in the race for useful and remunerative employment, and to encourage them. . . ."[25] Over a century later, Wilhelmina Holladay sees the new museum as teaching women their heritage and giving young girls "role models." The new building, its exhibitions, and its catalogues, she says, will help women find their way into established museums and textbooks. For all visitors the museum will engender "healthier attitudes about women's achievements in all fields of endeavor."[26]

In the 1970s it was primarily feminist artists and art historians

Left
Court of Honor, Woman's Building. Photograph from Hubert Howe Bancroft, The Book of the Fair (Chicago, 1893).

Below
National Museum of Women in the Arts, Washington, D.C., 1987.

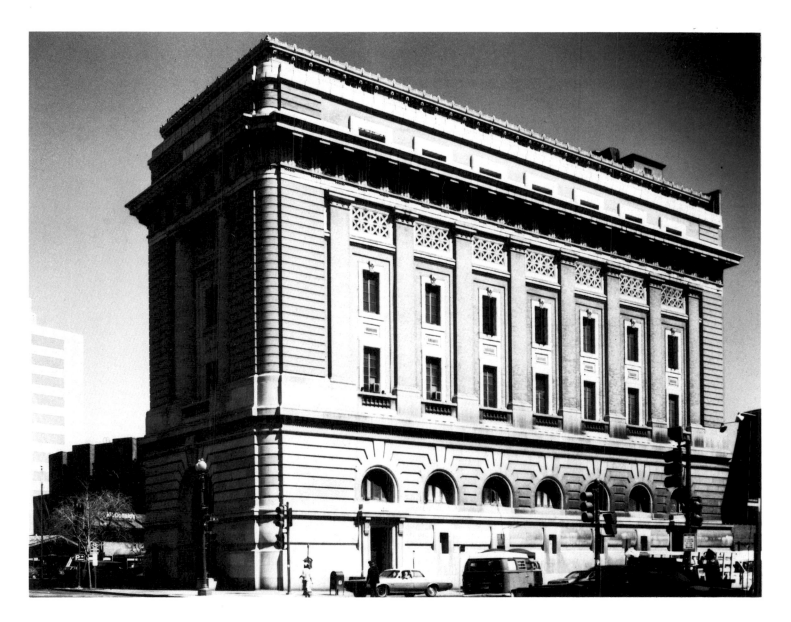

who campaigned for such goals: better exhibition space for women, better scholarship on women artists, and proper recognition of woman's creative excellence. These women were the first to discover an ancestry in the women's buildings of the nineteenth century. In 1973, when the leaders of the Feminist Studio Workshop of Los Angeles opened their new exhibition and educational complex, they called it the Woman's Building in homage to their Chicago forebearers. Today, as the corporate support for and nationwide membership in NMWA attests, a new, broadly based coalition of people embraces the causes initiated by feminists and once perceived as the exclusive concern of radical women. Much of this new support comes from women who have little if anything to do with politics or feminist causes but who, in today's new woman-conscious climate, seek ways to support their own sex. Time will tell whether such a new coalition, which makes up the founders and membership of the new museum, will be as successful as the Lady Managers were in 1893 in creating an ostensibly politics-free institution that nevertheless managed to bring together both feminist and non-feminist women.

Given the history of women's buildings, the new museum can, however, anticipate certain problems. Someone will have to mediate, as Bertha Palmer did so skillfully, between those who want their art mixed with politics, those who want open admissions so that *any* woman can show on the premises, and those who would exclude all but the finest women artists from the gallery walls. There will also be artists who will refuse to exhibit in a single-sex setting. Such controversies are indigenous to women's buildings. They were raised a hundred years ago and they are being raised again as the new museum opens. *The New York Times* has already run a skeptical column about the NMWA asking "Is This Museum Needed?"[27] If the record of the two great women's buildings in the nineteenth century is taken into account, the answer becomes an easy "yes." Until such time as female culture is fully integrated into our museums and cultural institutions, women's exhibition halls still have a job to do. When other institutions do so little, women's buildings foster respect for women's work—and in the process, give women back their past.

This essay anticipates my much longer study on the painted murals and decorations of the 1893 Chicago Woman's Building. I want to thank Estelle Freedman, historian of women and my colleague at Stanford University, for reading this piece. Any inaccuracies in it are my own, but her criticism was very helpful. See also Estelle Freedman, "Separatism as Strategy: Female Institution Building and American Feminism, 1870-1930," *Feminist Studies*, V (1979), 512-29.

[1] For a useful history of Philadelphia women artists during this period, see Pennsylvania Academy of the Fine Arts, *The Pennsylvania Academy and Its Women, 1850 to 1920* (Philadelphia, 1973).

[2] There were women's buildings, for instance, at the 1884-85 World's Industrial and Cotton Centennial Exposition in New Orleans; at the 1895 Cotton States and International Exposition in Atlanta; and at the 1901 Pan American Exposition in Buffalo. Although important scholarship on the women's buildings of 1876 and 1893 exists, a comprehensive history of women's buildings has yet to be written.

[3] Quoted without reference in Judith Paine, "The Women's Pavilion of 1876," *The Feminist Art Journal*, IV (Winter 1975/76), 5-12. Paine's article is the best work to date on the 1876 women's building, and I have relied on it heavily. An autobiographical account that provides good detail and local color is Mrs. E.D. Gillespie, *A Book of Remembrance* (Philadelphia and London, 1901), 269-331.

[4] Gillespie, *Book of Remembrance*, 315.

[5] J.S. Ingram, *The Centennial Exposition* (Philadelphia, 1876), 705.

[6] Elizabeth Cady Stanton, *Eighty Years and More* (New York, 1971), 4. Quoted in Paine, "The Women's Pavilion of 1876," 11.

[7] Jeanne Madeline Weimann's *The Fair Women* (Chicago, 1981) is a detailed history of the 1893 Woman's Building. From her account, it is clear that there were continual disagreements between the suffragists and those in power at the Woman's Building. Originally, in fact, a group of suffragists, the Isabellas, tried unsuccessfully to gain control of the building. Although the goals of the suffragists and the Board of Lady Managers were often at variance, most radical women came around to support the Woman's Building.

[8] *Addresses and Reports of Mrs. Potter Palmer* (Chicago, 1894).

[9] Quoted in Weimann, *The Fair Women*, 57. Weimann does not footnote her sources.

[10] *Addresses and Reports of Mrs. Potter Palmer*, 81.

[11] Ibid., 82.

[12] Ibid., 83.

[13] Quoted in Weimann, *The Fair Women*, 393.

[14] Besides Weimann's study, see the official catalogue of the Woman's Building for a detailed account of the exhibitions. Maud Howe Elliott, ed., *Art and Handicraft in the Woman's Building of the World's Columbian Exposition* (Chicago, 1893).

[15] For photographs of the building and its decorations, see Weimann's, *The Fair Women* and the building's catalogue cited above.

[16] Quoted in Weimann, *The Fair Women*, 297.

[17] Ibid., 296-97.

[18] Ibid., 300-309, for a checklist of the print exhibition.

[19] Ibid., 296.

[20] Ibid., 281.

[21] Ibid., 318.

[22] Hubert Howe Bancroft, *The Book of the Fair*, I (Chicago, 1893), 301.

[23] Ibid., 300.

[24] For the most thorough discussion of the Woman's Memorial Building, see Weimann, *The Fair Women*, 588-93.

[25] Gillespie, *Book of Remembrance*, 282.

[26] Wilhelmina Holladay, "Personal Statement; The Purpose of the National Museum of Women in the Arts," unpublished.

[27] "Is This Museum Needed?" *The New York Times*, 2 August 1985.

Portraiture

Sarah Miriam Peale (1800–1885)
Portrait of Eleanor Smith Gittings c.1830
Oil on canvas, 30 × 25⅛ in.
The Peale Museum, Baltimore, Maryland

Charles Willson Peale may have optimistically given his daughters the names of famous artists of the past: Angelica Kauffmann, Sophonisba Anguisciola, Rosalba Carriera, and Sybilla Miriam. But it was the daughters of his younger brother James who left their imprint on the history of art: Anna Claypoole, famous for her miniatures; Margaretta Angelica, known for her still lifes; and Sarah Miriam, adept at both portraiture and still lifes.

Born in Philadelphia in 1800, the seventh child of James Peale, Sarah Peale learned the art of miniature painting from her father, as did her siblings. Because she wished to extend her talent to oil painting, she moved to Baltimore to study with her older cousin Rembrandt, son of Charles Willson Peale. She then established a studio in Baltimore and in the ensuing years painted over one hundred portraits of prominent personages in this city and in nearby Washington, D.C. Her subjects included the French statesman and general Lafayette; Daniel Webster, secretary of state to President John Tyler; John Montgomery, the mayor of Baltimore; and José Sylvestre Rebello, the first Brazilian ambassador to the United States.

After a bout of illness Sarah Peale accepted an invitation in 1847 to journey westward to St. Louis. Possibly her friendship with the two senators from Missouri encouraged her decision to make the trip. In any case, she found the city enough to her liking to stay for three decades, and again she was in demand as portraitist to prominent families. Newspaper accounts describe her studio on Washington Avenue and her completed portraits; they also attest to her skill as a still-life painter. In 1859 she won first prize for a painting of a melon, in 1861 first and second prizes for fruit paintings, in 1862 second prize for *Fruit* and for *Flowers*, and similar awards in 1866 and 1867. She also appears to have been the teacher of some promising students, most notably the Maine-born Hannah Skeele (1829–1901), who arrived in St. Louis in 1858 and whose work is now receiving considerable attention.[1] Two handsome still lifes by Skeele are in the St. Louis Museum of Art, and many portraits are in the Brick Store Museum in Kennebunk, Maine.

Peale's style of painting was similar to that of the rest of her family, both in portraiture and in still life: a straightforward, austere directness that resulted in a realistic representation of the subject, enriched by deep resonating color. Her distinction is the exquisite treatment given to materials such as lace collars and embroidered shawls.

In 1877 the aging artist decided to rejoin her elder sisters, Anna and Margaretta, in Philadelphia. She died there after a long career at the age of eighty-four.

Among the prosperous citizens of Baltimore who commissioned portraits from Sarah Peale were Mr. and Mrs. John S. Gittings. Eleanor Smith Gittings (c. 1800–1848) is depicted here in an elegant red velvet dress and an ermine-trimmed mantle. The slimness of her figure is emphasized by the highlighted red at her waist. A classical column stabilizes the composition and tangibly suggests her position as a keeper of culture and pillar of society. Her grandfather, the successful merchant Cumberland Dugan, was the builder of Dugan's Wharf and owner of a large mansion on Water Street in Baltimore.

It was Peale's practice to make separate portraits of spouses rather than to combine them in a single composition and to turn the sitter's body slightly in the picture space in order to unite the two portaits. The portrait of Mrs. Gittings was the left one of this pair.

[1] Martha Gandy Fales, "Hannah B. Skeele, Maine artist," *Antiques* 121 (April 1982), 915–21.

Sarah Miriam Peale (1800-1885)
Portrait of John S. Gittings c. 1830
Oil on canvas, $35\frac{1}{2} \times 28$ in.
The Peale Museum, Baltimore, Maryland

The pendant portrait of John S. Gittings (1798-1879), self-confidently and genially seated in an armchair, pictorially conveys the aura of success surrounding this Baltimore businessman. When he was only twenty-five, Mr. Gittings inherited his grandfather's estate "Long Green" on the Gunpowder River. Some thirty-nine years earlier Sarah Peale's uncle, Charles Willson Peale, had painted the portrait of Mr. Gittings's grandparents, Mr. and Mrs. James Gittings, the previous owners of "Long Green".

Not content with the ease of inherited wealth, John Gittings became president of the Chesapeake Bank and set himself up as a real estate broker. In a forty-year career he built some 1,200 houses in Baltimore, including both working-class housing in Fells Point and Federal Hill and imposing Italianate mansions on Bolton Hill. At the time of his death he was a multimillionaire and the largest individual taxpayer in Baltimore. His wife Eleanor, seen in the companion portrait, died in her late forties and did not live to see his commercial successes.

3

Sarah Miriam Peale (1800–1885)
Portrait of Mrs. William Crane c. 1840
Oil on canvas, 30 × 25 in.
San Diego Museum of Art, Gift of Miss Vivian Conway

During Sarah Peale's years in Baltimore, before ill health prompted her to move inland, she painted this portrait of Mrs. William Crane. The artist's virtuosity can be seen in the eyelet lace, the lavender cap and bow, the delicately drawn lines around the sitter's eyes, and the tactile quality of the yellow shawl. Peale offers an especially emphatic rendering of the sitter, who was born Jean Nevin Daniel, the second child of Dr. and Mrs. John Moncure Daniel; the Daniels married in 1793. Like the other Baltimore citizens who could afford to commission portraits, Mrs. Crane had an historic lineage: her grandfather, Thomas Stone, had been a signer of the Declaration of Independence and her uncle a member of the Supreme Court. She died in 1881.

Vivian Conway of San Diego, great-granddaughter of the sitter's sister, gave the portrait to the San Diego Museum of Art in 1958.

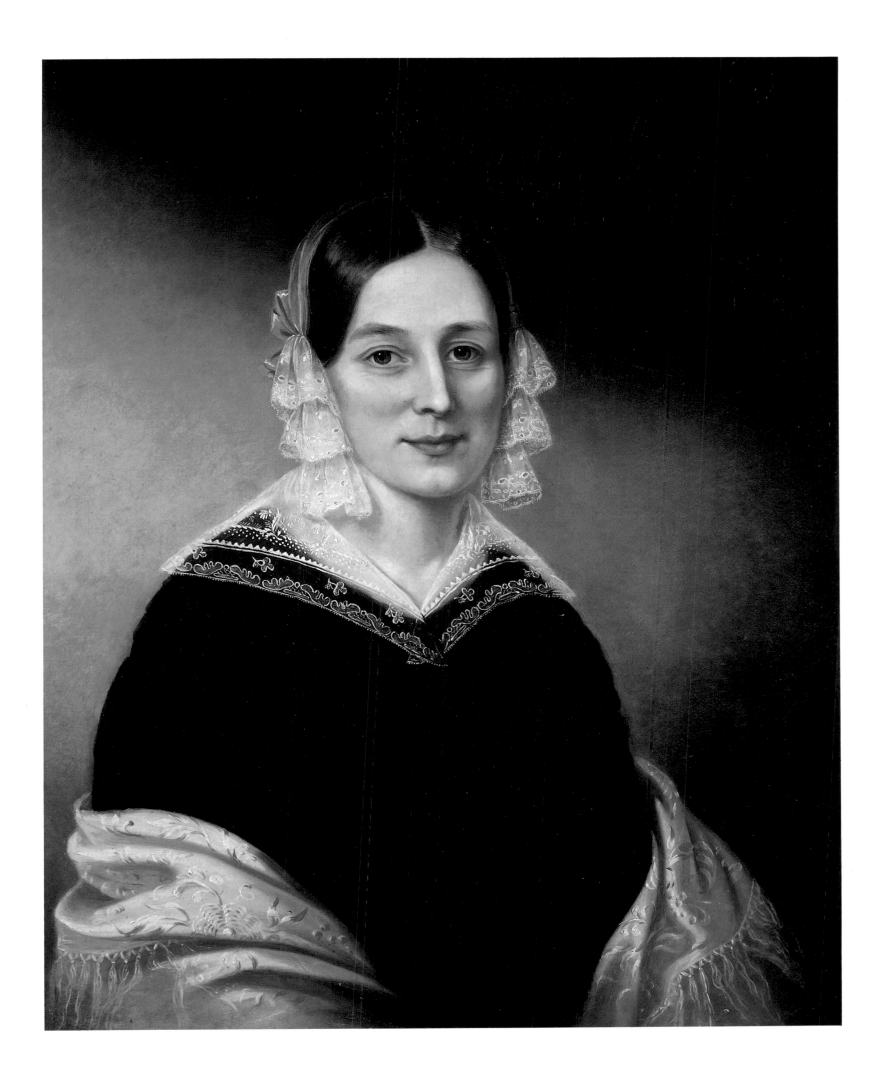

4

Sarah Miriam Peale (1800–1885)
Portrait of Senator Thomas Hart Benton 1842
Oil on canvas, 30 × 25 in.
Missouri Historical Society, St. Louis

Among the portraits Sarah Peale painted in Washington, D.C., was
that of the senator from Missouri, Thomas Hart Benton (1782–1858),
great-uncle of the painter of the same name. Peale captures the ebullience
of this politician, who managed to be elected five times to the United
States Senate from his adopted state. Born in North Carolina, Benton
moved to Tennessee where he was admitted to the bar in 1811. Four
years later he became editor of the *Missouri Enquirer*, and upon Missouri's
admission to the Union in 1821, he was first elected to the Senate.
Sarah Peale also painted the portrait of the other senator from Missouri,
Lewis Linn.

 Senator Benton was later to be immortalized by another woman artist,
Harriet Hosmer, who in 1860 was commissioned to sculpt an over-lifesize
statue of the senator, which she accomplished in her studio in Rome.
Today the ten-foot-high bronze sculpture, the first public monument ever
erected in Missouri, reigns indomitably in St. Louis's Lafayette Park.

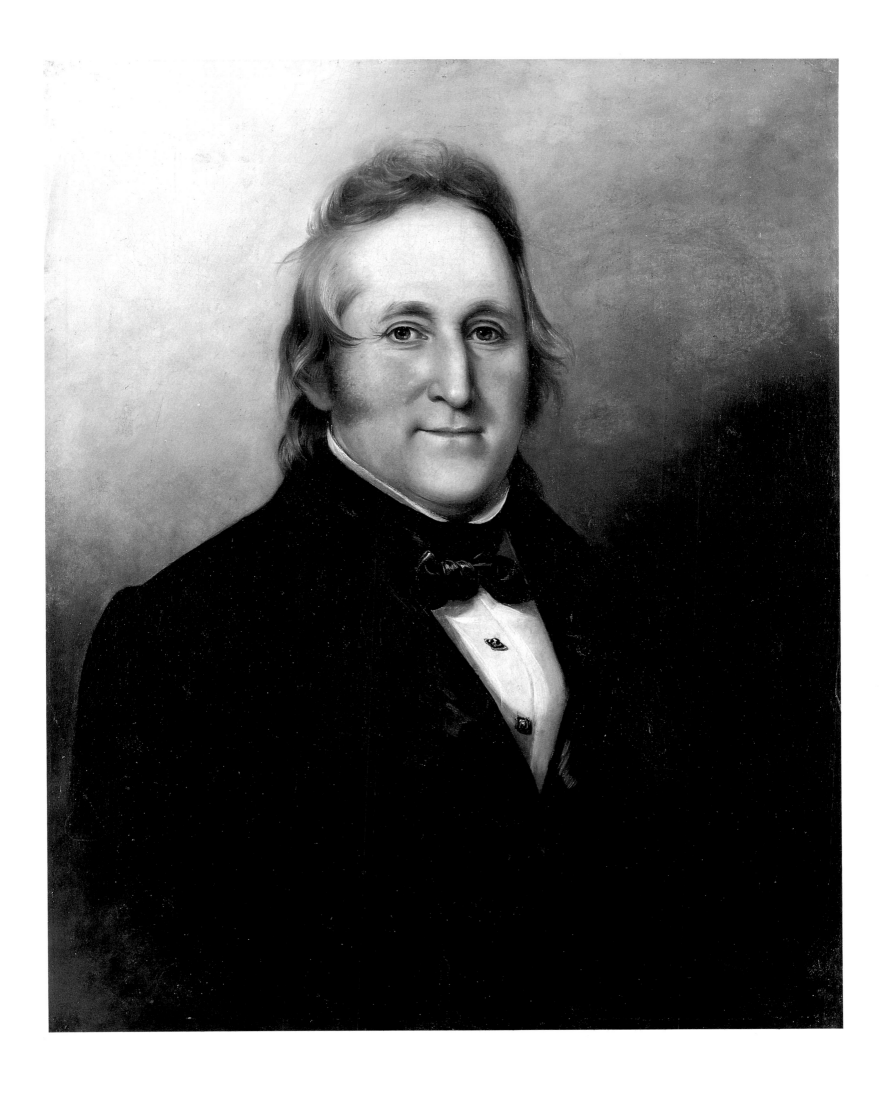

5
Sarah Miriam Peale (1800–1885)
Portrait of Congressman Henry A. Wise c. 1842
Oil on canvas, $29\frac{1}{2} \times 24\frac{1}{2}$ in.
Virginia Museum of Fine Arts, Gift of the Duchess of Richelieu,
in memory of James M. Wise and Julia Wise, 1963

The lawyer Henry Alexander Wise (1806–1876) served the
Commonwealth of Virginia in several capacities. From 1833 until 1844
he was a Democratic representative to the United States Congress; and
while he was in this office, his portrait was painted by Sarah Peale, who
at this time (specifically 1841–1843) was commuting rather regularly
between Baltimore and Washington. Henry Wise next served as
minister to Brazil (1844–1847), was elected governor of Virginia for the
years 1856–1860, and at fifty-five was appointed a general in the
Confederate army.

As is vividly evident, the dashing handsomeness of the politician did
not elude the capable portraitist. She depicts the self-assured sitter in a
black suit, with arms crossed, and in the background provides a
contrasting red patterned drapery furled around a column.

Other elected officials painted by Sarah Peale were Congressman
Caleb Cushing of Massachusetts, Senator William King of Alabama
(later named American Minister to France), and Senator Dixon H.
Lewis of Alabama (perhaps best remembered for a statistic inscribed on
the back of the canvas: "His weight was 460 pounds").[1]

[1] *American Paintings, Drawings and Sculpture Catalogue* (Sotheby's, New York, 26 and 27
January 1984), Lot 337.

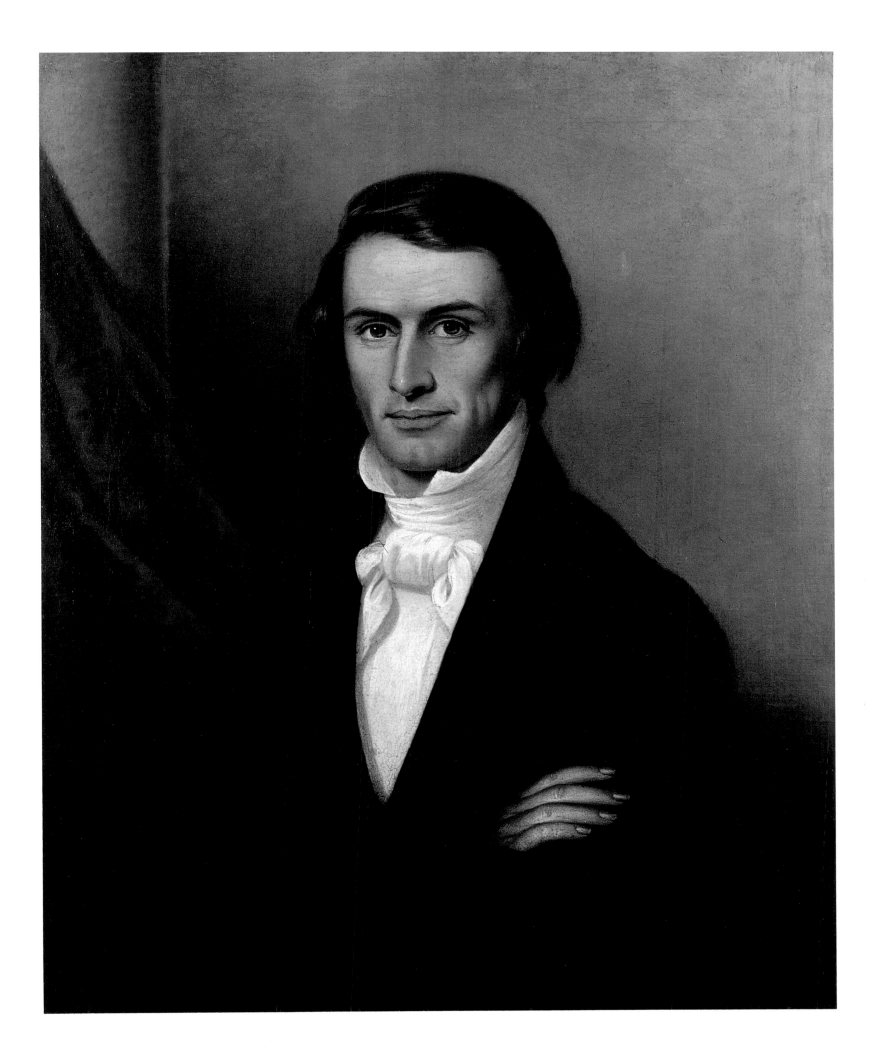

6

Mary Cassatt (1844-1926)
Woman and Child Driving 1879
Oil on canvas, $35\frac{1}{4} \times 51\frac{1}{2}$ in.
Philadelphia Museum of Art, W. P. Wilstach Collection

When Mary Cassatt was born in 1844, her family was living in Allegheny City, a suburb of Pittsburgh (incorporated into the city in 1907). Her father served as mayor of Allegheny City before moving his family to Pittsburgh. Then the peripatetic businessman took the family to Philadelphia, and scarcely two years later, in 1851, to Europe, where they remained for four years. When the family returned to Philadelphia, Mary Cassatt began her artistic training, enrolling at the Pennsylvania Academy of the Fine Arts in 1861 at the age of seventeen. After four years of study she knew she must go back to Europe, so in 1866 she settled in Paris to study with Jean-Léon Gérôme. In 1867 she took private lessons with Pierre Edouard Frère and Paul Constant Soyer at Ecouen, and in 1868 with Thomas Couture. In pursuit of old masters she visited Italy and Spain in 1872-73. Her paintings were accepted for five successive years by the official Paris Salon, but Cassatt was disturbed that she had to tone down a painting to make it acceptable. Thus when Degas visited her in 1877 and invited her to exhibit with the independent artists known as the Impressionists, she as an admirer of the new style eagerly accepted. In this same year her parents and her sister Lydia arrived to take up residence in Paris.

In the next Impressionist exhibition (the fourth), which occurred in 1879, Cassatt was represented by nine paintings. She continued loyally to exhibit through the final eighth show of 1886. She maintained throughout her career a dislike for prizes and actually declined them in American exhibitions, stating that she was not an amateur artist.

The seriousness with which Cassatt undertook her work was matched by the high respect expressed by critics. Her *Woman Reading* was purchased from the 1879 exhibition by Antonin Proust; Arthur Baignères found her *The Tea* in the 1880 exhibition very successful; and Elie de Mont wrote that Berthe Morisot and Mary Cassatt were the only interesting artists exhibiting.[1] It seems significant to note that Cassatt depicted women reading many times in her work.

In alternate years in the 1890s Cassatt presented her paintings in one-woman exhibitions at the Durand-Ruel Gallery. Her first was in 1891, followed by a comprehensive one in 1893; then Durand-Ruel organized large Cassatt exhibitions in New York in 1895 and again in 1903. The next year Cassatt's achievements were recognized by the French government, which made her Chevalier of the Legion of Honor. In these years she added printmaking to her activities, establishing innovations that modern printmakers praise today.[2] When Cassatt's eyesight weakened, she turned to painting pastels. She also traveled extensively in the early years of the twentieth century—to Constantinople, Egypt, the United States. In 1915 she displayed a touch of feminism in enthusiastically sending her paintings and Degas's to a benefit exhibition for women's suffrage in New York. Operations for cataracts were not successful, and when she died at her Château de Beaufresne at Mesnil-Théribus, north of Paris, in 1926, she was almost blind.

Cassatt was truly a painter of people, and a favorite model was her older sister Lydia (who was, sadly, to die prematurely of Bright's disease). In this outdoor Parisian scene Lydia is portrayed holding the reins and whip to drive the pony "Bichette." Degas's niece, Odile Fèvre, sits beside Lydia, and the groom is relegated to a rear seat. Susan Fillin Yeh has observed that "Cassatt is the only artist of the period to depict a woman driving a buggy."[3]

The rich pigments are generous in this painting, especially on the clothes of Lydia Cassatt and the little girl. All the sitters are of serious mien in this tableau of the moment.

[1] Charles S. Moffett et al., *The New Painting, Impressionism 1874-1886* (Fine Arts Museums of San Francisco, 1986); Frona E. Wissman, "Realists among the Impressionists," 347.
[2] George Biddle, the Philadelphia painter who visited Cassatt on her death bed, relates that she was still excited about dry-point plates.
[3] Susan Fillin Yeh, "Mary Cassatt's Images of Women," *Art Journal* 25, no. 4 (Summer 1976), pp. 362-63.

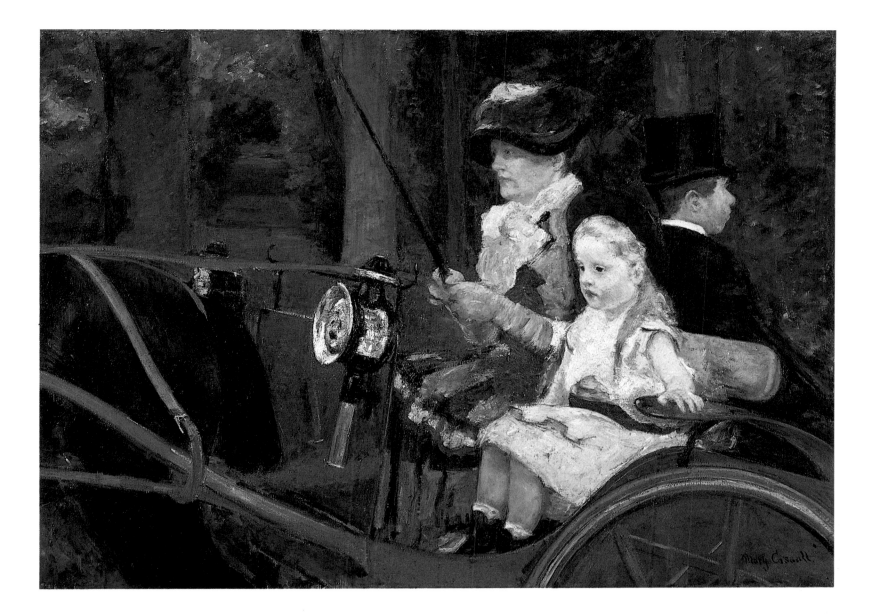

7
Mary Cassatt (1844–1926)
Susan on a Balcony Holding a Dog 1883
Oil on canvas, 39½ × 25½ in.
Corcoran Gallery of Art, Washington, D.C., Museum Purchase, 1909

Susan, a cousin of Mary Cassatt's housekeeper, Mathilde Vallet, sits on the balcony of Cassatt's apartment in Paris, holding the artist's Belgian griffon "Battie." The dog's ears are perked upward, and its gaze seems riveted by some action outdoors.

Cassatt magnificently achieves the effect of sunlight on Susan's white dress and hat. The brim of the hat shades the sitter's face, although some of the strong sunlight shines through a little onto her right cheek, and the light is caught in luscious pigments on the sleeves of the dress, on the hat, and on the bow that ties the hat under Susan's chin. The tan-gloved hand of the sitter caresses the dog, painted in tan and a bluish black, and additional colors are seen through the rattan chair on which Susan sits, in the green trees, and in the grayish blues of the distant buildings.

[Cassatt is also represented in this exhibition by a painting in the genre section, *Little Girl in a Blue Armchair*, 1878, cat. no. 41.]

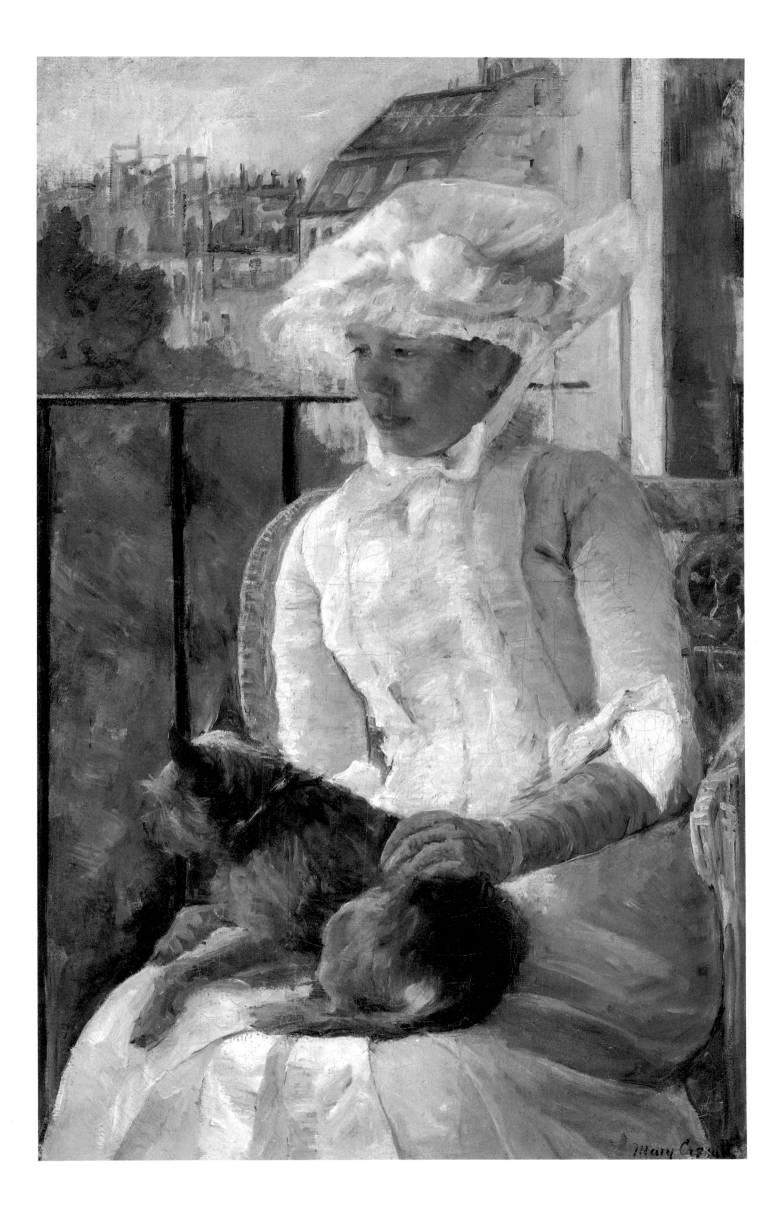

8

Cecilia Beaux (1855–1942)
Les Derniers Jours d'Enfance 1883–1885
Oil on canvas, $45\frac{3}{4} \times 54$ in.
Private collection

"Miss Beaux is not only the greatest living woman painter, but the best that has ever lived," maintained the artist William Merritt Chase at the presentation of the Carnegie Institute's Gold Medal to Beaux in 1899. Certainly Cecilia Beaux is much admired today for her large oeuvre of striking portraits.

Born in Philadelphia in 1855, Beaux lost her mother when she was young, and her distraught father returned to France, leaving his two daughters in the care of their maternal grandmother and two aunts in Philadelphia. As Beaux relates in her autobiography *Background with Figures* (1930), she had the example of an aunt who always carried her sketchbook and pencil with her. As a consequence, Beaux observed in the home how art and music were not playthings to be taken up lightly: "I already possessed the materials for oil painting, and had used them quite a little, but without advice." Instruction in drawing and copying art were given to her in the studio of another relative, Katharine Drinker, who painted historical and biblical subjects. Finally, Beaux's uncle contibuted financially to an arrangement for oil classes, whereby she and a classmate from Miss Lyman's School were to work from a model three mornings a week, and the painter William Sartain was to come from New York every fortnight to give a critique.

Once trained, what was the artist to do for her debut as a painter? Beaux decided to pose her older sister, who had married, with her son. This pivotal painting, *Les Derniers Jours d'Enfance*, is included in our exhibition.

In January 1888 Beaux and a cousin left for a nineteen-month trip to Europe. Beaux entered classes in Paris in which she received criticism from the painters William Bouguereau and Tony Robert-Fleury. She also studied the old master paintings that she saw in the museums, particularly those by Titian, Rembrandt, and Velázquez.

In the 1890s a surge of commissions caused Beaux to move to New York. She mentions in her memoirs that Ellen Emmet (see cat. nos. 17 and 18) took rooms below her.[1] Mrs. Theodore Roosevelt and her daughter Ethel were among Beaux's sitters, and even the president himself sat for a two-hour sketch during which he recited Kipling and read Browning.

In 1894 the National Academy of Design made Beaux an associate and nine years later elected her a full member. Six of her portraits were exhibited in the Paris Salon of 1896, bringing her international attention and election as an associate to the Société Nationale des Beaux-Arts. She was also the first female recipient of the Pennsylvania Academy of the Fine Arts's Gold Medal of Honor (1898).

One of Beaux's greatest distinctions is that she was the first woman to be engaged as a full member of the Pennsylvania Academy's faculty. She taught drawing and painting from 1895 to 1916 and was in charge of the portrait classes. At Simmons College in 1907 she gave a long lecture on portraiture that can be read today in Henry S. Drinker's *The Paintings and Drawings of Cecilia Beaux* (Philadelphia, 1955).

After World War I, Beaux made a second trip to Paris, and among the late paintings that she executed on her return to America was her portrait of Georges Clemenceau, the former premier of France, who had just signed the Peace Treaty of Versailles. She had assiduously studied his features for two hours as she sat in the "Loge Diplomatique" at the Chamber of Deputies, watching him present the treaty to the French deputies for their approval. In her painting she succeeds in conveying the powerful visage of "Le Tigre."

During her last years Beaux cultivated her rock garden, which gave her so much pleasure at her summer home and studio on Eastern Point in Gloucester, Massachusetts. She died there in 1942 at the age of eighty-seven.

For this premier painting Beaux posed her sister, Aimée Ernesta, holding her firstborn son, the three-year-old Henry S. Drinker, Jr. Because the sisters' father was French, the French words for "The Last Days of Childhood" formed a natural title. In her autobiography Beaux describes the unfitness of kitchen chairs for this portrait and the substitution of a steamer chair from the storeroom, the borrowing of a good rug from her family, and the loan from the Drinkers of a small table. Young "Harry" owned the garment she wished him to wear, but since she wanted her sister in black, she lent her a "black jersey" and "draped a canton crêpe shawl" of her grandmother's over her sister's knees and lap. For the background, she found a piece of paneling in a carpenter's shop, stained it to look like mahogany, and placed it behind the figures so that their heads would rise above this horizontal wainscoting and be seen against a lighter tonality.

This early painting met with success; it was not only accepted by the annual exhibition of the Pennsylvania Academy of the Fine Arts in 1885 but it won a prize. Another Philadelphia painter, Margaret Lesley (who became Mrs. Bush-Brown) was so impressed with this painting that she took it to France and entered it in the Paris Salon of 1887.

[1] Cecilia Beaux, *Background with Figures* (Boston, 1930), 220.

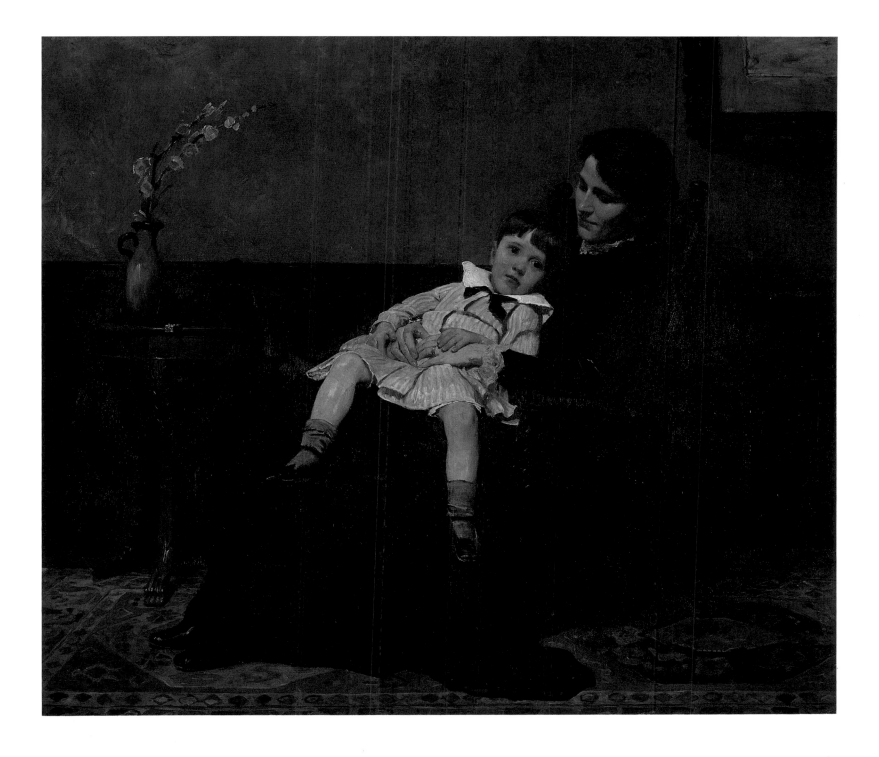

9
Cecilia Beaux (1855-1942)
New England Woman 1895
Oil on canvas, 43 × 24 in.
Pennsylvania Academy of the Fine Arts, Temple Fund Purchase

This spectacular portrait of Mrs. Jedediah H. Richards received
instantaneous acceptance: it was included in the annual exhibition of
1896 at the Pennsylvania Academy of the Fine Arts and at the Paris
Salon, and it was purchased for the permanent collection of the
Pennsylvania Academy. It remains a favorite painting with the public.
Light floods into the bedroom from an unseen window at the left, and its
illuminating rays sparkle on the sitter's white dress and on the trans-
parent white window curtains. The static scene is further brightened
by the woman's red hair, lavender cuffs and belt, and the palm-leaf fan
edged in pale green. Beaux writes proudly in her autobiography of the
New England stock on her mother's side, and this is a portrait of her
grandfather's cousin painted in Washington, Connecticut.

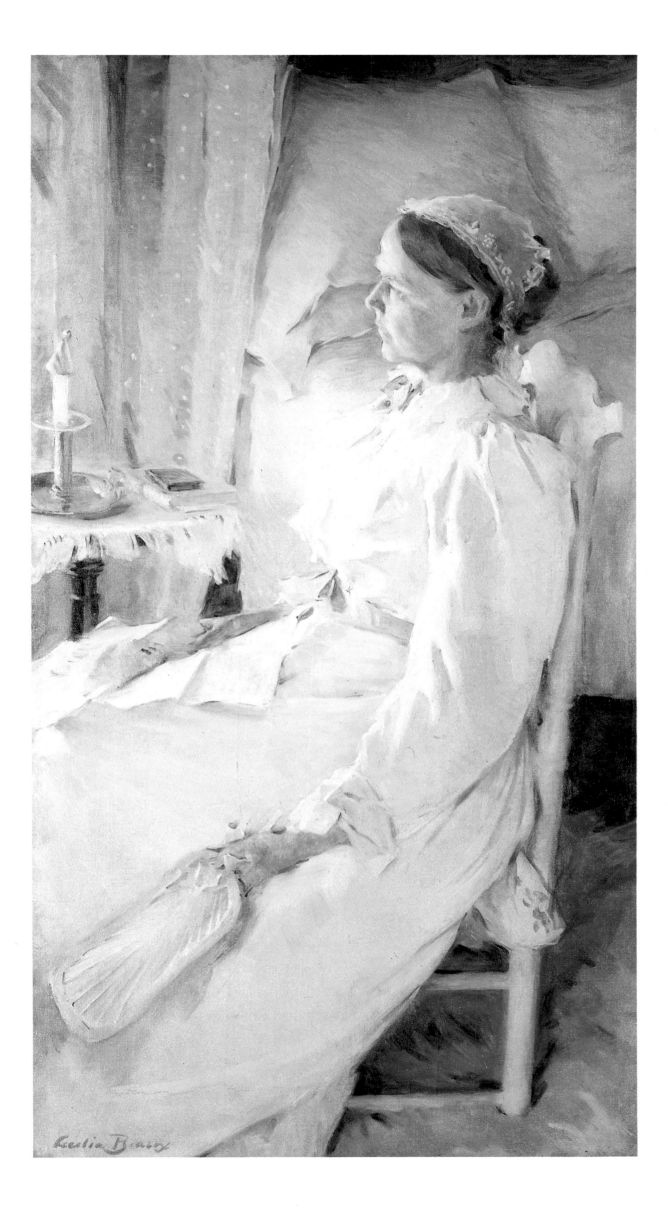

Cecilia Beaux (1855–1942)
Portrait of Bertha Vaughan 1901
Oil on canvas, $57\frac{1}{2} \times 37$ in.
Radcliffe College

Beaux painted several elegant portraits of socialites, among which this is
one of the most brilliant. The Bostonian stands in evening clothes of
green and pink, her cloak trimmed with fur; her gloved right hand holds
a *lorgnon*, while her left grasps a white feather fan. A warm red glow
emanates from the fireplace, and two brass candlesticks (paired to
heighten the recession in depth) stand on the mantelpiece in front of a
mirror. Beaux adroitly employs the device—time-honored since the days
of Poussin's self-portrait—of setting off the subject's eyes with the
horizontal reinforcement of a background frame (in this case a gold and
black oriental screen behind her head).

The adverse conditions under which the portrait was painted belie the
graciousness of the end product. Beaux distinctly remembers in her
autobiography the cabin studio of Professor Thayer's garden in which
she did this portrait of "Miss Vaughn"; she describes the wretched
icicles and the "grand wood fire" that was built to melt down her palette
and paint tubes. The dean of Radcliffe College let Beaux stay with her
that winter, and today this portrait, when not on loan, hangs in
President Matina S. Horner's office at the college.

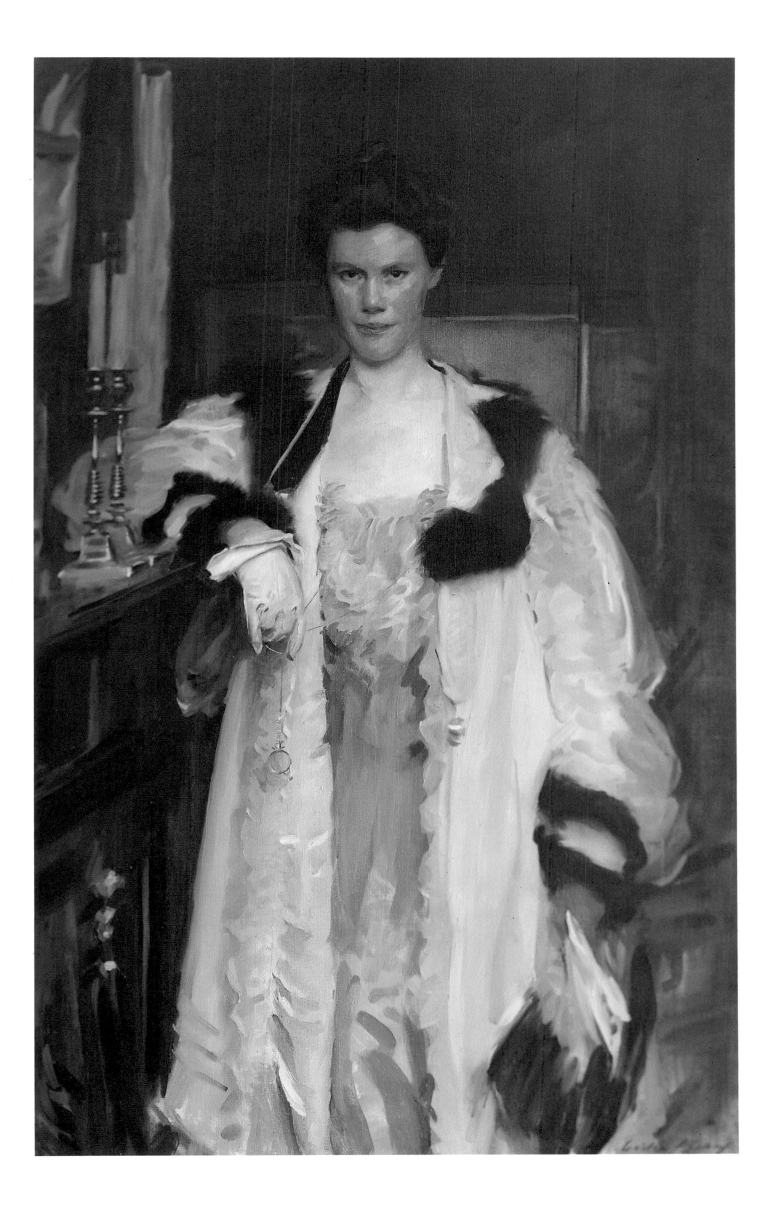

Susan Macdowell Eakins (1851-1938)
Portrait of a Lady 1880
Oil on canvas, 18 × 16¼ in.
Private collection

Throughout the Renaissance and the Baroque periods a woman generally became an artist only if she had the good fortune to have a father who was an artist and thus could provide instruction. The situation began to change in the successive centuries when occasionally a strong-willed painter like Mary Cassatt possessed the determination to pursue painting lessons on her own initiative. Susan Macdowell was fortunate enough to grow up in an artistic home. Her father was an engraver who worked with many of the leading artists in Philadelphia, and he provided his daughter with a studio in the attic. She painted portraits of numerous members of the family during the years she took courses at the Pennsylvania Academy of the Fine Arts (1876 to 1882). In the present exhibition Susan Macdowell is shown seated at her easel at the left side of Alice Barber's painting *Female Life Class* of 1879 (see cat. no. 43). As class secretary, Macdowell requested and obtained an additional life class for women. In 1879, she won the Mary Smith Prize for the best picture submitted to the academy by a woman artist residing in Philadelphia, and three years later she received the Charles Toppan Prize for her painting *The Old Clock on the Stairs*, based on Henry Wadsworth Longfellow's poem of the same name.

After Macdowell and the painter Thomas Eakins married in 1884, they both maintained studios on the fourth floor of their home in Philadelphia. She was primarily a portraitist who skillfully gave her sitters realistic three-dimensionality in interior settings. Though her palette was often rather dark, she cast a strong light on her sitters' carefully studied physiognomies. Perhaps this desire to scrutinize faces was the impetus that led her into photography early in the 1870s, even before she knew Eakins, who also became adept with the potentialities of the camera. Eakins predeceased his wife. Susan Eakins continued to paint through her eighty-sixth year and died at home on 27 December 1938.

One of the strongest paintings that Susan Macdowell did during her student years is the *Portrait of a Lady*. The woman, whose head is seen in profile, is wearing a vivid blue dress on which a tiny pink rose glistens, and she holds a colorful fan. Susan Casteras in her 1973 exhibition catalogue suggests that the sitter may be Macdowell's classmate Alice Barber. [1]

[1] Susan P. Casteras and Seymour Adelman, *Susan Macdowell Eakins, 1851-1938* (Pennsylvania Academy of the Fine Arts, Philadelphia, 1973), 44.

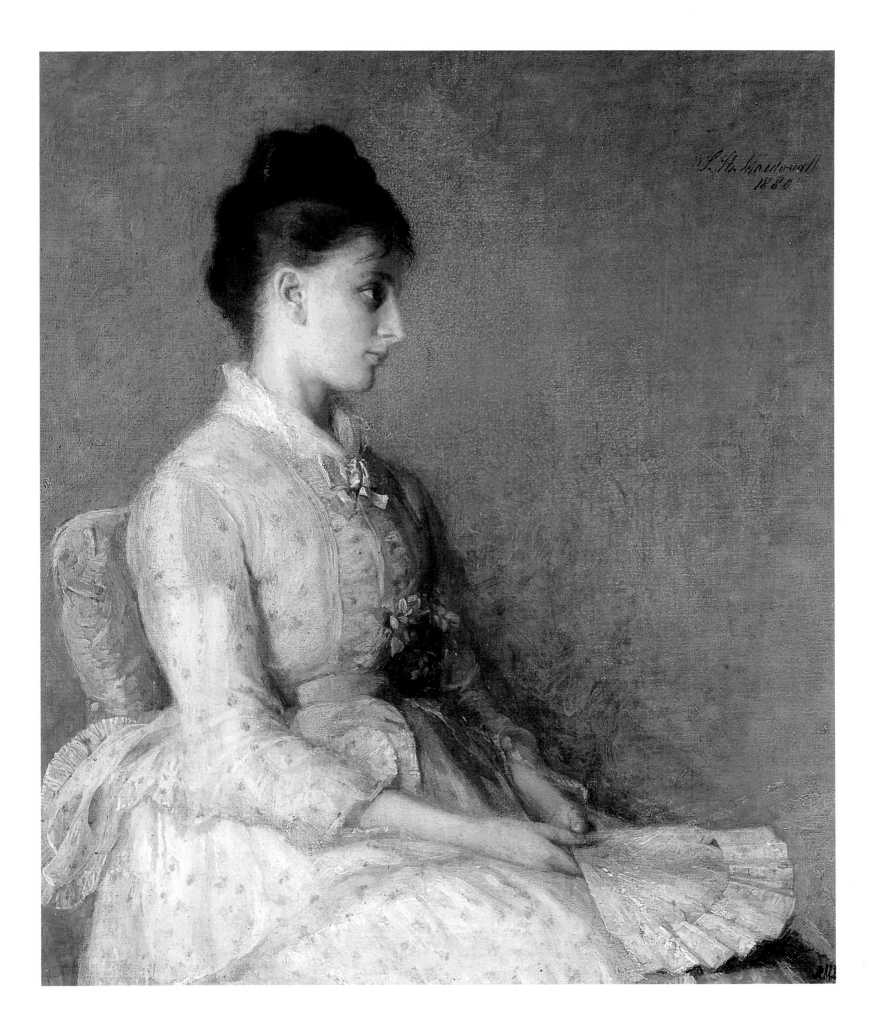

12
Susan Macdowell Eakins (1851-1938)
Portrait of Thomas Eakins c. 1920-25
Oil on canvas, 50 × 40 in.
Philadelphia Museum of Art, Gift of Charles Bregler

Thomas Eakins (1844-1916) is portrayed sitting before a canvas, holding a paint brush in his right hand, and resting his left elbow on the nearby table in a thoughtful pose. He seems wedged in closely between his easel and the table on which his palette lies. Daylight from the left is cast upon his painting hand, one side of his face, and the red and white pigments of his palette. Much of his torso is in a contrasting shadow. Susan Casteras believes that, even though the artist has written on the back "Thomas Eakins about 45 years old," the portrait may have been done between 1920 and 1925—after his death. Susan Eakins had both sketched and photographed her husband and therefore could have painted a posthumous portrait. This painting is characteristic of her close studies of serious faces.

13

Anna Elizabeth Klumpke (1856-1942)
Portrait of Rosa Bonheur 1898
Oil on canvas, 46 × 38½ in.
The Metropolitan Museum of Art,
Gift of the artist in memory of Rosa Bonheur, 1922

Anna Klumpke recounts in her *Memoirs* that the Klumpke family originally came from Holland but settled near Hanover, Germany, where her father John was born. He immigrated to the United States and settled in San Francisco. There he met and married Dorothea Tolle, a New Yorker who was visiting her married sister. Five girls and twin boys (one of whom died in infancy) were born to the couple, Anna being the eldest daughter. Anna fell from a chair in her youth, dislocating her right knee, but "surgical skill in San Francisco at that time left much to be desired,"[1] and she was left lame for life. She at first required a crutch but later was able to walk with the aid of a cane and a brace.

Eventually the parents' inability to resolve the differences between his Catholic background and her Protestant beliefs resulted in a separation, and Mrs. Klumpke decided to take her children to Switzerland for their education. After the second daughter, Augusta, completed her B.S. degree, they moved to Paris, where medical schools were open to women. All the daughters were achievers: Augusta rose to a position of importance as a neurologist; Dorothea, after obtaining her doctorate in mathematical science from the Sorbonne, became an astronomer; Mathilde, a pianist; Julia, a violinist and composer; and of course Anna, who studied at the Académie Julian under Tony Robert-Fleury and Jules Joseph Lefebvre, became a painter.

Encouragement in the form of awards came to Anna Klumpke in her years at the academy, where early on she received a medal and in 1888 the first prize. More impressively, she received an honorable mention at the Paris Salon of 1885. Funds to help her enter the academy were augmented by the sale of her copy of Rosa Bonheur's painting *Plowing in Nivernais*, which she had admired so much in the Luxembourg Museum that she had obtained permission to set up her easel in front of it for the purpose of learning how to paint. A gentleman who visited the gallery almost daily offered her $200 for her oil copy. At the Julian, classes were separate for men and women, and in the men's class a nude model posed all day, whereas in the women's class a draped model posed in the morning and a nude only in the afternoon. According to Klumpke, "The women's class had its talents, not to say its ambitions, and Marie Bashkirtseff circulated a petition that they too should be permitted to work all day after the nude model. Julian granted the request. . . ."[2]

Among the portraits that Klumpke painted in her Paris studio was one of Mrs. Randolph Coolidge and her son, which was exhibited in the Salon and subsequently purchased by the Coolidge family. This led to her being invited to Boston for additional portrait commissions, and led as well to an exhibition of her work at the St. Botolph Club. Five of her pastels, including the portrait of her mother that had been accepted by the Paris Salon, were also exhibited at the "Chicago Museum of Art."[3]

The commission of two more portraits then took Klumpke to the home of Mr. and Mrs. George Douglas Miller at Alexandria Bay on Deer Island, New York, in the St. Lawrence River. When Klumpke received a letter from Rosa Bonheur while there, Mrs. Miller asked Klumpke why she had not painted a portrait of Bonheur. This suggestion spurred Klumpke to write to Bonheur and ask if she might paint the older artist's portrait. When she received an affirmative response, she returned to France. Bonheur, who was to live only one more year, grew fond of the American artist and bequeathed her estate at By on the edge of the Fontainebleau Forest to Klumpke. Klumpke stayed at the château for the next thirty years, painting and writing Bonheur's biography. Then she and her sister Dorothea, the astronomer, returned to the United States in 1932 to view an important eclipse of the sun. In 1936 Anna Klumpke was awarded "the Cross of Officer of the Legion of Honor."[4] Retrospective exhibitions of her paintings were held at Doll and Richards Gallery in Boston and at the Palace of the Legion of Honor in San Francisco. Klumpke bought a house in San Francisco, painted landscapes and portraits, and died a decade later in her native city.

For this portrait Rosa Bonheur (1822-1899) selected a dark blue dress to which she pinned the medal of the Legion of Honor as well as the rosette denoting her second award as an officer of the Legion of Honor. The white-haired seventy-six-year-old artist is seated before her last huge painting *La Foulaison*, which stands today, unfinished, in her studio at By.

[Klumpke is also represented in this exhibition by a painting in the genre section, *In the Wash House*, 1888, cat. no. 47.]

[1] Anna Elizabeth Klumpke, *Memoirs of an Artist*, ed. Lilian Whiting (Boston, 1940), 12.
[2] Ibid., 20.
[3] Ibid., 34.
[4] Ibid., 90.

14

Ellen Day Hale (1855–1940)
Self-Portrait 1885
Oil on canvas, 28½ × 38¾ in.
Museum of Fine Arts, Boston,
Gift of Nancy Hale Bowers, Retained Life Interest

Ellen Hale came from a prominent Boston family that dates back to Nathan Hale the patriot and Lyman Beecher the preacher. Her father was the orator Edward Everett Hale, author of *The Man Without a Country*, and her great-aunts were Harriet Beecher Stowe, author of *Uncle Tom's Cabin*, and Catherine Beecher, the educator. Ellen probably received her first art lessons from her aunt Susan Hale (1833–1910), who was both an artist and an author. One of Ellen's younger brothers, Philip, also became a successful painter, as did his wife, Lilian Westcott Hale (represented in this exhibition; see cat. no. 54).

Ellen Hale's next art instruction came from Dr. William Rimmer in 1873 and then from the Boston painter William Morris Hunt and his assistant, Helen Knowlton. In the spring of 1878 and 1879, when Hale visited Margaret Lesley (see cat. no. 15) in Philadelphia, she attended classes with her friend at the Pennsylvania Academy of the Fine Arts, where she was given her earliest opportunity to paint a nude model. Hale's first exhibition—along with Helen Knowlton, Susan Hale, and Laura Coombs Hills—was at the Boston Art Club in 1878. This was followed by "the first sale ever in the United States exclusively of [works by] lady artists,"[1] which occurred in April 1881 at the Lewis J. Bird & Company auction house in Boston and included works by Ellen Hale, Helen Knowlton, and Caroline Cranch. In 1881 Hale and Knowlton traveled together in Europe before Hale entered the women's class at the Académie Colarossi. The next year she studied for four months in the class for women run by Emile-August Carolus-Duran and Jean-Jacques Henner.[2] The summer of 1882 she accompanied her father and aunt Susan on a trip through Spain and then returned to Paris to attend classes at the Académie Julian. On her second trip to Paris in 1885 she enrolled again in painting classes at the Julian. In addition, she learned etching techniques from her Philadelphia-born friend Gabrielle de Veaux Clements.

Back in America, Hale exhibited at the Pennsylvania Academy of the Fine Arts and made two trips west, expanding her subject matter to include portraits of Indians, and actually settling in Santa Barbara, California, from 1892 to 1893. Beginning in the late 1880s, Hale spent her summers on Cape Ann in Massachusetts, and by 1893 she and Gabrielle Clements had added a studio to their gray shingled house, which they called "The Thickets" after the wild plums that grew around it. At this time Hale supported herself by teaching art in Boston and by painting portraits. The sale of her etchings and commissions for church decorations augmented these earnings. Nancy Hale recalls that her painter aunt "had to climb up a stepladder to work on the upper reaches of church interiors."[3]

From 1904 to 1909, when Ellen Hale's Unitarian father served as chaplain to the United States Senate, Ellen acted as hostess for him in Washington, D.C., and during this period she made a drawing of President Theodore Roosevelt in his office "that radiates Teddy's famous gusto," according to Nancy Hale.[4] Also from these years came the commission to paint the United States Capitol's official portrait of John G. Carlisle, Speaker of the House of Representatives from 1883 to 1889.

Ellen Hale enjoyed traveling and in 1929 went on an adventurous excursion to Syria and Palestine. She continued painting into her eighties, even from a wheelchair after breaking her hip, and died in a nursing home in Brookline, Massachusetts, at the age of eighty-five.

The purposeful Ellen Hale has depicted herself here with an undaunted look as *Lady with a Fan*. Wearing black clothes and holding an ostrich feather fan, she sits with one arm over the back of a chair before a decorative blue drapery. Her head is tilted back, and her gaze is steady and unsmiling. Her niece writes, "A self-portrait painted when she was thirty-five, wearing a bonnet, against a bluish background that, with its fishlike streaks of green, resembled the bottom of the sea, shows her face was not unlovely."[5]

[Hale is also represented in this exhibition by a genre painting, *Morning News*, 1905, cat. no. 52.]

[1] Frederic A. Sharf and John H. Wright, *William Morris Hunt and the Summer Art Colony at Magnolia, Massachusetts, 1876–1879* (Salem, Mass., 1981), 21.
[2] Martha J. Hoppin, "Women Artists in Boston, 1870–1900: The Pupils of William Morris Hunt," *The American Art Journal* 13, no. 1 (Winter 1981), p. 40.
[3] Nancy Hale, *The Life in the Studio* (Boston, 1969), 103.
[4] Ibid., 100.
[5] Ibid., 105.

15
Margaret Lesley Bush-Brown (1857-1944)
Self-Portrait signed and dated 1914
Oil on canvas, $56\frac{1}{2} \times 42\frac{1}{2}$ in.
Pennsylvania Academy of the Fine Arts, Gift of the artist

Philadelphia can be proud of its nurturing of female artistic talent in the nineteenth century. In addition to producing the Peales and Cecilia Beaux, this city was also home to Sophia Towne Darrah and her sister Rosa Towne, to Catherine Drinker, and to Emily Sartain, who as principal of the School of Design for Women played an important role in appointing a strong faculty for her art school and in advocating the inclusion of women artists whenever she served on the jury for an exhibition. Another portraitist from Philadelphia was Margaret Lesley, who studied at the Pennsylvania Academy of the Fine Arts under Thomas Eakins before going to Paris in the early 1880s to study at the Académie Julian with Jules Lefebvre and Gustave Boulanger. In April 1886 she and the sculptor Henry K. Bush-Brown were married in Philadelphia and departed for a three-year stay in Paris and Italy. On their return, they established studios in Washington, D.C.

Margaret Bush-Brown's first medal was awarded at the Charleston Exposition of 1902. She exhibited regularly at the Pennsylvania Academy throughout her forty-year career. The Bush-Browns also raised three children: Lydia, born in Florence in 1887, who became well known as an artist, and two sons who became architects. Mrs. Bush-Brown, whose husband died in 1935, stayed in Washington until 1941, working as a portraitist and a miniaturist. She then returned to Philadelphia and died at the age of eighty-seven in the home of her son James in Ambler, a suburb of Philadelphia.[1]

Women artists have a long history of portraying themselves at their craft. The earliest known signed self-portraits of this type are those of Flemish painter Catharina van Hemessen in 1548 (Offentliche Kunstsammlung, Basel) and Bolognese artist Lavinia Fontana in 1579 (Uffizi, Florence).

This exhibition includes several examples of self-portraits by American women artists. One with quite a detailed ambience is this painting by Margaret Bush-Brown. She has depicted herself at fifty-seven years of age, standing in her Washington, D.C., studio with her palette and brushes in hand. She is brightly dressed in green and red, a color combination echoed in paler tones in the vase of flowers behind her. The depth of space is clearly defined through the use of chiaroscuro and through the receding lines of the mantelpiece, which is supported symbolically by two seated statuettes (one holding a book). This painting was hung in the place of honor in the Society of Washington Artists Annual Exhibition at the Corcoran Gallery of Art in 1915.

Bush-Brown's earlier, more freely brushed portrait of her father, Professor J. Peter Lesley, was accepted in 1887 for the 57th Annual Exhibition at the Pennsylvania Academy, along with her portrait of the *Honorable Frederick Fraley* and *Two Sisters*. In 1910 she painted the portrait of her friend Ellen Day Hale, a tour de force in black, with only the face illuminated in broad light; the sensitivity of a thoughtful face is especially well captured here (National Museum of American Art). Bush-Brown depicted her husband in around 1916, seated in his studio, wearing a smock and holding a sculptor's tool; one of his statuettes is placed behind him on a tall stool (The Arts Club, Washington, D.C.). She also painted portraits of the past presidents of the Southern Railroad System and of Henry T. Rainey, who was Speaker of the House of Representatives from 1933 to 1934 (United States Capitol).

[1] Obituary, "Mrs. H. Bush-Brown, Portrait Painter, 87," *The New York Times*, 18 November 1944, p. 13.

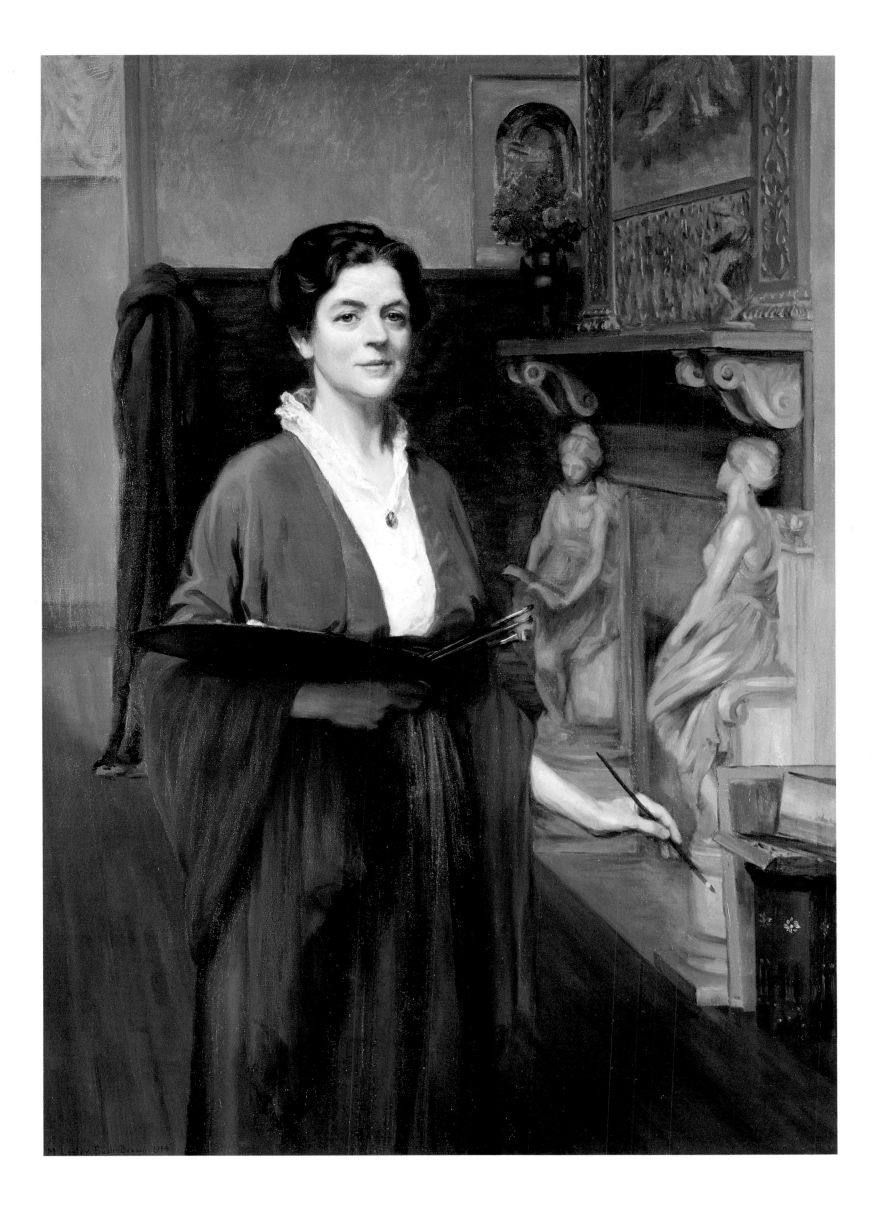

16

Margaret Foster Richardson (1881–c. 1945)
Self-Portrait, A Motion Picture 1912
Oil on canvas, $40\frac{3}{4} \times 23$ in.
Pennsylvania Academy of the Fine Arts, Gilpin Fund Purchase

Margaret Richardson, born in Winnetka, Illinois, received her art education in the East. After studying painting at the Massachusetts State Normal Art School in Boston from 1900 to 1905 with Joseph DeCamp and Ernest L. Major, she studied for two years with the painter Edmund C. Tarbell at the Boston Museum School. Her first recognition came with the Harris bronze medal and prize ($300) at the Art Institute of Chicago in 1911, followed by the Maynard portrait prize at the National Academy of Design two years later. Her *Self-Portrait, A Motion Picture*, was exhibited at the Pennsylvania Academy of the Fine Arts in 1913 before she departed on her own study tour of the art galleries of Europe—starting in Spain, continuing to Italy, Austria, Germany, Holland, Belgium, and France, and concluding in England.[1]

Among Richardson's early works are paintings in the Tarbell/ DeCamp style (inspired by Vermeer), such as the *Seated Woman*, signed and dated 1909, which was recently on the art market (Sotheby's, 26 and 27 January 1984, Lot 512). This handsome interior scene includes a full-length portrait of a seated woman, depicted in a side view and accompanied by still-life objects. There is a soft tonality to the realistic rendering of this single figure, her face averted.

Richardson was primarily a portraitist, and among her subjects were Mary Baker Eddy, founder of the Christian Science Church; Professor Robert H. Richards of the Massachusetts Institute of Technology; Dr. William E. Huntington, former president of Boston University; Admiral Phelps for the *U.S.S. Phelps*; portraits of headmasters of the Boston public schools; and portraits for the American Legion Post in Lynn, Massachusetts, and for the Public Library in Lawrence, Massachusetts.

In this extraordinary portrait the artist manages to convey the impression of movement across the canvas. This vitality made it one of the most memorable portraits from Christine Huber's landmark exhibition of 1974 entitled "The Pennsylvania Academy and Its Women." It is as if Richardson wanted to do in oil what Eadweard Muybridge had done in photography. The bespectacled figure, clothed in a long-flowing gray gown, strides energetically across the canvas, grasping paintbrushes in both hands. A winsome smile animates her eager face.

[1] Letter from Margaret F. Richardson to the Pennsylvania Academy of the Fine Arts, from Fenway Studios, Boston, 11 September 1939.

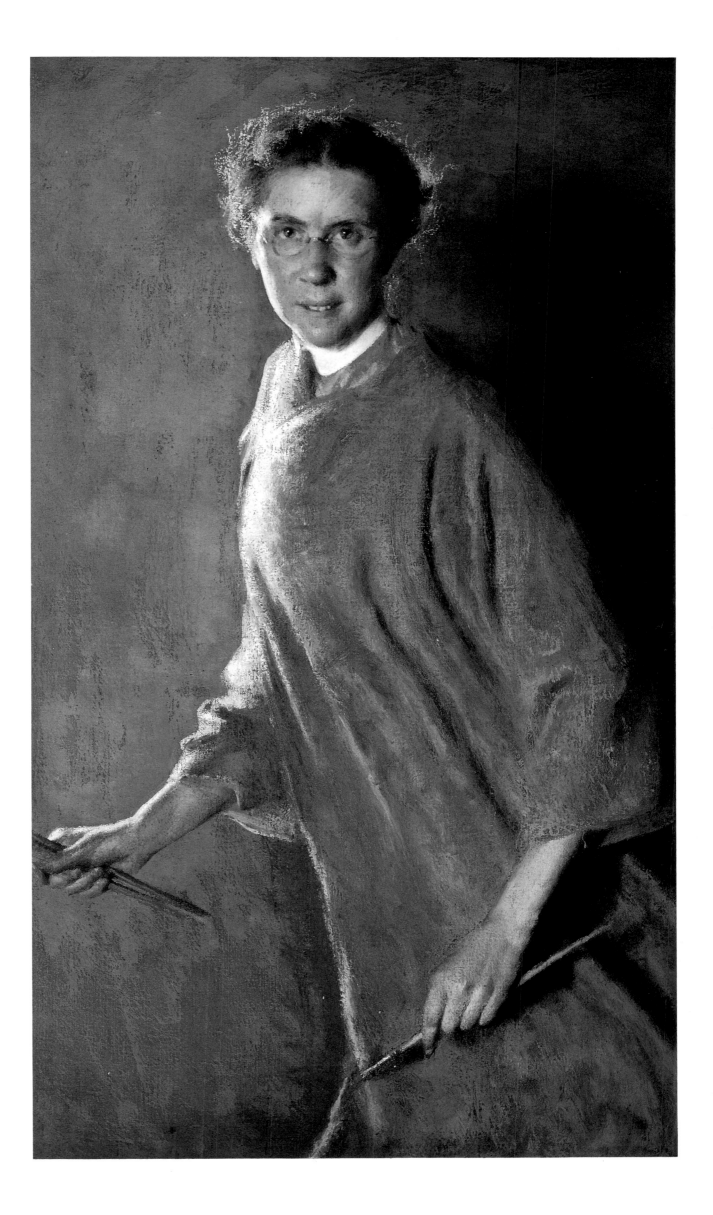

Ellen Emmet Rand (1876–1941)
Portrait of Henry James 1900
Oil on canvas, $21\frac{1}{2} \times 16\frac{1}{4}$ in.
Leon Edel

In America at the turn of the century the Emmet family boasted several popular painters: Rosina Emmet and her two sisters, Lydia and Jane, who were born in New York; and their younger cousin Ellen, who was born in San Francisco to parents who had moved there during the gold rush. Ellen's family moved back to New York after her father's death in 1884. Her art instruction consisted of drawing lessons at a very early age with Dennis Bunker in Boston, classes at the Art Students League from 1889 to 1893, then study one summer with William Merritt Chase at Shinnecock on Long Island, and three years in the Paris studio of Frederick MacMonnies, who had just switched from sculpting to painting.

On her return to New York in 1900, Ellen Emmet took a studio in Washington Square and became so busy with portrait commissions that Durand-Ruel Galleries could give her a one-woman exhibition as early as 1902, and ninety of her paintings were shown at Boston's Copley Hall in 1906. Solo exhibitions were a new idea at this time; only Whistler, Sargent, and Monet had been given one-man shows at Copley Hall before Emmet.[1] Emmet's marriage to William B. Rand in 1911 and the birth of three sons in the next three years did not prevent her from resuming her career. In fact, her income supported the family. During the school year the children stayed with her in a New York apartment on East 57th Street overlooking the East River, where she maintained a bustling new studio. They spent the summers on a farm in Salisbury, Connecticut, which her husband ran and where she kept a second studio.

Ellen Emmet Rand was awarded a silver medal at the St. Louis World's Fair in 1904, a bronze medal at the Buenos Aires Exposition of 1910, a gold medal at the Panama-Pacific Exposition of 1915, and the Beck Gold Medal at the Pennsylvania Academy of the Fine Arts in 1922. The National Academy of Design elected her an associate in 1926 and an academician in 1934. With some eight hundred portraits to her credit, it is reported that she earned $74,000 in 1930 at the peak of her career. She painted portraits of Pablo Casals, Augustus Saint Gaudens, Henry Francis du Pont, Mark Hanna, Henry Stimson, and President Mac-Cracken of Vassar College, and her portrait of *President Franklin D. Roosevelt* of 1934 is permanently on display in the Franklin D. Roosevelt Library at Hyde Park. After enjoying a stellar success, Ellen Emmet Rand died of a heart attack in a New York City hospital in her mid-sixties.[2]

"Bay" Emmet, as she was called, painted her cousin Henry James at Lamb House in Rye, England, when he was writing *The Ambassadors* and she was concluding her three years of study in Paris before returning to New York. James varnished the portrait himself, found an old frame for it, and hung it above the sideboard in his dining room where it remained until his death in 1916. Now it is a cherished possession of James's prize-winning biographer, Leon Edel.

This is a close-focus bust portrait of James's "newly-shaven countenance."[3] The reflected light shines on the balding head of the fifty-seven-year-old writer. He wears a beige vest, a dark suit jacket, and a sporty white bow tie. As always in Emmet's portraits, she achieves a penetrating facial characterization and lavishes attention on the hands. In this case the fingers of the right hand are plastically modeled, and they firmly grip the author's glasses. In her portrait of Endicott Peabody, headmaster of Groton School, the hands are clasped together on top of a table; in the three-quarter-length portrait of Robert W. De Forest, president of the American Federation of Arts and of The Metropolitan Museum of Art, one hand rests on the other; and in her portrait of William James (dated 1910, Harvard University), Professor James stands in his book-lined study, holding a sheaf of papers in his right hand with his left arm akimbo.

Edel has written that when the *Portrait of Henry James* was cleaned, the restorer found an earlier, bouncier sketch that Emmet did looking downward at the sitter, whose nose was painted with a great deal of red. The young artist, presumably in awe of her well-published cousin, opted in the end for a more sedate portrait. James wrote her two years later that the portrait served to remind him of "our so genial, roasting romantic summer-before-last here together, when we took grassy walks at even-tide and in the sunset, after each afternoon's repainting."[4]

[1] Albert F. McLean, Jr., "Ellen Gertrude Emmet Rand," *Notable American Women 1607–1950*, vol. 3 (Cambridge, Mass., 1971).
[2] Obituary, "Mrs. Ellen Rand, Noted Artist Dies," *The New York Times*, 19 December 1941, p. 25, says she "died here yesterday at the age of 65."
[3] Leon Edel, *Henry James, The Master* (Philadelphia and New York, 1972), vol. 5, p. 68.
[4] Ibid., 69.

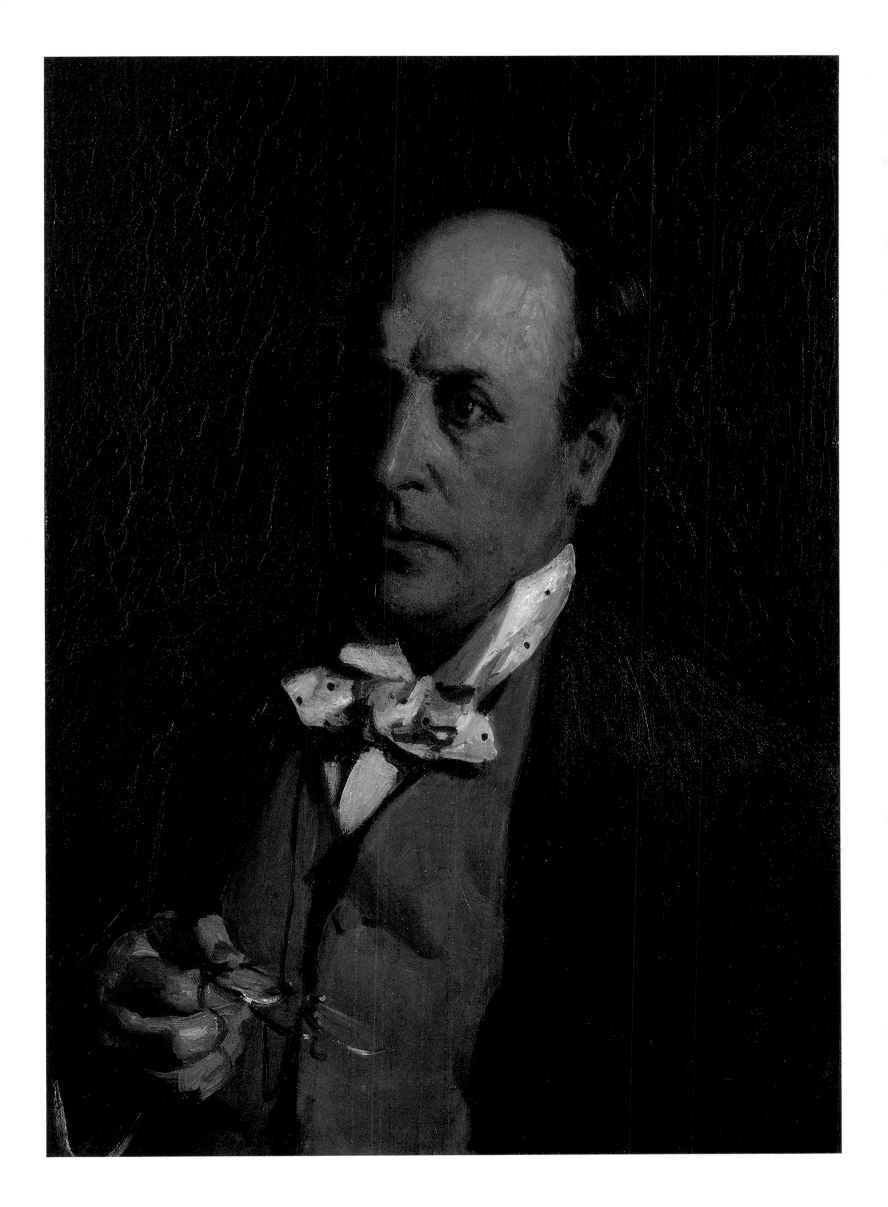

18

Ellen Emmet Rand (1876-1941)
In the Studio signed and dated 1910
Oil on canvas, $44\frac{1}{4} \times 36\frac{1}{4}$ in.
The William Benton Museum of Art, The University of Connecticut,
Gift of John A., William B., and Christopher T.E. Rand

Eleanor Peabody, the niece of the artist, is portrayed seated in a chair
before a large gold-framed mirror that reflects the interior of the studio.
The reflection shows the sitter's back, the artist standing at her stretched
canvas, and a green plant. Emmet probably had in mind Velázquez's
self-portrait in front of a large canvas in *Las Meninas*. Evidence of her
teacher William Merritt Chase's admiration for Velázquez can be found
in Chase's letter to Dora Wheeler, a classmate of the Emmets, in which
he exclaims that Velázquez is the greatest painter who ever lived.[1] John
Singer Sargent, whom Emmet met in London in 1896 en route to Paris,
was also a Spanish aficionado.

The black cat in young Eleanor's lap is beautifully set off against her
white dress, and the golden light on her hair is cleverly reflected in the
mirror image, as are the black bow in her hair, the cat's tail, the sole of
her shoe, and the back of the armchair. This painting, with its complex
composition, won a gold medal at the Panama-Pacific Exposition in
1915 and won the National Arts Club Prize in 1925.

[1] Candace Wheeler, *Yesterdays in a Busy Life* (New York, 1918), 247.

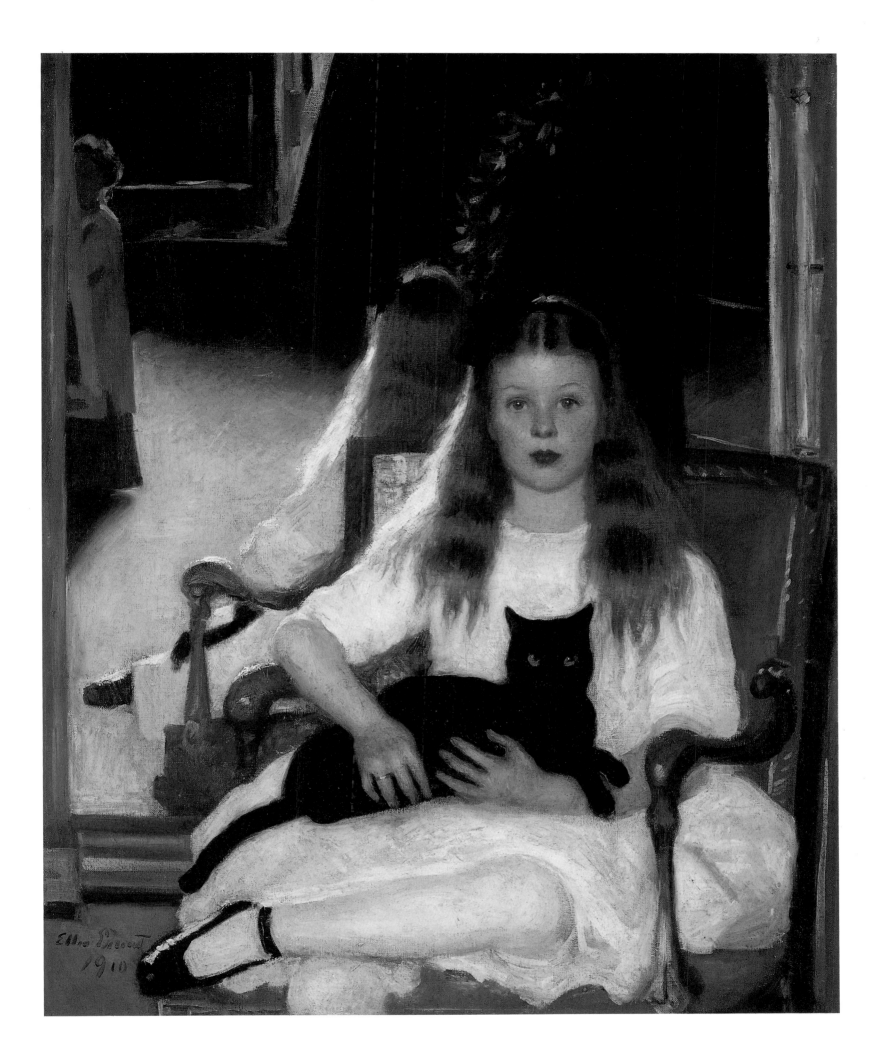

19
Marie Danforth Page (1869-1940)
Portrait of Henry, c. 1921
Oil on canvas, $44\frac{1}{2} \times 24\frac{1}{4}$ in.
Private collection

At seventeen the native Bostonian Marie Danforth began to take drawing lessons from Helen Knowlton, a well-established teacher and artist, with whom she studied until 1889. She spent the next five years at the School of the Museum of Fine Arts, Boston, as a student in the painting classes of Frank W. Benson and Edmund C. Tarbell. Upon her marriage to Dr. Calvin G. Page in 1896, the couple settled at 128 Marlborough Street in Boston, where the artist had a studio on the top floor. After a trip to Europe during which she copied Velázquez's paintings in Spain, she began to receive commissions, although at first some were simply for copies of portraits by earlier famous artists, such as Gilbert Stuart. Before long, however, she was being sought out by the leading families for original portraits. When three of her paintings were accepted for the Panama-Pacific Exhibition in 1915, Page traveled through the Panama Canal to attend the exhibition in San Francisco and receive a bronze medal. The next year her paintings were awarded prizes at the National Academy of Design and at the Newport Art Association. Her first one-woman exhibition was at the Guild of Boston Artists in 1921. Additional awards were accorded her before she was elected an associate at the National Academy of Design in 1927. More prizes (including an honorary M.A. from Tufts University) and almost yearly exhibitions followed until her death in Boston. During the Depression, when commissions fell off, she painted the Boston Symphony Orchestra in rehearsal under the conductor Serge Koussevitzky. The *Portrait of President Woolley* of Mt. Holyoke College, requested by the Class of 1931, seems to have been Page's last commission.

Today many of Page's finest paintings remain in family hands, among them some of her most complex compositions, which include mirror images. She was also successful in combining children in ambitious large domestic settings, such as *Sam, Lewis, and Ward*, 1912 (still in the Thorne family today).

Harvard University owns six portraits of professors by Marie Page, executed between the years of 1928 to 1931. Dr. Cannon is painted full-length in a laboratory; Professor Christian wears a doctoral robe with a purple and gold hood and a green necktie, echoed by the green hue in the background of the painting; and Dr. Monks is seated, wearing a dark gray suit with a vermilion tie that matches the red of the table covering at the left. Some of the other portraits are posthumous and were done from photographs. Because all but one are in the medical school, it is conceivable that the first commission may have been initiated through friendship, since Dr. Calvin Page taught at the Harvard Medical School from 1911 to 1925.

The sitter shown here, now a highly respected physician, recalls that he was about eight when Marie Page painted his portrait. The tall, thin boy with the closely cropped blond hair and steadfast blue eyes is a perfect hint of the present six-foot seven-inch gentleman, still thin, with closely cropped white hair and resolute mien.

Like Page's other portraits of children, one accoutrement accompanies the sitter. In this case the boy, clad in a white sailor suit, holds a toy sailboat in his left hand. Page creates an immediate communication with the youth by painting a three-quarter-length portrait, thus bringing the upper torso and visage closer to the viewer. The painter artistically silhouettes the brightly lit figure against a dark opaque background.

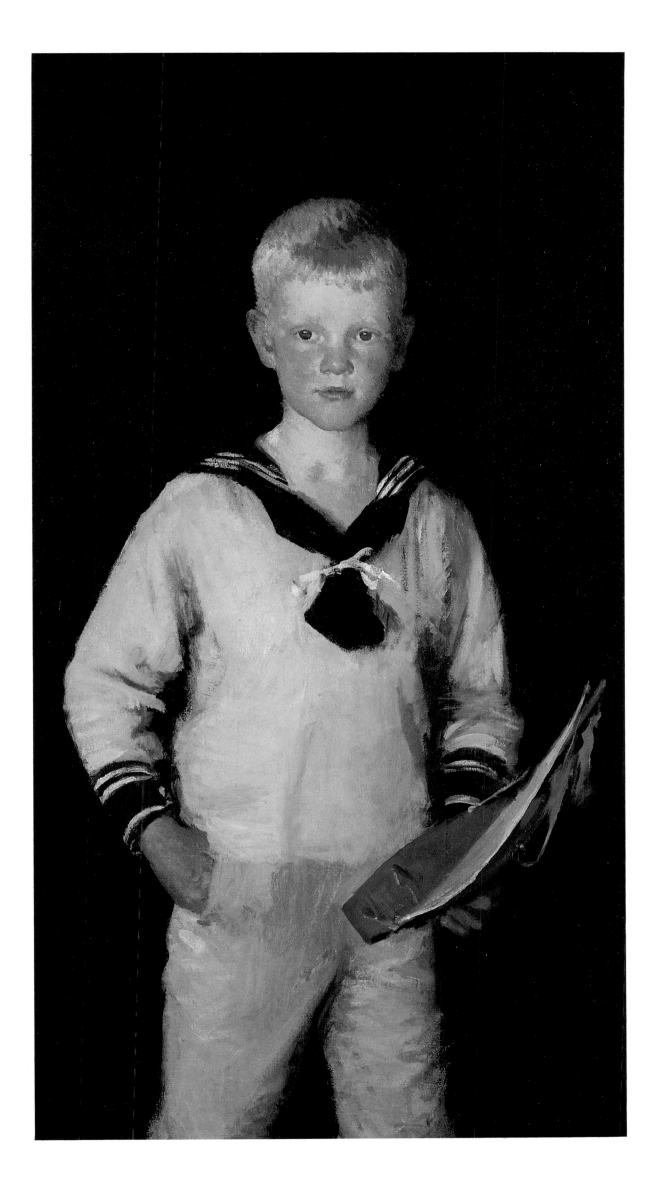

Lydia Field Emmet (1866-1952)
Portrait of Olivia 1911
Oil on canvas, 64 × 40½ in.
National Gallery of Art, Washington, Gift of Olivia Stokes Hatch

In Washington, D.C., on Massachusetts Avenue at 24th Street, stands a statue of the Irish patriot Robert Emmet, brother of Lydia Field Emmet's great-grandfather, Thomas Addis Emmet, who immigrated to the United States in 1804 and became attorney general of New York during the administration of DeWitt Clinton. His daughter Elizabeth (1794-1878), a portraitist, was the first in a dynasty of Emmet painters in America. In the next generation Julia Colt Pierson, who married William J. Emmet, studied art with the New York painter Daniel Huntington, and undoubtedly it was she who encouraged her daughters Rosina (b. 1854), Lydia (b. 1866), and Jane (b. 1873) to become artists. The tradition was continued into a fourth generation by Elizabeth Winthrop Emmet and Rosamond Sherwood, and into a fifth by Julia Townsend, granddaughter of Rosina Emmet Sherwood.

At the age of seventeen Lydia Emmet accompanied her older sister Rosina to Europe, where they enrolled for classes at the Académie Julian along with Bostonians Elizabeth Boott and Ellen Hale. A letter from Rosina proudly states that Lydia "got first prize for her composition over Miss Boott and Ellen Hale."[1] On her return to New York in 1885, Lydia studied with William Merritt Chase from 1889 to 1895 at the Art Students League. When Chase began his summer school at Shinnecock Hills in 1891, she was sufficiently advanced that he put her in charge of the preparatory class.

In her early work Lydia Emmet painted a wide range of subjects, including a mural, *Art, Science, and Literature*, for the Woman's Building at the World's Columbian Exposition of 1893 in Chicago, but soon her reputation as a portraitist of children superseded all else, and she was able to command handsome prices for her many commissions.

Emmet's obituary in the *New York Herald Tribune* mentions her portrait of Mrs. Herbert Hoover in the White House and states that Emmet died at the age of eighty-one in her home at 214 East 70th Street, New York. She still maintained her two studios (535 Park Avenue, New York, and for the summer, Strawberry Hill in Stockbridge, Massachusetts), and until her eightieth year she swam daily in her pond! She began building Strawberry Hill in 1905 and for many years would ride by horseback from New York to Stockbridge, breaking the trip with stops at the homes of friends along the Hudson River; then in the fall she would return on her horse to New York. In the Berkshires she acquired another mode of travel: a yellow Model T Ford, nicknamed "Yellow Peril" because of the breakneck speed with which she drove.

Lydia Emmet became famous for large portraits of children like this one of Olivia Stokes, daughter of Anson Phelps Stokes, a clergyman who was secretary of Yale University at the time of this commission and later served as canon of the Washington Cathedral. The Stokes were a prominent New York family: Olivia's grandfather, a financier, aided in the founding of The Metropolitan Museum of Art; the aunt for whom she was named was a philanthropist; and her uncle, the architect I.N. Phelps Stokes, was portrayed with his wife in 1897 when they were in Paris, by John Singer Sargent in an impressive painting that hangs today in the Metropolitan Museum. Olivia, who married John Davis Hatch in 1939, was residing in Lenox, Massachusetts, when she was killed in 1983 in an automobile accident.

Most arresting in this portrait is Olivia's radiant smile. Compelling from a compositional point of view is her golden hair, fully revealed because her hat, with lavender flowers on its brim, has slipped off and is being held suspended at her back by its ribbons. Her coral necklace provides a bright note to contrast with her white dress. Balancing the figure of the child is a vase of red flowers on a side table in the background to the left. This painting was awarded honorable mention at the Carnegie Institute's Sixteenth Annual Exhibition.

Some of Emmet's portraits of children were challenging to compose, such as *The Four Daughters of Winthrop Aldrich* (1927, Museum of the City of New York), in which we see her skill at varying the poses and yet combining four youngsters skillfully around an ample curule chair before a Japanese screen.

[1] Martha J. Hoppin, *The Emmets: A Family of Women Painters* (The Berkshire Museum, Pittsfield, Mass., 1982), 20.

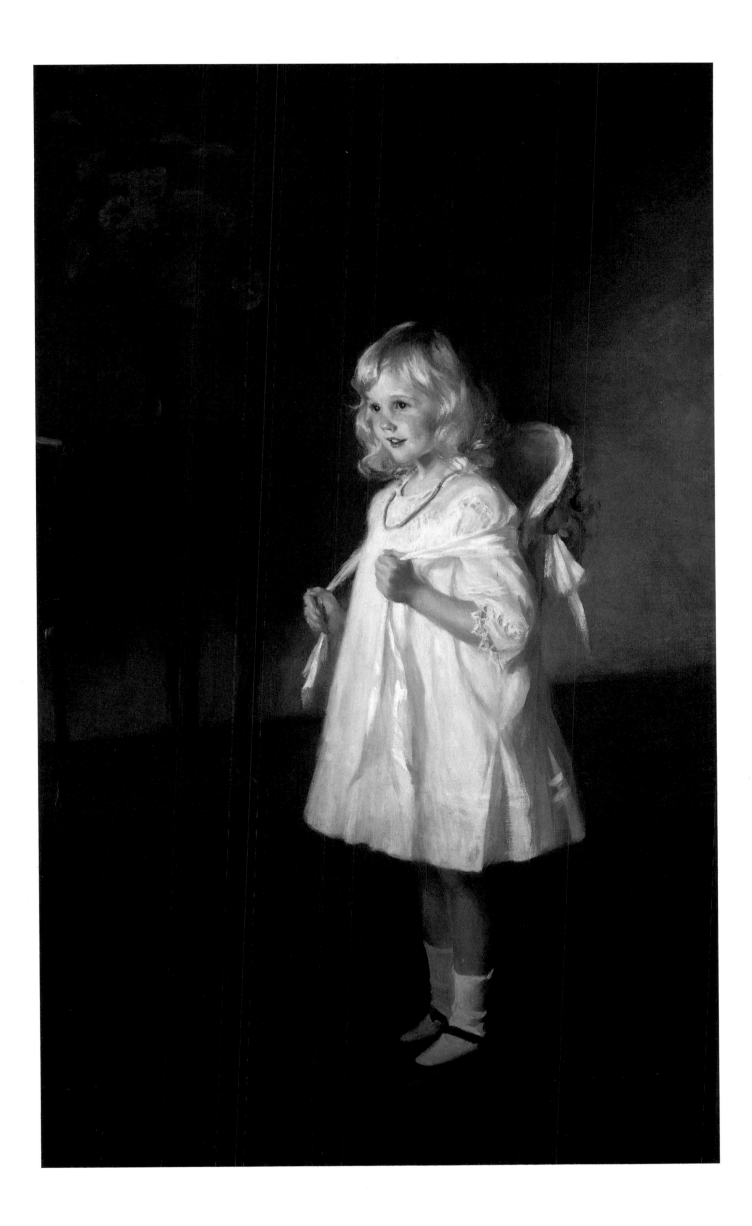

Marion Boyd Allen (1862‑1941)
Portrait of Anna Vaughan Hyatt 1915
Oil on canvas, 65 × 40 in.
Maier Museum of Art, Randolph‑Macon Woman's College,
Lynchburg, Virginia

The Bostonian painter Marion Boyd Allen began her career as a portraitist but late in life became more adventurous, traveling tirelessly through the American West in order to paint one scenic panorama after another. A headline in *The Art Digest* of 1934 reads "At 67, Mrs. Allen Braves Wilds to Paint," above an illustration of her painting *Brahma and Zoroaster, Grand Canyon of Arizona*, in a review of her exhibition of nineteen canvases at the Argent Galleries. The review relates that Mrs. Allen "does not hesitate to ride many miles over rough trails and to live in isolated cabins to get material for painting. As one friend remarked: 'She loves and understands the mountains, taking risks and undergoing hardships which would frighten many a painter. She has painted much in the North West of our country and has given those who have never braved mountain tops an idea of their grandeur.'"[1] An idea of the distance Allen covered is given by the title of this 1934 exhibition at the Argent Galleries (42 West 57th Street, New York): "Paintings of Grand Canyon of Arizona, Olympic Mts., Rainier and Canadian Rockies." Her entry in the annual exhibition of the National Association of Women Painters and Sculptors in 1931 was *Tahoma and Puyallup Glaciers, Mt. Rainier*.

An earlier exhibition (1928) at the Ferargil Galleries (37 East 57th Street, New York) gave evidence of the new split in her subject matter, consisting of one‑third portraits and two‑thirds landscapes. Among the fifteen paintings were *Lake Louise, Cathedral Mountain, Heights Above Lake Louise, Early Morning and Margot, The Ship‑Builder, Carlotta*, and *Portrait of Dallas Lore Sharp*.

The Boston native had studied with Edmund C. Tarbell and Frank W. Benson at the School of the Museum of Fine Arts. In 1905 she married William Augustus Allen. Her painting *Enameling* was accepted for the Panama‑Pacific International Exposition of 1915. The earliest awards accorded her work were honorable mention at the Connecticut Academy of Fine Arts in 1915 and 1921, the People's Prize at the Newport Art Association in 1919, and the Hudson Prize at the Connecticut Academy of Fine Arts 1920. In the 1930s, when she was still winning prizes—for instance, the Club Prize at the New Haven Paint and Clay Club in 1932—she was living at 60 The Fenway, Boston, while maintaining a studio at 30 Ipswich Street, in the same building where her contemporary Margaret Fitzhugh Browne (see cat. no. 61) was also working in her studio. Allen outlived her husband and died in Boston at the age of seventy‑nine.

Marion Allen and Anna Hyatt Huntington, as two of a small breed of women artists in Boston, were probably friends. Certainly the informal nature of this portrait—a side view of the artist at work in her studio—is in sharp contrast to the formal portraiture that was de rigueur in Boston at this time. Allen had depicted the elderly Italian general Giuseppe Garibaldi, attired in a resplendent red uniform, quietly sitting by a table. In another portrait entitled *Song Without Words* Allen had painted a woman seated in a chair and holding a violin—a work typical of the style of "The Ten," the group founded by her two teachers.

This portrait of Anna Hyatt Huntington actually creating a sculpture (see cat. no. 120) is far from the usual fare. What is similar to other paintings by Allen is the richness of the white pigment and the subtle tonality of the blue skirt. The modeling of the figure is also characteristically strong. The fact that this painting was in Allen's 1928 exhibition at the Ferargil Galleries in New York would suggest that the artist had not done the painting as a commissioned portrait for the Hyatt family but simply as an artistic composition.

The only light that Anna Huntington later threw on this subject was in 1958 when she wrote, "Mrs. Allen did the portrait in my studio at Annisquam on Cape Ann, when I was making an early maquette for my Joan of Arc statue."[2] Huntington's husband liked the portrait so much that he tried to buy it from Randolph‑Macon College. The college would not sell it but allowed Marion Allen to make a copy (in 1934), which now hangs in the library of the Mariners Museum in Newport News, Virginia.

[1] *The Art Digest* 8 (1 February 1934), 16.
[2] Mary Frances Williams, *Catalogue of the Collection of American Art at Randolph‑Macon Woman's College* (Charlottesville, 1977), 37.

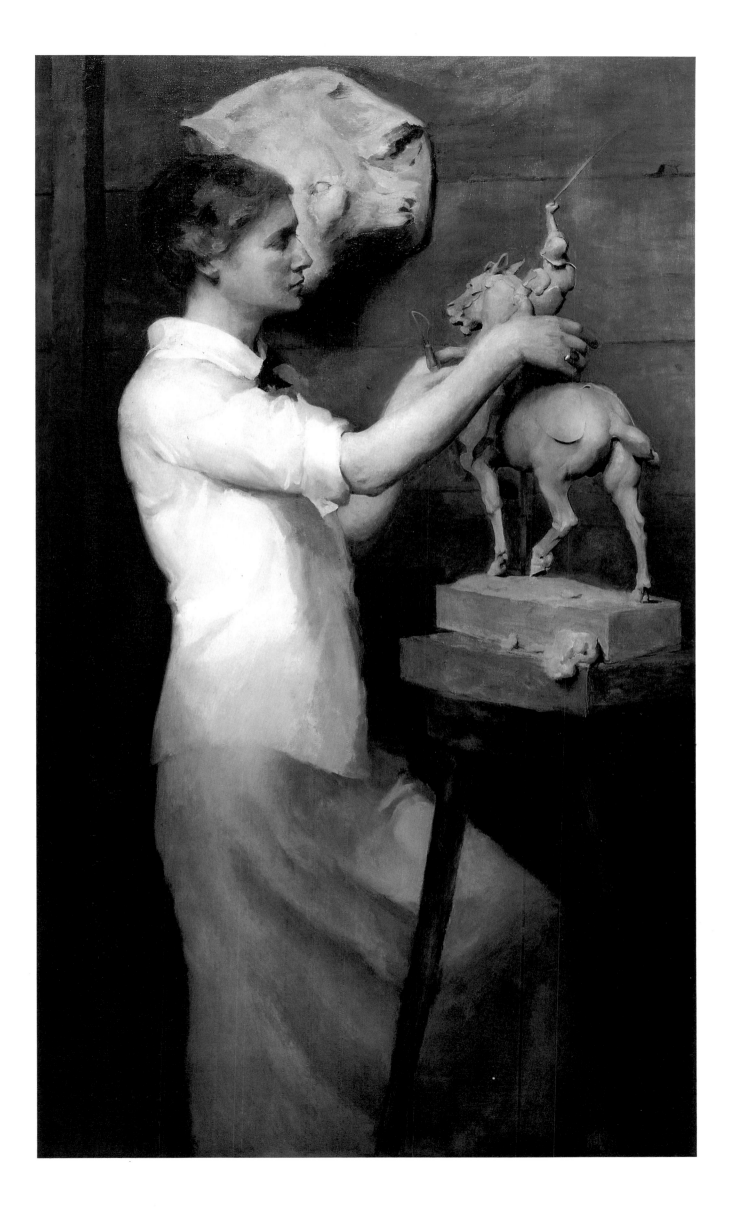

22

Jean MacLane (1878-1964)
The Visitor 1907
Oil on canvas, $65\frac{1}{2} \times 37\frac{1}{2}$ in.
Balogh Gallery, Inc., Charlottesville, Virginia, and
Christopher T.E. Rand

Jean MacLane is one of the critical discoveries of this exhibition; she is represented by three paintings in the portrait and genre categories, chosen from a wide selection of her works. Her *Fountain, Paris*, with a golden evening light reflected in the water, and her vivacious *Children in the Surf* are also spectacular.[1] During the first three decades of this century MacLane exhibited across the country and was constantly covered in the press, but since then her reputation has been eclipsed.

She was born Myrtle MacLane in Chicago in 1878 and went through various name transformations, finally settling on Jean for her first name but for a period spelling her last name McLane. After studying with John Vanderpoel at the Art Institute of Chicago, from which she graduated in 1897, MacLane studied with Frank Duveneck in Cincinnati and William Merritt Chase in New York. In 1905 she married the painter John Christen Johansen, who had earlier been a student at the Art Institute of Chicago. They set up adjoining studios in New York and traveled to Europe whenever they could afford it. Among MacLane's paintings are many beach scenes of Devonshire from the 1920s and portraits of her children, Margaret and John.

In 1912 the National Academy of Design made MacLane an associate and in 1926 a full academician. The long list of her awards begins with a bronze medal at the St. Louis Exposition in 1904; then prizes at the New York Woman's Art Club in 1907 and 1908; first prize at the International Art League, Paris, in 1907 and 1908; prizes at the National Association of Women Painters and Sculptors in 1907 and 1919; prizes at the National Academy in 1912, 1913, 1923, and 1935; prizes at the Pennsylvania Academy in 1914 and 1936; silver medal at the Panama-Pacific Exposition in San Francisco in 1915; and a prize at the Art Institute of Chicago in 1924. Her paintings are in the permanent collections of the Toledo Museum of Art, the Art Institute of Chicago, the Berkshire Museum in Pittsfield, Massachusetts, the San Antonio Art Museum, the Everson Museum of Art in Syracuse, New York, and the Milwaukee Art Museum.

During their last years MacLane and her husband lived in their daughter's home in New Canaan, Connecticut. MacLane died in a Stamford, Connecticut, nursing home on 23 January 1964, in her eighty-sixth year,[2] and her husband, still painting at eighty-seven, died five months later.

With an unerring eye for dramatic heightening, MacLane painted this life-size, full-length portrait of her maid in Paris. A fancy shawl with a colorful border has been placed over the maid's left shoulder and a hat decorated with purple flowers and ribbon is held in her right hand. The maid's dark glove stands out against the warm yellow lining of her jacket. Although the maid actually poses as a model would, she is shown in a natural gesture of knocking at the door and has a pleasant expression on her face. A diagonal thrust into space in the composition is created by the position of the chair, the open door, the patch of sunlight on the sitter's neck, and the luminous passage of light behind her standing figure.

Commissions for several portraits followed: a double portrait of a *Mother and Daughter* (reproduced in "Famous American Women Painters" in 1914[3]), of *Frances Perkins*, secretary of the United States Department of Labor—the first female cabinet member (1935)—and of *Elizabeth, Queen of the Belgians*, 1921.

[1] Seen at Balogh Gallery, Charlottesville, Va., and illustrated in Frederick Platt, *Jean MacLane* (Balogh Gallery, Charlottesville, 1984).
[2] Obituary, *The New York Times*, 24 January 1964, p. 24.
[3] Arthur Hoeber, "Famous American Women Painters," *The Mentor* 2, no. 3 (16 March 1914), p. 5.

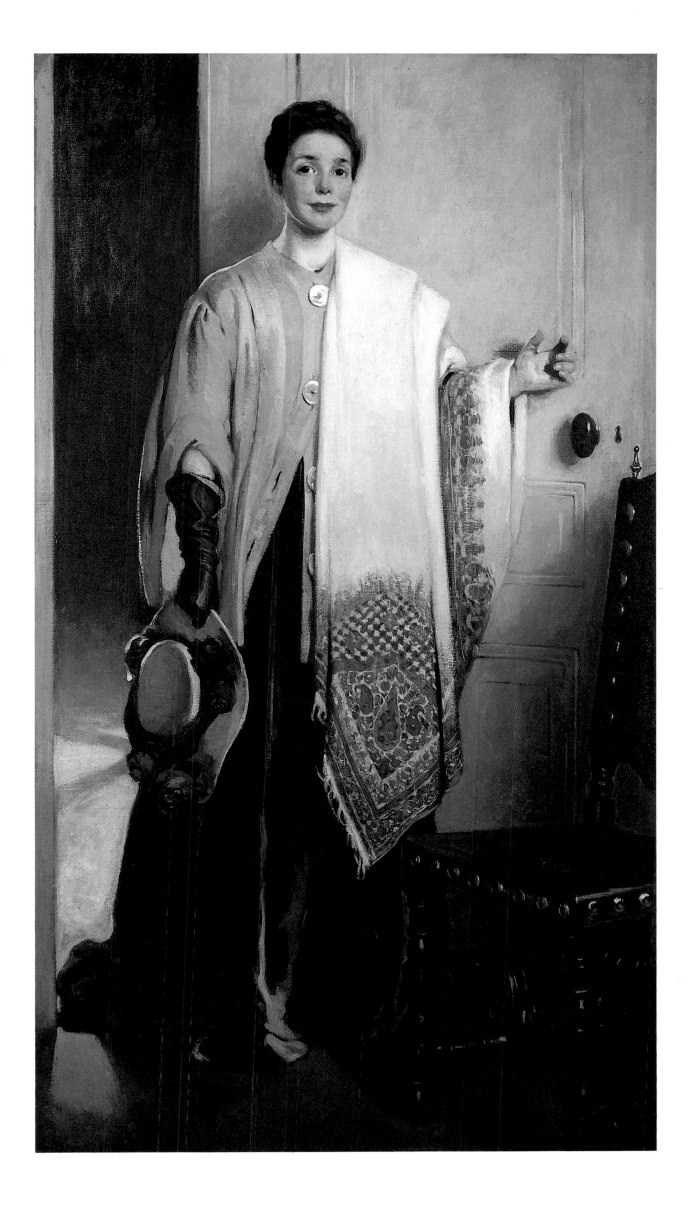

23
Jean MacLane (1878-1964)
Elizabeth, Queen of the Belgians signed and dated Bruxelles 1921
Oil on canvas, $62\frac{3}{8} \times 45\frac{3}{8}$ in.
National Museum of American Art, Smithsonian Institution,
Gift of the National Art Committee

In 1919 a movement was initiated in the United States to establish a
national portrait gallery, and eight American painters were chosen to
make three portraits each of important international personages at the
close of World War I.[1] All of the painters were given extra funds to
travel overseas to carry out their commissions. The two women selected
as portraitists were Cecilia Beaux and Jean MacLane. Beaux's three
subjects were Admiral Beatty, Cardinal Mercier, and Georges
Clemenceau (cat. no. 8); MacLane's were the queen of Belgium and the
prime ministers of Australia and Greece, but she completed only the
first, probably because travel to Australia and Greece would have posed
a problem in view of the distance and her family responsibilities.
Edmund C. Tarbell, Joseph DeCamp, and John Christen Johansen
were among the men chosen for the project. The National Portrait
Gallery did come into existence eventually, but since its policy is to
include portraits of only American sitters, most of these commissions
today rest in storage at the National Museum of American Art.

Her Majesty Elizabeth, the daughter of Duke Charles Theodore of
Bavaria, was born at the Castle of Possenhoven in 1876 and married
Albert, Duke of Saxony, in Munich on 2 October 1900. Albert I
succeeded his uncle, King Leopold II, in December 1909 to become
king of the Belgians and commander-in-chief of the Belgian armies.
During World War I Elizabeth became known for her relief work.
Then in 1919 after the war the king and queen visited the United States
with their son Prince Leopold. Two years later MacLane went to
Brussels to paint this portrait.

The attractive queen is portrayed in a white evening dress with a dark,
fur-collared cloak around her slim shoulders. She wears a long pearl
necklace, and a large emerald is centered on the silver band in her
auburn hair. She sits regally on a purple cushion in a low chair with
carved and gilded arms.

[MacLane is also represented in this exhibition by a genre painting,
Seaside Situation, late 1920s, cat. no. 57.]

[1] Frederick Platt, "The War Portraits," *Antiques* 26, no. 1 (July 1984), pp. 142-53.

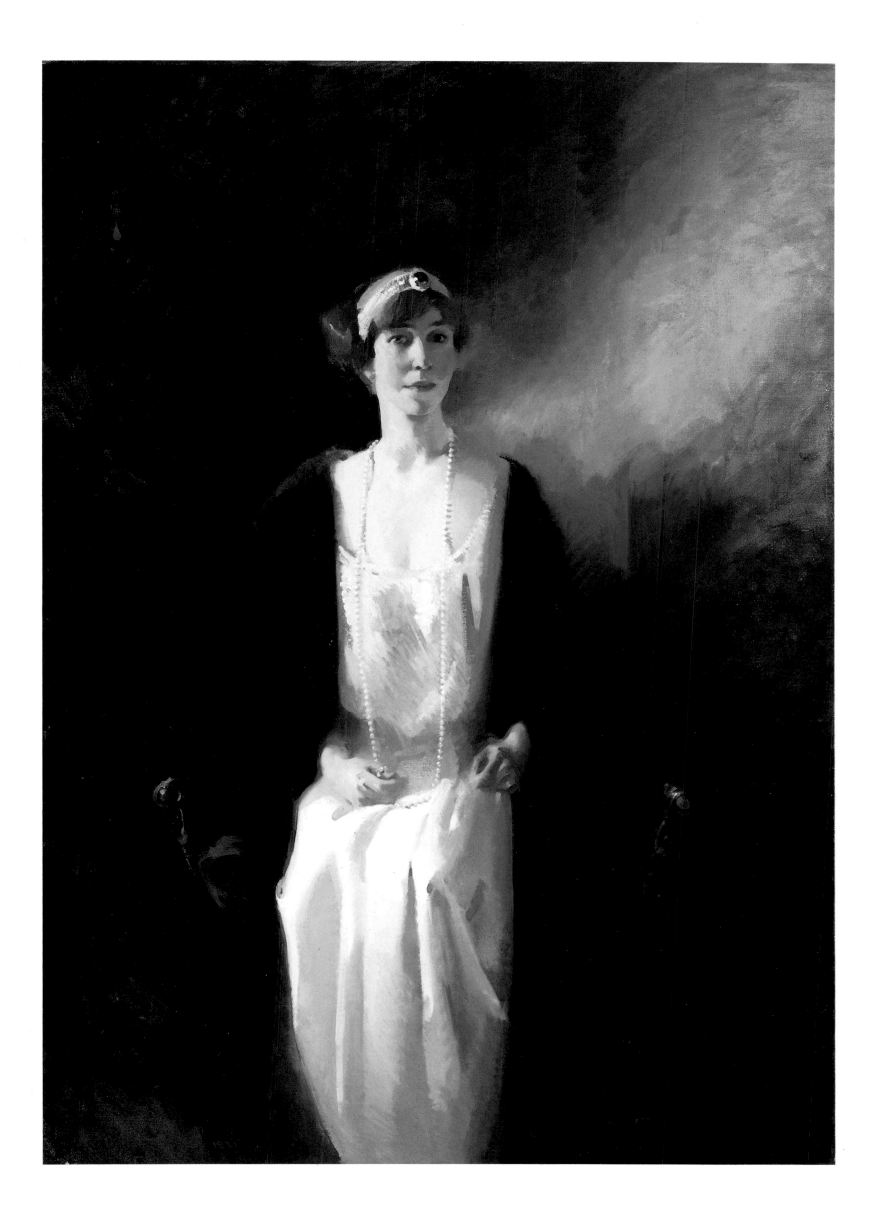

Romaine Goddard Brooks (1874–1970)
Renata Borgatti au Piano 1920
Oil on canvas, $55\frac{7}{8} \times 74\frac{1}{4}$ in.
National Museum of American Art, Smithsonian Institution,
Gift of the artist

An expatriate artist who was born in Rome and died in Nice, France, at the age of ninety-six, Romaine Goddard Brooks was American in her parentage and in some of her schooling. Her father, Major Harry Goddard, whose wealth came from Pennsylvania coal, separated from his wife but left the family well off. Romaine grew up in Europe with her eccentric mother and a mentally ill older brother. She attended St. Mary's Hall (an Episcopalian school) in New Jersey, a convent school in Italy, and Mademoiselle Tavan's Finishing School in Geneva before she seriously began the study of painting in Rome at the Scuola Nazionale by day and the Circolo Artistico in the evening during the years from 1896 to 1899. After a summer on Capri she studied at the Académie Colarossi in Paris. Then in 1902 she married an Englishman, John Ellingham Brooks, "whom she took with her to London and then discarded."[1] The years in England gave Brooks exposure to James Whistler's paintings, which made an indelible impression on her style. Her career peaked when she settled in Paris in 1905, and the Durand-Ruel Galleries gave her a solo exhibition in 1910, which went on to Goupil Gallery in London the next year. The French government awarded her the Cross of the Legion of Honor in 1920. Five years later she had a solo exhibition in London that traveled to Wildenstein Galleries in New York. In 1935–36 Brooks returned to New York where she rented a studio in Carnegie Hall and painted portraits of Americans.

Provided with a substantial inheritance, Brooks did not depend upon commissions, and she returned to Europe where she had a circle of friends in the orbit of Natalie Barney, the American renowned for her literary salon in Paris. Barney and Brooks lived together in a villa in Fiesole overlooking Florence during World War II, after which Brooks retired to her apartment in Nice. She died there in 1970, alone except for two faithful Italian servants.[2]

A resurgence of interest in Brooks occurred in 1971 when Adelyn Breeskin arranged an exhibition entitled *Romaine Brooks, "Thief of Souls."* It opened at the National Collection of Fine Arts and traveled to the Whitney Museum of American Art in New York. In 1980 the National Collection of Fine Arts gave Brooks a second exhibition, showing eighteen of the sixty-three works by her in its collection, and this was followed by an exhibition of her drawings at this same institution (now renamed National Museum of American Art) in 1986.

Romaine Brooks portrayed a number of her artistic and literary friends, generally in her monochromatic gray, Whistlerian style and usually accompanied by some germane attribute. The Eiffel Tower appears behind Jean Cocteau; Gabriele d'Annunzio, the poet and adventurer, wears a dashing black cape and stands before an infinite expanse of sea; Natalie Barney, called "L'Amazone," is posed next to a small horse; and *Una, Lady Troubridge*, the lesbian friend of the author Radclyffe Hall wears a tuxedo and a monocle.

Renata Borgatti, the daughter of an Italian Wagnerian tenor, studied piano in Bologna and Munich and began her concert career as accompanist to her father. In later years she appeared as soloist with leading orchestras of Europe. She was famous for her recitals of Debussy and Bach, so very appropriately Brooks has portrayed her friend seated at the piano.

The painting is signed "Romaine" and inscribed with her symbol, which is the wing of a butterfly "held down by a chain or rope, a melancholy symbol."[3]

[1] Adelyn D. Breeskin, "The rare, subtle talent of Romaine Brooks," *Art News* 79, no. 8 (October 1980), p. 157.
[2] Meryle Secrest, *Between Me and Life, A Biography of Romaine Brooks* (Garden City, New York, 1974), 6 and 388.
[3] Adelyn D. Breeskin, *Romaine Brooks* (National Museum of American Art, Washington, D.C., 1986), 41.

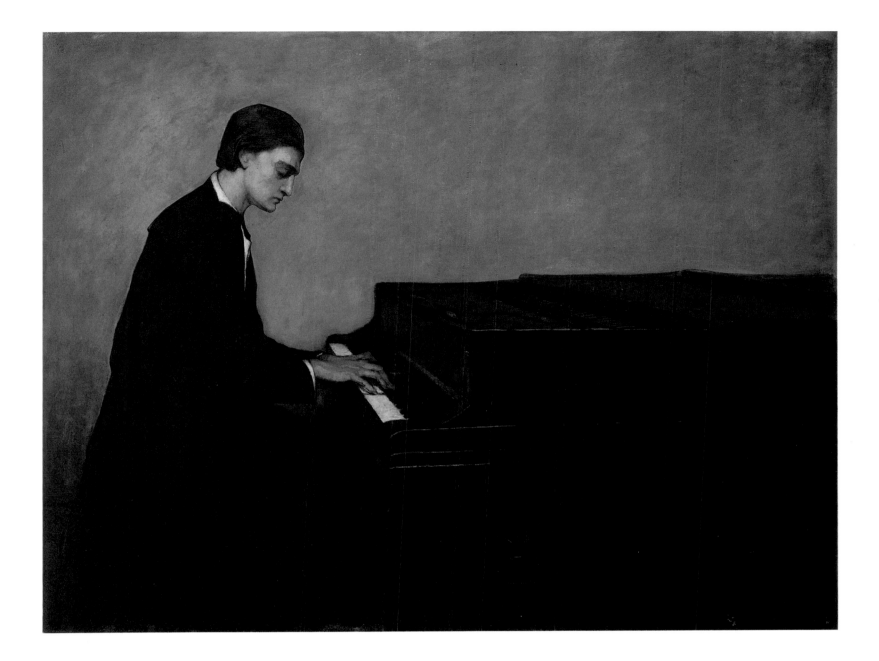

25
Laura Wheeler Waring (1887-1948)
Anna Washington Derry 1927
Oil on canvas, 20 × 16 in.
National Museum of American Art, Smithsonian Institution,
Gift of the Harmon Foundation

Any exhibition of women artists, 1830 to 1930, has a rich resource of Black Americans from which to choose. Edmonia Lewis was among the nineteenth-century Americans who fearlessly settled in Rome to realize a career as a professional sculptor. Among the sculptors who distinguished themselves early in the twentieth-century were Meta Warrick Fuller (1877-1967) and Augusta Savage (1892-1962). Annie Walker (1855-1929) was an impressive painter late in the last century (see her *La Parisienne* from 1896 at Howard University), as was Laura Wheeler Waring earlier in the present century.

This Hartford-born painter, upon graduation from Oberlin College, studied from 1918 to 1924 at the Pennsylvania Academy of the Fine Arts, winning a Cresson traveling scholarship that enabled her to visit Europe. In Paris Waring enrolled for further study at the Académie de la Grand Chaumière (1924-25). She returned to America and in 1927 received the Harmon Foundation's Gold Award in Fine Arts. Her work then began to be included in major exhibitions at such museums as the Art Institute of Chicago in 1933, the Pennsylvania Academy in 1935 and 1938, the Dallas Museum of Fine Arts in 1936, and Howard University in 1937, 1939, and 1949 (a retrospective of forty paintings).

Primarily a portraitist, Waring is best known for the commission she shared with Betsy Graves Reyneau of "Outstanding Americans of Negro Origin" for the Harmon Foundation. Waring painted portraits of *Marian Anderson* (1944) and *W.E.B. DuBois* (1945) (both in the National Portrait Gallery, Washington, D.C.). She also did a strong, seated portrait in reds and greens of the painter *Alma Thomas* (1947, Howard University). In addition, she painted many still lifes, landscapes, and genre scenes.

Waring was an instructor of art at Cheyney State Teachers College in Pennsylvania for many years and then head of the department, while her husband served as a professor in the Romance language department at Lincoln University. She died in their Philadelphia home three months before her sixty-first birthday.

Waring, like Rembrandt, tells much about a sitter's inner life as reflected in the face. In this powerfully empathetic portrait Waring captures a sense of weariness in the face of this patient-looking, serious woman. The clothes are only sketchily painted in contrast to the profound attention devoted to the face. The artistry of the portrait is enhanced by the block lettering of the sitter's name and the date in pale blue against a cream-colored background and by the shadow cast by the woman's head. The only ornament is a simple gold wedding band, signifying Derry's marital status.

Other portraits by Waring show a similar directness: the scholar DuBois exudes dignity; the contralto Anderson looks majestic in a long evening dress. On the other hand, the versatile Waring in a genre painting like *Jazz Dancer I* (c. 1939)[1] lavishly conveys the vivacity of dancers in a stage setting. Waring adjusts to her subject matter and knows exactly how much or how little to include in order to produce her strongest impact.

[1] Illustrated in Arna Alexander Bontemps, *Forever Free : Art by African-American Women* (Alexandria, Va., 1980), 141.

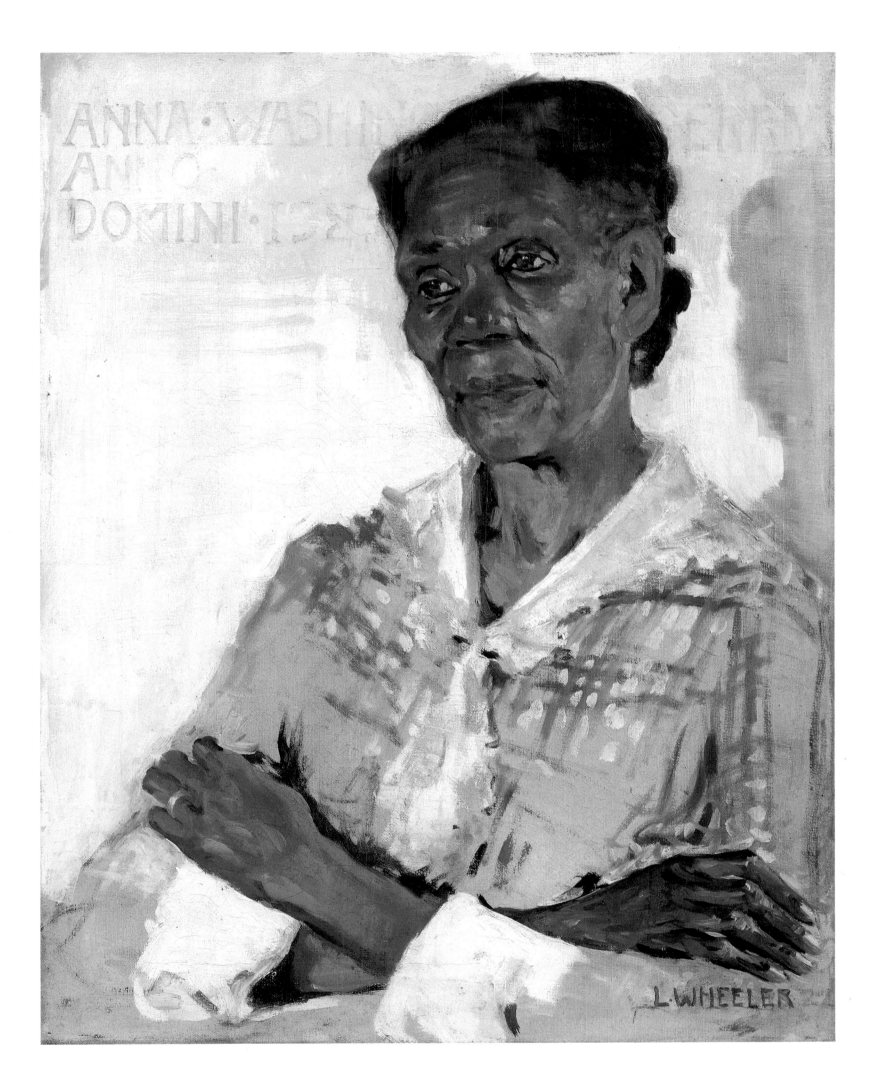

26
Katherine S. Dreier (1877–1952)
Abstract Portrait of Marcel Duchamp 1918
Oil on canvas, 18 × 32 in.
The Museum of Modern Art, New York,
Abby Aldrich Rockefeller Fund, 1949

Katherine Dreier may be better known today as the founder of the Société Anonyme than as a painter, but as Hilton Kramer wrote in *The New York Times* in 1975, praising the recent exhibition of "Avant-Garde Painting & Sculpture in America 1910-25," organized by Professor William I. Homer, "Some remarkable women artists have been effectively rescued from oblivion—Katherine Dreier, well enough known as a patron of Dada and abstract art . . . but rarely, if ever, seen as a painter in her own right; and the sculptors Adelheid Roosevelt and Alice Morgan Wright."[1]

The fifth surviving child and youngest daughter of Theodor and Dorothea Adelheid Dreier, Katherine was born in the family home in Brooklyn.[2] She shared an interest in painting with her older sister Dorothea and began taking a weekly art class when she was twelve. Then from 1895 to 1897 she studied at the Brooklyn Art Students League. Her German parents had a commitment to social reform that they instilled in their children. Mrs. Dreier founded the Home for Recreation of Women and Children in Brooklyn, and Katherine was co-founder of the Little Italy Settlement House in Brooklyn. All the sisters were active in the campaign for women's rights and for labor laws protecting women. Katherine was a delegate to the Sixth Convention of the International Woman Suffrage Alliance in Stockholm (1911) and later headed the German-American Committee of the Woman Suffrage Party in New York City.

Dreier never lost sight of her goal to become a painter, however, and advanced her career by studying at Pratt Institute in 1900 and traveling in Europe with Dorothea. On her return to America, she took private painting lessons with Walter Shirlaw from 1904 to 1905. She went back to London to paint from 1909 to 1911 and while there became engaged to an American; she broke off relations, however, when she discovered he was already married. Dreier had her first exhibition in London at the Doré Galleries. Her first success in America came in 1913 when she had two paintings accepted into the Armory Show.

Of her early training Dreier once commented, "I was brought up to believe that painting ended with the Renaissance, that all left for modern artists was to repeat, repeat."[3] Now with her exposure to modern art from her European travels (including visits to Gertrude Stein's Paris home with its paintings by Picasso and Matisse) and to the avant-garde work exhibited in the Armory Show, she was incensed by the public's scorn of the new styles and became a champion of freedom for the artist, declaring that "out of freedom alone can come the greatest art."[4] In 1916 she helped to form the Society of Independent Artists and thus began her long and close association with Marcel Duchamp (1887-1967). The fruit of this collaboration was their founding of America's first museum of modern art, the Société Anonyme, in 1920—in a gallery at 19 East 47th Street in New York—to educate the American public about modern art. In some eighty-three exhibitions, more than seventy-three artists were introduced in America, among them Kurt Schwitters, Paul Klee, Kasimir Malevich, and Joan Miro. Dreier also arranged the first one-man exhibitions in America for Alexander Archipenko, Wassily Kandinsky, Fernand Léger, and others. By 1918 her own works had become non-objective.

When the stock market collapsed in 1929, Dreier's inheritance was no longer sufficient to sustain the Société, and she retired to a house in Reading, Connecticut, where she resumed her painting. In 1941 Dreier and Duchamp gave the 616 works of art in the collection of the Société to Yale University and spent the rest of the decade producing a catalogue with Professor George Heard Hamilton. In the introduction written by Dreier, as president of the Société Anonyme, she pays tribute to her father, who had "the vision he firmly held to, ahead of his time, of giving the same privileges to his daughters as he gave to his son."[5] The entry in the Yale catalogue on Katherine Dreier's paintings was written by Duchamp.

Dreier died at her home in Milford, Connecticut, on 29 March 1952 in her seventy-fifth year and was survived by her sister Mary of New York City and her brother Henry of Fort Salonga, Long Island.

The section of full-size portraits in this exhibition ends with the beginning of modernism in America as represented in an abstraction painted by that crusading champion of non-objective art, Katherine Dreier. Regarding her psychological portraits of friends, such as this of Duchamp, Dreier said that each shape and color was chosen to embody specific personality characteristics.[6] The end result in this case is a dynamic composition symbolic of the force, originality, and multi-layered personality of Duchamp.

Duchamp himself wrote of Dreier's art: "Free-hand geometric patterns set in backgrounds of color perspective and interwoven in the general framing of the abstract theme are the chief characteristics of her personal contribution to painting, best shown in her 'psychological portraits' as well as her 'cosmological interpretations.'"[7]

[1] Hilton Kramer, "A Fresh Look at Early American Modernists," *The New York Times*, 27 April 1975, sect. D, p. 31.
[2] Eleanor S. Apter, "Katherine Sophie Dreier," *Notable American Women, The Modern Period* (Cambridge, Mass., 1980), 202.
[3] Ruth L. Bohan "Katherine Sophie Dreier and New York Dada," *Arts Magazine* 51, no. 9 (May 1977), p. 97.
[4] Ibid.
[5] *Collection of the Société Anonyme: Museum of Modern Art 1920* (Yale University Art Gallery, New Haven, 1950), x.
[6] *Avant-Garde Painting & Sculpture in America 1910-25* (University of Delaware, Newark, Del., 1975), 70.
[7] *Collection of the Société Anonyme*, 83.

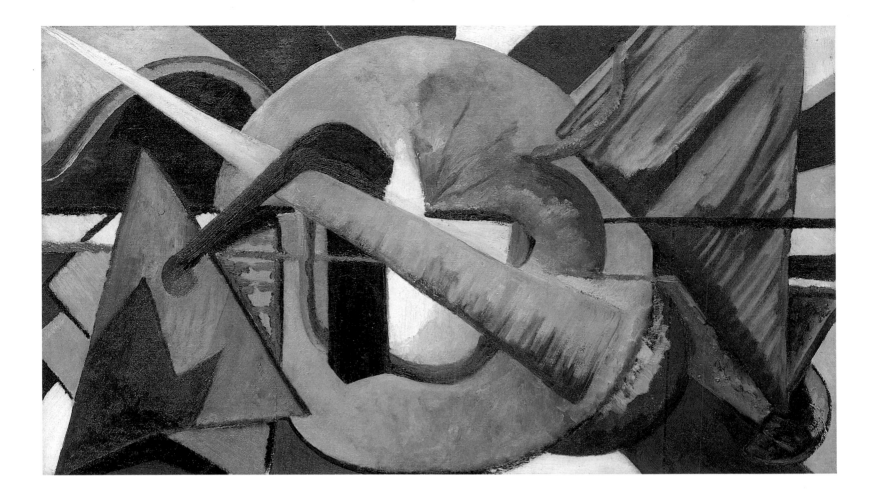

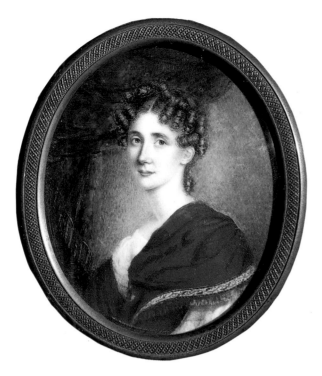

27
Anna Claypoole Peale (1791-1878)
Portrait of Nancy Aertsen first half of the nineteenth century
Watercolor on ivory, $3\frac{1}{2} \times 2\frac{7}{8}$ in.
The National Museum of Women in the Arts,
The Holladay Collection

Anna Claypoole Peale, the fourth child of James Peale, was trained by h[?] father to assist him in his painting commissions. She shared a studio i[?] Baltimore in the 1820s with her younger sister Sarah (see cat. nos. 1/5[?] and then in 1829 married Dr. William Staughton, who died within th[?] year. Anna continued to paint until her second marriage in 1841, workin[?] in her native city of Philadelphia, as well as in other cities on the Easter[?] seaboard from Boston to Washington. Among her sitters she could coun[?] such distinguished statesmen as President James Monroe, Andre[?] Jackson, and Henry Clay. After Anna's second marriage—to Genera[?] William Duncan—her painting career ended.

Anna Peale exhibited at the Pennsylvania Academy of the Fine Art[?] every year from 1811 to 1842, and in 1824 she and Sarah were the first women elected Pennsylvania academicians.[1] She showed an amazing ability to represent textures on her small ivory miniatures: for example, the gold epaulets in her *Andrew Jackson* portrait (1819, Yale University Art Gallery), the long lace veil in her portrait of *Mrs. Roger Boyce* (Maryland Historical Society), and the paisley shawl worn by Susannah Williams (1825, Maryland Historical Society). Several pairs of portraits by Peale have survived intact, such as that of the Main Line Philadelphia couple *Mr. and Mrs. Henry Haydock Lawrence* (1817, private collection, Dallas), in which the blond curls of each sitter are skillfully depicted and their clothes are adorned with a sparkling jewel; their bodies turn slightly toward each other, linking the two portraits. Another pair of portraits hangs in the Kestner Museum in Hanover, Germany.

In the oval format traditional for nineteenth-century miniatures, the young sitter is depicted here in a white dress and a red shawl with a decorative paisley band. Her brown eyes glow warmly under thick dark eyebrows, and her curly brown hair is silhouetted against a blue drapery behind her at the left and a light brown background at the right. The sitter's aquiline nose and delicate mouth are minutely recorded in watercolor on ivory.

According to a label on the reverse, Nancy Aertsen (almost exactly contemporaneous with the artist) was born in Charlestown, South Carolina, in 1795 and died in Phillipsburg, New Jersey, in 1876; she is buried at St. Luke's Church in Germantown, Philadelphia.

[Anna Peale is also represented in this exhibition by a still life in cat. no. 84.]

Miniatures are reproduced original size.

[1] Louise Lippincott, "Charles Willson Peale and His Family of Painters," *In This Academy, The Pennsylvania Academy of the Fine Arts* (Philadelphia, 1976), 94.

28
Sarah Goodridge (1788-1853)
Portrait of Daniel Webster 1827
Watercolor on ivory, $3\frac{3}{8} \times 2\frac{3}{4}$ in.
Massachusetts Historical Society

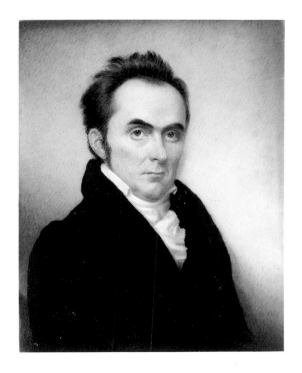

One of the most prolific miniaturists in Boston between 1820 and 1850, Sarah Goodridge often painted as many as three miniatures in a week. Twenty of her portraits today are in the Boston Museum of Fine Arts, eight are in the National Museum of American Art, many are in the Narragansett Historical Society in Templeton, Massachusetts, and others are in the Metropolitan Museum of Art, the Yale Art Gallery, the New-York Historical Society, the Essex Institute in Salem, Massachusetts, Bowdoin College, the Worcester Art Museum, and private collections.

Goodridge was born in Templeton, Massachusetts, the sixth of nine children. She had a natural propensity for drawing, and when she lacked paper, which was expensive, she drew portraits on sanded floors with a stick or on birch bark with a pin. At seventeen she went to live in Milton, Massachusetts, with her eldest brother and his family; and a man in that household gave her drawing lessons, which she supplemented with reading about artistic media and techniques. Then she moved to Boston to live with her sister and brother-in-law, Beulah and Thomas Appleton. After learning to paint in oil and studying with a miniaturist, Goodridge opened her own studio in Boston in 1820.

Gilbert Stuart visited Goodridge's studio, offering her avuncular advice. And when she painted his portrait, he proclaimed it "the most lifelike of anything ever painted of him in this country."[1]

Goodridge had five exhibitions at the Boston Athenaeum between 1827 and 1835, and twice she traveled to Washington to carry out commissions, in 1828-29 and in 1841-42. She earned enough money to support her mother during the latter's last eleven years and to bring up an orphaned niece. In 1850 her eyesight began to fail, and the next year she gave up painting, retiring to a house she bought in Reading, Massachusetts. Goodridge died at sixty-five in Boston where she had gone to spend Christmas.

Most of Goodridge's miniatures are of watercolor on ivory and display a photographic technique for detail. Her younger sister, Eliza Goodridge Stone (1798-1882), also became a miniaturist.

Between 1827 and 1845 Sarah Goodridge painted almost a dozen portraits of the United States Senator Daniel Webster (1782-1852). Webster, born in New Hampshire, had moved to Boston to practice law and at this time was representing Massachusetts in the Senate, where he distinguished himself as a great orator and defender of the Constitution.

This miniature, like most of Goodridge's, is of a rectangular format and is a bust portrait. It differs from her portraits of Daniel Webster in the museums at Dartmouth College and at Amherst College in that Webster's hair stands up more prominently above his forehead in this miniature rather than lying flat and smooth as in the other two. In all three miniatures the senator stares out intently under heavy dark eyebrows and displays a serious expression.

[1] Charlotte Streifer Rubinstein, *American Women Artists from Early Indian Times to the Present* (Boston, 1982), 26.

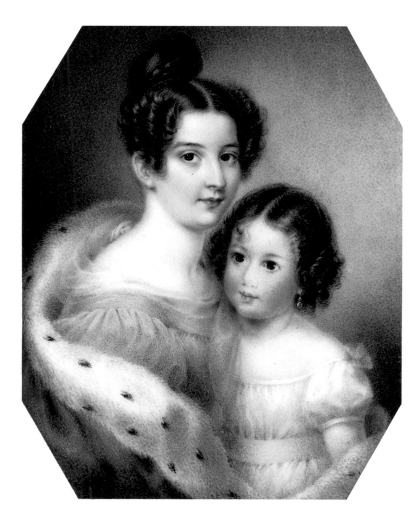

29
Anne Hall (1792–1863)
Mrs. Catherine Hone Clinton and Her Daughter 1834
Watercolor on ivory, $4\frac{9}{16} \times 3\frac{7}{8}$ in.
The New-York Historical Society, New York

Anne Hall's distinction among miniaturists was her ability to present more than one figure within the limited space available in a single miniature. She showed a special gift, even courage, for painting group portraits in this small format. As early as 1834 the American historian William Dunlap wrote of Anne Hall: "Her late portraits in miniature are of the first order. I have seen groups of children composed with the taste and skill of a master and the delicacy which the female character can infuse into works of beauty beyond the reach of man. . . ." [1]

Hall was born in Pomfret, Connecticut, the third daughter and sixth of eleven children of Dr. Jonathan Hall and his wife Bathsheba Mumford. She early showed a talent for art, which the family encouraged with gifts of watercolors, pencils, and a box of colors from China. Her first art instruction came during a visit to Newport, Rhode Island, where Samuel King, who had been the teacher of Washington Allston and the miniaturist Edward Green Malbone, gave her lessons in painting miniatures on ivory. Next, on a visit to New York, she studied oil painting with Alexander Robertson and began to exhibit her miniatures in 1817 at the American Academy of the Fine Arts in New York. [2]

Hall moved to New York in the mid-1820s and became the first woman admitted into the National Academy of Design. She began showing miniatures in the annual exhibitions in 1828, continuing to do so until 1852. *The Knickerbocker* review of the 1835 exhibition says of Hall's *Full Length Miniature of a Child*: "This of Miss Hall's is one of the best, although we do and ever must exclaim against the excessive warmth of her flesh tints." [3] At the Boston Athenaeum in 1830 she exhibited her miniature of a Greek girl captured by the Turks during the Greek War for Independence, *Garafilia Mahalbi, a Greek Girl of Ipsera, Died at Boston, March 17, 1830, Aged 13*, which was so much admired that it was reproduced as an engraving.

According to Mrs. Elizabeth Ellet, Hall received commissions from many prominent New York families, fetching as much as $500 for group miniatures. [4] In an oil painting from the same year as the miniature in our exhibition, Hall depicts herself seated at work, making a sketch of members of her sister's family: Mrs. Eliza Hall Ward and her husband Henry Ward in their living room with a daughter playing the spinet, a son reading, and an elderly mother sewing. Behind Hall on an easel is one of her oil paintings, evidence of her ability to work on a larger scale. [5]

Hall died in New York City at the age of seventy-one, and the funeral was held at Grace Episcopal Church, 802 Broadway. [6]

A mother and child miniature such as this is typical for Hall. Catherine Hone (1810–1841), the daughter of a wealthy New York merchant, grew up on Bowling Green in lower Manhattan and married Charles Alexander Clinton on 3 May 1827. She is shown here with her daughter, probably Catherine S., the first of her five children. The birth dates of the successive children were 1834, c. 1836, 1837, and 1839. [7] Young Catherine married J.M. Carville and named her daughter Katherine J. Clinton Carville.

Mrs. Clinton's hair has been coiffed in the latest fashion in this miniature, and her figure is elegantly encircled by the ermine lining of her loosely draped cloak. Delicate flesh tones illuminate the attractive faces.

[1] William Dunlap, *A History of the Rise and Progress of the Arts of Design in the United States*, vol. 2 (reprint, New York, 1960), 369.
[2] William H. Gerdts, "Anne Hall," *Notable American Women*, vol. 2 (Cambridge, 1971), 118.
[3] "The Fine Arts," *The Knickerbocker* 5 (1835), 554.
[4] Elizabeth Fries Ellet, *Woman Artists in All Ages and Countries* (New York, 1859), 300.
[5] Illustrated in C. Kurt Dewhurst, Betty MacDowell, and Marsha MacDowell, *Artists in Aprons, Folk Art by American Women* (New York, 1979), 87.
[6] Obituary, *The New York Times*, 14 December 1863, p. 8.
[7] *Catalogue of American Portraits in The New-York Historical Society*, vol. 1 (New Haven, 1974), 145.

30
Clarissa Peters Russell (1809–?)
Self-Portrait c. 1850
Watercolor on ivory, $2\frac{11}{16} \times 2\frac{1}{16}$ in.
Private collection

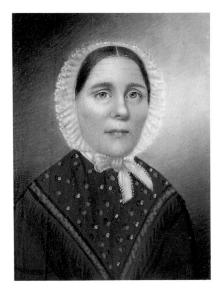

Very little is known about Clarissa Russell. She was born in Andover, Massachusetts, on 1 February 1809 to Elizabeth Davis and John Peters.[1] A younger sister in this family of twelve children, Sarah Peters Grozelier (1821–1907), also became a miniaturist. Clarissa Peters married the painter Moses B. Russell (c. 1810–1884), and their son, whom they propitiously named Albert Cuyp Russell after the seventeenth-century Dutch landscape painter, was born in 1838; he too became an artist, specializing in engraving and illustration.

Clarissa Russell was active in Boston from about 1842 to 1854 and exhibited at the Boston Athenaeum. According to *The Boston Athenaeum Art Exhibitions Index, 1827–1874,* she exhibited the following miniatures: *E.D. White* in 1842, *O.A. Brownson* and a *Gentleman* in 1843, and a *Lady* in 1844. Her address at this time was School Street, Boston.

Some of Russell's miniatures are of the long-popular oval format, and others are rectangular. Her style is exceedingly realistic. *Woman of the Russell Family* (private collection), for example, is a straightforward oval presentation of a dark-eyed woman, her dark brown hair braided in a knot and a simple black necklace accompanying her black dress.

Occasionally there are primitive vestiges in Russell's portraits of children: in both *Girl with Cherries* (private collection) and *William Henry Baldrey* (private collection), the heads are large in proportion to the bodies. In the latter miniature on ivory, the blond child with wisps of curly hair at his temples holds a carved yellow bird, and documentation states that this son of Captain and Mrs. Samuel Baldrey, who was born in 1850, was portrayed at ten months, fifteen days, which gives the miniature a date of 1850 or 1851. In each of the miniatures Russell has painted a lively pattern on the clothes worn by the children.

Russell's penchant for realism in combination with decorative fabric is seen here in this rectangular miniature. The most telling aspect of her realism lies in the unusual staccato eyebrows, under which peer out finely delineated, earnest blue eyes. Russell's straight, dark brown hair is tidily swept under a white lace bonnet. The gaily painted fabric in this miniature is a shawl peppered with red, yellow, and green dots and bordered in green.

[1] I am grateful to the owner of the Russell miniature in this exhibition for researching the birth of Clarissa Russell and passing on this new, precise information to me.

31
Nina Fagnani (c. 1860–after 1898)
Portrait of Robert Stockwell Reynolds Hitt signed and dated 1893
Watercolor on ivory, $3\frac{5}{8} \times 3$ in.
Private collection

Biographical facts about Nina Fagnani are elusive. She was born in New York City,[1] and it is tempting to postulate that she was the daughter of the painter Giuseppe Fagnani (1819–1873), a Neapolitan who accompanied the English ambassador Sir Henry Bulwer to Washington in 1849. Joseph Fagnani, as he was called after becoming an American citizen, painted portraits of Daniel Webster, President Millard Fillmore, and Henry Clay. In 1851 he married Harriet Emma Everett Goodwin of Charlestown, Massachusetts, and they took up residence in New York City.[2] During the 1860s he submitted paintings to the annual exhibitions of the Pennsylvania Academy of the Fine Arts from New York, and according to *The New York Times*, he died suddenly in May 1873, leaving a wife and family.[3]

Nina Fagnani studied in Paris with Mme Grec and later with Mme William Wyld (widow of the English painter William Wyld who lived and worked in France). Her first appearance in an exhibition was in 1880 at the Paris Salon, which accepted her *Portrait of an Infant* on enamel. She continued to exhibit miniatures at the Paris Salons of 1890, 1895, 1896, and 1898 and also exhibited a miniature at the Royal Academy in London in 1892, giving as her address 14 rue Lauriston, Paris. The place and date of her death are unknown.

This handsome miniature of Robert Stockwell Reynolds Hitt (1876–1938) attests to the skillful artistry of Nine Fagnani. Hitt, the son of Congressman Robert Roberts Hitt of Illinois, was born in Paris and presumably sat for this portrait in Paris where Fagnani was living in the 1890s. He may have been traveling with his parents at this time, prior to attending Yale, from which he graduated in 1898. He earned a law degree from Harvard in 1901 and entered the United States foreign service.

In this portrait of the serious-looking seventeen-year-old student, Fagnani has created a sonorous harmony of muted colors: dark brown hair, blue eyes, gray suit, blue tie, and flecks of these colors in the background.

[1] I am indebted to Lewis Hoyer Rabbage for this information.
[2] Charles E. Fairman, *Art and Artists of the Capitol of the United States of America* (Washington, 1927), 133.
[3] Obituary, *The New York Times*, 25 May 1873, p. 5

32

Ethel B. Underwood (active 1901–1911)
Study signed and dated 1904
Watercolor on ivory, $3\frac{5}{8} \times 2\frac{3}{4}$ in.
Private collection

"A talented enigma" is the way the owner of the Underwood miniature in this exhibition describes the artist. Underwood's biography is unknown, but the engaging portrait shown here is formidable. The American Society of Miniature Painters displayed a total of fourteen miniatures by Underwood in eight of its annual exhibitions from 1901 through 1911. A review in *The New York Times* of the Third Annual Exhibition of the American Society, held at the Knoedler Galleries in 1902, mentions Ethel B. Underwood as one of the non-members vying with the members.[1] The *American Art Annual* lists Underwood with an address in New York City for the years 1907–1908.

The only hypothesis proposed by the owner of this miniature is that the artist might be Ethel Brinkerhoft Underwood, born in Boston in 1874, the daughter of a physician and great-granddaughter of the founder of the Underwood meat-packing firm. She was living in New York City around 1910, and she died in upstate New York sometime after 1950.

By the beginning of the twentieth century, rectangular portrait miniatures that could be hung on the wall were very popular. These watercolors on ivory were less expensive than big oil paintings. The miniature artists could achieve a verisimilitude that pleased the sitters, and the miniaturists flourished until photographers superseded them.

Underwood exhibited five pieces entitled *Study* during the years 1902–1904, and this may be the *Study* that was included in the American Society of Miniature Painters' annual exhibition of 1904 along with her miniature of *Miss R. Field*. This designation "study" may differentiate between an artist's figure study and a commissioned portrait. At any rate, this study differs from a strict portrait in the independent idea for the pose: the young woman seated sideways on a wooden chair with her hands clasped over the back of the chair. Underwood shows a delicate skill in depicting the sitter's earnest expression, her long blond hair, and the detailed folds of the dress.

[1] "Painters of Miniatures," *The New York Times*, 2 February 1902, p. 10.

33
Lucia Fairchild Fuller (1872-1924)
In The Looking Glass 1905
Watercolor on ivory, 6 × 4 in.
Family of the artist

Born in Boston, Lucia Fairchild studied painting at the Cowles Art School with Dennis Bunker after attending Mrs. Shaw's private school. She then moved on to New York City, where, beginning in 1889, she attended the classes of William Merritt Chase and H. Siddons Mowbray at the Art Students League. In 1893 she was invited to paint a mural for the Woman's Building at the World's Columbian Exposition in Chicago. This mural, entitled *The Women of Plymouth*, appeared on the east side of the gallery, on the wall opposite the murals by the sisters Lydia Field Emmet and Rosina Emmet Sherwood.

On 25 October 1893 Fairchild married Henry Brown Fuller (1867-1934), a painter whom she had met at the Cowles Art School, and as she combined her career and family, she turned to portraiture on ivory. In 1897 the Fullers and their two newly arrived children began to spend their summers in the art colony that sprang up around Augustus Saint-Gaudens at Cornish, New Hampshire. They built a "low-spreading Italian structure" with an enclosed court that provided them with an outdoor studio.[1] During these bucolic summers they participated in the dramatic productions performed by the children of the art colony. In 1906, for example, Lucia Fuller painted the scenery for *The Rose and the Ring*, while Ethel Barrymore coached the young performers. Although Fuller primarily painted portraits of the summer residents, she did paint one large colonial scene for which the local people posed, and that is preserved in Blowmedown Grange, Plainfield, New Hampshire.[2]

In her New York studio Fuller was in demand for her miniature portraits. Her sitters included Mrs. J.P. Morgan and the Morgan children, Mrs. H.P. Whitney and her children, James J. Higginson, and Dr. Edwin A. Tucker.[3] Her portrait of Annie Adams Field, author and literary hostess in Boston, is in the Boston Athenaeum today, and a *Portrait of a Child* (a little girl standing in her nightgown tenderly holding a doll) is in the Metropolitan Museum. In 1899 Lucia Fuller, Laura Coombs Hill, William Baer, and I.A. Josephi founded the American Society of Miniature Painters, of which Fuller later served as president.

Among Fuller's prizes were a bronze medal at the Paris Exposition of 1900, a silver medal for *Girl Drying Her Foot* at the Pan-American Exposition in Buffalo (1901), and gold medals for *The Chinese Jacket* and *In the Days of King Arthur* at the St. Louis Exposition of 1904. She was one of the first women elected to the American Society of Painters (1899) and was made an associate of the National Academy of Design in 1906.

Fuller's fame outstripped her husband's, and they separated. She then moved to Madison, Wisconsin, where her maternal grandfather, Jairus Cassius Fairchild, had been the first mayor in 1846, and her uncle had been governor of Wisconsin. The last seventeen years of Fuller's life were painful due to multiple sclerosis[4] and were not conducive to work. She died at her home in Madison at the age of fifty-three.

Lucia Fuller amply shows her skills as a miniaturist in this ambitious composition. Within the small space available she comfortably includes not only a full-length image of herself, seated and at work in front of an easel, but includes a whole environment: the garret window, the banister, the low bench on which she sits, and the curvaceous base of the easel. Fine details are also meticulously rendered such as her pince-nez, white lace collar, and the yellowish texture on the wall behind the balusters.

Fuller is equally expansive in the 7 × 4½ inch miniature entitled *In The Days of King Arthur* (1903-1904), in which two children are shown full-length with their dog plus a print on the wall, as the youngsters, seated on a high-back bench, read an illustrated volume of the legends. Even more astonishing is her miniature entitled *Pres d'une claire fontaine* (1907, National Museum of American Art, Washington, D.C.), showing a nude woman seated by a reflecting pool and silhouetted against green foliage—all within an area measuring 6¼ × 5 inches.

[1] *A Circle of Friends: Art Colonies of Cornish and Dublin* (Thorne-Sagendorph Art Gallery, Keene State College, Keene, N.H.; and University Art Galleries, University of New Hampshire, Durham, N.H., 1985), 87.
[2] Ibid., 88.
[3] William M. Jewell, "Lucia Fairchild Fuller," *Notable American Women*, vol. 1 (Cambridge, Mass., 1971), 677.
[4] Ibid., 678.

34
Lucy May Stanton (1875–1931)
Self-Portrait ("Silver Goblet") 1912
Watercolor on ivory, $5\frac{3}{8} \times 3\frac{3}{4}$ in.
National Portrait Gallery, Smithsonian Institution,
Gift of Mrs. Edward C. Loughlin

Lucy May Stanton, born in Atlanta just eleven years after the city was burned to the ground in the Civil War, is probably the most representative painter of the South in this exhibition, as far as her entire oeuvre is concerned. She consistently drew on her southern heritage for her subject matter, and her miniature portrait of a Black from the South was the first ever exhibited at the Pennsylvania Academy of the Fine Arts (in 1899). Thereafter her miniature portraits of Blacks, mountain people, and frontier types traveled in Europe, South America, and throughout the United States. Included in her series "Little Murals" were scenes she entitled *Negroes Resting, Working on the Street, Loading Cotton,* and *Aunt Liza's House.*

At the age of seven Stanton was given her first set of oil paints and she began her studies with a French artist, Mme Seago, in New Orleans, where her father's business took the family in the winter. After her mother's death she was sent to Southern Female Seminary in La Grange, Georgia, and again she studied painting with a French teacher, Mme Ada Autrie. When her father took her to Europe in 1889–1890, Stanton painted watercolors in Venice. After graduation from Southern Baptist College for Women in 1895, she stayed on for another year assisting Professor James P. Field, with whom she had studied painting. At this time she painted three miniatures of the famous soprano Adelina Patti. In 1896 Stanton left for three years of study in Paris: at the Ecole de la Grande Chaumière; plus private lessons with Augustus Koopman, Virginia Reynolds, the miniaturist, and James McNeill Whistler; and anatomy at the Sorbonne.

Stanton opened studios in several different locales during the first decade of the twentieth century: first in Atlanta, where she taught night classes at the YMCA, then in New York City at the Bryant Park Studios, in Los Angeles, and in Paris at 70 rue Notre-Dame des Champs. In the next decade she had studios in Athens, Georgia, in the Great Smoky Mountains of North Carolina, in New York City, and on Beacon Hill in Boston. She also maintained a summer studio in Ogunquit, Maine, until 1926, when she switched her allegiance to Nantucket Island. Throughout these transient years her themes remained essentially southern; for example, the Georgian *Linton Ingraham, Ex-Slave* (Museum of American China Trade, Milton, Massachusetts), was painted in her Boston studio. Her 1912 oil portrait of Howell Cobb from Georgia, Speaker of the House of Representatives, hangs in the United States Capitol; and her *North Carolina Mountain Woman* (c. 1913–15) is at the Metropolitan Museum of Art.

From 1899 to 1931 Stanton exhibited more than one hundred miniatures at the Pennsylvania Society of Miniature Painters[1] and exhibited a total of some ninety-three pieces, mostly miniatures, at the Pennsylvania Academy of the Fine Arts.[2] She also exhibited at the Royal Society of Miniaturists in London in 1914 and at the Panama-Pacific Exposition in San Francisco in 1915. Among her awards were a blue ribbon at the Paris Salon of 1906 and a medal of honor bestowed by the Concord Art Association (Massachusetts) in 1923. She was given one-person exhibitions at galleries in New York, Boston, Baltimore, and New Orleans.

Despite her peregrinations, Stanton had considered Athens, Georgia, her home since the time of her first studio there in 1910, and she returned there in 1926 to complete her "Southern Historical Series." In March 1931 she suffered a chill that developed into double pneumonia, and she died in the Athens hospital at the age of fifty-five. Just three years earlier she and a young student of botany had taken a canoe trip on the Oconee River to collect plants, and now, prematurely, Stanton was to be buried at the Oconee Hill Cemetery.

As the monograph on Lucy Stanton states, her works are not just miniatures but rather small watercolor portraits to be hung on the wall.[3] The National Portrait Gallery in Washington, D.C., has two such portraits by her: *Joel Chandler Harris* (7 × 5 inches) and this *Self-Portrait.* In 1881 Harris moved with his family to a house in Atlanta directly across the street from the Stantons, and Lucy and her younger sister heard the Uncle Remus stories as they were being written. She first painted Harris's portrait in 1906 (preserved in the Robert W. Woodruff Library, Emory University).

Both of the Stanton portraits on ivory in the National Portrait Gallery have keen, sharp facial delineations, while the rest of the figure is painted in broad washes: a purplish-brown suit on Joel Chandler Harris and a magnificent blue dress on Lucy Stanton, and big broad-brimmed hats on both sitters. In both paintings Stanton has applied the same major color used in the clothes for the background, thus placing Harris against a plum-covered background and Stanton against a blue. As she wrote in her diary, "I have sought for a harmony of color and to do the difficult task of painting blue against blue."[4] In the self-portrait Stanton holds a glittering silver goblet, which has given this painting its alternative name.

[1] W. Stanton Forbes, *Lucy M. Stanton, Artist* (Emory University, Atlanta, Ga., 1975), 47.
[2] Ibid., 76.
[3] Ibid., 1.
[4] Ibid., 28.

35
Margaret Foote Hawley (1880-1963)
Natalie Shipman 1927
Watercolor on ivory, $4\frac{3}{4} \times 3\frac{5}{8}$ in.
Private collection

Both Mary Foote (1872-1968) and her younger sister Margaret became painters. They were born in Guilford, Connecticut, but orphaned when Margaret was only five. Margaret was adopted by her aunt Harriet Foote Hawley and her husband, a United States senator, who took her to live with them in Washington, D.C. Mary, who remained in Connecticut studied nearby at the Yale University Art School and won a scholarship to Paris, where she studied painting with Frederick MacMonnies and shared a studio with her friend Ellen Emmet (cat. nos. 17 and 18). Margaret attended public schools in Washington and then enrolled at the Corcoran Art School, which awarded her a gold medal for the best drawing from life. She also took private lessons with the painter Howard Helmick of Georgetown. Upon graduation, she taught at a girls' boarding school and saved enough money to travel to Paris for two summers of study at the Académie Colarossi.

A facile and prolific portraitist, Hawley immediately began to receive awards: a medal of honor from the Pennsylvania Society of Miniature Painters in 1918; the Lea Prize from the Pennsylvania Academy of the Fine Arts in 1920; the Smith Memorial Prize from the Baltimore Watercolor Club in 1925; a bronze medal at the Sesquicentennial Exposition in Philadelphia, 1926; a medal of honor from the Brooklyn Society of Miniature Painters in 1931; and a medal for best miniature from the National Association of Women Painters and Sculptors in 1931.

Hawley was elected president of the American Society of Miniature Painters in 1923, and she regularly exhibited in its annual shows. She also exhibited in London from 1926 to 1929, giving as her studio address 58 West 57th Street, New York City, and was elected to the Royal Miniature Society in 1927.

Her oeuvre is estimated at four hundred miniatures, mostly in private collections, where they are treasured family heirlooms. A number are in major museums. Her remarkable portrait of the bespectacled *Alexander Petrunkevitch* seated in a chair (1913) is in the Metropolitan Museum,[1] her *Portrait of F.I. Paradise* (c. 1920) is in the National Museum of American Art, and others are in the Wadsworth Atheneum, the Brooklyn Museum, the Corcoran Gallery of Art, and the Stowe-Day Foundation in Hartford. Portraits by both Margaret Hawley and Mary Foote were included in the 1945 *Portraits of Americans by Americans* exhibition in New York.[2]

Hawley had studios in both New York and Boston when she died at eighty-three in New York City's Midtown Hospital. The only survivors listed in the obituary were her sister and two stepsisters.[3]

The miniatures in this exhibition have been chosen to show the evolution from the earliest, realistic American portraits by Anna Claypoole Peale and Sarah Goodridge through the popular turn-of-the-century miniatures to the relaxed, elegant portraits of the "roaring twenties."

The blue-eyed, fair-haired Natalie Shipman, a native of Hartford, Connecticut, who later became Mrs. Gurdon Worcester, is shown in this portrait leaning back comfortably on a soft sofa. She wears a simple pink shift dress with a flower pattern on the skirt and a long string of pearls, which she casually fingers with her left hand. A decorative shawl seems to have been placed over the back of the sofa. This soigné oval portrait, indicative of the gracious living of both the sitter and of Margaret Hawley, bodes no warning of the crash to come, but rather suggests the Charleston and the Scott Fitzgeralds.

[1] Illustrated in Elizabeth Lounsbery, "American Miniature Painters," *The Mentor*, no. 233 (15 January 1917), p. 11; and Lucia Fairchild Fuller, "Modern American Miniature Painters," *Scribner's* 67, no. 3 (March 1920), p. 384.
[2] See *Portraits of Americans by Americans* (National Association of Portrait Painters, The New-York Historical Society, New York, 1945), 86, for an illustration of Margaret Foote Hawley's *Virgil Barker*.
[3] Obituary, "Margaret Foote Hawley, Portrait Painter, 83, Dies," *The New York Times*, 19 December 1963, p. 33.

Genre & History

36
Lilly Martin Spencer (1822–1902)
The Young Husband: First Marketing signed and dated 1854
Oil on canvas, 29½ × 24¾ in.
Private collection

An outstanding genre painter of the mid-nineteenth century, Lilly Martin Spencer has not had to wait for recognition in the present exhibition. Robin Bolton-Smith and William H. Truettner put her in a limelight that is still beaming today with their retrospective exhibition of sixty-eight of her works at the National Museum of American Art in 1973. The contribution that the current exhibition makes to that exemplary showing is to display two of her still lifes.

Lilly Martin was born in Exeter, England, to parents from Brittany who had emigrated to England to teach French. In 1830 the family moved to New York, then settled in Marietta, Ohio, where Lilly spent her youth and had her first exhibition in 1841. That fall she carried her paintings to an exhibition in Cincinnati, and she stayed there for the next eight years. She took art lessons from John Insco Williams and received advice from other established artists. In 1844 she married Benjamin Rush Spencer, an English tailor, who lost his job the next year and fell ill. When he recuperated, he turned to preparing the canvases and frames for his wife's paintings in order to cut costs, and helped with domestic duties as well: "With its reversal of the conventional role of breadwinner, the Spencers' marriage departed from the norm."[1] Lilly Spencer had a studio in the new Western Art Union Building in Cincinnati and both exhibited and sold her paintings in Cincinnati. But the lure of better patronage attracted many mid-nineteenth-century artists to New York City, and the Spencers moved there in 1848. Within two years Mrs. Spencer was exhibiting at the National Academy of Design and was elected an honorary member of the academy, where she was taking evening drawing classes. She continued to exhibit almost annually at the National Academy. *Sartain's Magazine* in 1849 took note of Spencer's arrival in New York, stating that "her pictures are attracting much attention. The Art-Union has already purchased two of them. . . ."[2]

In 1858, to cope with the expenses of their growing family, they moved to Newark, and in partial payment of their rent, Mrs. Spencer painted a life-size portrait of the four children of her landlord, Marcus L. Ward (Newark Museum). They moved again in 1879 to Highland, New York, overlooking the Hudson River. Then in 1900, ten years after her husband died, Mrs. Spencer returned to New York City, where she painted until her death on 22 May in her eightieth year.

Spencer's high-spirited genre paintings are quite anecdotal and frequently need the titles for the viewer to understand the full import. For example, without the title *Peeling Onions* (c. 1852, private collection) one might not know right away why the sad-looking woman in the painting is wiping away a tear, or with *Kiss Me and You'll Kiss the 'Lasses* (1856, The Brooklyn Museum), it takes a minute to understand that "'lasses" is short for "molasses"! Some of the titles are expecially sprightly, matching the animation of the scenes—for instance, *Fi! Fo! Fum!* (1858, private collection) in which Mr. Spencer entertains two of their younger children; and *Grandpa's Prodigies* (c. 1860, on loan to the Brockton Art Museum) in which one can almost hear the playful infants. The canvases in this period are painted in bright, crisp colors; in her later work her brush stroke became looser and drier.

Mrs. Spencer gave birth to thirteen children, seven of whom reached maturity, and the family served often as the subject of her genre scenes. The only criticism of her style has been her tendency to paint large heads, but there may be an autobiographical explanation, for a photograph of the artist,[3] who was under five feet tall,[4] shows that she herself had a large head in proportion to her diminutive stature.

This painting and its companion, *The Young Wife: First Stew*, were exhibited together at the National Academy of Design in 1856. Here the novice shopper looks with consternation at the food that has fallen onto the sidewalk from his overloaded basket. Other pedestrians are able to walk under the protection of umbrellas on this rainy day, but the new husband's hands are too busy as he grabs a chicken that is slipping out of the basket. A small vignette in the background shows a young woman raising her skirts to keep them dry, revealing a white petticoat and long stockings.

The popularity of this pair of paintings was so great that copies were made on the base of candlesticks in cast metal.[5] Since the painting *The Young Wife* has not been located, the copy becomes especially valuable. Two women are shown in a kitchen (balancing the two men prominent in *The Young Husband*), and the wife stands, working with food on a table in much the same way the maid stands in *Shake Hands?* (1854, Ohio Historical Center, Columbus).

[1] Robin Bolton-Smith and William H. Truettner, *Lilly Martin Spencer: The Joys of Sentiment* (Washington, D.C., 1973), 21.
[2] "A Female Artist," *Sartain's Magazine* 4, no. 1 (1849), p. 77.
[3] Bolton-Smith and Truettner, *Lilly Martin Spencer*, fig. 48, p. 75.
[4] Ann Byrd Schumer, "Lilly Martin Spencer," *Notable American Women*, vol. 3 (Cambridge, Mass., 1971), 335.
[5] Dorothy E. Ellesin, "Collectors' notes," *Antiques* 107, no. 2 (February 1975), p. 262.

37
Lilly Martin Spencer (1822–1902)
War Spirit at Home signed and dated 1866
Oil on canvas, 30 × 32¾ in.
The Newark Museum

This narrative scene was painted during the American Civil War, and it shows the artist holding her latest baby as she sits reading the headlines in *The New-York Times*. Three other children parade through the room celebrating Grant's victory at Vicksburg on 4 July 1863. A weary looking family servant stands behind this group drying a plate. And a cat plays on the floor with the trailing sash of the girl beating the bottom of a pan. The brushwork in this painting, done a decade later than the previous canvas, is drier and not as glossy.

[Spencer is also represented in this exhibition by two still lifes, cat. nos. 88 and 89.]

Fidelia Bridges (1834–1923)
Laura Brown in a Wing Chair dated 1867
Oil on canvas, 21 × 18 in.
George C. Lay

Fidelia Bridges is best known for her landscapes with birds and for her delicate paintings of flowers. She also illustrated several books, such as Celia Thaxter's *Poems* (1876), *A Garland of Love* (1882), *Familiar Birds and What the Poets Sing of Them* (1886), John Burroughs's *The Return of the Birds* (1884), *Birds and Blossoms and What the Poets Sing of Them* (1887), and *Favorite Birds and What the Poets Sing of Them* (1888). Louis Prang & Company reproduced many of her paintings on cards. *Birds in Snowscape* (1903, The Connecticut Gallery, Marlborough, Connecticut) is typical of her naturalistic landscapes. Bridges's paintings have been included in many recent exhibitions: "American Cornucopia" (1976, Hunt Institute for Botanical Documentation, Carnegie-Mellon University), "Down Garden Paths" (1983, Montclair Art Museum), "Reflections of Nature" (1984, Whitney Museum of American Art), and "The New Path, Ruskin and the American Pre-Raphaelites" (1985, The Brooklyn Museum).

Bridges, born in Salem, Massachusetts, lost both her parents when she was fifteen; her father, a sea captain engaged in the China trade, died in Canton, and her mother died in Salem three hours before news of her husband's death reached her.[1] Responsibility for the three younger children fell to Eliza Bridges, the eldest, who opened a school, while Fidelia took drawing lessons and began caring for two children of the shipowner William Augustus Brown. When the Brown family moved to Brooklyn in 1854, Fidelia was invited to join their household as a mother's helper. Eliza closed her school then and moved with Fidelia to Brooklyn, where she opened another school, enrolling as her first four students the children of Anne Whitney's brothers. The Bridges sisters had met Anne Whitney (see cat. nos. 109–113) when she taught school in Salem, and Anne took a strong hand in guiding Fidelia's artistic training. In 1860 when the painter William Trost Richards invited Anne to attend evening lectures he would be giving in Philadelphia, Anne urged Fidelia to join her for the lectures and for drawing classes at the Pennsylvania Academy of the Fine Arts in the daytime. Richards had returned from England a leading disciple of the English Pre-Raphaelites, and through the class that he opened, Bridges became a good friend of the Richards family, with whom she spent the summer in Bethlehem, Pennsylvania, sketching directly from nature. By 1862 Bridges had her own studio in Philadelphia and was exhibiting at the Pennsylvania Academy. When she returned to Brooklyn in the fall of 1863, the Browns gave her a studio on the top floor of their house.

After the Civil War, Bridges sailed for Europe with Anne Whitney and Adeline Manning, arriving at Le Havre on 19 March 1867 and traveling on to Rome where Bridges remained until April 1868. She came into her own as a professional artist when she returned to New York and rented a studio at 650 Broadway.[2] She began in 1869 to exhibit at the National Academy of Design, which elected her an associate in 1873, and in 1875 she was elected a member of the American Society of Painters in Water Colors. She was invited to exhibit three paintings at the Philadelphia Centennial Exhibition of 1876.

Her association with Louis Prang, the chromolithographer, began in 1875 when he bought a series of her paintings of the months for a calendar; in 1881 she entered his Christmas card competition and was selected as one of his permanent designers. She also had illustrations published in *Scribner's Monthly* (August 1876) for an article by the naturalist John Burroughs and in *St. Nicholas*, accompanying a poem by Lucy Larcom.[3] An exhibition of her paintings at a Fifth Avenue gallery in March 1879 resulted in an increasing number of patrons, among them Mark Twain, who also employed her as a governess in 1883 when his three daughters' regular governess was on an overseas vacation. During Bridges's trip to England in 1880 to see her brother, she exhibited at the Royal Academy.[4]

In 1871 Bridges began spending summers in Stratford, Connecticut, where she could paint the birds and wildflowers along the banks of the Housatonic River and in the salt marshes. "She wrote of working ten hours a day outside where she had been painting a woodthrush on her nest, probably the *Thrush's Nest* shown in 1873 at the Brooklyn Art Association."[5] In 1892 she moved to Canaan, Connecticut, and rented a house on a hillside. She continued to paint and to exhibit her works at the Pennsylvania Academy until 1896, the National Academy until 1908 and the American Water Color Society until 1912, all told, exhibiting several hundred works.[6] Bridges died in Canaan on 14 May 1923, five days short of her eighty-ninth birthday.

After Fidelia Bridges was orphaned at fifteen, Mr. and Mrs. William Augustus Brown of Salem invited her into their home to help with their two small children. When Mr. Brown's change of business resulted in the family's move to Brooklyn in 1854, Bridges was invited along. Two more children were born to the Browns: a son in 1855 and a daughter Laura in 1856. The charming painting shown here is one of two oils that Bridges did of the interior of the Brown's home at 93 First Place before she left for Europe on 2 March 1867, the other one being the "Sitting Room, Brooklyn" (1867); she also painted a watercolor of "Laura Brown" (c. 1866) (all in the collection of George C. Lay).

The ten-year-old Laura is shown in this painting as she sits in the embrace of a big chair. She is depicted in profile, with long brown corkscrew curls, reading a book by the light of the nearby window. The attention to minute detail, which is characteristic of Bridges's nature studies, is evident here in the precise rendering of a Wedgwood vase, the vines growing around the window, an oriental rug on the carpeted floor, a landscape painting by Bridges on the wall, the brass tacks in the wing chair, and the books on a suspended bookcase over a side table. Warm reds glow in the interior in contrast to the pale blue sky seen through the window.

Similarly, in the "Sitting Room, Brooklyn," Bridges recreates this cozy, comfortable interior: a chair (empty this time) before a window with red drapes that have been pulled back to let the sunlight stream across an oriental carpet, potted plants before the window, a bird cage, and a little white seated statue. Bridges was best known as a naturalistic painter of the outdoors, but she demonstrated in her early work an equal ability to portray intimate interiors.

[1] Frederic A. Sharf, "Fidelia Bridges, Painter of Birds and Flowers," *Essex Institute Historical Collections* 104, no. 3 (1968), p. 217.
[2] Maria Naylor, *The National Academy of Design Exhibition Record 1861–1900*, vol. 1 (New York, 1973), 94.
[3] Frederic A. Sharf, "Fidelia Bridges," *Notable American Women*, vol. 1 (Cambridge, Mass., 1971), 238.
[4] Algernon Graves, *The Royal Academy of Arts, Dictionary of Contributors 1769–1904*, vol. 1 (London, 1905), 278.
[5] Mary Brawley Hill, *Fidelia Bridges, American Pre-Raphaelite* (New Britain Museum of American Art, 1981), 15.
[6] Ibid., 21.

Cornelia Adele Strong Fassett (1831-1898)
Mrs. Lamb in Her Study signed and dated 1878
Oil on canvas, 15 × 24½ in.
The New-York Historical Society, New York

Fassett has left her imprint on history with her group painting *Electoral Commission of 1877* (1879), which includes almost two hundred portraits, all painted individually from life at the artist's studio. She had previously painted an extraordinary large portrait of the Supreme Court Justices (1876), which was exhibited at the Philadelphia Centennial before being placed in the conference room of the United States Supreme Court.[1]

Cornelia Strong was born on 9 November 1831 in Owasco, Cayuga County, New York, and she married the Chicago photographer-artist Samuel Montague Fassett in 1851. After studying watercolor painting with the Scottish artist James B. Wandesforde, she traveled to Italy and Paris and studied with Giuseppe Castiglione, La Tour, and Gabriel Mathieu during the years from 1852 to 1855. The Fassetts settled in Chicago in 1855 and lived there for the next twenty years, raising a family of eight children while Mrs. Fassett painted portraits and Mr. Fassett ran a photographic studio. They made a trip to Europe in 1866 with their fourteen-year-old son Wallis, eight-year-old daughter Flora, three-year-old son Montague, one-year-old son Raphael, and a servant, Bridget Daily.[2] The great Chicago fire of 1871 damaged Mr. Fassett's business to the extent that he took a job as photographer to the Supervising Architect of the United States Treasury Department, and the family moved to Washington, D.C., in 1875. The Boston *Daily Evening Transcript* of 26 March 1875 noted the arrival of "Miss Fassett" in the capital that winter.[3] Mr. and Mrs. Fassett set up adjacent studios in a business building at 925 Pennsylvania Avenue.[4]

Cornelia Fassett's career soared in Washington. In addition to the two large group portraits already mentioned, she was kept busy with commissions for individual portraits: United States Presidents Grant, Hayes, and Garfield, and President Rankin of Howard University among others. *The Art Journal* of 1880 reported that she had painted the posthumous portrait of Richard Rush in a series of secretaries of the treasury.[5]

Mrs. Fassett was elected an associate member of the Chicago Academy of Design in 1874 and elected to the Washington Art Club in 1876. On 4 January 1898, as she rushed from one Washington reception to another, she suffered a heart attack and died at the age of sixty-six. She is represented in this exhibition by two of her most renowned compositions; they are rarely seen by the public, for one hangs in a corridor of the United States Capitol and the other is in storage at the New-York Historical Society.

What a wonderful view into a nineteenth-century woman scholar's study! The desk shows evidence of activity, bookshelves line the left and right walls, and the remaining wall space is decorated with art works, including two sculptures: a small bust portrait and an oval medallion portrait just to the left of the window—much like works in the present exhibition. One is reminded of the contemporaneous photograph of Annie A. Fields's Beacon Hill parlor in Boston in which she and the writer Sarah Orne Jewett sit reading under the watchful eyes of several marble and painted portraits.

Martha Nash Lamb (1826-1893), the author and historian, is shown seated in an armchair, holding a sheaf of papers. The first volume of her *History of the City of New York: Its Origin, Rise, and Progress* (786 pages), had just been published in 1877, and encouraged by its warm reception, she was proceeding with a second, longer volume (which was declared to be the best history yet written of New York by historian George Bancroft).[6] Warm sunlight streams into Mrs. Lamb's study as depicted here, giving the vase of flowers, painted in rich impasto, a jewel-like look. The whole room is bright with loose dabs of of scintillating color.

Martha Nash and Charles Lamb married in 1852 (a year after the Fassetts) in Maumee, Ohio, where she was teaching, and moved to Chicago in 1857. Mrs. Lamb was active in charity work and may have met Mrs. Fassett at this time. After the Civil War, the Lambs divorced, and Mrs. Lamb moved to New York City to pursue her literary career. She published several books and in 1883 purchased and began to edit the *Magazine of American History*. She died in New York at the age of sixty-six.

This painting was exhibited at the National Academy of Design in 1878 and more recently (1971) in an exhibition entitled "What is American in American Art" at the Knoedler Gallery in New York.

[1] Charles E. Fairman, *Art and Artists of the Capitol of the United States of America* (Washington, D.C., 1927), 314.
[2] I am grateful to Merl M. Moore for sending me a copy of Samuel M. Fassett's passport application, dated 17 September 1866.
[3] "Art and Artists," Boston *Daily Evening Transcript*, 26 March 1875, p. 6.
[4] Charlotte Streifer Rubinstein, *American Women Artists from Early Indian Times to the Present* (Boston, 1982), 55.
[5] "Art in the Cities: Washington," *The Art Journal* 6 (1880), 160.
[6] Raymond H. Robinson, "Martha Joanna Reade Nash Lamb," *Notable American Women*, vol. 2 (Cambridge, Mass., 1971), 361.

40

Cornelia Adele Strong Fassett (1831–1898)
Electoral Commission of 1877 signed and dated 1879
Oil on canvas, 60 × 75 in.
Architect of the Capitol

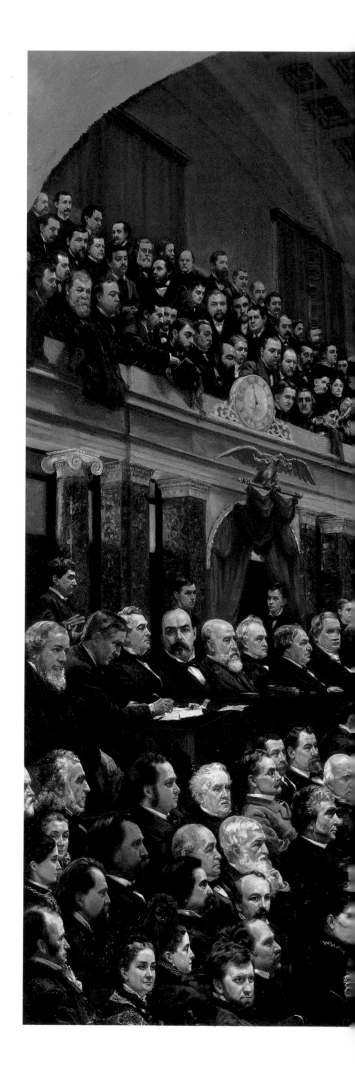

The 1876 Hayes–Tilden presidential election, which ended in a tie, was referred to an electoral commission for a final decision, and Fassett decided of her own volition to paint this historical event. She incorporated 196 portraits into this group scene, including her own self-portrait (she shows herself sketching in the center foreground) and a profile of her twenty-one-year-old daughter Flora (the young blond woman seen below the first pilaster from the right). She depicted William M. Evarts, counsel for Hayes, standing and gesticulating with his right hand as he addressed the fifteen members of the electoral commission, on the dais at the left. The gentleman seated in front of the dais with a pen in his right hand was the secretary of the commission, and the young man scribbling notes under the pointing hand of Evarts was a reporter for New York Associated Press. The other members of the press are shown in the press gallery: forty-five men and seventeen women (it is interesting to note which newspapers hired women journalists at this time, among them, *Cleveland Plaindealer*, *New Orleans Picayune*, *Kansas City Journal*, *Louisville Courier-Journal*, and *Grand Rapids Eagle*). Fassett received permission to paint the Supreme Court Chamber where the debate took place, thus documenting the appearance of this old chamber with its coffered ceiling, marble columns and pilasters, and sculptured portrait busts of former chief justices.

Among the forty-four women on the floor is another painter, Imogene Robinson Morrell (in a black hat, standing in front of the third pilaster from the right), who accompanied Elizabeth Gardner (see cat. no. 46) to Paris in 1864. Mrs. Julia Tyler, widow of ex-president John Tyler, and Mrs. James A. Garfield, wife of the future president, are in the group just to the left of Mr. Evarts's profile. Among the men, Frederick Douglass, the lecturer and writer, is seated with the spectators in the foreground at the far right. Samuel Randall, Speaker of the House of Representatives, stands holding his top hat in the background (near the second pilaster from the right).

It was bruited about that the government was going to pay Mrs. Fassett $15,000 for this historic document, with the result that at least one newspaper complained that this price and Caroline Ransom's fee of $10,000 for a portrait of General Thomas were excessive.[1] In the end, the Senate in 1886 paid $7,500 for this painting, which today hangs in the east corridor on the third floor of the Senate wing of the Capitol.

[1] "National Subsidies for Artists," *The American Architect and Building News* 17 (24 January 1885), 37.

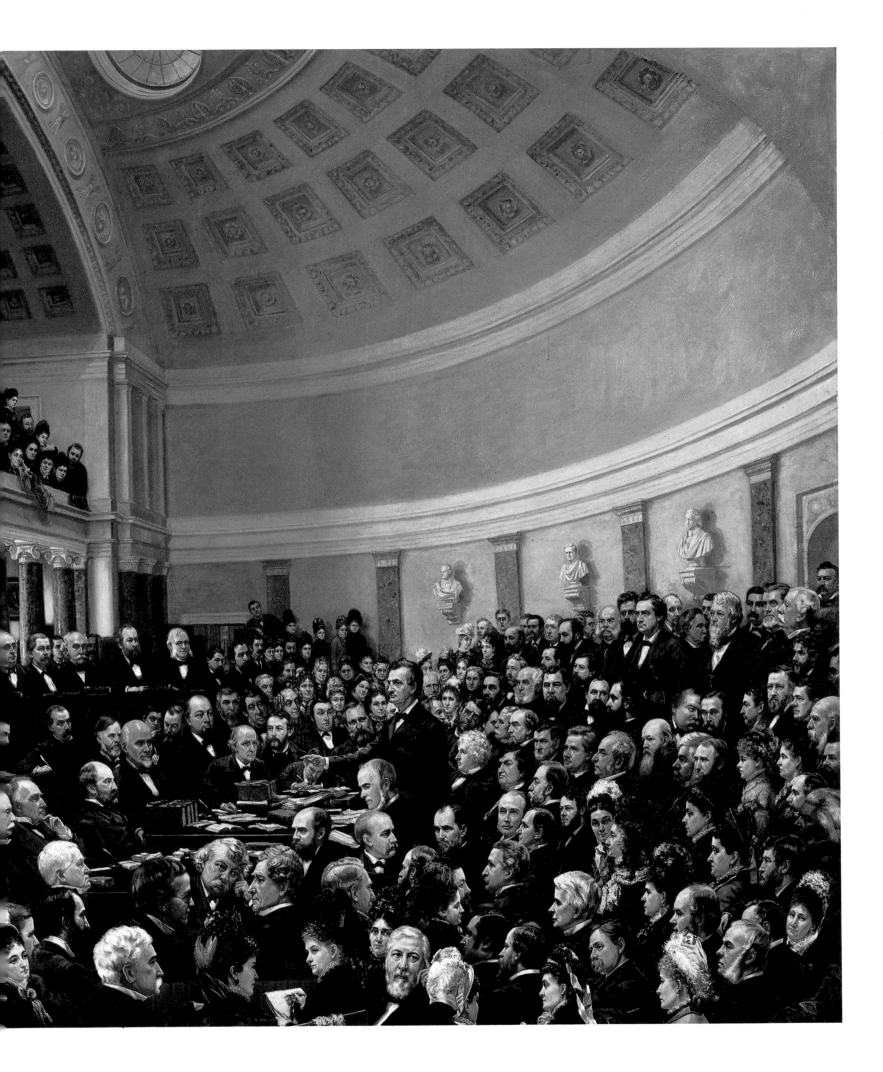

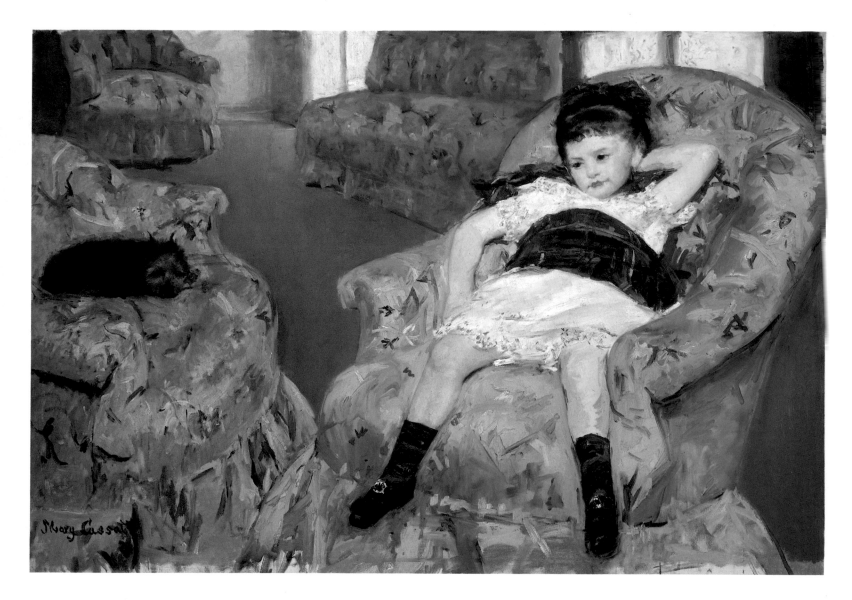

41
Mary Cassatt (1844–1926)
Little Girl in a Blue Armchair 1878
Oil on canvas, $35\frac{1}{4} \times 51\frac{1}{8}$ in.
National Gallery of Art, Washington, Collection of
Mr. and Mrs. Paul Mellon

In this ambitious composition Mary Cassatt depicts a deeper interior
space than is usual in her paintings and conveys an appealing sense of
lassitude: a Belgian griffin is asleep on one chair, and a young girl (the
daughter of a friend of Edgar Degas's) has flopped down in another.
Cassatt marvelously captures their relaxed poses in the ample armchairs.

Blues of different patterns contrast with each other in this painting: the
plaid scarf encircling the little girl's white dress against the floral print of
the armchair. The colored stripes in the scarf are repeated in the girl's
socks and the bow in her hair. The buckles on her shoes are indicated in
flashing white impasto.

Volumes are well modeled, with light from the above left giving
shape to the armchair occupied by the child, and shadows rounding out
her limbs. In the space created behind the two sitters stand two more
upholstered pieces of furniture—in shade and therefore of deeper blue.
From four components—the girl and her dog, the four pieces of matched
furniture, the receding gray floor, and the dramatic punctuation of the
wall by French windows—Cassatt has set into perpetual vibration a
dynamic aesthetic whole.

[For Cassatt's biography, see cat. no. 6.]

42

Jennie Augusta Brownscombe (1850–1936)
In Anticipation of the Invitation signed and dated 1888
Oil on canvas, 36 × 26 in.
Marge and Leslie Greenbaum

The most famous painting by Jennie Brownscombe, a history and genre painter, is *The First Thanksgiving* (1914), seen by droves of tourists every year when they visit the Museum of Pilgrim Treasures in Plymouth, Massachusetts. Other history paintings by Brownscombe are *The Peace Ball at Fredericksburg, Virginia* (1897, Newark Museum), and a number of scenes from the life of America's first president, such as *George and Martha Washington Leaving Church* (1911) and *Washington Greeting Lafayette at Mt. Vernon* (Lafayette College).

Brownscombe was born in the northeastern corner of Pennsylvania in a town called Honesdale. She attended high school there and taught for two years in the late 1860s before moving to New York City. In May 1871 she graduated from the School of Design for Women of The Cooper Union and for the next four years studied at the National Academy of Design. She was one of the founders of the Art Students League and in the late 1870s alternated her studies with Lemuel Wilmarth between the two institutions, winning honorable mention and then first prize at the academy and exhibiting annually at the academy from 1874 to 1887 and occasionally until 1910.[1]

Brownscombe traveled to Europe in 1882–83 to study in Paris with the American genre painter Henry Mosler, and on her return to America she exhibited *Brittany Peasant Girl* at the National Academy. From 1888 to 1895 she spent part of each year in Europe, maintaining a studio near Rome in the winter. She exhibited her work at the Royal Academy in London in 1900 and at the Water Color Society in Rome. She also exhibited in Philadelphia and Chicago. While in Rome, she met George Henry Hall,[2] an American painter of genre and still life who had studied in Düsseldorf. From about 1908 until his death in 1913, they shared a summer studio in the Catskill Mountains at Palenville, New York.[3]

Brownscombe's illustrations in *Scribner's Magazine* and *Harper's Weekly* and on Louis Prang's cards and calendars were popular as well as income-producing for the artist. Still active at age seventy-six, she made color illustrations for Pauline Bouvé's *Tales of the Mayflower Children*, a project that must have had great appeal for her, since she was a member of the Mayflower Descendants and of the Daughters of the American Revolution.

A writer for the Honesdale newspaper reported in 1934 that Brownscombe had just celebrated her eighty-fourth birthday and was still busy with commissions in her studio in Bayside, Long Island, having recently painted the portraits of two judges, an air force captain, two doctors, and a trustee of Rutgers College.[4] She was living with a cousin in Bayside, and when she died in her eighty-sixth year, her body was taken to Honesdale for burial next to her parents in Glen Dyberry Cemetery.

Brownscombe's earliest subject matter was contemporary genre scenes. For example, in *The New Scholar* (1878, Thomas Gilcrease Institute of American History and Art, Tulsa), the artist recalls her own early childhood days of attending a one-room schoolhouse in rural Pennsylvania. The first painting she sold was *Grandmother's Treasures*, exhibited in the National Academy in 1876, which was described in the New York *Evening Post* as "a large and cleverly painted interior . . . with figures."[5] In *Homecoming* of 1885 a mother holds up her baby to greet the returning farmer-father,[6] and in *Love's Young Dream* (1887, Holladay Collection, The National Museum of Women in the Arts) a young woman looks off expectantly toward the approaching figure of a man on horseback as her elderly mother and father sit ostensibly absorbed in their respective activities of knitting and reading.

In the sophisticated painting shown here, a pretty young woman gazes at herself in a hand mirror holding a rose to her dress. She stands before a tapestry that is pulled back to reveal a clock, a stained-glass window, and several large pieces of blue and white porcelain. The young woman is dressed in white with a blue ribbon around her waist matching the ribbon in her bonnet, and beside her is the bouquet of roses from which her single flower comes, as well as the envelope that may contain the "invitation" of the title.

[1] Kent Ahrens, "Jennie Brownscombe: American History Painter," *Woman's Art Journal* 1, no. 2 (Fall 1980/Winter 1981), p. 26.
[2] During the years from 1888 to 1895 Hall was submitting such paintings as *Girl of the Trastevere, Rome*; *Teresina, A Little Roman Girl*; *Italian Boy*; *The Bath at a Roman Fountain*; and *A Fountain at Frascati* to the National Academy's annual exhibitions and in both 1890 and 1895 listed Rome as his address. See Maria Naylor, *The National Academy of Design Exhibition Record, 1826–1900*, vol. 1 (Kennedy Galleries, New York, 1973), 385–86.
[3] Florence Woolsey Hazzard, "Jennie Augusta Brownscombe," *Notable American Women*, vol. 1 (Cambridge, Mass., 1971), 259.
[4] Edwin B. Callaway, "Thrilling Scenes In American History, Vividly Told in Brush Stories by Miss Jennie Brownscombe, Internationally Known Artist," *The Wayne Independent*, 11 December 1934. (I am grateful to Heidi Attar in my 1985 Women Artists course at Southern Methodist University for obtaining clippings on Brownscombe from the Wayne County Historical Society.)
[5] "National Academy of Design, The Fifty-first Annual Exhibition," *The Evening Post*, 28 March 1876, p. 3.
[6] *American Paintings* (R.H. Love Galleries, Chicago, 1977), 41.

Alice Barber Stephens (1858–1932)
Female Life Class 1879
Oil on cardboard, 12 × 14 in.
Pennsylvania Academy of the Fine Arts, Gift of the artist

One of the most successful illustrators, male or female, of the late nineteenth century, Alice Barber Stephens was also a painter, a teacher, a wood-engraver, a photographer, a wife, and a mother. She was born on a farm near Salem, New Jersey, and when the family moved to Philadelphia, she completed her public school education there. By 1873 she was enrolled as a full-time student at the Philadelphia School of Design for Women. Here she learned wood-engraving, and her illustrations began to appear regularly in *Scribner's Monthly*.[1] In the fall of 1876 she entered the Pennsylvania Academy of the Fine Arts and was fortunate to have Thomas Eakins as her teacher. Her famous painting of the *Female Life Class* taught by Eakins is in the present exhibition.

As one of nine children, Alice Barber felt the need to support herself upon leaving the academy in 1880, so she became a professional illustrator, with her works soon appearing in *Harper's*, *Century*, *Cosmopolitan*, *Collier's*, *McClure's*, and *Frank Leslie's Weekly*. To supplement this income, she gave classes in her Chestnut Street studio, but the pace of activities exhausted her, and in the winter of 1886-87 she traveled to Europe to recuperate. She studied in Paris at the Académie Julian and Académie Colarossi and sketched in Italy. She exhibited a pastel study and an engraving at the Paris Salon of 1887.[2] On her return to America, she became a leading illustrator, contributing regularly to the *Ladies' Home Journal*. She also illustrated many books, among them, Nathaniel Hawthorne's *The Marble Faun* (1900), Louisa May Alcott's *Little Women* (1902), and Kate Douglas Wiggin's *Mother Carey's Chickens* (1911).

From 1883 to 1893 Barber taught life classes at the Philadelphia School of Design. She exhibited oil paintings at the Pennsylvania Academy annually from 1884 through 1890, winning the last year the prize of best painting by a resident woman artist for her *Portrait of a Little Boy*. In June 1890 she married Charles Hallowell Stephens, a former classmate at the Pennsylvania Academy, who was now teaching drawing and painting at the academy. She continued to paint, signing her illustrations with her married name. In 1895 she won a medal at the Atlanta Exposition and in 1899 won a gold medal at an exhibition of women's work held at Earl's Court, London, the latter for her drawings for George Eliot's *Middlemarch* and paintings for Dinah Maria Mulock Craik's *John Halifax, Gentleman*.[3] A transformation occurred in her work in the 1890s when half-tone reproduction processes enabled her to add color to her illustrations. In 1897 Alice Barber Stephens and Emily Sartain (the artist who served as principal of the Philadelphia School of Design for Women) founded in Philadelphia the Plastic Club, the oldest art club for women in continuous existence in the United States, and the next year Stephens had an exhibition of eighty of her works there.

When Stephens's health was again impaired, a prolonged trip to Europe was her antidote (1901-1902), after which she settled with her husband and son outside Philadelphia. She stopped illustrating in 1926 and died six years later at her home in Moylan, Pennsylvania, following a paralytic stroke, at age seventy-four.

Her son donated a large collection of her crayon-on-paper illustrations to the Library of Congress where they can be seen on request. One of her few surviving portraits, *Alice Fisher* (1887), hangs today in the Historical Society of Philadelphia and demonstrates the painter's powers of characterization.

When an article entitled "The Art Schools of Philadelphia" was to appear in the September 1879 issue of *Scribner's Monthly*, Thomas Eakins asked his advanced students to depict scenes of the classes at the Pennsylvania Academy. Alice Barber's painting of the *Female Life Class* was chosen for publication with the article. Thanks to Eakins, progress had been made at the academy, and live models were substituted for antique casts, albeit women and men had their separate life classes.

Seated at the easel in the left foreground of this painting, with her paint box open beside her, is Susan MacDowell (see cat. nos. 11 and 12), a fellow student of Barber's and Thomas Eakins's future wife. Comparison of this portrait with a photograph of Susan MacDowell shows what an excellent likeness Barber achieved. The composition is well organized, with enough students gazing directly toward the model and MacDowell to make this section the focal point. The dark clothes of the women cause their three-dimensionally defined figures to stand out against the brown tones of the background. This painting not only gives us a realistic depiction of the Pennsylvania Academy but also serves as an important document in view of the historic personages involved.

[1] Ann Barton Brown, *Alice Barber Stephens, A Pioneer Woman Illustrator* (Brandywine River Museum, Chadds Ford, Pa., 1984), 8.
[2] Agnes Addison Gilchrist, "Alice Barber Stephens," *Notable American Women*, vol. 3 (Cambridge, Mass., 1971), 360.
[3] Ibid.

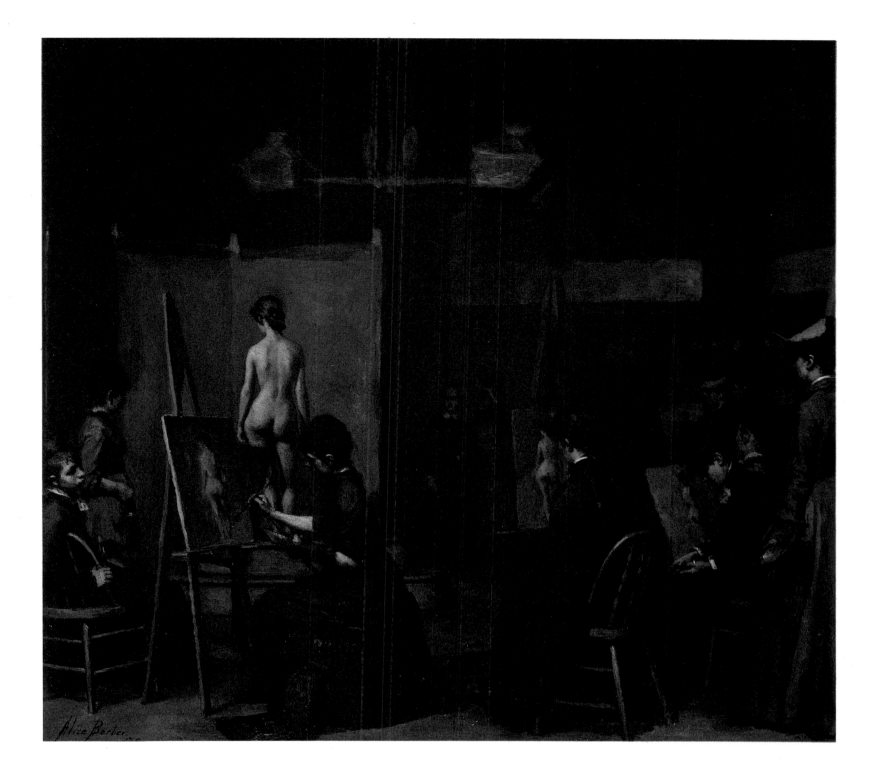

44

Alice Barber Stephens (1858-1932)
The Woman in Business 1897
Oil on canvas, 25 × 18 in.
Brandywine River Museum, Acquisition made possible by Ray and
Beverly Sacks

In 1897 the *Ladies' Home Journal* serialized six illustrations by Stephens that depicted American women in contemporary settings: *The Woman in Society*, *The Woman in Religion*, *The Woman in the Home*, *The American Girl in Summer*, *The Woman in Business*, and *The Beauty of Motherhood*.[1] A seventh painting, *The Dinner Party*, appeared on the cover of the February issue; this elegant scene of men and women catches the same flavor of high society that Stephens's contemporaries John Singer Sargent and Charles Dana Gibson also portrayed.

The *Woman in Business*, which was printed on the cover of the September issue, shows a well-dressed lady seated at the counter in John Wanamaker's Philadelphia store, being shown a selection of white cloth by a sales clerk. Many other clerks are crowded into the narrow standing space between the counter and the fluted Corinthian columns that support the shelving area behind. In the greater space for customers at the left, a dog comfortably waits at his mistress's feet. The composition has a steep perspective that plunges back into space from the sad-looking, doe-eyed young shop assistant in the foreground to the stained-glass window at the end. Since this painting was to be used as an early printing illustration, the colors are restricted to brown, black, and white. Within these limited means Stephens still manages a pictorial élan in her scene of everyday life.

[1] These were published in the January, March, May, July, September, and November issues of *The Ladies' Home Journal*, vol. 14 (1897).

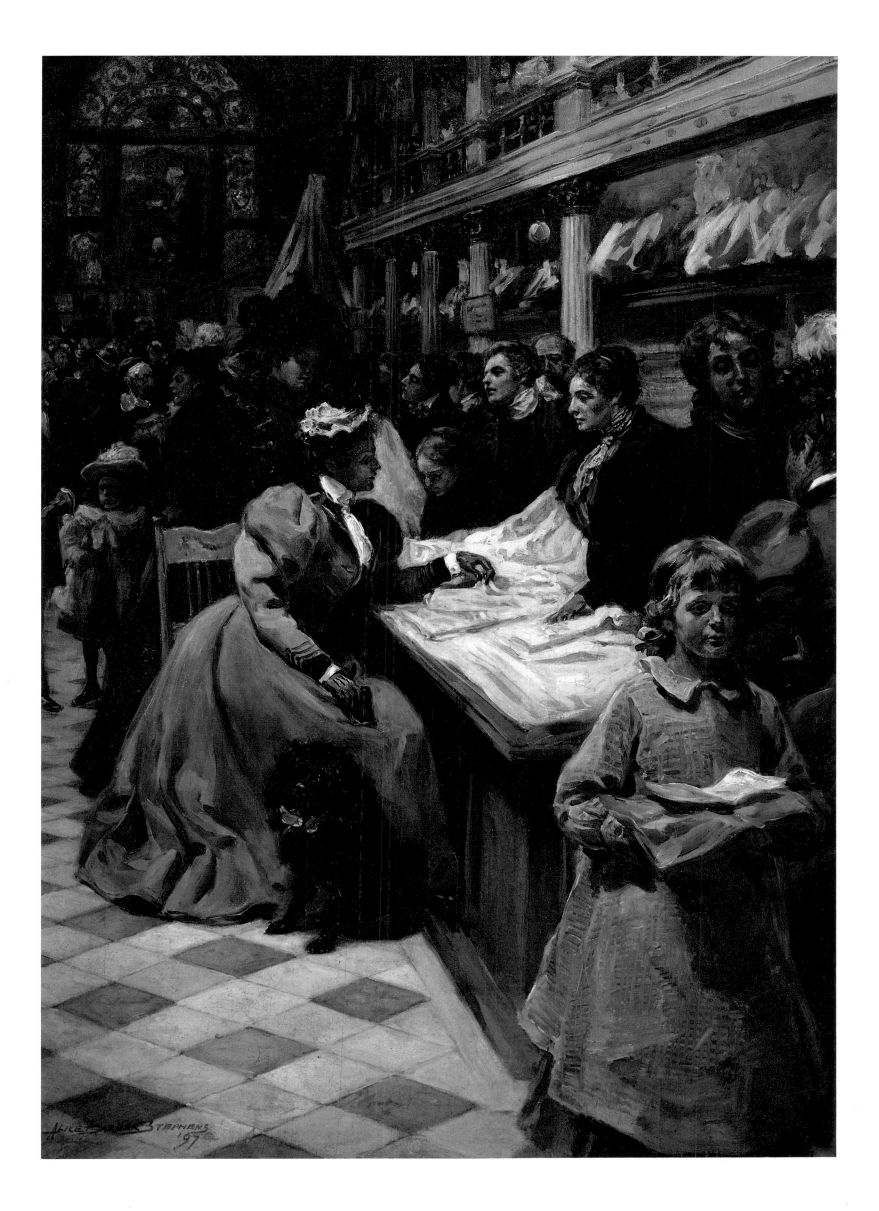

45

Ella Ferris Pell (1846-1922)
Salomé signed and dated Paris 1890
Oil on canvas, $51\frac{3}{4} \times 34$ in.
Collection of Sandra and Bram Dijkstra

A painter, sculptor, and illustrator in her prime, the little-known Ella Pell is buried in a pauper's grave in Fishkill Rural Cemetery in New York. Her unmarked grave is close-by her sister's, which does have a tombstone. Senator Claiborne Pell of Rhode Island has written that Ella Ferris Pell is "probably a great niece of William Ferris Pell, who was my great-great grandfather."[1] The Pells are also related to the Folgers of Rhode Island, who established the Folger Shakespeare Library in Washington, D.C.[2]

According to *Who Was Who in America*, Ella Pell was born in St. Louis on 18 January 1846. She studied under William Rimmer at the Design School for Women at Cooper Union in New York and graduated in 1870.[3] While studying with Rimmer, she must have sculpted the *Puck* that was singled out for praise in the New York *Evening Post*:

Some of our women artists have exhibited decided talent in sculpture. Indeed, if we are to judge from the prominence which has been given Miss Hosmer, Miss Foley, Miss Stebbins, Miss Lewis and others, we infer that the plastic art is responsive to the female nature. Miss Ella Pell is evidence of this truth: her figure of Puck imprisoning toads in acorn cups, which is now at the Academy, is charming in fancy and admirably modeled.[4]

An item in the *Daily Evening Transcript* places Pell at Bread Loaf Mountain in Vermont in the summer of 1872:

. . . we had the truest and most artistic statuary tableaux I have ever seen gotten amateurly up. I but echo the notes of seventy people, many of whom have "travelled," . . . Miss Pell, the sculptress, who so soon leaves for the "land of song," (Memnon, I suppose, where the marbles speak,) managed and arranged all. The curtain parted and Psyche paid her respects; and we did, too, in a natural and handy way. Cordelia, with Lear, the broken man, was chiselled (not pictured) to the letter. Iago, Puck, Cupid, were accurately presented. Iago was truly a "whitened sepulchre;" Cupid even lighter than the whitest of the statued. Cleopatra (having given out that she was dead) stood in her poise of doubt and dread, a vivid type of the Egyptian queen. . . .[5]

The allusion to Pell's approaching departure refers to the overseas trip she was planning with her sister and brother-in-law, Evelyn and Charles H. Todd. On Pell's application for a passport, dated 29 August 1872, the twenty-six-year-old artist described herself as five feet seven inches tall with blue eyes, light brown hair, a small nose, a large mouth, and a long face.[6] The trio left on 15 September 1872 for Europe, North Africa, and the Near East, a trip that lasted "five years, seven months and 18 days" according to Pell's diary.[7] She painted as they traveled—Algerian street scenes, whirling dervishes, the interior of their Nile boat, landscapes in Normandy—and her brother-in-law wrote a manuscript entitled "Bible Synopsis and Jewish Institutions," which he completed in Switzerland in July 1877; it contains maps of ancient Palestine drawn by the two sisters. In the early 1880s when Pell began exhibiting at the National Academy of Design, she was living in New York City. A sample of her entries reflects her travels: *La Annunziata* and *Water Vendor, Cairo, Egypt*.

When Pell exhibited at the Paris Salons of 1889 and 1890, she listed as her teachers Jean-Paul Laurens, a history painter; Jacques Fernand Humbert, a history and religious painter; and Gaston Casimir Saint-Pierre, a painter of portraits and genre at the Académie des Beaux-Arts des Champs-Elysées. The painting she exhibited in 1889 was entitled *The Angel Making Adam See the Consequences of His Sin*, and the two she entered in 1890 were *Salomé* and *Portrait of Mme T.*

In the 1890s Pell was again living in New York City. She illustrated Paul Tyner's love story *Through the Invisible*, which was published in 1897 and had work accepted for reproduction by the chromolithographer Louis Prang (e.g., Christmas cards, Easter designs, and figures). Summers were spent with her family north of the city, and one of Pell's paintings depicts her chalet studio near Hunter in the Catskills.[8] Pell's subject matter ran a wide gamut. It was, however, generally realistic except for two rather mystical paintings: *The Evolution of Soul* (c. 1896)[9] and *Storm Gods of Rig Veda* (exhibited at the Black and White Club in New York in 1900) based on a hymn in the Sacred Vedas.[10]

Pell died at seventy-six, a year after her sister, in Beacon, New York. Fifty-eight oil paintings, drawings, her diaries, and other memorabilia rescued from the attic have been deposited with the Pell Family Collection at Fort Ticonderoga Museum in Ticonderoga, New York.

In France, Pell worked stylistically within the academic tradition but iconographically managed to be quite daring. Instead of the sultry, slim temptress of Gustave Moreau's nude *Salomé* (1876), who dementedly contemplates the head of John the Baptist, Pell paints a buxom young woman lost in private ruminations. Other Americans at the turn of the century, like Henry O. Tanner and Claude Buck, perpetuated Moreau's image of the nude dancing figure who lusts after the decapitated head. Pell, on the other hand, depicts Salomé holding an empty charger in her left hand, a solitary figure similar to that in her painting of *Agnus Dei* (1899, Columbus Museum of Art). In each painting, the attractive life-size woman is powerfully modeled and possesses an air of self-sufficiency. One is reminded of the seventeenth-century precedent in Artemisia Gentileschi's paintings of Old Testament heroines (Judith, Esther, Susanna, and Bathsheba), who appear physically capable of their historic tasks. Pell elucidates: "The picture represents Salomé at the moment when she first discovers the head of John the Baptist."[11] The other element of daring in Pell's interpretation is the semi-nudity, unusual in the work of an American woman painter at this time.

[1] Senator Claiborne Pell letter of 4 December 1981 to Sandra Dijkstra, owner of *Salomé*. I am deeply grateful to Sandra and Bram Dijkstra for sharing their file on Ella Pell with me.
[2] Jeffrey Borak, "Long Forgotten, The Lady Is Now Remembered," *Poughkeepsie Journal*, 25 March, 1973, p. 1D.
[3] *Woman's Who's Who of America*, 1914-15.
[4] "The Women Artists of New York and its Vicinity," *The Evening Post*, 24 February 1868, p. 2.
[5] W.C.W., "Bread-Loaf Notes," *Daily Evening Transcript*, Boston, 19 August 1872, p. 1.
[6] I am very grateful to Merl M. Moore, Jr., for providing me with a copy of this passport application and the two previous newspaper articles.
[7] Borak, "Long Forgotten, The Lady Is Now Remembered." The diaries of Ella Pell and her sister were found in an attic in Beacon, New York, by Mrs. Jane Hewes, who has placed them with Pell's paintings at the Fort Ticonderoga Museum.
[8] Reproduced in Alfred Trumble, "Art's Summer Outings," *The Quarterly Illustrator* 2, no. 4 (October-December 1894), p. 388.
[9] Reproduced in Charles C. Eldredge, *American Imagination and Symbolist Painting* (Grey Art Gallery, New York University, 1979), 40.
[10] Reproduced in catalogue for Black and White Club exhibition (Durand-Ruel Galleries, New York, 1900), and "In the Field," *Art Education* (February 1901), 263.
[11] Edgar Mayhew Bacon, "The Making of Masterpieces," *The Quarterly Illustrator* 1, no. 4 (October-December 1893), p. 310.

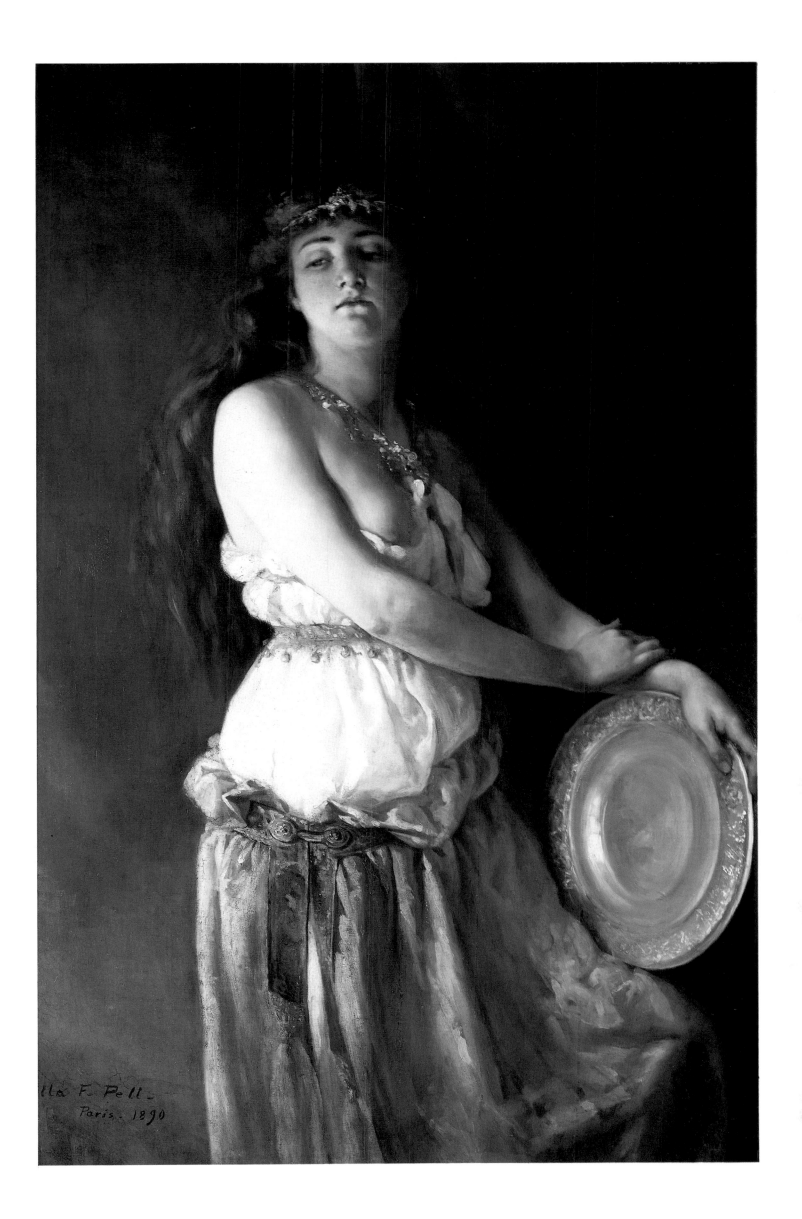

Elizabeth Jane Gardner Bouguereau (1837-1922)
David, the Shepherd c. 1894
Oil on canvas, $61\frac{1}{2} \times 43$ in.
The National Museum of Women in the Arts,
The Holladay Collection

The Federal style house in which Elizabeth Gardner grew up still stands today, facing onto the main square of Exeter, New Hampshire, within sight of her father's hardware store, which remained in the family for generations. After her schooling in Exeter, Gardner studied language and art at Lasell Female Seminary (now a junior college) in Auburndale, Massachusetts, graduating in 1856. During the next few years she taught French at the Worcester School of Design and Fine Arts with Imogene Robinson, her former art teacher at Lasell. In 1864 Robinson and Gardner moved to Paris and worked that first summer as copyists—filling orders from America for copies of paintings at the Louvre and Luxembourg museums. In the fall when Gardner tried to enroll in formal classes, she found that the Ecole des Beaux-Arts was open to men only. The solution was a women's cooperative studio in which the women hired their own models.[1] Her first big success occurred in 1868 when two of her pictures (a still life and a figure painting) were accepted for the annual Salon, whose jury rejected eight hundred works, and one of her paintings then sold for $400.[2] She listed as her teacher at the time of the 1868 and 1869 Salons the French painter Hughes Merle.

Gardner has been called the first American woman in the nineteenth century to try to study in Paris. In desperation she dressed as a boy to accompany Imogene Robinson's nephew to all-male drawing classes. As she herself remarked, following Rosa Bonheur's example, she applied to the Paris Police Department for permission to wear male attire in order to attend the men's drawing classes at the Gobelin tapestry school.[3] Rodolphe Julian was sufficiently impressed with Gardner's earnestness that he admitted her into his academy, where she studied with Jules Lefebvre.[4] By 1879 Gardner—at the age of forty-two—had attained the right to have paintings accepted at the annual Salon without subjecting her work to the jury, and she received an honorable mention for an entry.

William Bouguereau (1825-1905), by this time acknowledged as Gardner's teacher, had been a widower for two years, and in 1879 announced his engagement to Gardner, who was also his next-door neighbor on rue Notre-Dame des Champs. Because of the objections of his elderly mother, Bouguereau was not free to marry Gardner until his mother died in 1896 (when he was seventy-one and Gardner fifty-eight). After his death, Gardner continued to live in France, exhibiting at the Salon until it was interrupted in 1915 by World War I. She died at her summer home in St. Cloud near Paris at eighty-four.[5]

Gardner painted a wide range of subject matter: portraits, genre, and history (both religious and mythological), but always in the academic tradition. Although she and Mary Cassatt were contemporaries in Paris, Gardner adhered staunchly to the conservative style and declared, "I would rather be known as the best imitator of Bouguereau than be nobody!"[6] Her work was recognized with prizes: a gold medal at one of the Paris Salons and a bronze medal at the Exposition Universelle in 1889. And at her zenith she was selling her paintings for $1,600, far more than the Impressionists commanded.[7] Typical of her work are compositions of children engaged in a common activity, illuminated against a dark woodland setting, such as *The Little Mother*, *At the Well*, and *Crossing the Brook*.

Elizabeth Gardner's *David, the Shepherd*, met with immediate success. In a letter to her family in 1895, she wrote that she liked the hanging of *David* in the Salon and was gratified that Goupil had chosen her painting "for a full page in his first publication on the best pictures of the year." Just ten months later she could report with satisfaction that when

Mrs. Thaw of Pittsburgh returned to Paris to see a finished portrait she had commissioned of Gardner, she was so pleased that she "purchased at a good price my large painting of David. . . . She has a fine large house in Pittsburgh, where the picture will be well hung and admired. This work has been the great success of my life with the artists etc. It has done much for my reputation. . . . I so much prefer this sale to giving the painting to any dealer."[8]

In I Samuel 17:34-35 the young David tells Saul how he rescued a lamb from the mouth of a lion, to prove that he would be able to confront Goliath. At the time of Gardner's marriage *The Boston Journal* illustrated her *David, the Shepherd*, and described how in the summer of 1894 she had studied the animals at a zoo near her studio in preparation for this painting. She sketched a lion in every position, until one day the manager warned her that her favorite model was ill:

"You will not want to paint him."
"Oh, but I will!" she declared.
"No, really you will not, for we think he is dying."
"Oh, but I must see him!" she pleaded.

Then they permitted her to go to his cage. She took a number of photographs of him, and made a color sketch of him with his mouth open and his head thrown back in his last agony. Then when he was dead she bought the body and had it conveyed to her studio, and for days she had a dead lion and a live lamb in her rooms, that she might get exactly the color and texture of the different parts. The feet of the lion, for instance, are a lighter brown than the back, and the mane richer than any other. She did not leave a detail unnoticed. The lion is there and looks the thing he is represented—life in death. The tender little lamb she portrayed had his home in her studio during the process of his painting. Young lambs, she said, are always very white and silky, and in what a masterly way she painted the two different textures of the two different whites, one against the other, an exceedingly difficult thing to do. The delicate fleecy purity of the young lamb against the white fabric of the shepherd's tunic. The blue of the distant Judean hills rises behind the figure and forms the background.[9]

This fidelity in the rendering of the animals reminds one again of Gardner's good fortune in having Rosa Bonheur as a role model (Bonheur kept all kinds of animals, including her pet lion, on her estate near Fontainebleau). Gardner composed such a handsome tribute to Bonheur upon her death that Theodore Stanton used it to end his biography of the French painter.[10] Gardner especially cherished a visit that Bonheur made to her studio a few weeks before her death (1899).

In Gardner's *David*, the shepherd's blue eyes gaze heavenward. The fleecy lamb with its pink nose and pale pink ears is pressed against David's white tunic and red belt. The vanquished lion, so realistically modeled after the dying one in the zoo, is depicted with an open mouth, pink tongue, big white teeth, white whiskers, and a dark, languid tail. The distant bluish mountains and the scraggy bush at the right are scarcely defined. Attention is focused on the handsome David highlighted against the dark mass of the background.

[1] Madeleine Fidell-Beaufort, "Elizabeth Jane Gardner Bouguereau: A Parisian Artist from New Hampshire," *Archives of American Art Journal* 24, no. 2 (1984), p. 3.
[2] The relative value can be better appreciated when we know that the annual rent for both her studio and her apartment totaled $700 (ibid., 8).
[3] Lida Rose McCabe, "Mme. Bouguereau, Pathfinder," *The New York Times Book Review and Magazine*, 19 February 1922, p. 16.
[4] *William Bouguereau*, "Biography" by Mark Steven Walker (Montreal Museum of Fine Arts, Montreal, 1984), 52.
[5] Obituary, *The Exeter News-Letter* 92, no. 5 (3 February 1922), p. 1.
[6] McCabe, "Mme. Bouguereau."
[7] Fidell-Beaufort, "Elizabeth Jane Gardner Bouguereau," 7.
[8] Letters of 3 May 1895 and 20 March 1896 (Archives of American Art).
[9] I am grateful to Mrs. Miriam Dunnan, great-niece of Elizabeth Gardner, for bringing this newspaper article from her family files to my attention.
[10] Theodore Stanton, *Reminiscences of Rosa Bonheur* (New York, 1910; reprint ed., New York, 1976), 404-405.

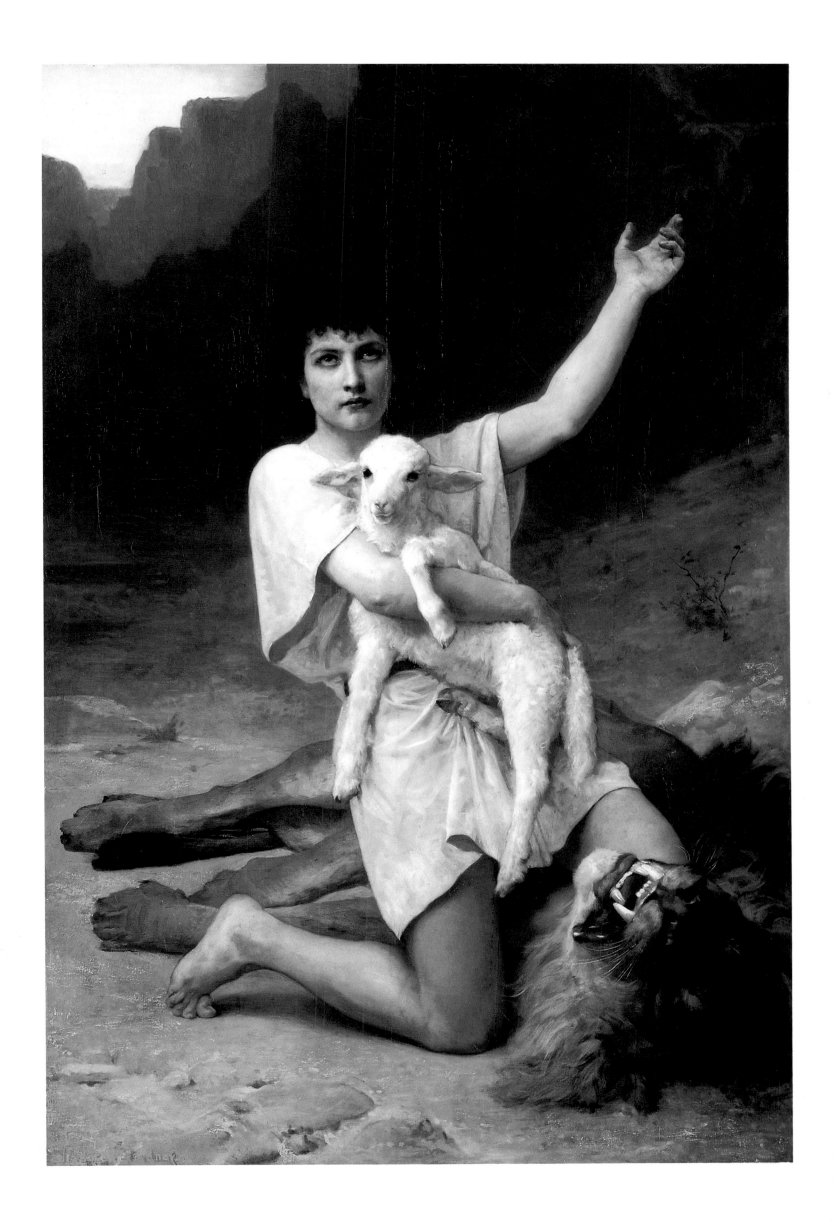

47
Anna Elizabeth Klumpke (1856–1942)
In the Wash House signed and dated Paris 1888
Oil on canvas, 79 × 67 in.
Pennsylvania Academy of the Fine Arts, Gift of the artist

With this genre scene Anna Klumpke became the first woman to receive the Pennsylvania Academy of the Fine Arts's Temple Gold Medal for the best figure picture (in the annual exhibition of 1889). Klumpke describes in her *Memoirs* how she was visiting the painter Felix de Vuillefroy and his wife for a month at their home, Château de Thury, on the Oise River: "Returning from a sketching tour, . . . paint-box in hand, I came upon the laundry house belonging to the Château, where a group of peasant women stood around a large tub, blithe and busy with their work, and then and there, on the instant, I made a sketch of the homely scene. Monsieur de Vuillefroy liked the composition and advised me to develop it into a large picture and send it to the spring Salon of 1888. It was accepted and well hung. It caught the attention of Miss Sara Hallowell, the official delegate from the Chicago Institute. On her advice the Institute requested it for their autumn exposition of that year, and from Chicago it went to Philadelphia for their exhibition the following spring of 1889."[1] Klumpke goes on to say that the Pear's Soap Manufacturers were eager to buy it, probably as an advertisement, but her mother had already offered the painting to the Pennsylvania Academy.

In this painting four French women in their characteristic black dresses stand about a single tub. Each woman is in a slightly different pose: the most distant one at the left is bent over from the waist; the next, with her face turned toward the viewer, is not quite so bowed; the third is progressively higher; and the fourth woman stands at full height before the window. Despite the tiring work, the girl in the left foreground has a cheerful countenance, and sunlight from the window brightens the scene.

The Pennsylvania Academy of the Fine Arts also accepted Klumpke's *Portrait of Elizabeth Cady Stanton* (National Portrait Gallery) for its 1889 exhibition and her *Rosa Bonheur* (cat. no. 13) for its 1902 show.

[For Klumpke's biography, see cat. no. 13.]

[1] Anna Elizabeth Klumpke, *Memoirs of an Artist*, ed. Lilian Whiting (Boston, 1940), 26.

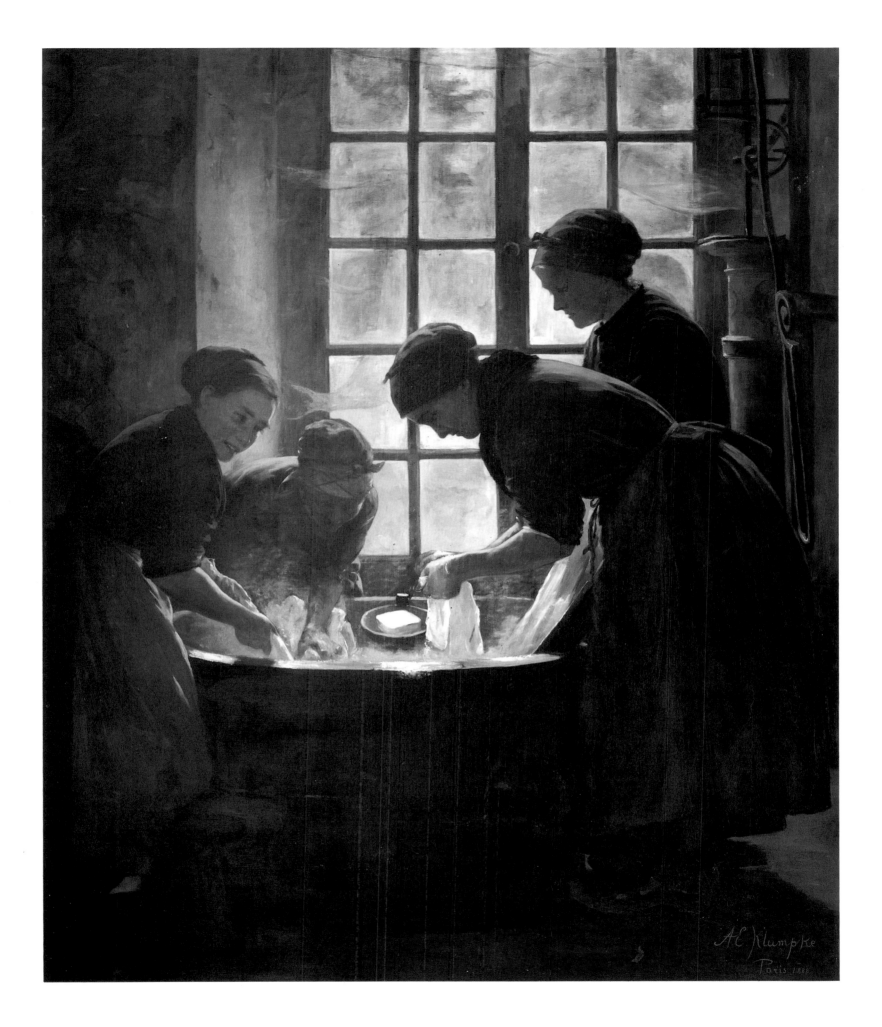

48

Harriet Campbell Foss (1860–1938)
The Flower Maker signed and dated 1892
Oil on panel, $51\frac{1}{2} \times 72\frac{1}{4}$
Private collection, Courtesy Ira Spanierman Gallery, New York

Harriet Campbell Foss was born in Middletown, Connecticut, where her father, the Reverend Archibald Campbell Foss, a Methodist minister, taught at Wesleyan University. Reverend Foss died in 1869 while traveling with his family in Europe, and Mrs. Foss returned to Middletown with the three children.[1]

Harriet Foss graduated from Wilberham Academy and attended Smith College for the 1883–84 academic year, but she then decided to pursue her artistic training in New York. She enrolled at the Woman's School of Design at Cooper Union and also took classes with the American Impressionist J. Alden Weir. In the late 1880s she went to Paris, where she lived for five years, studying privately with the genre painter Alfred Stevens. She also attended William Bouguereau's classes at the Académie Julian and Gustave Courtois's classes at the Académie Colarossi.

Foss began exhibiting in the Paris Salon as early as 1887 and exhibited again in 1892 before returning to New York. Her 1887 entry was a portrait entitled *Arabian Lady*. When this painting was later shown at Judah & Seamen's in Los Angeles, it was praised for "its charming tone . . . naturalness of the pose . . . and individuality."[2] The critic added that the dress worn in the painting was designed by Sarah Bernhardt for herself and was lent to Foss for this portrait. Foss also sent a portrait to the National Academy of Design in New York for its 1890 exhibition, listing "Paris" as her address, and submitted a still life to its 1892 exhibition. This still life of pale blue flowers, an inkwell, and a quill pen is signed and dated "H. Campbell Foss/1892 Paris."[3] She used this signature on her paintings in order to escape any possible prejudice against women artists.

From 1892 to 1895 Foss taught drawing and painting at the Women's College of Baltimore (now known as Goucher College). Then in 1899 when *The Flower Maker* seen here was shown at the Royal Academy in London, Foss gave as her address "43 Avenue Victor Hugo, Paris."[4] The next year a pastel painting of red phlox was included in the Paris World Exposition. Another pastel, *Market Garden*, was recently on view at the Adams Davidson Galleries in Washington, D.C.—an impressionistic landscape with a wagon departing on a path through the field.

Starting in 1905, Foss maintained a studio in New York and a home in Stamford, Connecticut. In 1909 she moved to Darien where she was active with the Seven Arts League and continued painting a wide range of subject matter. She died at her home on Fairmead Road in Darien on 29 June 1938, leaving her sister Caroline Foss as survivor.

With this strong painting, "H. Campbell Foss," as she signed her work, proves herself capable of creating a masterpiece. A French woman sits in a dark interior on a winter's day, working by the light of a window and warmed by the fire burning below in the fireplace (one of those that opens to the outdoors for cleaning—with the chimney on our left). With silk, scissors, thread, tincture, and a curling iron, she is making flowers in imitation of the real ones before her on the table. The daylight catches her profile and her reddish hair, and the red glow from the fire is reflected on her long blue apron. Tongs lean against the wall to the right of the fireplace.

The captivating view through the window is in contrast to the darkness in the room. Beyond the book, candlestick, and two potted plants on the window sill, two pedestrians can be seen walking on this side of the street, and many shoppers stroll in front of the stores on the other side—some are seen through the clear glass, but two figures are viewed more tantalizingly through the transparent curtain.

After this painting was accepted by the Paris Salon of 1892 and illustrated in its catalogue, it was exhibited at the World's Columbian Exposition in Chicago in 1893, the Tennessee Centennial Exposition in Nashville of 1897, the Trans-Mississippi Exposition in Omaha in 1898, the Royal Academy in 1899, the Pan-American Exposition in Buffalo in 1901, and more recently, at the Ira Spanierman Gallery in New York in 1986.[5]

[1] I am indebted to the Spanierman Gallery (David Henry and Lisa Peters) for sharing its findings on this unpublished artist. Until Lana Jokel's extensive research on Foss, under the instruction of Professor Barbara Weinberg, in the Sotheby's American Works of Art Program, the only information available was the short entry in Thieme-Becker.

[2] "A Famous Portrait: A Painting from the Hands of an Artist," *The Los Angeles Times*, 5 November 1890 (a clipping read by Lana Jokel in the Foss file at the Kennedy Galleries in New York).

[3] Seen by the author at the Kennedy Galleries, 31 May 1985, along with a small *Self-Portrait* in which the artist wears pince-nez, and *Seamstress, Darien*, an impressionist painting of a woman seated by a window.

[4] Jane Johnson and A. Greutzner, *Dictionary of British Artists, 1880–1940* (Suffolk, England, 1976), 182.

[5] I am grateful to Linda Ferber, chief curator of The Brooklyn Museum, for calling this painting to my attention, and to the new owners for graciously lending their acquisition to the present exhibition.

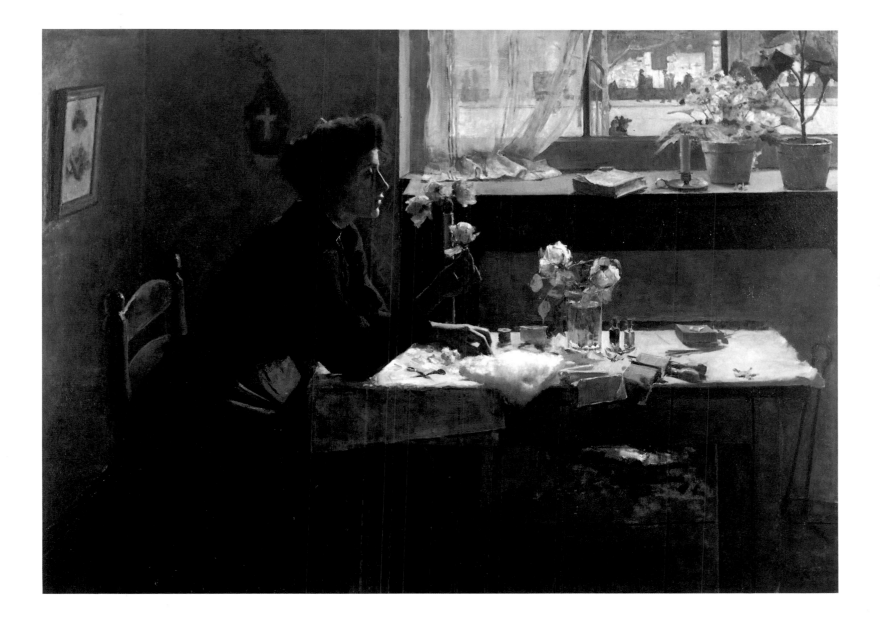

49
Elizabeth Nourse (1859–1938)
In the Church at Volendam 1892
Oil on canvas, 49 × 62 in.
Thomas Burke Memorial, Washington State Museum

This Cincinnati-born artist became a well-known expatriate painter of European peasants, supporting her older sister Louise and herself by the sale of her work and leaving at her death $50,000 in bonds and real estate to four nieces. Nourse studied at the Cincinnati School of Design from 1874 until her graduation in 1881 and exhibited for the first time in 1879 at the annual Cincinnati Industrial Exposition. One of the earliest ways she found to support herself was by painting decorative oil panels for homes, and among her clients was Alice Pike Barney, who also studied with Nourse and eventually became a painter in her own right. Barney commissioned of Nourse a *Flock of Geese* panel, which she later transferred from her Cincinnati home and installed over the fireplace in her Sheridan Circle studio in Washington, D.C.

By 1887 Nourse had saved enough money to move to Paris, where she enrolled at the Académie Julian. Of the various teachers with whom she studied there, she worked most closely with Jules Lefebvre. In January 1889 she traveled to Russia with a sculpture student, Tolla Certowicz, and spent six weeks in the Ukraine. A summer of painting in the French countryside followed. Nourse next went to Italy in January 1890 with her sister Louise and stayed for a year and a half. Assisi was a place of pilgrimage for the two sisters, both devout Catholics, and they became members of a lay group known as the Third Order of Saint Francis.[1] As always, the travels provided new subject matter for the artist, and with this goal in mind, the sisters settled in Volendam, Holland, for three months in 1892.

Nourse's first acceptance into the Paris Salon Exhibition was in 1888 with a painting entitled *La mère* (Pleasant Dreams), bought in 1913 by Mrs. Woodrow Wilson for the Princeton study of her husband, then governor of New Jersey. Nourse continued to exhibit regularly in the Paris Salons until 1920 and was elected to the prestigious Société Nationale des Beaux-Arts in 1901.

Nourse returned to America only once: in 1893 when she had three paintings selected for the World's Columbian Exposition in Chicago, and more importantly, the first large exhibition of her works opened at the Cincinnati Art Museum—to be followed the next year by a smaller exhibition in Washington, D.C., at which twenty-one paintings were sold. These successes enabled Nourse and her sister Louise to return to Paris for the rest of their lives. Earlier they had lived at 72 rue Notre-Dame des Champs and knew their neighbor Elizabeth Gardner (see cat. no. 46). On their return in 1894 they settled at their final address: 80 rue d'Assas, where they had a view of the Luxembourg Gardens from their fourth-floor apartment. Among the paintings that Nourse made during a three-month trip to North Africa in 1897 is *Moorish Prince*, "an exceptionally well-done image," writes Daniel Dubois, director of the New Britain Museum of American Art, who cites this as his favorite work by a woman artist in his museum.[2] A trip to Spain in 1906 provided Nourse with new sights for her painting.

Nourse's sister Louise helped with business arrangements and with shipping, keeping up with the requests for Elizabeth's paintings in international exhibitions (Tunis in 1897, Liège in 1909, Vienna in 1910, London in 1914). Nourse received invitations to show at the annual exhibitions of American painting in Chicago and Philadelphia and at the Carnegie International Exhibition in Pittsburgh, as well as almost every year in Cincinnati until World War I.[3] Nourse also exhibited annually with the American Woman's Art Association in Paris and served as its president in 1899–1900. Another member of this group, Mary Cassatt, inscribed a pastel to Nourse, "To my friend/Elizabeth Nourse/Mary Cassatt."[4]

In January 1937, when Louise died at the age of eighty-four, Elizabeth seems to have lost her will to live. She died on 8 October, just eighteen days before her seventy-ninth birthday and was buried, wearing the habit of the Third Order of Saint Francis, next to her sister in the village of Saint Léger-en-Yvelines.

The National Museum of American Art and the Cincinnati Art Museum made a wonderful contribution to the history of art by arranging a major exhibition of Nourse's paintings in 1983. They brought together seven hundred works by this woman who dedicated her life to being a professional artist, enabling us to see Nourse's range of working women in a variety of landscapes and domestic interiors. Nourse was in general closer to the French and American nineteenth-century realists than to the Impressionists. Her occasional experiments with impressionism occurred in such sunlit landscapes as *Summer Hours* (1895, Newark Museum) and *La Reverie* (c. 1910, College-Conservatory of Music, University of Cincinnati) in which a woman in a lavender dress gazes at a luminous fish bowl; she stands before an open window through which we see a maze of colorful flowers in a garden that is reflected in the glass of the open casement window behind her.

In July 1892 Elizabeth Nourse, her sister Louise, and two Cincinnati friends rented a house in Volendam, Holland, for three months. In this fishing village on the Zuider Zee, Nourse found exciting new subjects to paint among the working-class families. She seems to have taken special delight in painting the transparent lace caps with picturesque flaps worn by the Dutch women and girls. In this church scene Sunday hats are worn over two of these lace caps. Nourse also shows the varying degrees of interest that these youthful parishioners take in the service, including a charming vignette of contrasting merriment and absorption in the foreground. This painting received a silver medal at the Exposition Universelle of 1900 and was among the paintings bought in Paris by Judge and Mrs. Thomas J. Burke who later gave them to the University of Washington.

As Lois Fink points out in a perceptive study of Nourse:

Early in her career, Elizabeth Nourse had determined the basic themes of her art: female imagery, especially the themes of mothers and children, and hardworking women of the lower economic classes, and although she did not stray far from basic academic precepts she adapted innovations in late nineteenth-century painting that were consistent with her aims. . . . Further, it seems very doubtful that she would have found any subject in the United States as congenial to her as the European peasantry. The Breton peasants and the Dutch and the Picardy fisher women were not only picturesque but belonged to their land; their lives were as deeply rooted in the past as the ethical ideals that governed Nourse's life and art. . . . Elizabeth Nourse needed a sense of the significance for her creative efforts but like other American expatriates of her time, both artists and writers, she could not find this in her native land.[4]

[1] Mary Alice Heekin Burke, *Elizabeth Nourse, 1859–1938, A Salon Career* (Washington, D.C., 1983), 39.
[2] Letter of 10 October 1985, from Daniel DuBois to Eleanor Tufts.
[3] Burke, *Elizabeth Nourse*, 52.
[4] Ibid., 59.
[5] Lois Marie Fink, "Elizabeth Nourse: Painting the Motif of Humanity," in ibid., 135.

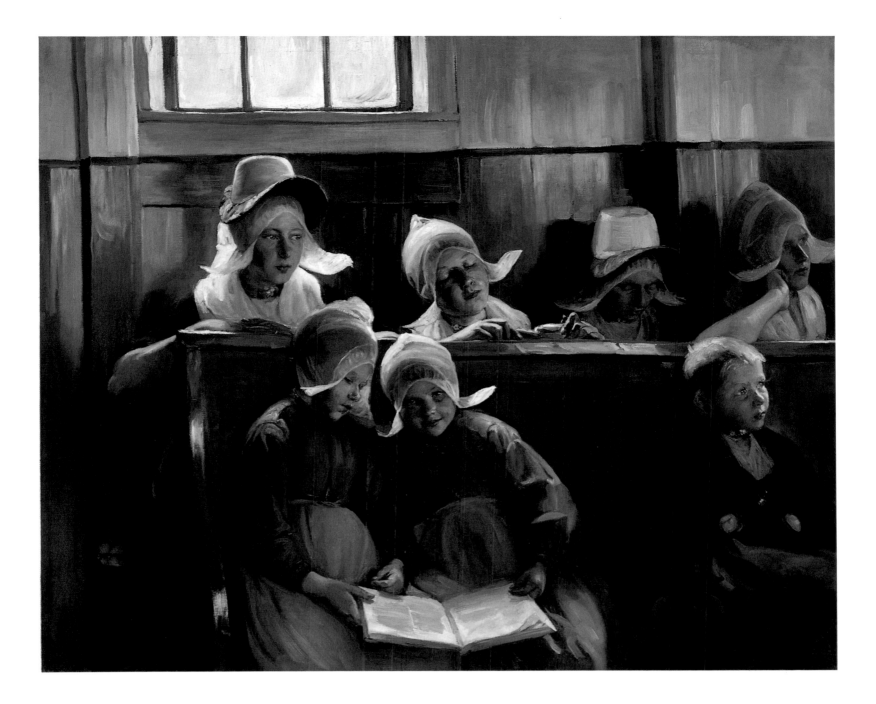

Lilla Cabot Perry (1848-1933)
The Trio, Tokyo, Japan between 1898 and 1901
Oil on canvas, 29 × 39¾ in.
Harvard University Art Museums (The Fogg Art Museum);
Purchase, Friends of the Fogg Art Museum

Lilla Cabot, the eldest of eight children, was born in 1848 in Boston, where, as we have long heard, "the Lowells talk to the Cabots and the Cabots talk only to God." Her mother, a cousin of James Russell Lowell, bears out this oft-quoted saying, but apparently Thomas Sergeant Perry, an instructor at Harvard, was close enough to being God to merit conversation, because Lilla Cabot married him 9 April 1874. Lilla Perry, who had begun as a poet, probably received encouragement for her painting from her husband's brother-in-law, the artist John La Farge, who—alongside his other commissions—designed a stained-glass window for the married couple's new home at 312 Marlborough Street, Boston. Her private lessons with the painter Robert Vonnoh began in January 1886[1] upon her receipt of a substantial inheritance after her father's death the preceding year, and in November 1886 she enrolled at the Cowles School of Art to study with Dennis Bunker. By painting portraits of the daughters of the head of the Waltham Watch Company, Perry earned enough money to take her husband and three daughters "on first-class passage"[2] to Europe in June 1887 and to remain until November 1889.

Perry studied in Paris at the Académie Colarossi and the Académie Julian, but the really momentous event in her artistic development was her introduction to Claude Monet at Giverny in the summer of 1889. For the next two decades the Perrys spent as many summers as possible next door to Monet, and although he did not take pupils, Perry learned all she could about impressionist techniques from the French master. Today her painting *Alice on the Path* (1891) hangs in Monet's bedroom, a large room over his studio, where as she wrote after Monet's death in 1927, "he had quite a gallery of the works of such Impressionists as Renoir....There was also a delightful picture by Berthe Morisot, the one woman of his set I have heard him praise. And richly she deserved it! I met her only once, at Miss Cassatt's...."[3] Among the eight pictures Perry exhibited at the World's Columbian Exposition in 1893 were several painted at Giverny.[4]

On the family's third trip to Europe (1894-1897) they went to Spain before going to Giverny so that Perry could further her studies by copying the paintings of Velázquez and Ribera.[5] Proof of her success as an artist can be seen in the fact that her paintings were accepted for shows in Paris and Berlin in 1896 and in Florence, Dresden, and Munich the next year. Puvis de Chavannes complimented her by remarking that her work "was very original, of charming colour and very delicate."[6]

By this time Thomas Perry, a grand-nephew of Commodore Matthew C. Perry, had turned to free-lance writing, and in 1897 he accepted an invitation to be professor of English literature at Keiogijiku University in Tokyo. Mrs. Perry and the daughters joined him in Tokyo in July 1898, and Lilla used their three years in Japan to absorb at first-hand *Japonisme*, which was all the rage with the French Impressionists, and to continue her painting: "During my stay in Japan I painted the few portraits of foreigners, devoting myself principally to landscapes to which one is tempted in so beautiful a place as Japan, and also painting portraits of prominent or typical Japanese."[7] Her husband in a letter of 29 November 1900 describes her activities as follows: "My wife is hard at work with her painting. She has just finished a portrait of a Shinto priest, who has charge of the fire-walking. He is a curious soul. He made us a call a few days ago and he looked at all the pictures of Japan with great interest. His wife, a head priestess, is now sitting in her most gorgeous robes and with her hair dressed in the most complicated way, for her portrait...."[8]

On her return to America, Perry resumed her active exhibition schedule, winning a bronze medal at both the St. Louis Exposition of 1904 and the Panama-Pacific Exposition of 1915. She was a founder of the Guild of Boston Artists (1914), where she had a number of solo exhibitions. Her work was also included in annual exhibitions at the Pennsylvania Academy and at the Corcoran Gallery of Art.

Perry was a painter of portraiture, genre subjects, and landscape. Among the portraits she painted were those of the writer William Dean Howells, the poet Edwin Arlington Robinson, and Mrs. Edward MacDowell, wife of the composer. In genre her work was very much in keeping with the popular Boston mode of the day: intimate interiors often of simply one woman. Her particular specialty was the single standing woman, seen from the side, with her head averted: for example, *In the Studio* (c. 1895), *Mother and Child Reading, Lady in Blue Evening Dress, The Pink Rose* (1910), and *A Japanese Print* (1917). In landscapes she was close to Monet's impressionism and was, in fact, a plein-air painter. Her own words inform us of the sensation she caused when she painted outdoors in Japan: "You would be amazed to see the people collected to watch my work when I was painting out of doors. Once my daughter happened to turn round, and in her astonishment at the number counted them—and there were 62 gathered to watch! They seem much impressed with our different approach to the subject of the picture. Their painting is, of course entirely conventional."[9]

Upon finding an area in New England that reminded her of Normandy, Perry in 1903 bought a farm in Hancock, New Hampshire, and landscapes once again became the subject of her brush. In the same way she had posed a little peasant girl before a window affording a view of Giverny in 1889 (*La Petite Angèle*), she painted her housekeeper, *Marie at the Window, Autumn* (dated 1921), in Hancock, as well as the young woman seated before a springtime view entitled *By the Window* (1923). Edmund C. Tarbell, the American Impressionist, relates in the 1933 Memorial Exhibition catalogue that Perry was painting one of her beloved winter landscapes in Hancock the day before she died in February 1933.

Perry's daughters were often her subjects, whether in Giverny, in the United States, or as here, in Japan during the family's three-year stay. The youngest, Alice,[10] is at the piano; Edith, the middle child, plays the cello; and Margaret, the eldest, plays the violin. The setting is a Japanese interior with tatami on the floor and only a few selected objects displayed discreetly behind. The influence of Japanese prints can be seen in the high floor line. The white luminosity of the daughters' clothes is contrasted delicately with a blue collar and belt on Alice's dress and a red collar and belt on Edith's. One other note of differentiation is in hair styles: braids on Alice and a topknot of hair on her sisters.

[1] Lisa Ward, "Lilla Cabot Perry and the Emergence of the Professional Woman Artist in America: 1885-1905" (M.A. thesis, University of Texas at Austin, 1985), 25.
[2] Lilla Cabot Perry letter of 9 August 1929, to her granddaughter Elsie Grew, kindly made available to me by Mrs. Elsie Grew Lyon. A charming insight into the young Lilla Cabot's adventure-loving character is afforded by the following passage from the same letter: "You will laugh when I tell you that I had so few story books when I was a child that before I was 7 years old I read, devoured in fact two little old fashioned volumes of Greek and Roman History with long ss like ff in them—and the battle, murder, and sudden death with which they were filled so excited my imagination that I talked about them in my sleep.... Mother took them away from me and gave me a volume of Natural History to read instead, much to my grief.... Years after Mother told me that I cried at parting from the thrilling Roman and Greek histories...and said 'I hate the book of Natural History, it hasn't even a murder to make it interesting.'"
[3] Lilla Cabot Perry, "Reminiscences of Claude Monet from 1889 to 1909," *The American Magazine of Art* 18, no. 3 (March 1927), p. 125.
[4] *World's Columbian Exposition, 1893, Official Catalogue* (Chicago, 1893), 24.
[5] Virginia Harlow, *Thomas Sergeant Perry: A Biography* (Durham, N.C., 1950), 160.
[6] Ibid., 161.
[7] Alma S. King, *Lilla Cabot Perry, Days to Remember* (Santa Fé East Galleries, Santa Fe, N.M., October 1983).
[8] John T. Morse, Jr., *Thomas Sergeant Perry, A Memoir* (Boston, 1929), 91.
[9] "Boston Artists and Sculptors in Intimate Talks: XIII Lilla Cabot Perry," unknown newspaper, c. 1920, family papers, Hancock, N.H.
[10] Alice later returned to Japan when her husband Joseph Grew became United States Ambassador.

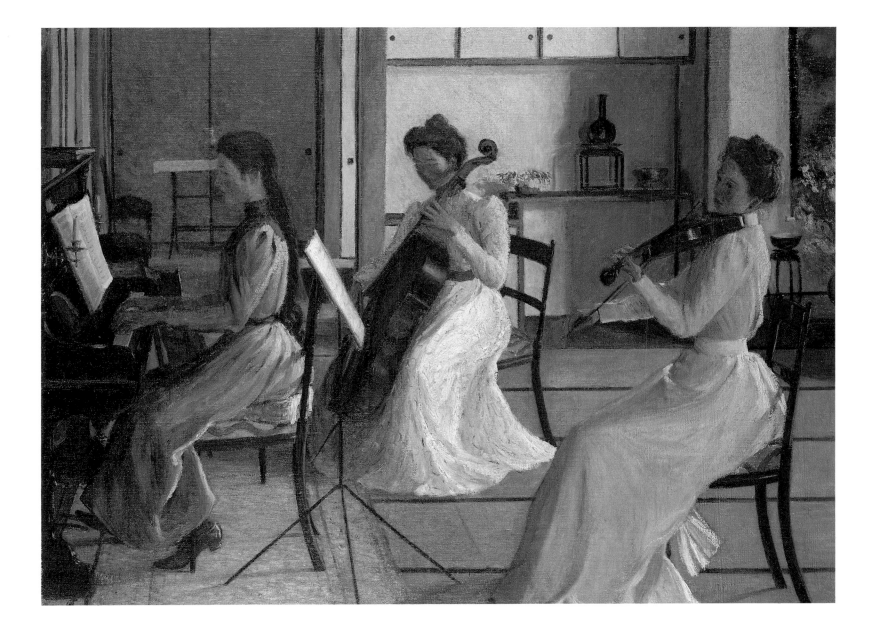

51
Lilla Cabot Perry (1848-1933)
Lady at the Tea Table c. 1905
Oil on canvas, 45 × 34½ in.
Richard H. Love Gallery, Chicago

An entire exhibition could be done of ladies at the tea table. One of the most painterly is Lilla Cabot Perry's, in which the woman is training her small dog to beg for the thin cookie that she holds suspended in her left hand. In true impressionist fashion Perry paints the shadows on the white clothes of the lady in swatches of green and violet. Quite characteristic of Perry, the lady is depicted in profile (and so is the dog). They sit on a lovely sofa covered with a fabric of green stripes that alternate with a tiny variegated design. The tea set rests on a handsome lace tablecloth in the foreground.

[Perry is also represented in this exhibition by her *Giverny Landscape, in Monet's Garden*, c. 1897, cat. no. 65.]

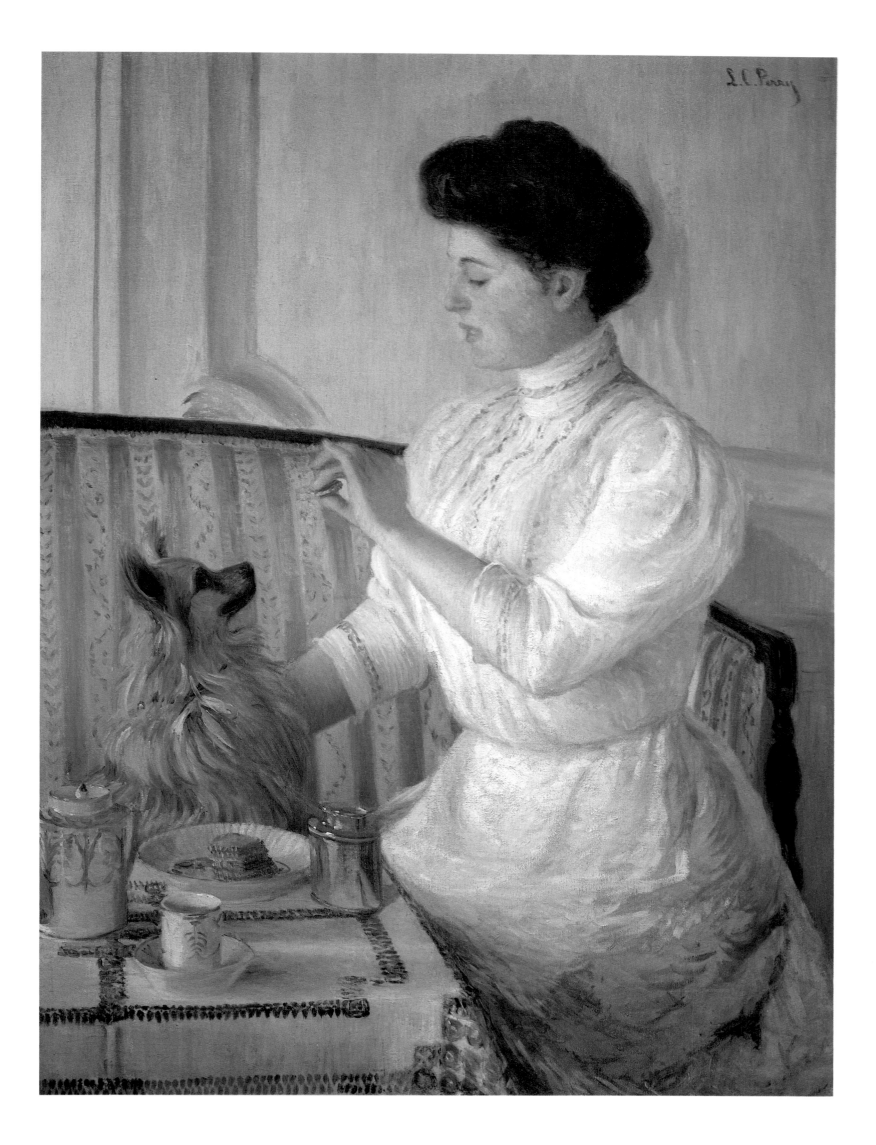

52
Ellen Day Hale (1855–1940)
Morning News signed and dated 1905
Oil on canvas, 50 × 36 in.
Private collection

Of the many pictures of women reading newspapers in domestic
interiors painted at the turn of the century, this is perhaps the most
aesthetically pleasing. Working in a more impressionistic style than
earlier (see her *Self-Portrait*, cat. no. 14), Ellen Hale defines the figure in a
multitude of delicate colors—subtle nuances of yellow, green, white, and
mauve. The exquisite profile of the reader is illuminated against a dark
brown wall. A tea set, painted in white and violet, scintillates behind
her at the left. This is an artful study in compositional and psychological
balances, in which to the extreme upper left a medallion portrait profile
of a woman stares silently at the young woman who in turn is intent
upon reading the morning paper, held between but repeating the two
horizontals of a tea-laden sideboard and a low book-laden table.

[For Hale's biography, see cat. no. 14.]

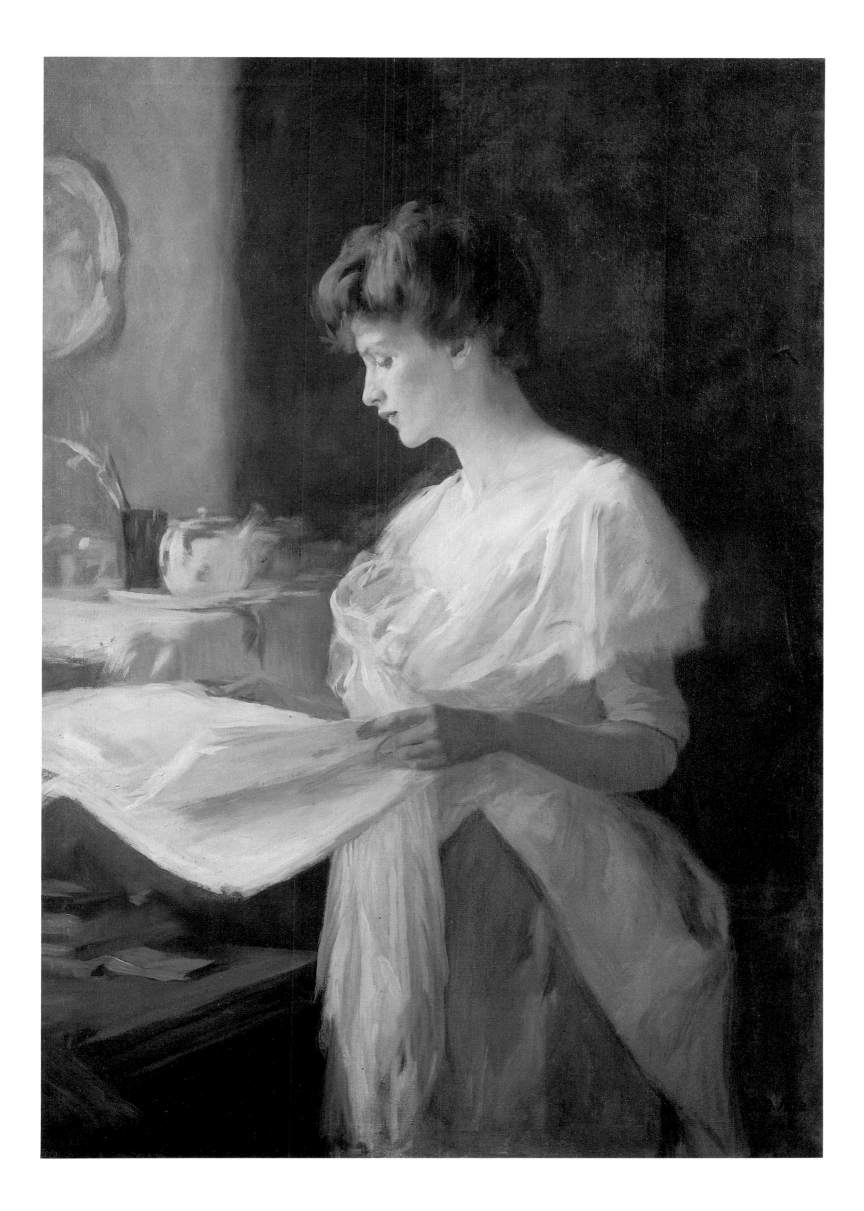

53
Lilian Westcott Hale (1881–1963)
L'Edition de Luxe 1910
Oil on canvas, $23\frac{1}{4} \times 15$ in.
Museum of Fine Arts, Boston

The Hartford-born Lilian Westcott has credited the following as her teachers: Elizabeth Stevens, Edmund C. Tarbell, and William Merritt Chase. Her studies began at the Hartford Art School, for her mother insisted, as Lilian and her sister Nancy grew up on Sigourney Street, that they receive good training, her sister on the violin, Lilian in painting. In 1902 she obtained her diploma from the Boston Museum School, shortly before marrying one of the instructors, Philip Leslie Hale. She was twenty at the time, and he was seventeen years her senior.[1] Their daughter, Nancy Hale, has described the Dedham, Massachusetts, home in which her parents' two studios existed, claiming that her mother was the more successful of the two: "she had more portrait orders than she could fill, and her prices were steadily rising."[2] She was also an innovator: "One of her great artistic coups was inventing for herself a way of doing charcoal drawings of scenes in the falling snow—church spires, farm houses, heavy-laden pines. . . ."[3]

Lilian Hale exhibited frequently at the Pennsylvania Academy of the Fine Arts from 1903 to 1927 and won a Gold Medal of Honor at the Panama-Pacific Exposition in San Francisco in 1915. She was elected an associate member of the National Academy of Design in 1927 (the same year Marie Danforth Page was elected; see cat. no. 19) and was then promoted to full membership four years later. The diploma painting that she gave the National Academy was a pure landscape entitled *An Old Cherry Tree*. Her paintings garnered many awards over the years.

After Philip died in 1931, Lilian remained in Dedham, except for the summers, which she spent on Cape Ann next door to her sister-in-law Ellen Hale (see cat. nos. 14 and 52). Then in 1953 she moved to an apartment in Charlottesville, Virginia, to be near her daughter. Since she had never seen first-hand the paintings in Europe about which she had heard so much, she and her daughter traveled to Italy in 1963. On their return home she announced that she was going to visit her sister in Minneapolis. While there, she suffered a heart attack, and she died in St. Paul on 7 November, just a month before her eighty-second birthday. Her last painting had been conch shells in a still life.

In addition to portraits, Lilian Hale painted many genre pictures of a single figure in an interior setting as Vermeer had. She and her husband Philip Hale, whose book on Vermeer was published in 1913, both obviously admired the Dutch artist. In the painting shown here a solitary woman is seated at a table absorbed in a special edition of prints, showing no awareness of the rest of her surroundings. The quiet figure is silhouetted against a pinkish window and curtain, and a soft light permeates the room, creating subtle reflections on the table top. Prominent in the foreground, balancing the set-back figure of the copper-haired woman, is a delicate branch of flowers in a porcelain bowl on the table.

The North Carolina Museum of Art has a painting by Hale entitled *Alice* that is similar in mood and very typical of her work: a girl seated before a fireplace, apparently entranced by the flickering fire. And in the Pennsylvania Academy's *Portrait of a Young Girl* by Hale a girl is posed in a comfortable domestic setting. In *Lavender and Old Ivory*, the painting that Hale exhibited at the Panama-Pacific International Exposition, a woman in a soft chemise stands before a fireplace; she holds a small basket of flowers in one hand and with her left hand reaches out toward flowering branches that stand in a vase on the floor. *Blue Taffeta* is similar: a lady stands in a gorgeously painted long blue dress (with the shadows in the folds painted green), and the trailing effect of the skirt is matched by a vine that spills out of a flower pot at the side. In all of these paintings Hale's pigment is applied in a porous way that verges on being impressionistic.

[1] Nancy Hale, *The Life in the Studio* (Boston, 1957), 36.
[2] Ibid., 14.
[3] Ibid., 15.

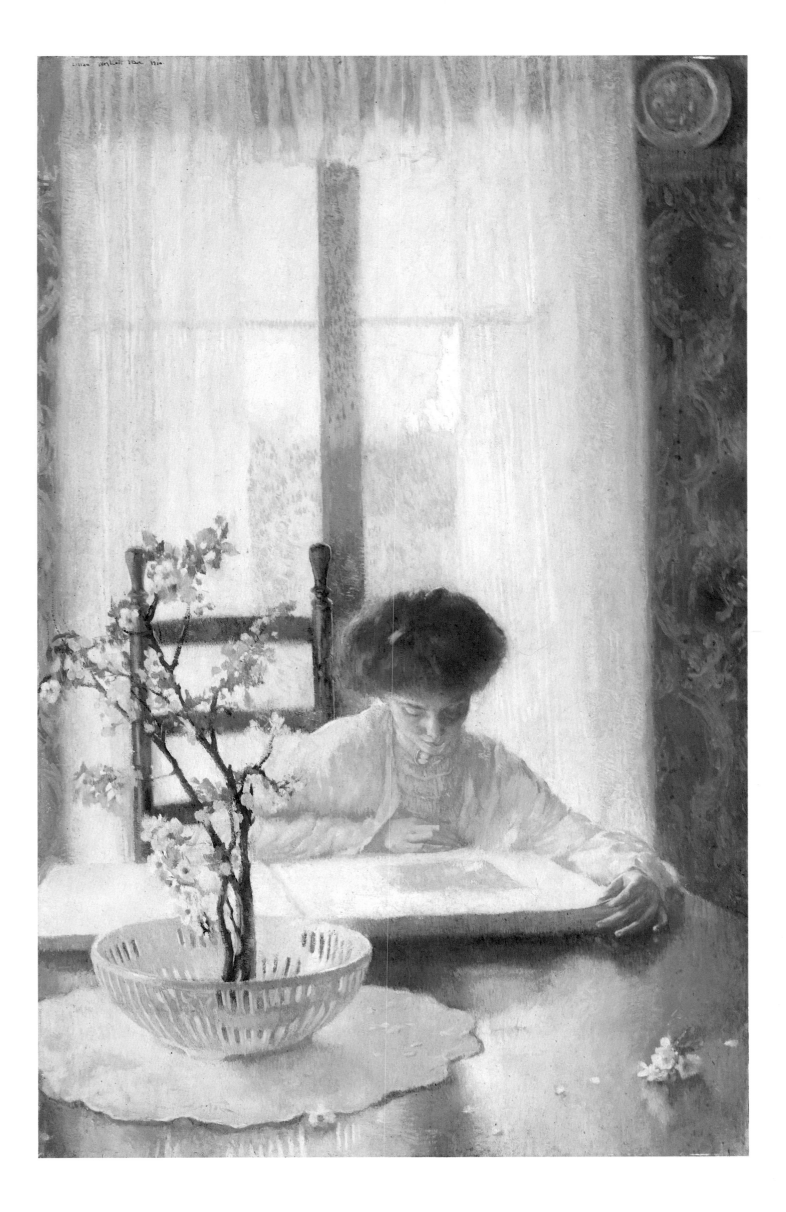

54
Mary Bradish Titcomb (1856–1927)
Summer Girls c. 1912–1913
Oil on canvas, 40 × 30 in.
Mr. Edward Judd

Born in Windham, New Hampshire (a small town in the southeast corner of the state), the artistically talented Mary Titcomb, upon graduating from high school, accepted a position teaching drawing in the public schools of Brockton, Massachusetts. After serving in this capacity for fourteen years, she resigned in 1889 to study painting at the Boston Museum School. Her teachers were Edmund C. Tarbell and Frank W. Benson. In the 1890s she went to Paris to study impressionist painting under Jules Lefebvre, and while there, visited Brittany, Spain, Italy, and England as well.

On her return to Boston, Titcomb took a studio adjoining those of Tarbell, Benson, and Philip Hale at the Harcourt Studios. She became a member of the Copley Society in 1895 and began exhibiting periodically in Boston. From 1904 through 1927 she participated in twenty-nine exhibitions at the Pennsylvania Academy of the Fine Arts. To avoid any possible prejudice in juried shows, she started signing her name "M. Bradish Titcomb" in 1905.

Titcomb's most celebrated sale occurred in 1915 when President Woodrow Wilson bought her *Portrait of Geraldine J.* at the Corcoran Gallery of Art's Fifth Exhibition of Oil Paintings by Contemporary American Artists. The Boston newspapers heralded the purchase with the following headlines: in one paper, "President Praises Boston Artist"; in a second paper, "Miss Titcomb's Portrait of Geraldine J. Is in White House," with accompanying photograph of the painting; and in a third, the *Boston Evening Record*, "Rises from Brockton Teacher to 'Painter for President,'" along with a photograph of the artist in her studio.[1] The story does not end there, because it turns out in recent times that Jane Russell, the actress, visited the Woodrow Wilson House in Washington and asked if she could *buy* this painting since it is a portrait of her mother, Geraldine Jacobi Russell. When she was told it would not be possible, she obtained permission to have a copy made by another artist. The portrait shows a young woman, seated on a sofa, wearing a blue mandarin coat and a large hat with pink and blue flowers that match the decorative colors in the coat.

Another portrait by Titcomb, *Frank P. Sibley*, was highly acclaimed when it was exhibited at the Copley Gallery, and it was reproduced in the *Boston Globe* during World War I under the headline "Portrait Shows the 'Sib' Known to His Friends," plus the subheading "Genuinely Fine Portrait of Globe War Correspondent, Painted by Miss Titcomb, Is On Exhibition." Also at this time Titcomb was included in a traveling exhibition with Cecilia Beaux, Lydia Field Emmet, Jean MacLane, and Lillian Genth. A review in the *Kansas City Star* begins "The work of the five foremost women artists, who appear in the present exhibit of figure painters at the Fine Arts Institute may make one forget that woman in art is just sixty years young. And in the world of art, which is centuries old, this means that she is, as yet, but a babe who with difficulty has been placing her feet in the paths of her predecessors. The modern woman artist, however, has grown bolder and more independent, until she has struck out on a path all her own."[2] The painter Lucy S. Conant founded "The Group" of Boston women painters in 1916 and organized traveling exhibitions for its members. Titcomb was an original member of "The Group," which showed at the Worcester Art Museum in 1917 (a total of seventy paintings, ten per member), at the Detroit Institute of Art in 1918, and again at Worcester in 1919.

Titcomb generally painted people and landscapes. In addition to a studio in Boston, which at this point was in the Grundmann Building on Clarendon Street, she had studios in Provincetown and Marblehead, Massachusetts, and spent her summers painting at different locations along the New England coast. She made one trip west to Nogalas, Arizona, taking her palette and brushes with her, to visit her brother and his family.

Among the shows in which Titcomb participated were an exhibition of Boston artists at the Boston Museum of Fine Arts in 1911 (which included twenty women),[3] the 18th International Exhibition at Carnegie Institute, Pittsburgh, in 1914; the Panama-Pacific Exposition in San Francisco in 1915 with three paintings, and in the Third, Fifth, and Ninth Biennals at the Corcoran Gallery of Art. She received honorable mention at the Connecticut Academy of Fine Arts in Hartford in 1917. The last show to which she sent work before her death in Marblehead was the Fifth Annual Exhibition of the North Shore Art Association of Gloucester; Sotheby's recently sold her *Park Benches* from that exhibition.[4]

This scene of three young women was painted in Gloucester, Massachusetts, at Stage Fort Park, which is on the route from the summer resorts of Manchester and Magnolia just before the road descends into Gloucester Harbor. On this balmy summer day a sea breeze causes the ribbons and scarfs worn by the women to flutter in the sunlight. From the rocky bluff high above the harbor the distant buildings of Gloucester can be seen through the trees.

Titcomb, who studied with the American Impressionists Edmund Tarbell and Frank Benson, uses an impressionistic technique in the white blouses and dress, which reflect such colors as blue, mauve, yellow, and green, and in the short strokes of various colors that define the rocks and scrub in the foreground. Beams of sunlight are captured on the young women's shoulders and on two of the hats.

This painting has been exhibited under various titles: *Summer Girls, Three Girls,* and *Stage Fort Park*. It was first shown in 1913 at the St. Louis Art Museum in the Eighth Annual Exhibition of Selected Paintings by American Artists and then at the Chicago Art Institute in its 26th Annual Exhibition. In Titcomb's November 1914 exhibition at the Copley Gallery she showed this along with *Geraldine J.* and ten additional paintings. In 1915 it was shown at the Panama-Pacific International Exposition and in 1919 at the Worcester Art Museum.

[1] The first is from the *Boston Advertiser*, 15 February 1915; the second, written by Marian P. Waitt, is from another Boston paper but the title does not show on the clipping fragment; and the third is from the *Boston Evening Record* 18 February 1915. I am very grateful to Earl James, director, and Jane L.G. Couser Barton, assistant director, the Woodrow Wilson House, for their cooperation in letting me see this portrait and in giving me photocopies of the clippings.
[2] I am indebted to Charles B. Tyler of Los Angeles for photocopies of these two undated clippings from the Titcomb estate.
[3] "Mary Bradish Titcomb," *American Art Newsletter* (Deville Galleries, Los Angeles), no. 3 (1985).
[4] *Fine 19th and 20th Century American European Paintings* (Sotheby's, Los Angeles, 17 and 18 November 1980), Sale 292, Lot 286.

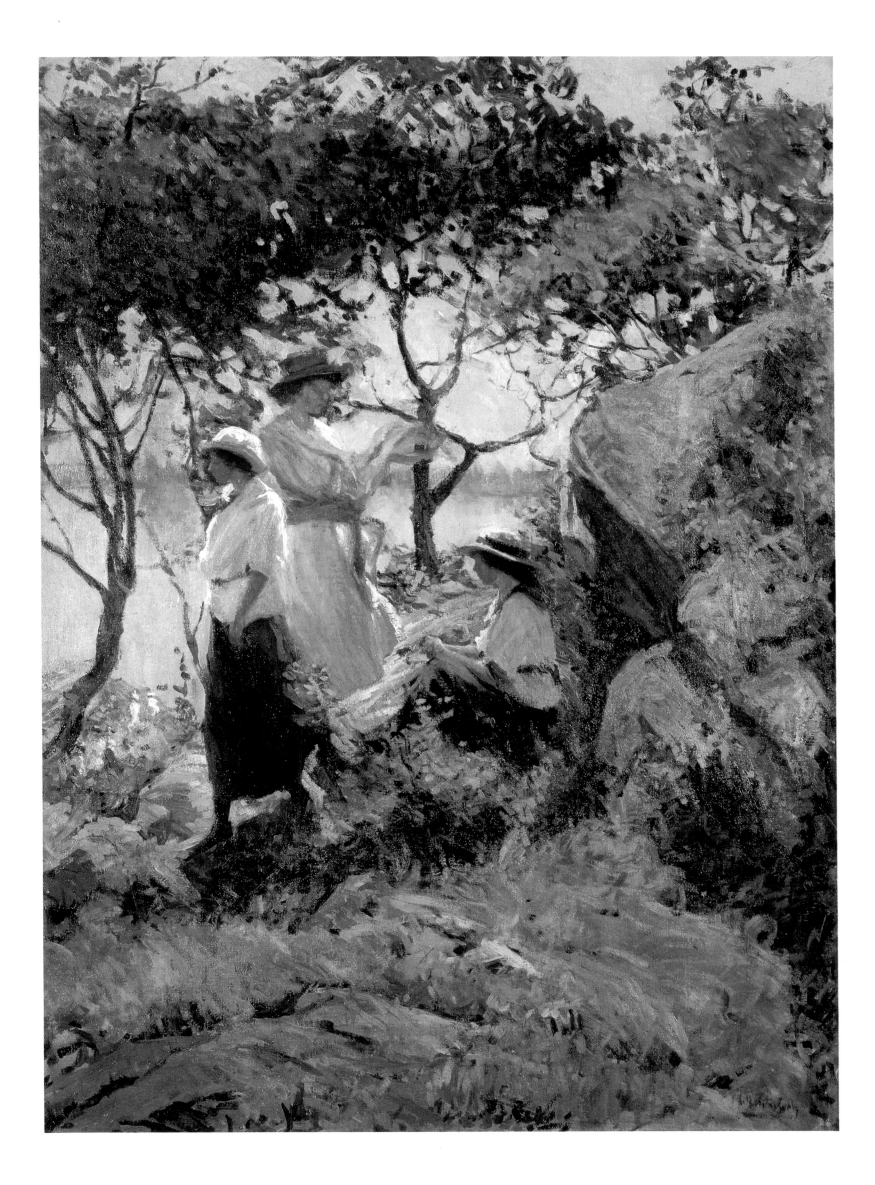

55
Kathleen McEnery (Cunningham) (1885–1971)
Going to the Bath between 1908 and 1913
Oil on canvas, $50\frac{1}{8} \times 31\frac{3}{8}$ in.
National Museum of American Art, Smithsonian Institution,
Gift of the Estate of Kathleen McEnery Cunningham

Kathleen McEnery is one of the discoveries of this exhibition. A whole corpus of impressive works exists in the homes of her children as testament to her painterly accomplishment. Two of her paintings were in the Armory Show of 1913, and her works were exhibited in New York galleries. But after this promising beginning, she yielded to her responsibilities as wife and mother and gave up her artistic commitment. A retrospective exhibition was given her work at the University of Rochester Art Gallery after her death.

Kathleen McEnery was born in Brooklyn, New York, and spent one academic year (1897–98) at a convent in Tildonc, Belgium, where a sister of her Irish-born father was a teaching nun. When she was back in New York, she began studies at the Pratt Institute, then became a student of Robert Henri's at the New York School of Art; she was a member of Henri's class in Spain in the summers of both 1906 and 1908. Among McEnery's preserved paintings is her copy of Velázquez's *Portrait of the Infanta Dona Margarita* (Prado no. 1192, c. 1660). Regarding her copying in the Prado in 1906, she wrote in a letter home, "Mr. Henri came to the Prado and criticized our copies. He thought mine very fine and wonderful." She also wrote enthusiastically about "painting outdoors—crazy about it."[1] On the second trip in 1908, she wrote, "Mr. Henri's most flattering encouragement. . . . Mr. Henri told me I was *too clever*. His worst criticism and, alas! the one I get most often." At the end of the summer McEnery was making plans to work in Paris when Henri told her "it was foolish to go to school in Paris . . . that I must develop myself. He left school long before he was as advanced in painting as I am."

Undeterred, McEnery moved to Paris and lived in a pension with an older cousin as her chaperone. Among the works she painted in her rented studio where *Girl with Umbrella* (a life-size, full-length portrait of her landlady's daughter—a somber symphony in grays and blues), *Seated Woman in Striped Dress with Red Flower in Hat*, and *Luxembourg Gardens*. After a prolific period of work, she returned to New York and took a studio in a building (in the West 50s) with other artists. When it came time to submit to the Armory Show, she was recuperating from pleurisy at her sister's home in Montclair, New Jersey, so the painter Leon Kroll, also a tenant in this studio building, picked out two of her paintings for submission to the jury of this 1913 exhibition, unbeknownst to McEnery, who was delighted to learn later of their acceptance.

In 1914 her marriage to Francis E. Cunningham took her to Rochester, New York, where he manufactured in his grandfather's carriage factory the Cunningham automobile, "the nearest thing to a Rolls-Royce produced in America."[2] They had a daughter and two sons in the first decade of their marriage, and in 1917 the family moved to a new house, which included a spacious studio. McEnery continued to paint—as evidenced by her scene of a woman painter and a violinist in her Rochester studio (collection of Joan Cunningham Williams), her *Portrait of Eugene Goosens*, conductor of the Rochester Philharmonic Orchestra (after 1923, Eastman School of Music), and her portrait of her daughter *Joan* as a young girl reading. In 1915 she showed her paintings at the Macdowell Club in New York, where she had exhibited earlier, and at the University of Rochester Art Gallery. Another New York exhibit was held at the Ferargil Gallery in the early 1930s. McEnery painted portraits (Toto the clown, Leopold Mannes) and still lifes until her family and community interests superseded. In her last years arthritis made it impossible for her to continue her active life (the woman's suffrage movement had been one of her interests), and she died at eighty-four. Her artistic talent was inherited by her daughter, who among other paintings, did the mural for the post office in Poteau, Oklahoma, under the aegis of the Federal Works Project in 1940.

Both of McEnery's paintings in the New York Armory Show of 1913 were daring for a woman artist at this time: two full-length female nude in *Going to the Bath* and a single half-length female nude in *The Dream* (1912).[3] *Going to the Bath* may have been painted in her Paris studio, but it is likely that both of these works were painted in her New York studio in about 1912. Both paintings are modern in their simplicity of modeling and in their direct confrontation with the viewer; the figures are depicted close to the picture surface without any conventional development of background space.

McEnery's style resembled her teacher Henri's only in such an early example as *Portrait of a Little Girl*[4] in which a smiling urchin looks out from a black background. She developed her own post-impressionist style with the hard outlines of Gauguin. She wrote of the 1908 Paris Salon, "Many frightful pictures belonging to what is called the neo-impressionistic school. . . . At first they made me laugh but afterwards *mad*. . . . I feel all the time that I could do much better . . . so now I'm going to confine myself to the Louvre." The result in her genre paintings and her portraiture was a modern technique applied to traditional (male) subject matter.

On the back of this painting McEnery sketched in blue oil a young woman standing frontally.

[McEnery is also represented in this exhibition by her *Breakfast Still Life*, c. 1916, cat. no. 97.]

[1] I am deeply grateful to Mrs. Joan Cunningham Williams, who is preserving her mother's letters, for the quotations used in this catalogue entry.
[2] Herbert M. Stern, "A Reminiscence," *Kathleen McEnery Cunningham Memorial Exhibition* (University of Rochester Art Gallery, Rochester, N.Y., 1972), [3].
[3] Both paintings are illustrated in *1913 Armory Show, 50th Anniversary Exhibition, 1963* (Munson-Williams-Proctor Institute, Utica, N.Y., 1963), no. 3 and no. 4, p. 113.
[4] Illustrated in *Kathleen McEnery Cunningham Memorial Exhibition*, fig. 1.

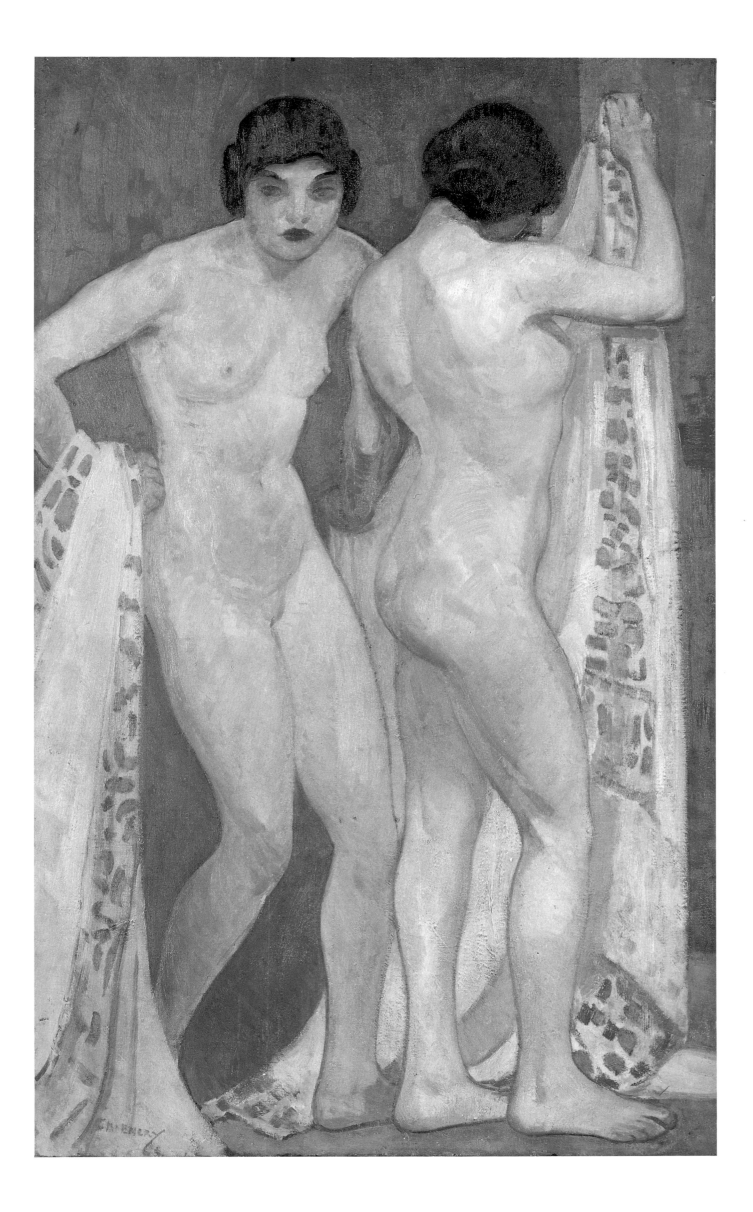

56

Helen Turner (1858–1958)
Lillies, Lanterns, and Sunshine 1923
Oil on canvas, 35 × 43 in.
The Chrysler Museum, Norfolk, Virginia

Among the Southern artists whose work was considered for this exhibition were Katharine Augusta Carl, born in New Orleans c. 1865 and famous for the commission that took her to China to paint the portrait of the Dowager Empress; and Anne Goldthwaite, born in Alabama in 1869 and especially notable for her prints. Helen Turner is better known as a painter than either of these two, partly because her longevity gave her more than fifty years of continuous productivity and partly because a major retrospective of her work, including a well-illustrated catalogue, was organized in 1983.[1] Furthermore, she maintained a very active exhibition schedule, and today her sparkling paintings are in many museums throughout the United States.

Turner came from a Louisiana family. Her father was a prosperous coal merchant from Alexandria whose fleet of boats plied the Mississippi. Helen was born in Louisville, Kentucky, where her mother had gone on an extended visit to her sister's home. The Civil War then wreaked havoc on the family, causing the death of the oldest son and ruining Mr. Turner's business. The family home in Alexandria was burned to the ground, and in 1865 Mrs. Turner died after a lingering illness. Her brother took the Turner children with his own to New Orleans when Helen was seven. Turner grew up in this city, where her grandfather had been a prominent doctor, and she began painting around 1880 when the New Orleans Art Union was founded. In 1893 she accepted a position as instructor of art at St. Mary's Institute, an Episcopal girls' school in Dallas, and taught there for two years before moving to New York City. She studied first in New York with Kenyon Cox and Douglas Volk at the Art Students League and then at the Design School for Women at Cooper Union, which awarded her a first prize, a bronze medal for an oil portrait, and a diploma in 1901.

From 1902 to 1919 Turner supported herself in New York by teaching art at the YWCA, and she began exhibiting her oil paintings and miniatures. Her first solo exhibition was at the Milch Gallery in 1917. Also in this year the Association of Museum Directors organized a traveling exhibition entitled "Six American Women," which included Mary Cassatt, Johanna H.K. Hailmann, Jane Peterson, Alice Schille, Helen Turner, and Martha Walter (all but Hailmann are included in the present exhibition). Prizes were awarded to Turner's paintings by the National Academy of Design and the National Association of Women Painters and Sculptors. When the National Academy promoted her from an associate member to full academician in 1921, she became the third woman to receive this recognition, following in the distinguished footsteps of Cecilia Beaux and Lydia Field Emmet (also included in this exhibition).

Turner spent her summers painting in the art colony at Cragsmoor, 80 miles north of New York City near Ellenville in the Shawangunk Mountains, not far from the Hudson Valley. She built a house with a spacious studio on the second floor, which she used every summer until she was eighty-three, with the exception of 1911 when she studied with William Merritt Chase in Italy and 1922 when she visited Paris and traveled extensively through Spain with another artist, Thalia Millet Malcom.[2]

After an exhibition of thirty-seven of her paintings opened in Houston and traveled to Dallas and Norfolk in 1926. Turner closed her New York studio and returned to New Orleans. A trip to Mexico in 1930 produced additional paintings, but cataracts were beginning to impair her color perception.[3] She painted only sporadically thereafter, but even at eighty-eight she picked up her brushes again to do a portrait of a New Orleans friend. On her ninetieth birthday the New Orleans Museum of Art honored her with a special exhibition. She died in New Orleans on 31 January 1958, approximately three months after her ninety-ninth birthday.

The body of work that Turner has left consists of portraiture, both in oils and in miniature; impressionistic landscapes, genre scenes, and still life; and intimate interiors reminiscent of Edouard Vuillard's muted domestic vignettes. According to a 1929 book that illustrates her portrait of Mrs. Charles Robertson of Houston, "Many of her portraits are in the South, *Miss McLellan* and *Miss Virginia Claiborne* of New Orleans; *Mrs. William Sloane* of Norfolk; *Mrs. James Sharp* and *Mrs. Griffiths* of Dallas; *Mrs. J. Willis Slaughter* of Houston, and *Two Women* in the Houston Museum of Fine Arts."[4]

This outdoor scene, with its dappled light, its bluish shadows, and its splashes of red, yellow, violet, and green, is typical of Turner's impressionistic paintings. The lantern at the center of the composition, catching rays of sunlight, serves as a focal point; another lantern is held on the lap of the seated woman, and a third rests on the green bench just behind the dog in the right foreground. The setting is similar to that in Turner's earlier porch painting, *Morning* (1919, Zigler Museum, Jennings, Louisiana), in which a young woman, viewed in filtered sunlight, sits on a green bench next to a basket of flowers and before a pillar that separates the porch from the dashes of color shimmering in the garden behind. Turner used the daughter of one of Cragsmoor's summer residents as her model for both figures in this painting as well as for another 1923 painting *Alice in Wonderland*,[5] in which a woman reclines on a sofa reading a book in a sitting room.

In 1914 Turner painted an earlier impressionistic life-size *Girl with Lantern* (which was included in the 1917 exhibition at the Corcoran Gallery of Art). The motif of children playing with Japanese lanterns in a garden might be traced back to John Singer Sargent's *Carnation, Lily, Lily, Rose*, of 1885–86 (Tate Gallery).

[1] Lewis Hoyer Rabbage, *Helen M. Turner, A Retrospective Exhibition* (The Cragsmoor Free Library, Cragsmoor, N.Y., 1983).
[2] Ibid., 6.
[3] Ibid., 7.
[4] Cuthbert Lee, *Contemporary American Portrait Painters* (New York, 1929), 42–43.
[5] Rabbage, *Helen M. Turner*, 6.

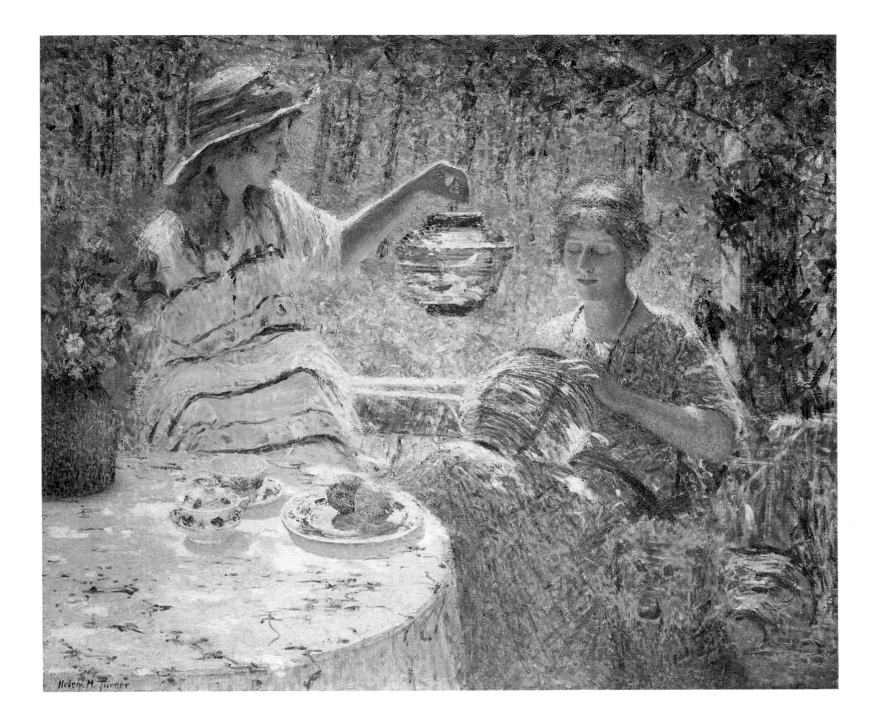

57
Jean MacLane (1878–1964)
Seaside Situation late 1920s
Oil on canvas, 36 × 46 in.
Balogh Gallery, Inc., Charlottesville, Virginia

Of all MacLane's beach scenes, *Seaside Situation* is her most dramatic.
She exhibits daring in the unusual convergence of two big energetic dogs
with a press of bathers. The verve of the painting is characteristic of the
Art Deco period, the jazz age of optimism.

The human figures and the animals are interlocked here in a zigzag
design—with the whitish masses in the background filling triangles
defined by the tanned and heavily shadowed boys and the dogs in the
foreground. A subtle key to holding this structured design together is the
thin but taut leash of the dog. Perhaps the lessons of her plein-air teacher
William Merritt Chase launched MacLane in her paintings of broadly
lit beach frolics, with the figures saturated in sunshine and reflections
bobbing about in the wet sand. In addition to the roundly modeled boys
and dogs in the foreground, MacLane reinforces the front plane by
outlining the disappearing foot at the left in brown and the arm at the
right in red.

This painting combines the two dogs of *Country Dog Show* (1933–
34), and the figures casting reflections in the wet sand of *On the Beach,
Devonshire* (1926, both in the Toledo Museum of Art) and suggests a
dating of the same period.

[For MacLane's biography, see cat. no. 22.]

58
Martha Walter (1875–1976)
The Telegram, Detention Room (Ellis Island) 1922
Oil on panel, 14 × 18 in.
David David Gallery, Philadelphia

Can it be possible that longevity is the laurel bestowed upon women artists, or is good health simply a happy coincidence for them? This exhibition is full of long-lived artists—with Martha Walter, who almost reached her 101st birthday, heading the list.

Born in Philadelphia on 19 March 1875, Walter, upon graduating from high school, attended the Pennsylvania Academy of the Fine Arts, where she studied with William Merritt Chase. The academy awarded her the Toppan Prize in 1902 and a two-year Cresson traveling scholarship in 1903, which enabled her to study in Paris as well as to visit Italy, Holland, and Spain. At first she studied at the Grand Chaumière, but finding its approach too classical, she changed to the Académie Julian. Again she wearied of the academic tradition and established her own studio on the Rue de Bagneaux with several other young American women artists. In 1909 she won the Pennsylvania Academy's Mary Smith Prize for the best work by a woman and exhibited in its annuals for over fifty years, winning a gold medal in 1923.

World War I caused Walter to return to the United States, and with her penchant for plein-air painting, she took her palette, brushes, and easel to the beaches of Gloucester and Atlantic City. She maintained studios in both New York and Gloucester and in the next decades energetically pursued an international career, teaching at the New York School of Art and in Brittany.

In 1922 the Galeries Georges Petit in Paris gave Walter an exhibition, from which the French government purchased her painting *La Cape Ecossaise (The Plaid Cape)* for the Musée du Luxembourg. The introduction to the catalogue of this exhibition says (in French) "The name of Miss Martha Walter is known in America as that of one of the most reputable women painters—and God knows they are numerous!—by their talent."[1] In the 1930s she was represented by the Milch Galleries in New York and began her travels in North Africa, where she was especially challenged by the relentlessly bright light. The Milch catalogue for the 1931 exhibition of thirty-nine of her works included *Portrait of her Majesty, the Queen of Spain; Andalusian; Mantillas; Spanish Gypsies;* and *Goat Market, North Africa.*

The Art Club of Chicago exhibited seventy-eight paintings (oils and watercolors) by Walter in 1941, and the Woodmere Art Museum in Philadelphia exhibited 135 of her paintings in 1955, among which were her Ellis Island series, *Tobacco Factory, Seville; Cafés in Tunis; Luxembourg Garden; Harbor—Rockport; Canal on the Bridge of Sighs;* and *Women Mending Nets, French Town.* Her paintings are in the collections of the Toledo Museum, the Terra Museum of American Art, the Art Institute of Chicago, the Detroit Institute of Art, the Milwaukee Art Center, the Woodmere Art Museum, and Cheekwood Fine Arts Center in Nashville.

At the time of the Woodmere retrospective, Walter was living at 315 Edgehill Road in Glenside, Pennsylvania. She continued to paint people and landscapes until a few years before her death on 18 January 1976, two months before her 101st birthday.

Intrigued by Ellis Island and the influx of immigrants, Martha Walter obtained permission in 1922 from the United States Immigration Service to paint the crowded scenes in the waiting rooms. She was especially fascinated by the varieties of native costumes and returned every Sunday for months, painting groups of Yugoslavs, Armenians, Jews, Italians, Spaniards, and Germans, until her series totaled thirty-six canvases.

In *The Telegram, Detention Room,* the attention of the group of women in the foreground is riveted on the precious piece of paper, the telegram. Colorfully dressed women, some holding babies, are packed into the pillared hall. A rich white impasto is used to show patches of sunlight amidst babushkas.

In *Just off the Ship* men, women, and children are depicted frontally, huddled next to their baskets of clothes; in *Waiting to be Called For* (both at the David David Gallery) Walter views from above, almost at a snapshot angle, a cluster of humanity with a sympathetic woman highlighted among many shawled figures.

[1] Léonce Bénédite, *Exposition, Tableaux par Miss Martha Walter* (Galeries Georges Petit, Paris, 1922), 3.

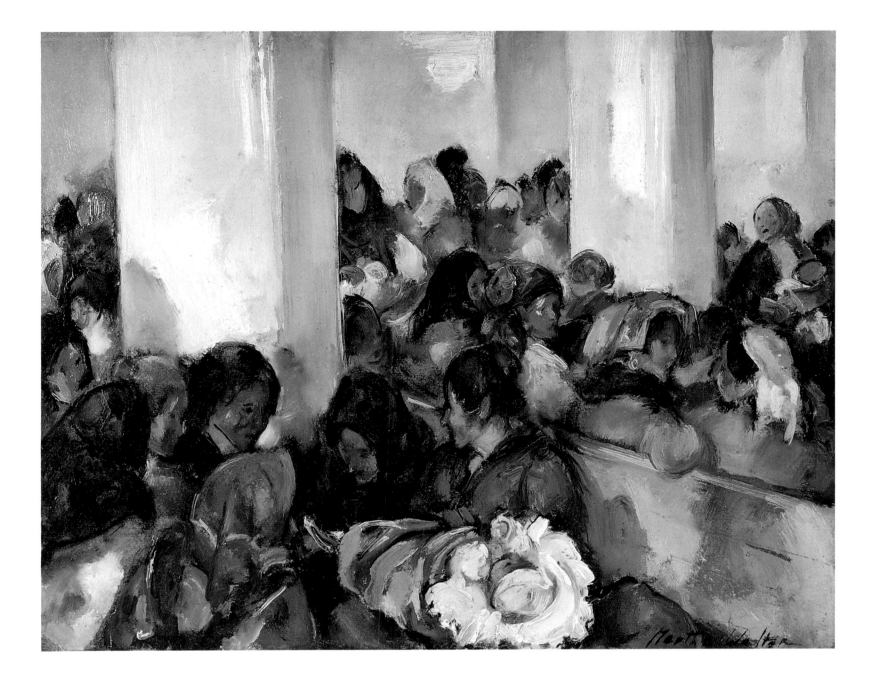

Catharine C. Critcher (1868–1964)
Taos Farmers c. 1929
Oil on canvas, 40 × 36 in.
San Antonio Art League

In 1924, upon her unanimous election into the Taos Society of Artists, Catharine Critcher proudly wrote to her friend C. Powell Minnigerode, director of the Corcoran Gallery of Art, "It's nice to be the first and only woman in it."[1]

Critcher was born just after the Civil War to Judge and Mrs. John Critcher at Audrey, the family estate in Westmoreland County, Virginia. The Critchers were among the First Families of Virginia,[2] and in her youth Catharine became an expert equestrian. For advanced art instruction, she studied one year at Cooper Union in New York and then at the Corcoran School of Art in Washington, D.C., with Eliphalet Frazer Andrews.[3] She began her professional career by painting portraits of prominent Virginia families. In 1904 she went to Paris and enrolled at the Académie Julian for further training, but because she encountered difficulty with the French language, she decided to establish a school, the Cours Critcher, to offer art instruction in English to Americans. On her return to Washington in 1909, she became an instructor at the Corcoran Art School, where she remained for ten years, leaving only because she wanted to start her own school. She opened the Critcher School of Painting in Washington in 1919 and ran it until 1940.

During the 1920s Critcher spent many summers in Taos, New Mexico, enchanted by her new subject matter, the Indians. In the autumns, when she returned East, her paintings of the Taos and Hopi Indians were accepted for the Corcoran biennial exhibitions and the international exhibitions of the Carnegie Institute. She enjoyed traveling and went to Mexico in 1936, to Canada where she painted French Canadians of the Laurentian Mountains and Nova Scotia fishermen, and to Gloucester for scenes of the fishermen in 1941. She also belonged to the Provincetown Art Association and showed her work in its exhibitions. As her fame spread, her commissions proliferated; she painted Woodrow Wilson's portrait (at Princeton), Senator Harry F. Byrd's, and portraits of twenty generals, including George Marshall and Mark Clark.[4] The Corcoran Gallery gave her a one-person exhibition in 1940 and the Washington County Museum of Fine Art in Hagerstown, Maryland, a retrospective exhibition in 1949.

During the decades of the 1940s and 1950s Critcher lived in Charles Town, West Virginia, where she completed at least forty-two portraits. When her health began to fail, she moved to Norfolk to live with a niece. In June 1964, at age ninety-five, she died at a nursing home in Blackstone, Virginia.

Critcher emphasizes the human figure in her numerous paintings of American Indians. *Taos Farmers* is typical of her work in the 1920s: two Indian residents of the Taos Pueblo are shown seated next to a burlap bag of dried ears of corn. Rich colors abound: in the red checked shirt of the man, in the pale blue striped skirt of the woman, and in the corn itself, which runs the gamut of yellow, russet, and black. Behind the sitters on a shelf is a handsome earthenware pot with a black-glaze pattern. *Taos Farmers* received the purchase prize at the Southern States Art League exhibition in 1929.[5]

In Critcher's *Covered Wagon* there is a similar close-up view of a man and woman seated at the front of a covered wagon, holding reins to an unseen animal. *Hopi Pottery Maker* (both paintings illustrated in Broder, *Taos*) is another close-focus painting of a well-modeled, serious figure, seated next to a table displaying three handsome jars. Critcher's paintings are realistic in rendition but exclusive in the selection of the environmental surrounding.

Paintings by Indian artists were also considered for this exhibition. Some of the best known extant examples by Marie Abeita, Lorencita Atencio, Lois Smoky, Tonita Peña, and Pablita Velarde are gouache paintings in the Thomas Gilcrease Museum and other southwestern museums. They date from the decades of the 1930s, 1940s, and 1950s however, and are therefore just beyond the limits of this present exhibition.

[1] Patricia Janis Broder, *Taos, A Painter's Dream* (Boston, 1980), 241.
[2] Mary Carroll Nelson, *The Legendary Artists of Taos* (New York, 1980), 99.
[3] Andrew J. Cosentino and Henry H. Glassie, *The Capital Image, Painters in Washington, 1800–1915* (Washington, D.C., 1983), 257.
[4] Nelson *Legendary Artists of Taos.*
[5] Phil Kovinick, *The Woman Artist in the American West 1860–1960* (Muckenthaler Cultural Center, Fullerton, Calif., 1976), 18.

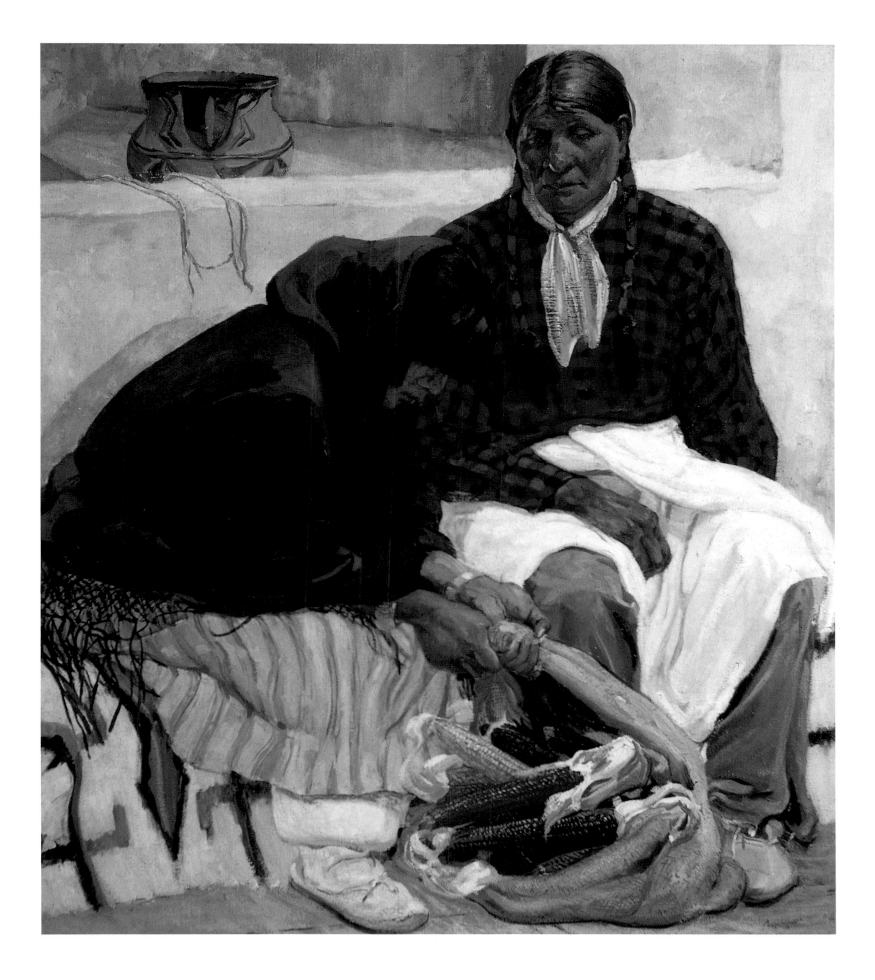

Margaret Fitzhugh Browne (1884–1972)
Blessé de Guerre 1935
Oil on canvas, 37 × 31 in.
Childs Gallery, Boston and New York

Born in West Roxbury, Massachusetts, Browne attended the Massachusetts Normal Art School and the Museum School of the Boston Museum of Fine Arts. Her instructors included Joseph DeCamp and Frank W. Benson.

Although known best as a portraitist, Browne painted many genre subjects and floral still lifes. She maintained studios in the Fenway Studios, Boston, and in Annisquam on Cape Ann. A prestigious commission in 1927 sent her to Spain to paint King Alphonso XIII for the New York Yacht Club,[1] and among her sitters at the height of her career in the 1930s was Henry Ford. One of the portraits from the next decade was that of her friend the painter Jane Peterson (collection of J. Jonathan Joseph), who is colorfully accompanied by flowers, which were Peterson's passion. In Browne's book *Portrait Painting* (1933) she advises potential portraitists to work quickly to capture their sitter's features in order not to exhaust their clients with endless sittings. In this book she also shows a good understanding of the psychological way to prepare children for having their portraits painted, and indeed with *The Big Armchair* (1950, Childs Gallery) her skill is apparent, as she captured three youngsters in one composition. For an illustration of a successful portrayal of a child, Browne shows *Davis Given* by Lydia Field Emmet.

Timothy Crouse gratefully recalls Margaret Browne as the creator of the Wax Works at the annual Annisquam Sea Fair. He writes that this "short, handsome woman whose brisk carriage and slightly owlish features gave her an air of sharpness and command,"[2] mounted a group of tableaux vivants in which the participants pretended to be wax figures, and each summer, as she walked the tree-lined streets with her Pekinese trotting behind her, she was constantly on the lookout for faces that resembled great personages for her annual tableaux.

Browne was active in a number of art associations, such as the Copley Society, North Shore Arts Association (of which she was president beginning in 1935), Connecticut Academy of Fine Arts, Allied Artists of America, and the Boston Art Club. She died just before reaching her eighty-eighth birthday.

Wounded in the War is one of Margaret Browne's most powerful paintings. The man, blinded in World War I, holds his head high in adversity. He holds his dog on his lap, his hands clasped in front, while behind him a bright red drapery is in shocking contrast to the muted colors of the seated principals. This hot red backdrop creates a dynamic foil to the sensitivity expressed in the foreground figures.

Browne usually accompanied her sitters with some telling attribute. *The Finnish Girl*, in the Fortieth Annual Exhibition of the National Association of Women Painters and Sculptors (1931), is dressed in distinctive native attire, holding her crocheting and seated on a decorated peasant chair. Six years later in this association's show Browne exhibited a *Portrait of Dr. Arthur D. Little*, who stands in his living room next to some objets d'art, along with a painting entitled *Before the Fight*, in which a robust black boxer is seen in his dressing gown, wearing his shorts and huge gloves; his street clothes are hanging beside him, and a bulky towel lies in readiness on the nearby table.

In her book *Portrait Painting* Browne writes about the difference she perceives in showing the lines of age in women's faces and in men's. With men, "the marks of years are often a help to the character and strength you want to bring out in their faces."[3] She probably interpreted the deep grooves in the blind man's cheeks below his dark glasses as expressing character. This painting was shown in the 1936 exhibition of the National Association of Women Painters and Sculptors in New York.

[1] Cuthbert Lee, *Contemporary American Portrait Painters* (New York, 1929), 96.
[2] Timothy Crouse, "The Wax Works," *The New Yorker*, 30 July 1984, p. 62.
[3] Margaret Fitzhugh Browne, *Portrait Painting* (New York, 1933), 10.

61

Ethel Magafan (b. 1916)
Lawrence Massacre 1936
Egg tempera on gessoed panel, $15\frac{5}{8} \times 40\frac{3}{16}$ in.
Denver Art Museum, Gift of the New York World's Fair

◆

The twins Ethel and Jenne Magafan, who became known for their mural paintings in the Depression, were born on 10 August 1916 in Chicago to a Polish mother and a Greek father. They were raised in Colorado, where they began painting at an early age, and encouraged by their grade school teachers as well as by a scholarship they shared, they enrolled for further study at the Colorado Springs Fine Art Center. Ethel studied chiefly with Frank Mechau and Peppino Mangravite and became Mechau's assistant on several mural commissions. Later Mangravite invited her to assist him on murals he was completing in Atlantic City.

The twins entered the national competition for murals sponsored by the United States Treasury Department in the 1930s, and Ethel in her early twenties won her first commission: *Wheat Threshing* for the post office in Auburn, Nebraska.[1] A total of seven governmental commissions were awarded to her, five through national competitions: one is in the Senate Chamber, one in the Recorder of Deeds Building, one in the Social Security Building (all in Washington, D.C.), and the others are in post office buildings in Wynne, Arkansas (*Cotton Pickers*), Mudill, Oklahoma (*Prairie Fire*), and South Denver, Colorado (*Horse Corral*). The twins jointly won the contest for the Social Security Building with a 10 by 20 foot canvas of a Colorado scene called *Mountains in Snow*.

The Magafan sisters also used to exhibit together, making their New York debut at the Contemporary Arts Gallery in 1940. Ethel continued at the Ganso Gallery in the 1950s, Seligman Galleries in the 1960s, and since the 1960s at the Midtown Galleries.

In 1946 Ethel married the painter Bruce Currie, and they both won Fulbright grants in 1951, which they used to paint landscapes in Greece. By this time Ethel and Bruce, as well as Jenne and her husband, the painter Edward Chavez, had moved to Woodstock, New York. But tragedy struck in 1952 when Jenne suddenly died of a cerebral hemorrhage. The loss of her sister weighed heavily on Ethel, and even today, when she learned that she would be included in the present exhibition, Ethel asked if Jenne might also be represented.

Ethel Magafan, who painted realistically in the 1930s, continues to paint mountainous landscapes today, but in an abstract style, occasionally with horses or goats suggested in the foreground. *Lonesome Valley* (egg tempera, 1950, Metropolitan Museum of Art) has a horse in a fenced-in pasture with a mountain range behind.

Magafan's prizes include a Tiffany Fellowship, 1949; honorable mention in *American Painting Today* at the Metropolitan Museum, 1950 Altman Prize at the National Academy of Design, 1951 and 1964 purchase prize in *Contemporary Arts of the USA*, Pomona, California 1956; purchase award, Museum of Art, Columbia, South Carolina, 1956 (*Night Forest*, egg tempera); and many more. As recently as 1976, she won another mural commission: *General Grant in the Battle of the Wilderness* for the National Military Park in Fredericksburg, Virginia. She has also had one-woman exhibitions at several museums across the country.

The Lawrence massacre took place on 21 August 1863, when a group of four hundred Missouri Bushrangers under William Quantrell burned the town of Lawrence, Kansas, with all of its 150 citizens, leaving in their wake "bleeding Kansas," as it was called. The town had been settled by abolitionists and had become a center of the "underground railway" during the slavery dispute.

Ethel Magafan has captured the melée with her vigorous painting of riders on horseback who attack and kill the citizenry. The village buildings in the background are in flames, and the devastating effect of Quantrell's raid is eminently evident. Lawrence rebuilt after the conflagration and adopted as its symbol the phoenix.

This painting, which was to cover a wall of the post office in Fort Scott, Kansas, was never carried out, but the Treasury Department's Superintendent of the Section of Painting and Sculpture wrote to Magafan on 23 April 1937:

I want to tell you how highly we respect your fine design. In our estimation it was one of the best compositions that was submitted in the competition and very ably handled but unfortunately you chose a theme which the people of the locale are trying to forget and we did not feel justified in overriding the committee on this point. Particularly fine in your composition were the two women with the wounded man on the left, the mother and child on the right and the dramatic female figure on the right staying the hand of one of the men.

On the basis of this competent work I am recommending you to the Section for a future appointment on another building.[2]

Magafan thinks "the Lawrence Massacre was a very important historical event. I would still like to execute the design somewhere."[3]

[1] Charlotte Streifer Rubinstein, *American Women Artists from Early Indian Times to the Present* (Boston, 1982), 235. *Wheat Threshing* is illustrated in Karal Ann Marling, *Wall-to-Wall America* (Minneapolis, 1982), 207.
[2] In response to my inquiry, Ethel Magafan kindly sent me a copy of this letter; it is from Edward B. Rowan.
[3] Magafan's letter of 15 September 1986 to the author.

Landscape

62

Henrietta Foxhall McKenney (1825–1887)
Harper's Ferry 1841
Oil on canvas, $29\frac{1}{2} \times 44$ in.
Mr. and Mrs. Edward M. Giles

Henrietta McKenney was born to Mary Ann Foxhall McKenney and Samuel McKenney on 11 November 1825, in Georgetown. She was the granddaughter of the famous ironmaster, Henry Foxhall. A talented artist in her youth, McKenney painted *View of Mt. Vernon* at fifteen, *Harper's Ferry* in this exhibition the next year, and a harbor scene in 1845. Her only other canvases known to date are of two foreign scenes.[1] She married a man named Cragin and died at the age of sixty-one on 2 February 1887 in Washington, D.C.

McKenney painted the village of Harper's Ferry, West Virginia, before it was immortalized by John Brown. Brown's plan in 1859 had been to seize a mountain fortress from which he could make raids to free slaves, and because he needed guns, he chose Harper's Ferry, which was the site of a United States arsenal. In October of that year he led eighteen followers on his attack. Defeated by the local militia and the United States Marines, he was tried for treason and sentenced to death by hanging.

McKenney's earlier view is from a high vantage point overlooking this village, which lies on the Potomac River where the eastern border of West Virginia meets the boundaries of Maryland and Virginia. Dramatic rocky cliffs line the river's edge on both sides in the back-ground, while a more idyllic scene animates the foreground. Like the staffage in Dutch seventeenth-century landscapes, tiny figures populate the hillside and lead the viewer's eye into the town: a black man with a prancing dog, a woman standing with her daughter, and a second mother with a seated child; lower on the slope, a mother in a cape and bonnet with two children is preceded by a taller woman. At the edge of the town a man in a red vest stands by a fence behind which the whole settlement unfolds, climaxing with a white church steeple at the right.

In the middle distance a covered bridge spans the rivers, and a horse is depicted on the concrete conduit. Thin lines of white crests appear in the water at the left and recur, alternating with rocks, throughout the length of the river. Light blue passages in the river are contrasted with the deeper blue water in the far distance.

Among Currier and Ives prints, an undated view of *Harper's Ferry: From the Potomac Side* might be based on McKenney's painting (or both might be traced to a common earlier source).[2] The foreground figures are very different, and the connecting link of a man beside the fence is missing in the lithograph, as is the distinctive tall tree at the right. The white spire, the covered bridge, and the palisades are viewed similarly in each.

[1] George C. Groce and David H. Wallace, *The New-York Historical Society's Dictionary of Artists in America 1564–1860* (New Haven, 1957), 415.

[2] I am grateful to Angela Noel, director of the Childs Gallery (New York), and Wendy Shadwell, curator of prints at the New-York Historical Society, for sharing this discovery with me.

63

Leila T. Bauman (active c. 1855–1870)
Geese in Flight c. 1855
Oil on canvas, $20\frac{1}{4} \times 26\frac{1}{4}$ in.
National Gallery of Art, Washington,
Gift of Edgar William and Bernice Chrysler Garbisch

Two paintings by Leila T. Bauman are known today, and both are in the Edgar William and Bernice Chrysler Garbisch Collection in the National Gallery of Art. The paintings are of equal size and are both river views. As for the painter herself, the only clear fact is that her home was in Verona, New Jersey, a town in Essex County, west of Montclair and the Passaic and Hudson rivers. She may have worked for Currier and Ives,[1] and her years of activity may have spanned c. 1855–1870.

In both *Geese in Flight* and Bauman's other known extant painting, *U.S. Mail Boat*, a steamer plies the river. The artist has in each case skillfully conveyed the movement of the ship, which leaves a great white wake and a trail of steam emitted from its stacks. Also, in both, she uses human figures to animate the foreground and palisades to define the opposite shore.

Movement is one of the charms of *Geese in Flight*. Many modes of transportation are represented. The artist has included—in addition to the geese flying in formation—a train steaming in the foreground, a horse and carriage moving briskly along the road, a canoe on the water, the ship named "York," and many sailboats, as well as numerous pedestrians. Figures walk down the road, and others, having crossed the bridge, stroll into the woods. A single spirited horse exercises within its fenced-off pasture. Bauman also displays a facility with reflections: of the canoe and its four passengers and of the white sails in the distant water at the left and right.

Transportation experts date the train, carriage, and steamship in this painting to about 1850, and therefore the forthcoming catalogue of the Garbisch Collection will revise the dating of this work from c. 1870 to c. 1855.[2] As for the name "York" on the ship, it does not appear on steamship registers, and the authorities consulted by the National Gallery believe the name to be imaginary.

The fort in *U.S. Mail Boat* has been identified as an exaggerated depiction of a Martello tower, several of which were erected in America at the time of the War of 1812. A few remained around New York harbor until the end of the Civil War, and because of the proximity of Verona, New Jersey, to New York City, it is possible that Bauman's views were inspired by sights along New York waterways. The new Garbisch Collection catalogue will propose "1855 or later" for this companion scene.

[1] Karen Petersen and J.J. Wilson, *Women Artists, Recognition and Reappraisal From the Early Middle Ages to the Twentieth Century* (New York, 1976), 70.
[2] Researched by Julia Aronson, a former staff assistant in the American Art Department of the National Gallery of Art; I am grateful to the department for its willingness to share this information, which will appear in its forthcoming catalogue of the Garbisch Collection.

Amanda Petronella Austin (1859-1917)
Morning Glories 1881
Oil on canvas, $16\frac{3}{8} \times 24$ in.
Crocker Art Museum, Sacramento, California,
Gift of John B. and Ernest H. Peaslee

Recently rediscovered, Amanda Austin can be described as prolific in painting, sculpture, and drawing (three hundred known works). She exhibited frequently in California and France with the top echelon of artists in the late nineteenth century.

Austin was born in Carrollton, Missouri, in 1859 and studied from 1877 to 1879 at the University of Missouri, where she was a favorite pupil of the famous genre painter George Caleb Bingham; in fact, she gave Bingham two of her paintings. In July 1879 she moved to Sacramento, California, to care for an ailing great-uncle, who in return supplied the funds necessary for her to continue her artistic training, and she immediately commenced study in the studio of Norton Bush, a landscape painter. The first exposure Austin's work received was at the California State Fair in 1880, when she exhibited one oil painting and four charcoal drawings. She was praised by *The Sacramento Bee* critic who wrote that her drawings showed "talent of high order."[1] However, it was *Morning Glories* (1881, Crocker Art Museum), exhibited at the fair the following year, that won her real recognition.

In May 1882, with a promising career under way, Austin enrolled in the San Francisco School of Design, where she worked in a variety of media, ranging from oil on canvas, watercolor, and pen and ink, to charcoal drawings. She exhibited regularly in Sacramento during this time, and later at the San Francisco Art Association she received an honorable mention and a gold medal. For a few months in 1885 she taught at the School of Design in Sacramento. Then on 16 January 1886 she opened her own studio in the Oddfellow building in Sacramento for a painting class, which attracted large enrollments.

In 1908 Austin sailed for Europe, maintaining a studio in Paris until 1912 and studying with Jean Escoula and Emile Renard. It was in Paris that she began working in sculpture, undoubtedly encouraged by Jean Escoula (1851-1911), Auguste Rodin's chief cutter. Austin's marble bust of *Miss Quinn*, an American student in Paris (1909, Crocker Art Museum), was accepted for exhibition at the Salon of the Société Nationale des Beaux-Arts, which won Austin membership in the Union Internationale des Beaux-Arts et des Lettres.

Austin returned to Sacramento in 1912, and her bust of *Miss Quinn*, sculpture of *St. John*, and painting of *Market Street* were shown at the Panama-Pacific International Exposition of 1915. The two sculptures traveled on to the Buffalo Fine Arts Academy (Albright-Knox Art Gallery) and the 29th Exhibition of Sculpture at the Art Institute of Chicago. In the summer of 1916 Austin went to Paris to execute a commissioned monument for the city of Sacramento, only to be advised by her Paris physician to return home, for she was dying of cancer. She died in New York City, en route to California, three days before her fifty-eighth birthday.

In *Morning Glories* Amanda Austin confronts the viewer with a weathered picket fence entangled with pink morning glories. More than two thirds of the canvas are dominated by the fence, which recedes into space establishing an interesting sense of depth at the right. A small patch of low-lying weeds at the left and two stakes for tomato vines in the center foreground offer a contrast to the delicately painted flowers on the fence. The morning glories are depicted realistically, whereas the lower portions of the canvas are painted in an impressionistic manner.

[1] Corrine Geeting, "The Rediscovery of Amanda Austin," *WestArt* (9 June 1978), 2.
I am indebted to Jo An Butterfield, chairperson of research docents at the Crocker Art Museum, for sending me material on Austin, and to Dr. Heather Anderson, an authority on California women artists, for looking at this painting for me.

65
Lilla Cabot Perry (1848–1933)
Giverny Landscape, in Monet's Garden c. 1897
Oil on canvas, 26 × 32 in.
Richard H. Love Gallery, Chicago

Lilla Cabot Perry painted not only her famous neighbor's garden
several times but also another of his recurrent themes, haystacks. In her
"Reminiscences of Claude Monet" Perry tells of her letter of intro-
duction to Monet, whom she met her first summer in Giverny, 1889,
when she and her family stayed at the Hotel Baudy on the main street of
this village: "from this first visit dates a friendship which led us to spend
ten summers in Giverny. For some seasons, indeed, we had the house
and garden next to his, and he would sometimes stroll in and smoke his
after-luncheon cigarette in our garden before beginning on his afternoon
work."[1] She also relates that she was then a student in the Paris studios
of Académie Julian and Académie Colarossi and had shown at the
Salon for the first time that spring. A sizable cluster of American artists
gravitated to Giverny, among them Frederick MacMonnies and his wife,
the painter Mary Fairchild. Also, Mary C. Wheeler, who ran a girls'
school in Providence, took her students to Giverny. A street plan
showing where the Perrys and all these others lived appears in David
Sellin's catalogue *Americans in Brittany and Normandy 1860–1910* (1982).

Perry adopted the impressionistic technique of applying dabs of color
to form trees and bushes, of painting her shadows violet instead of black,
and of delighting in water reflections, as we see here in the narrow brook.
Yellow strips of sunlight alternate with the violet shadows, and the tree
trunks and the spring house provide strong structural accents to the
composition.

[For Perry's biography, see cat. no. 50; see also cat. no. 51.]

[1] Lilla Cabot Perry, "Reminiscences of Claude Monet from 1889 to 1909,"
The American Magazine of Art 18, no. 3 (March 1927), 119.

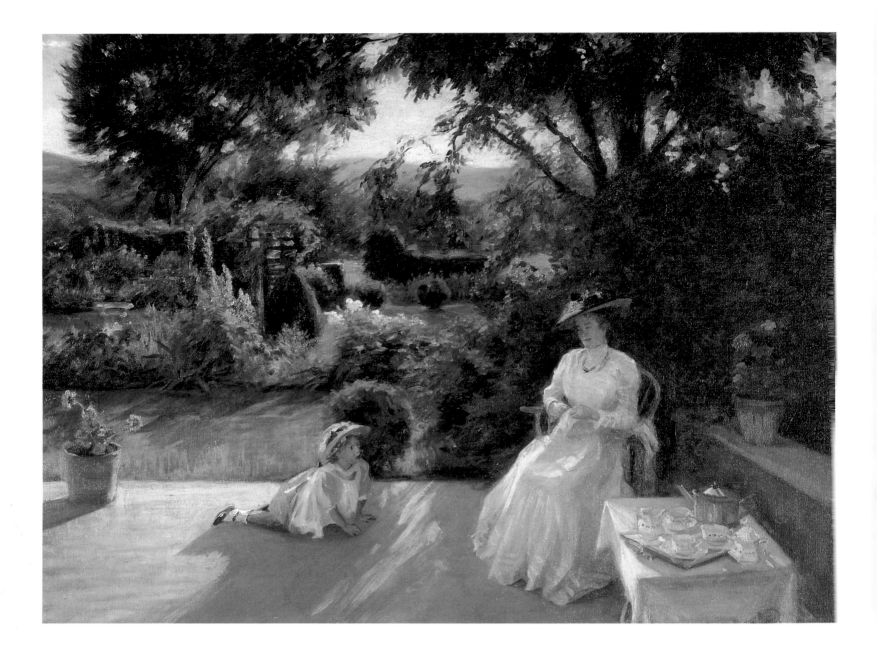

66
Lydia Field Emmet (1866–1952)
Grandmother's Garden c. 1912
Oil on canvas, 32 × 43 in.
National Academy of Design, New York

Lydia Emmet, a painter of both portraits and landscapes, was elected an
associate of the National Academy of Design in 1909, and upon election
to full membership in 1912, presented this painting as her diploma piece.
Her summers at William Merritt Chase's Shinnecock School had given
her many opportunities for plein-air painting. Impressionistic techniques
are evident here in the white sunlit passages and the bluish shadows on
the grandmother's dress, as well as in the tea set on the table in the
foreground. A child in a lavender dress and white pinafore crawls across
a pink terrace toward the seated grandmother. Two pots of pink
geraniums flank the figures at the sides, and the remaining two thirds of
the picture surface are devoted to a verdant landscape punctuated by tall
larkspurs and towering trees. Emmet displays great facility at combining
figures and landscape.
 [For Emmet's biography, see cat. no. 20.]

Marguerite Thompson Zorach (1887–1968)
Market Outside Damascus Gate, Jerusalem 1911
Oil on canvas, 23½ × 28¾ in.
Kraushaar Galleries

"One of the forerunners of modern art in America,"[1] Marguerite Zorach exhibited in the famous Armory Show of 1913 and helped to introduce Fauvism into the United States. A Californian—born Marguerite Thompson in Santa Rosa and raised in Fresno—she was taken to Paris in 1908 by her aunt Harriet Adelaide Harris: "An Aunt who had real talent but had spent her life teaching school took me to Paris. The day I arrived I went to the Automne Salon where the Fauvres [*sic*] were showing for the first time and I liked them. I worked there four years."[2] Through her aunt, a painter who had known Gertrude Stein in San Francisco, she was introduced to Stein and Picasso and became a friend of sculptor Ossip Zadkine's.[3] She studied at the Parisian art school, La Palette, run by John Duncan Fergusson, a "Post-Impressionist." This is the term Marguerite would later use to describe herself, believing that it described all modern movements after Impressionism, including Fauvism.[4] In 1911 she exhibited at the Salon of the Société des Artistes Indépendants and at the Salon d'Automne before she departed in October with her aunt and Minnie Dunlap (another Californian painter) for a trip around the world. They visited Egypt, Palestine, India, Burma, Malaysia, Indonesia, China, Korea, and Japan en route to California.

While studying at La Palette, Marguerite had met William Zorach (1887–1966), another American artist, and once she had returned to America, they were married in December 1912. They lived in New York after their marriage and often spent their summers in New England. In 1923 they bought a farm on Georgetown Island in Maine, where the cooler climate in the summers was conducive to their art and good for their two children.

In her later work Marguerite Zorach continued to apply her paint in brilliant, unmixed colors but combined with a more Cubistic style of sharp, wedge-shaped forms. She painted the human figure as well as landscapes. In her own words:

> When the artist meets the public, there are a few vital and perennial questions—I will answer them before they are asked.
>
> How long have you been painting? Since the age of three when I produced a goose that everyone knew was a goose.
>
> Do you still paint? Certainly. Painting is my life. There have been periods when I was discovered with much publicity and newspaper articles, and periods when I have been forgotten—usually periods when I was not associated with any gallery.
>
> Hasn't your style changed? I am not interested in style, or a certain way of painting, or a certain range of color or form. I am interested in expression through art. If there is variety in my work, and there is, it is variety of interest and variety of vision. . . .
>
> To me there is a great beauty and interest in the world we live in, and always new wonders of form and color and life. A usual thing may be with me, but I do nothing—then suddenly it becomes an unusual and special thing to me. Then I reach out and capture it with as much depth and power and imagination as I can.[5]

Marguerite Zorach's work is in the permanent collections of the National Museum of American Art, the Whitney Museum, the Newark Museum, the Museum of Modern Art, and the Metropolitan Museum of Art.

On Marguerite Thompson Zorach's seven-month trip from Paris to San Francisco via the Orient (5 October 1911–24 April 1912) she and her two traveling companions lingered longest in Palestine and India,[6] where she was thus able to paint the local scenes. In this painting of *Damascus Gate* she sketches the whole environment: Bedouins and their wives with their heads covered and wearing long robes, a standing camel at the center next to recumbent ones, goats, the crenellated city gate, and a distant mosque. The figures are outlined in thick, dark, staccato strokes, and various colors define the huddled group just to the right of the standing camel. Orange robes spark an interest in the merchants who stand beyond the brown goat at the far right.

The amusing circumstances under which this painting was done were related by Zorach as follows: It was painted from the roof garden of a shop, where the Turkish storekeeper kept his harem; Zorach found it difficult to concentrate amid the babies tugging at her skirts, "the cluster of half-clad women," the two dirty sheep, and "a colony of hens and roosters."[7]

[1] Catalogue introduction by Dahlov Ipcar, *William and Marguerite Zorach* (Maine Art Gallery, Wiscassett, Me., 1968). Mrs. Dahlov Zorach Ipcar is also a painter.

[2] Introduction to catalogue, *Marguerite Zorach* (Knoedler Galleries, New York, 1944).

[3] Roberta K. Tarbell, *Marguerite Zorach: The Early Years, 1908–1920* (Smithsonian Institution, Washington, D.C., 1973), 15.

[4] Ibid., 17.

[5] Artist's statement, *Marguerite Zorach* (Kraushaar Galleries, New York, 1962).

[6] Tarbell, *Marguerite Zorach*, 26.

[7] Roberta K. Tarbell, "Early Paintings by Marguerite Thompson Zorach," *American Art Review* 1, no. 3 (1974), p. 57.

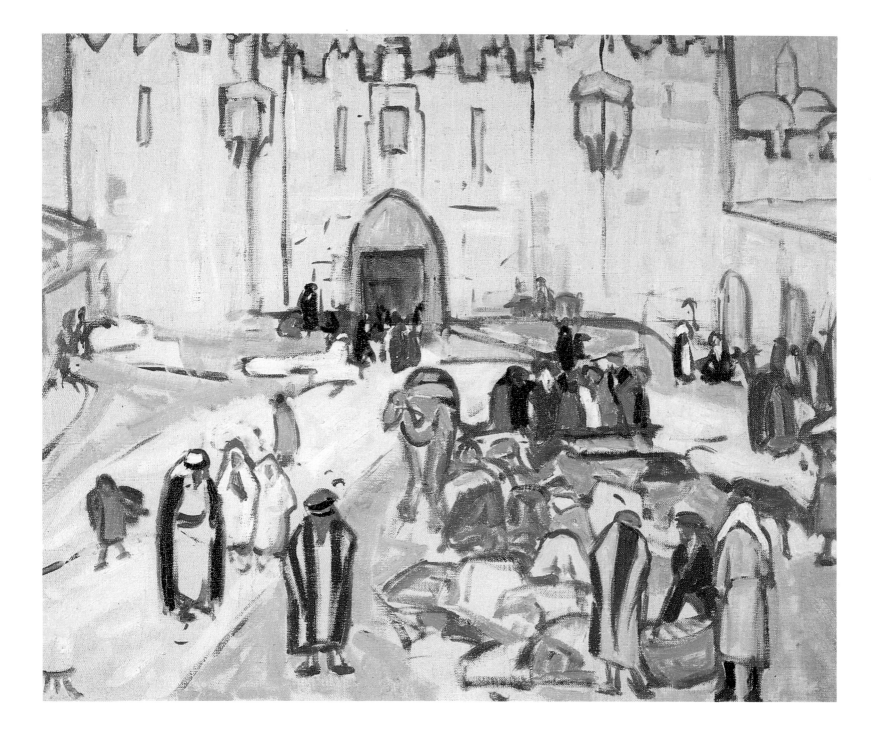

68
Marguerite Thompson Zorach (1887–1968)
Village in India 1911
Oil on canvas, $19\frac{5}{8} \times 25\frac{1}{2}$ in.
Kraushaar Galleries

The bright colors of this painting by Marguerite Thompson are
characteristically Fauvist: the figures clad in red and blue in the
foreground; the blue shadows in the landscape; the yellow, pink, and
orange houses; the pink tree boughs, chartreuse leaves, and green sky.
Form is present in the boldly outlined buildings and in the human
beings, but within these variously colored shapes there is little detail.
Zorach suggests a lush vegetation in the Indian village in comparison
with the dryness of the Jerusalem market.

 Both paintings by Thompson in this exhibition are signed with her
monogram at the lower left.

69

Alice Schille (1869–1955)
Tunisian Market c. 1922
Watercolor on paper, $17\frac{1}{2} \times 20\frac{1}{2}$ in.
Private collection, Courtesy of Keny and Johnson Gallery,
Columbus, Ohio

When *Ohio Art and Artists* was published in 1932, Alice Schille was called "the foremost woman painter in Ohio."[1] A long newspaper article on her that appeared in her hometown of Columbus, Ohio, in 1964 put it this way: "Today the name 'Alice Schille' is a source of pride for Columbus and the synonym for a wealth of watercolors and oils of children's faces, French villages and Guatemalan peasants."[2] The claim is almost too modest for Schille, who for fifty-three years painted landscapes from Spain, North Africa, Corsica, England, and Norway, to Greece and the Middle East, from California and the Yucatan to Long Island and New England. A repeated thread in her geographical tapestry was beaches. Schille was inspired by the visual possibilities of colorful clothes, buildings, or boats placed against sun-drenched sand and paralleling water that reflected the gay colors.

In 1887 Schille graduated from Columbus's Central High School, fourteen years before George Bellows, and then enrolled at the Columbus Art School. Upon completion of this training in 1889, she went to New York City to study at the Art Students League with Kenyon Cox and with William Merritt Chase, who called her his best student at the time,[3] inviting her to his new summer school at Shinnecock and later purchasing two of her paintings.[4] During 1893–94, while she attended classes at the Pennsylvania Academy of the Fine Arts, she met William Glackens, John Sloan, and Robert Henri (who with several others became known as "The Eight") and had work accepted for the academy's annual exhibition. She then spent six years in Europe, where she studied briefly at Académie Colarossi in Paris, met Maurice Prendergast and Ernest Lawson (more members of "The Eight"), copied Velázquez at the Prado, painted the seashore in Holland and Belgium, became a friend of Gertrude Stein's, and exhibited two paintings in a special show at the Louvre in 1900.

Schille returned to the United States and from 1902 to 1942 taught at the Columbus Art School, using her summers for travel and regularly submitting work to annual exhibitions. She garnered many awards in the course of her career, among them the Corcoran Prize from the Washington Watercolor Club in 1908, gold medal at the Panama-Pacific Exposition in 1915, the Fine Arts Prize from the National Association of Women Painters and Sculptors in 1929, and first prize at the Philadelphia Watercolor Club in 1932. Her first one-woman exhibition was at the Cincinnati Art Museum in 1911 (watercolors of the Dalmatian coast). An early article on her art appeared in *International Studio* in 1913, illustrating four landscapes and a double portrait and mentioning a current project of painting oil portraits of emeriti professors for Ohio State University.

In the 1930s and 1940s Schille explored Central America and New Mexico, finding new subjects and meeting new people—Georgia O'Keeffe for one. Schille's last years were spent in Columbus, where she died at the age of eighty-six.

Schille's watercolors, like *Tomato Market, Italy* (c. 1913, Keny and Johnson Gallery, Columbus),[5] radiate spontaneity and vivaciousness. In some of her paintings her style is close to Prendergast's: a mosaic-like effect with the white of the canvas (or paper) showing between squares of color, as in, for example, her Parisian painting *The Street of Many Gay Spots* (c. 1915, Keny and Johnson Gallery).

A voracious traveler, Alice Schille documented her trips across North and Central America, Europe, North Africa, and the eastern part of the Mediterranean in her paintings at the end of the nineteenth century and during the first four decades of the twentieth. Watercolor was her preferred medium during these journeys, not only for sketches but for finished works.[6]

In this Tunisian market scene, dominated by one mighty camel, farmers proceed down the narrow street with two more camels, and donkeys laden with wares enter from the other direction. The dark silhouettes of the donkeys contrast vividly with the luminosity of the buildings' white walls. The confines of the setting are colorfully demarked by the green overhanging roof at the right and by the graceful arcade at the left.

[1] Edna Maria Clark, *Ohio Art and Artists* (Richmond, Va., 1932), 319.
[2] Lynn B. Hammond, "Alice Schille—Everybody's Artist," *The Columbus Dispatch*, Sunday Magazine, 7.
[3] Nicholas Fox Weber, *American Painters of the Impressionist Period Rediscovered* (Waterville, Me., 1975), 93.
[4] *Alice Schille, A.W.S.* (Vose Galleries, Boston, 1982), 14.
[5] Illustrated in color in ibid., 8.
[6] Gary Wells, "Alice Schille: Painter from the Midwest," *Art and Antiques* (September-October 1983), 67.

70
Rosina Emmet Sherwood (1854–1948)
San Pedro, Manila signed and dated 1922
Watercolor on paper, 20½ × 14 in.
Theodosia S. Cochrane

Rosina Emmet was the first daughter born to Julia Pierson Emmet and may well have received her earliest instruction in art from her mother, who had studied painting before her marriage to Rosina's father, William J. Emmet. Descendants of the Emmet family today possess an 1873 sketchbook of Rosina Emmet's as well as a scrapbook of her first trip to Europe in 1876–77, when she was presented to Queen Victoria, an amateur painter herself. Upon her return to New York, Emmet and her friend Dora Wheeler became pupils of William Merritt Chase, and by 1881 she was ready for her own studio in the Tenth Street Studio Building, which also housed other young American painters (Albert Bierstadt, Frederic Church, John La Farge, and Winslow Homer).

Some of Emmet's earliest works were illustrations—for *Harper's Magazine*, among other publications. Another of her early successes is recorded in a short news item that appeared in *The Art Journal* in 1880: Prang & Company had opened a competition for Christmas cards in American Art-Gallery, New York, for which there were about six hundred designs, some "by well-known artists. A lady, Miss Rosina Emmet, of New York, won the first prize, of $1000."[1] Emmet also worked collaboratively with Dora Wheeler in a design firm, Associated Artists, run by Dora's mother, Candace Wheeler, where they designed tapestries, curtains, and wall paper. Mrs. Wheeler describes the life-size cartoons for tapestries that the young artists created from American literature: for instance, the "Hiawatha Tapestry,"[2] which they sketched while back in Paris in 1884–85 attending classes at the Académie Julian.

Rosina Emmet married Arthur Sherwood in 1887, and although they had five children, Rosina continued working, often using her family as subjects. For instance, in *Family at Christmas* (c. 1902, collection of Rosamond Sherwood) all the children are depicted, including Robert Emmet Sherwood, who grew up to be the famous Pulitzer-prize-winning playwright. Among those commissioning her to paint their portraits was Archer Huntington, who later married the sculptor Anna Hyatt (see cat. no. 120); this half-length portrait of Huntington, signed and dated 1892, hangs at the Hispanic Society of America in New York. Rosina Sherwood was also commissioned to paint a mural for the Woman's Building at the Columbian Exposition in 1893; the six-figure, allegorical composition was entitled *The Republic's Welcome to Her Daughters*. Sherwood took on portraiture commissions again in 1918 in order to support the family, while still doing landscapes in watercolor at the cottage next to her sister Lydia's on Strawberry Hill in Stockbridge, Massachusetts. She and her sister also had longevity in common, for Rosina lived into her nineties.

In 1922 Rosina Emmet Sherwood took a trip around the world with her twin brother Robert and her daughter Rosamond, and en route she visited her son Philip, who was stationed in the Philippines with the army. She painted many watercolors as she traveled. In this scene of the entrance to the church of San Pedro in Manila, she has depicted a flower seller seated on the steps next to his plants and a potential customer standing before the assorted flowers. Behind, she shows a mother and child entering the church, and at the right a woman holding a baby in her arms. The artist has captured here an exotic vignette that extends beyond the confines of the paper, as seen by the tree branches at the top and two partially visible pottery jars on the right. She has wonderfully replicated the different components of the church portal, including the lacy grillwork.

[1] *The Art Journal* 6 (1880), 224.
[2] Candace Wheeler, *Yesterdays in a Busy Life* (New York, 1918), 258.

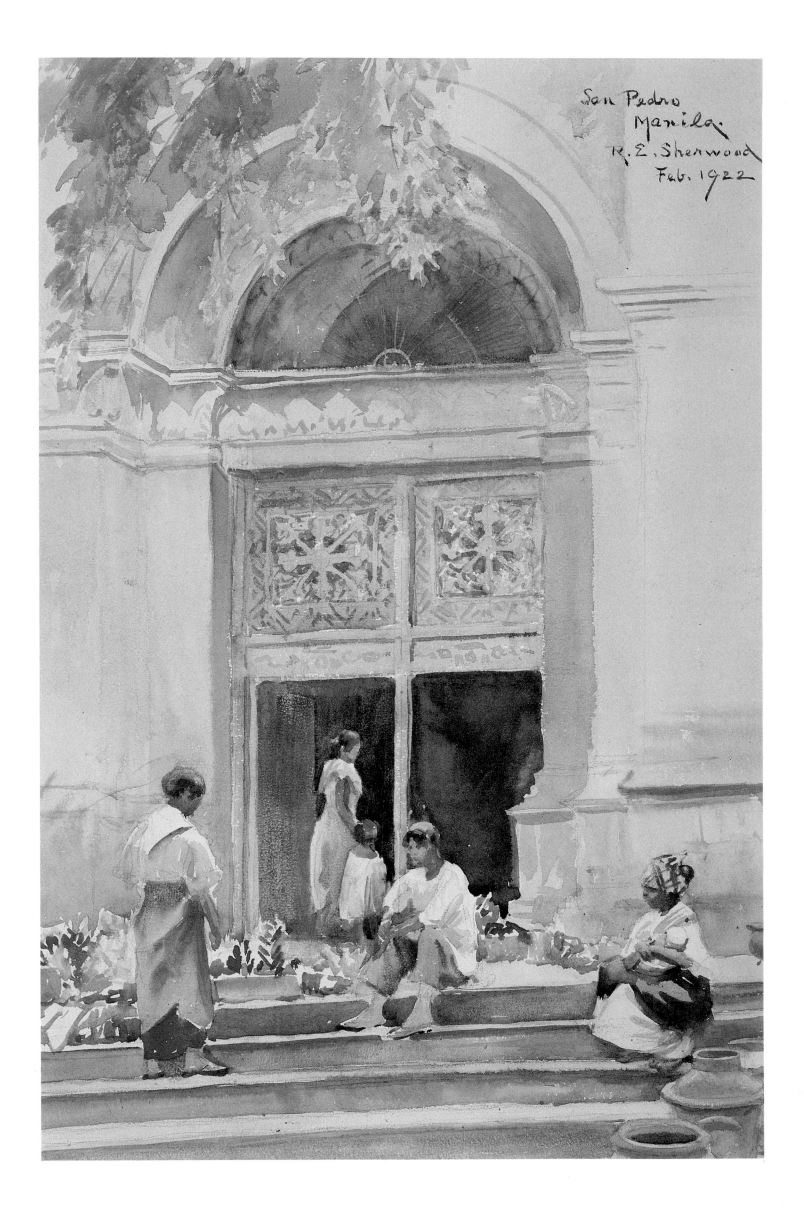

San Pedro
Manila.
R. E. Sherwood
Feb. 1922

Emma Fordyce MacRae (1887–1974)
St. Mark's Square c. 1929
Oil on artist's board, 14 × 17 in.
Stephen L. Wald

Born of American parents in Vienna, Emma Fordyce grew up in New York City (her father was a dermatologist at Columbia Medical Center). After attending Miss Chapin's School and the Brearley School, she studied at the Art Students League with F. Luis Mora and Ernest Blumenshein and at the New York School of Art with Kenneth Hayes Miller.

Her extensive exhibition activity began in 1914 with a two-woman show at the Anderson Galleries in New York City in which she was represented by twenty-nine paintings, mainly landscapes. Having married Thomas MacRae on 18 January 1910, and given birth to a daughter Alice, she managed to combine marriage and a career. However, when her husband wished to move to Arizona, the city-bred artist balked and obtained a divorce. In 1922 she married Dr. Homer Swift of Rockefeller University. She strode every day from their large apartment at 888 Park Avenue to her studio at 12 West 69th Street, crossing Central Park. When it became illegal to walk on the grass in Central Park, she obtained a permit (preserved today in England by her granddaughter-in-law) that allowed her to set up her easel on the grass immune from police interference.[1] The family spent the summers in Gloucester, Massachusetts, where Dr. Swift raised flowers that became the subject of MacRae's paintings in her spacious Cape Ann studio. MacRae also liked painting in Europe, so summers were often varied with overseas trips, especially to Switzerland and to Annecy in France.

In addition to landscapes and floral still lifes, MacRae also painted the human figure in interior spaces, generally a female figure against a very decorative backdrop with a still life on the foreground plane and with all elements woven together into a flat tapestry effect as in *Stelka* (1926, cover of *Town & Country*, 15 April 1929), *Naida with Lilies* (1927, retrospective exhibition, Richard York Gallery, New York, 1983), *Naida Gray* (*Exhibition of Paintings by Emma Fordyce MacRae*, Roerich Museum, New York, 1930), and *Melina in Green* (*Muskogee Sunday Phoenix & Times-Democrat*, 11 February 1951, sect. II, p. 4).[2] *Naida Gray* was given a prize by the National Association of Women Painters and Sculptors in 1928, and *Stelka* received the National Arts Club Medal in 1930. MacRae's paintings were included in exhibitions at the Pennsylvania Academy of the Fine Arts, the Corcoran Gallery of Art, the Metropolitan Museum of Art, and many other museums. In 1951 MacRae, who had been elected an associate of the National Academy of Design when she was forty-four, was recognized by that body with promotion to the full status of academician. As with so many of these women painters, art seems to have been a salubrious pursuit, and Emma MacRae lived to be eighty-seven.

In this cheerful painting MacRae successfully captures the pleasure of sitting at a café in Venice. Seltzer bottles appear on the foreground tables, where some tourists relax in the shade while others gaze at the bulbous domes and glistening mosaics of St. Mark's or at the lion on the clock tower at the left. A breeze rustles the three flags, unfurling them so that at the left the tricolor flag of Italy is easily identifiable, at the center the symbolic flag of Venice emblazoned with a gold lion, and at the right perhaps a Government of Venice flag. Apparently the soft colors and the ambience of this romantic city appealed to MacRae, who chose to leave the faces of her tourists undefined.

This work and her two paintings of Santa Maria della Salute (*Morning* and *Before Sunset*) were exhibited in her 1930 one-woman show at the Roerich Museum in New York and again in her retrospective of 1983 at the Richard York Gallery in New York. When the Doll and Richards Gallery in Boston gave her an exhibition in 1935, *St. Mark's Square* and *Venice* were among the paintings shown.

On the reverse of this painting is a sketch of two women.

[1] Lori Roberts, an enterprising student in my 1985 Women Artists course at Southern Methodist University, located Mrs. Stephen Kissel who kindly responded with information on MacRae.

[2] Fourteen paintings by MacRae toured America in 1951; another review accompanied by an illustration appeared in the *Spartanburg Journal* on 7 September 1951.

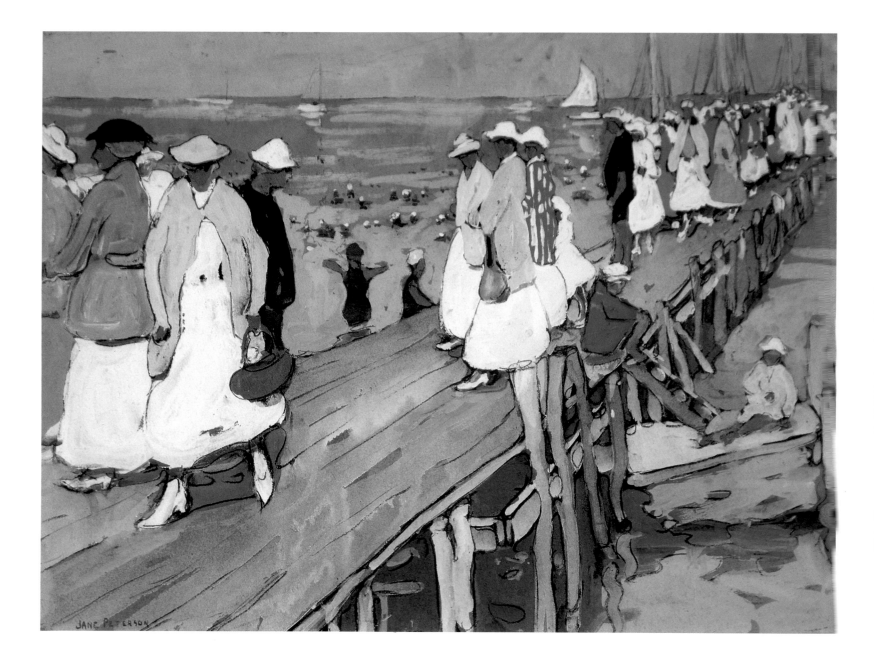

72
Jane Peterson (1876-1965)
The Landing Pier, Edgartown 1916
Gouache and charcoal on paper, 18 × 24 in.
J. Jonathan Joseph

The travels of women artists at the turn of the century were remarkable, and Jane Peterson was one of the most intrepid of these ambitious visitors to foreign lands. If an exhibition documenting these travels were arranged, Peterson's paintings of Venice and her exotic scenes of Istanbul and North Africa would dazzle.

Peterson's peregrinations began when, after studying art in the public schools of her native city of Elgin, Illinois, she traveled to New York in the fall of 1895 to study at the Pratt Institute in Brooklyn, graduating in 1901. Following studies at the Art Students League, she taught art in Elmira, New York, in Boston, and at the Maryland Institute in Baltimore. She sailed to Europe in 1907, studying with Frank Brangwyn in London; and in 1908, when she was living in Paris at 19 rue Vavin—near Elizabeth Gardner Bouguereau (see cat. no. 46) on Notre-Dame des Champs and Gertrude Stein on rue de Fleurus—her paintings were shown at the Société des Artistes Français. The success of this exhibition resulted in her works being shown immediately upon her return to America in 1909: at the St. Botolph Club in Boston and at the Knoedler Galleries in New York City.

The teacher who most influenced Peterson's style was Joaquín Sorolla with whom Peterson began studying in Madrid during the summer of

1909. She left him in 1910 to paint in Egypt and Algeria, where travel was primitive but where the light was glorious, and by December of that year she had eighty-seven paintings ready for a one-woman exhibition at the Art Institute of Chicago. From 1913 to 1919 she was "Instructor of Watercolor" at the Art Students League in New York. Among the exhibitions in which she showed during these years was the Panama-Pacific International Exposition of 1915, where five of her landscapes were included; the American Water Color Society of New York in 1916; and another solo exhibition at the Art Institute of Chicago.

In 1924 Peterson spent six months in Turkey, and on her return to America, exhibited twenty-nine of her Turkish paintings at the Ehrich Gallery in New York. Her marriage in 1925 to an elderly widower meant that a summer home in Ipswich, Massachusetts, was substituted for foreign travel, but the resilient Peterson learned the beauty of flowers, and thereafter floral paintings dominated her exhibitions. In 1946 she wrote a book entitled *Flower Painting* and had a solo exhibition of her new subject matter at the Newhouse Galleries in New York. Fifty-four of her paintings were shown at the Art Club of St. Petersburg, Florida, in 1952, and although arthritis began to limit her production, she sent three paintings to the North Shore Arts Association in Gloucester, Massachusetts, in 1960. Her last trip was taken in that year to join a niece in Kansas, where she died in 1965, three months before her eighty-ninth birthday.

Jonathan Joseph owns two paintings by Peterson of the landing pier at Edgartown, both of which are animated by bright colors and groups of sprightly figures. The action is particularly directed forward in the version in this exhibition, mainly through the broad step of the woman with the yellow hat and the brown handbag who strides toward the viewer in the immediate foreground. Red bathing caps bob through the water, and white sailboats crest the horizon. The figures are outlined in a thin dark line, and the colors applied in flat passages.

Peterson found gouache to be an excellent medium for her travels. Using watercolors opaquely, she could make fast-drying outdoor sketches.[1] On a trip to Alaska and the Canadian Northwest arranged by Louis Comfort Tiffany in 1916, Peterson used gouache exclusively for her landscapes, and she continued to favor this medium during the ensuing summer as she visited Martha's Vineyard and other art colonies in New England.

73
Jane Peterson (1876-1965)
Harbor Reflections (Gloucester) c. 1923
Oil on canvas, 17 × 23½ in.
Dr. G. Patrick Maxwell

Stunning impasto ribbons of color lace the water in this close-focus view of a section of Gloucester harbor in Massachusetts. Although undated, this scene probably was painted when Peterson did other Gloucester views in oil, such as *Niles Pond* (collection of J. Jonathan Joseph) and *The Pier, Rocky Neck* (collection of Christine R. and Matthew Jobe Pierce). In *Niles Pond* water lilies float across a great expanse of water, and in all three paintings the shimmering ripples of undercurrents are magnificently rendered. One is reminded that the Spanish Impressionist painter Sorolla was Peterson's teacher; in his *Sea Idyl* (1908, The Hispanic Society of America) Sorolla has depicted similar swirls of water.

[1] J. Jonathan Joseph, *Jane Peterson, An American Artist* (Boston, 1981), 31. Mr. Joseph of Boston, Massachusetts, owns the largest private collection of Peterson paintings and very graciously allowed me unlimited time to study the works in his possession.

74

Florine Stettheimer (1871–1944)
Picnic at Bedford Hills 1918
Oil on canvas, 40 × 50 in.
Pennsylvania Academy of the Fine Arts, Gift of Miss Ettie Stettheimer

Florine Stettheimer differs from the majority of artists in this exhibition in many ways. She is well-known through many exhibitions held since her death (the first of which was a retrospective at the Museum of Modern Art with works chosen by Marcel Duchamp), and yet during her lifetime she had only a single one-woman show. She was wealthy enough to paint simply for her own pleasure and was under no compulsion to sell. Her style was unique, with no obvious concessions to new modernist modes—except for amusing liberties with perspective.

Born in Rochester, New York, in 1871, Florine was the next to youngest of the five children of Rosetta Walter and Joseph Stettheimer, both from prosperous German-Jewish banking families. Joseph deserted the family, however, and the two eldest children departed upon their marriages, with the result that Rosetta and the three youngest girls—Carrie, Florine, and Ettie—formed a close unit. Florine studied at the Art Students League from 1892 to 1895, principally with Kenyon Cox, and then had a private studio in New York until 1906 when "the unit" moved to Europe. Ettie, who had studied philosophy at Columbia, wrote her dissertation on William James and received her doctorate at the University of Freiburg in 1908, while Florine took painting lessons in Germany and traveled to the major art museums. The outbreak of war in 1914 prompted the quartet to return to New York, and in 1916 the Knoedler Galleries exhibited Florine's paintings.

The family became famous for their entertaining at Alwyn Court, a chateau-like apartment building at 182 West 58th Street, and their circle of friends included the leading avant-garde dancers, musicians, artists, and writers. Meanwhile, Florine maintained a studio, in which she painted her family and friends, in the Beaux Arts Building on Bryant Park. Carrie was also creative: most memorably, she constructed a doll house that she filled with miniature replicas of paintings and sculptures by the family's illustrious artist-friends (City Museum of New York). An especially important collaboration occurred when Virgil Thomson asked Florine in 1929 to do the sets and costumes for Gertrude Stein's *Four Saints in Three Acts*, for which he had just written the music. Florine painted Thomson's portrait in 1930 (Art Institute of Chicago).

Florine Stettheimer's last series of paintings were large-size canvas tributes to Manhattan called *Cathedrals of New York*. In fact, she was still working on *Cathedrals of Art* (Metropolitan Museum of Art) when illness necessitated two operations in 1942. Two years later she died in The New York Hospital, and within a few weeks Carrie also died, leaving Ettie alone until her death in 1955.

The cast of characters in this painting is as follows: Florine Stettheimer in her favorite white dress and holding a parasol at the left; her sister Ettie, recumbent in a red dress, being courted by the sculptor Elie Nadelman; and in the foreground Marcel Duchamp in a violet suit helping Carrie Stettheimer serve lobsters. The location: the novelist Rupert Hughes's farm in the exclusive town of Bedford Hills in Westchester County, north of Manhattan.

The figures are Stettheimer's usual wispy, calligraphic sketches, culminating in pointed, dainty toes at one end and, at the other, hair in bangs and emphatically articulated dark eyes for the Stettheimer sisters. The viewer's perspective is from above so that we see a somewhat flattened out, witty scenario: gracefully posed humans (three a bit languid); a couple of little white dogs, one upside down wriggling on its back; and various other blocks of color formed by cushions and mats stretched out over the yellow ground. The two trees cast an unusual green shadow, and off in the distance farmers are bringing in the hay, which has been stacked in a routine manner—much in contrast to the stylish foreground hedonism. The New York art critic Henry McBride later wrote that he wished he had been at the picnic![1]

[1] Parker Tyler, *Florine Stettheimer: A Life in Art* (New York, 1963), 106.

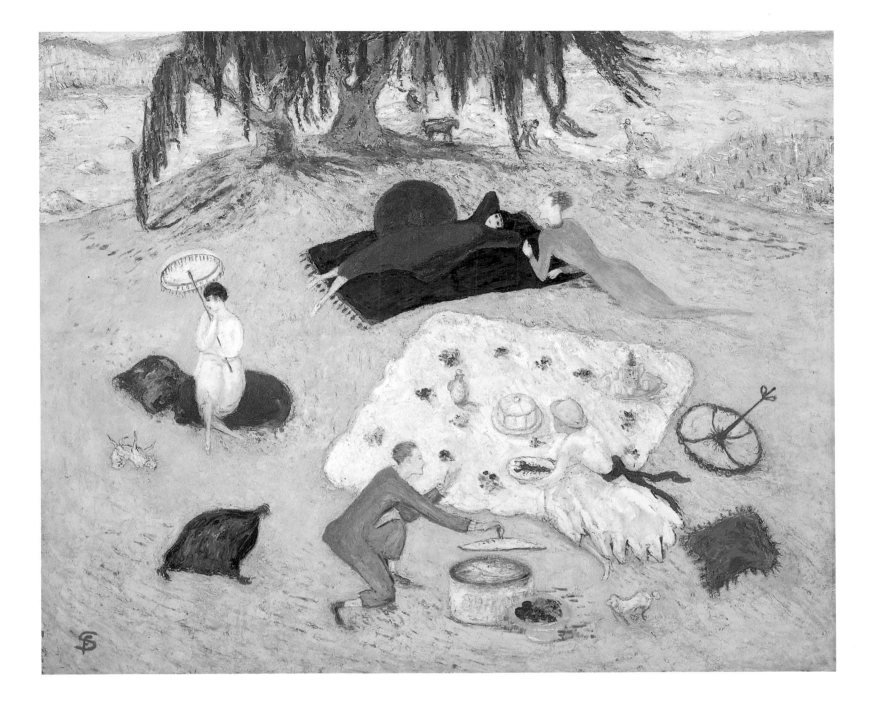

Abby Rhoda Williams Hill (1861-1943)
Grand Canyon 1930
Oil on canvas, 30 × 19 in.
University of Puget Sound

The legacy left by the Western painter Abby Hill is extraordinary. Commissioned by two major railway companies to produce a series of landscapes along their scenic routes in the Northwest, Hill was so successful with her first twenty paintings of the Cascade Range, completed in three-months' time, that a second contract was awarded her for an expanded itinerary to Yellowstone National Park, Montana, and Idaho.[1]

This painter, who is responsible for some one hundred canvases of the Cascades, the Tetons, the Grand Canyon, Yellowstone, and Laguna Beach, was born in Grinnell, Iowa, the second daughter of a cabinet-maker. In 1880 she enrolled at the Art Institute of Chicago to study with Henry Fenton Spread, and upon completion of her program, taught painting for a year at a girls' private school in Bertier en Haut, Canada. From 1888 to 1889 she studied with William Merritt Chase at the Art Students League in New York. After she married Dr. Frank Hill in 1888, the couple moved to Tacoma, Washington, to enable him to open his medical practice. Their only child, a son, was born partially paralyzed and required education at home. In addition, the Hills adopted three girls, so for a decade Mrs. Hill devoted herself to raising a family. But she resuscitated her artistic energies by studying in Hamburg with the illustrator Hermann Haase in 1896-97 while her husband did post-doctoral work.

When the Great Northern and the North Pacific Railway companies commissioned her to paint the northern Cascades, the impetus was to advertise rail travel at the Louisiana Purchase Exposition of 1904 in St. Louis. Hill was given 1,000-mile rail tickets for her party of four, and off they went into very rugged terrain: Tumwater Canyon, Lake Chelan, Horseshoe Basin, and the Peaks of Agnes. Once deposited by the train, they traveled by stagecoach, steamboat, and pack train, establishing camps in the mountains. Hill created a "painting tent-studio" in which to work, and she finished each canvas on site. The second contract called for travel during the summers of 1904 and 1905 in order to have the canvases of Wyoming and adjacent mountain states ready for the Lewis and Clark Exposition of 1905 in Portland, Oregon. At the Alaska-Yukon-Pacific Exposition of 1909 in Seattle her work received two gold medals.

After these extensive panoramic paintings Hill, who had great respect for Indians and their culture, began concentrating in 1906 on painting portraits on reservations. "She became a good friend to members of the Sioux, Flathead, Nez Perce, and Yakima tribes"[2] and wrote later that she wished she had learned the Indian languages. Her affinity was so great that she did learn the "Indian Woman's dance"[3] and was photographed in Indian clothes.

In 1909 Dr. Hill became too ill to continue his practice, and the family moved to Laguna Beach, California. When his health improved, they purchased a nine-passenger Hudson and toured the national parks from 1924 to 1932, spending the winters in Tucson. Dr. Hill's final illness in 1932 committed him to Bishops Hospital where he died six years later. The family had settled in nearby San Diego, but by then Abby Hill's energies were expended, and she died in her eighty-second year.

With her perspective from high above, Abby Hill almost deludes the viewer into believing that she had the advantage of flying over this scenic wonder in an airplane. In this painting of the *Grand Canyon* and in one of *Bryce Canyon* (1926),[4] the view is downward onto jagged geological formations, which—with their high horizon line—fill the picture space leaving only a fringe of sky. Hill is the precursor of the American painter Diane Burko, who in 1977 had the advantage not only of an airplane but of a camera to aid her in creating her canvases of the Grand Canyon.

In her colorful, naturalistic scenes of glacial peaks and mirror lakes Abby Hill continues the great nineteenth-century American tradition of landscape painting made famous by Frederick Church and Albert Bierstadt.

[1] Ronald Fields, *Abby Williams Hill, 1861-1943* (University of Puget Sound, Tacoma, Wash., 1979). I am grateful to Charlotte S. Rubinstein for alerting me to this brochure on Hill.
[2] Ibid.
[3] Ibid.
[4] Hill's paintings were presented to the University of Puget Sound by her daughter-in-law, Mrs. Romayne Hill, in 1957.

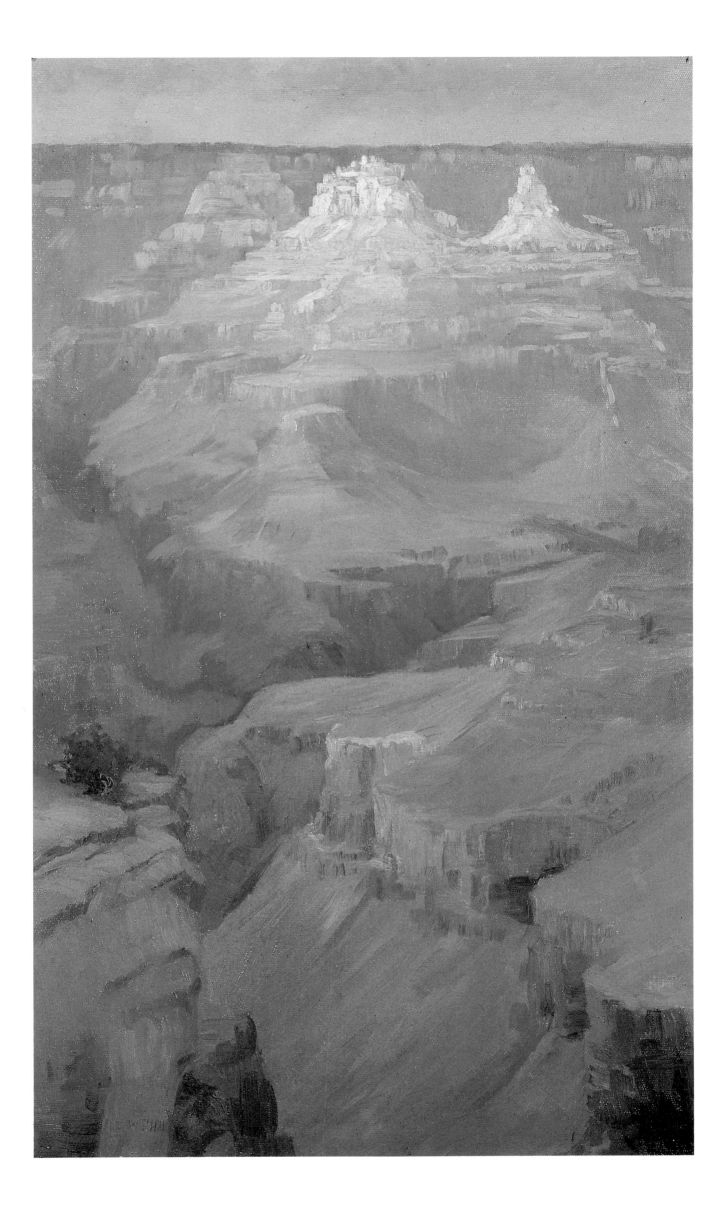

Mary-Russell Ferrell Colton (1889-1971)
Aspens on the San Francisco Peaks—The View from Hart Prairie 1930
Oil on canvas, 30 × 24 in.
Museum of Northern Arizona

Born in Louisville, Kentucky, Mary Russell Ferrell began her artistic career in Philadelphia, where she studied at Moore Institute and at the Philadelphia School of Design for Women from 1904 to 1909 under Elliott Daingerfield and Henry Snell. Upon graduation she and a friend opened their own studio and supported themselves with the restoration of paintings and commercial art projects. Perhaps more significantly for the history of women artists, Ferrell was a founding member of "The Ten," a group of ten women artists, all professionally trained in Philadelphia. From 1910 to 1941 "The Ten" sustained an active exhibition schedule in Philadelphia, which expanded to touring up and down the eastern seaboard, out to the Middle West, and even occasionally to Europe. "Newspaper accounts of the period record the popular reception accorded the frequent exhibitions by 'The Ten' and mention with critical regard Mary-Russell's paintings."[1]

In 1912 Ferrell married Harold S. Colton, a zoology instructor, and fourteen years later they moved to Flagstaff, Arizona. She remained a participating member of the "The Ten," although it became more difficult for her to exhibit large oil paintings. *The Art Digest* of 1934 states that in that year she sent no oils but only "a portfolio containing some of her water colors and prints,"[2] and *The Philadelphia Inquirer* of 9 March 1941 writes, "Nine women, according to the official listing, make up the Ten this year, and of these, one, Mary Russell Ferrell Colton, is not exhibiting. . . ."

In the second phase of Colton's career, she, ever open to new stimuli, became a painter of the Southwest, both of landscapes and of the Indians. She has preserved in her oils many vignettes of the Hopis and the Navajos in portraiture and at their crafts.

Mary Russell Ferrell and Harold S. Colton spent their honeymoon in 1912 on the Colorado Plateau of Arizona, hiking in the San Francisco Peaks.[3] After they settled in Flagstaff fourteen years later, Dr. Colton founded the Museum of Northern Arizona and served for over four decades as its director.[4] Although Mrs. Colton worked at times as curator, her appetite for painting remained unabated.

Here, eighteen years after the honeymoon, she records the snowy San Francisco Peaks as seen through a grove of tall aspen trees. She has painted a blue cloudless sky on a sunny day. The trees throw violet shadows in striations across the ground, while fluttering leaves above cast blue shadows on the upper trunks of the aspens. In this scene of carefully observed nature the painter wonderfully develops an unfolding depth through alternating colors in the landscape. We note that by this time she was hyphenating her first two names in her signature at the left.

[1] Katherin L. Chase, *Brushstrokes on the Plateau* (Museum of Northern Arizona, Flagstaff, 1984), 23.
[2] "Laurels for Ten," *The Art Digest* 8, no. 9 (1 February 1934), 16.
[3] Chase, *Brushstrokes*. I am indebted to Chris Petteys for bringing this painting to my attention.
[4] Phil Kovinick, *The Woman Artist in the American West, 1860-1960* (Muckenthaler Cultural Center, Fullerton, Calif., 1976), 17.

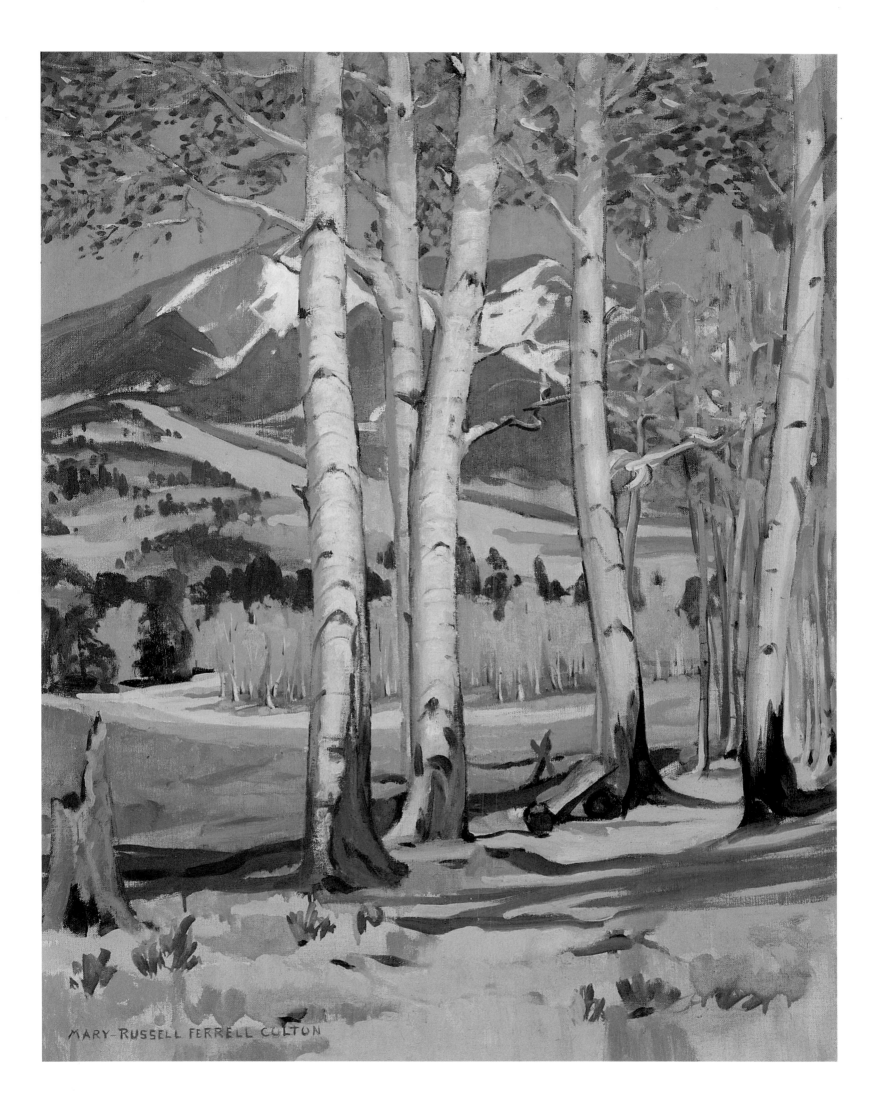

MARY-RUSSELL FERRELL COLTON

Molly Luce (1869⁄1986)
Pennsylvania Coal Country 1927
Oil on canvas, $22\frac{1}{16} \times 28\frac{1}{8}$ in.
Museum of Art, Carnegie Institute, Pittsburgh,
Gift of the H.J. Heinz II Charitable and Family Trust, 1980

"The American Breughel" is the sobriquet bestowed on Molly Luce by art critic Henry McBride.[1] Her realistic paintings of American towns inhabited by brightly garbed citizenry have long been popular. Luce's first one⁄person exhibition at the Whitney Studio Club in 1924 was followed by the purchase of two of her paintings by the Whitney Museum, and the Metropolitan Museum of Art acquired its first painting by her in 1934, to be followed by her *Winter in the Suburbs* in 1940, which the museum reproduced as a Christmas card. A revival of interest in her work has recently been marked by a retrospective at the Rhode Island School of Design in 1979 and by the mounting of fifty⁄five of her paintings in an "Eight Decades" exhibition that was shown in thirteen museums around the country from 1980 to 1983.

This Pittsburgh⁄born painter, who cited Rosa Bonheur's *The Horse Fair* as the first picture to affect her, studied art at Wheaton College in Norton, Massachusetts, with Amy Otis, a miniaturist by profession.[2] She went on to the Art Students League where her teachers were F. Luis Mora, George Bellows, and Kenneth Hayes Miller. Luce traveled through Europe in 1922⁄23 when these studies were completed, and upon her return exhibited at the Whitney Studio Club (which later became the Whitney Museum); she continued to exhibit at the Whitney in the annual and biennial exhibitions up to 1950. Luce was also included "in the Whitney Traveling Exhibition in 1925⁄26 that went across the country to major museums like the Minneapolis Institute of Arts, to show what younger artists in the East were doing."[3]

In 1925 Luce lived in Minneapolis, and among the paintings she showed two years later in a one⁄woman exhibition at the Montross Gallery in New York was *Backyards of Minneapolis*. Critics liked the new Americana paintings by Luce and the other realist painters. As the *Brooklyn Eagle* reported, "By setting down their reactions in direct, almost naïve statements, which is also an effort to break away from the ubiquitous French influence, they have already established a distinct tendency in contemporary American painting."[4]

Upon her marriage in 1926 to Alan Burroughs, an art historian at the Fogg Art Museum who became well known as a conservator and X⁄ray specialist, Luce moved to Cambridge, Massachusetts. One of her liveliest paintings, *Winter Sports* (1931), was painted in the Boston suburb of Belmont to which they moved in 1929. This painting was accepted for annual exhibitions at the Cincinnati Art Museum in 1931⁄32 and the Art Institute of Chicago in 1932⁄33, while her *Lobster Boats* was in the Pennsylvania Academy of the Fine Arts's annual of 1937, and *Roadside Stand* was at the Dallas Museum of Art that same year.

In 1942 Luce and her husband bought "Threeways," an eighteenth⁄century house in Little Compton, Rhode Island. From this small picturesque town Luce sustained a healthy painting and exhibition record. Alan Burroughs died in 1965, and Luce died at "Threeways" on 16 April 1986, at the age of eighty⁄nine.[5]

Luce's early style of painting in the 1920s, as in *Back Street*, has a parallel in Charles Burchfield's urban realism. In the late 1920s her style evolved into a Precisionist mode, seen in the sharply defined cylindrical grain storage tanks in *Backyards of Minneapolis* (1925⁄26) and the circular tanks and houses in *Outskirts of Town* (1927). Some of her later paintings of people in landscapes might remind one of Norman Rockwell's illustrations: for instance, her *Allegory—Life of the Artist* (1932), *Reading from Robert Frost* (1932), and *Women Working* (1946). Luce's forte seems to have been the scenes that capture the essence of an American locale or tradition in a realism elevated by poetics: *Concert in the Park* (1929), *Southeast Storm* (1935), *Spring Shower* (1936), *Harvest Supper* (1941).

One of Luce's most dramatic compositions is the one she returned to paint in Pennsylvania, the state of her birth. A huge black mountain of coal slag dominates the painting. Set in contrast is a beautiful red promenade populated by Sunday strollers. In the middle distance are neat rows of houses and other typical town buildings, brightly colored and suggesting a thriving community.

The picture's sharp lines and rectilinear regularity are consonant with the Precisionist style of painting characteristic of Charles Sheeler and Charles Demuth in the late 1920s and 1930s. The dynamism of the composition, like that in *Pouring a Gun* (1935), with its powerful chiaroscuro inside an industrial building, set it apart from other paintings of the American scene.

[1] D. Roger Howlett, *Molly Luce, Eight Decades of the American Scene* (Childs Gallery, Boston, 1980), [13].
[2] Robert Taylor, "The Ordinary, the Fantastic," *The Boston Globe Magazine*, 26 October 1980, p. 47.
[3] Howlett, *Molly Luce,* [13].
[4] Ibid., [14].
[5] I am grateful to Angela Noel of the Childs Gallery for sending me the obituaries that appeared in *The Boston Globe* and *The Boston Herald* on 17 April 1986.

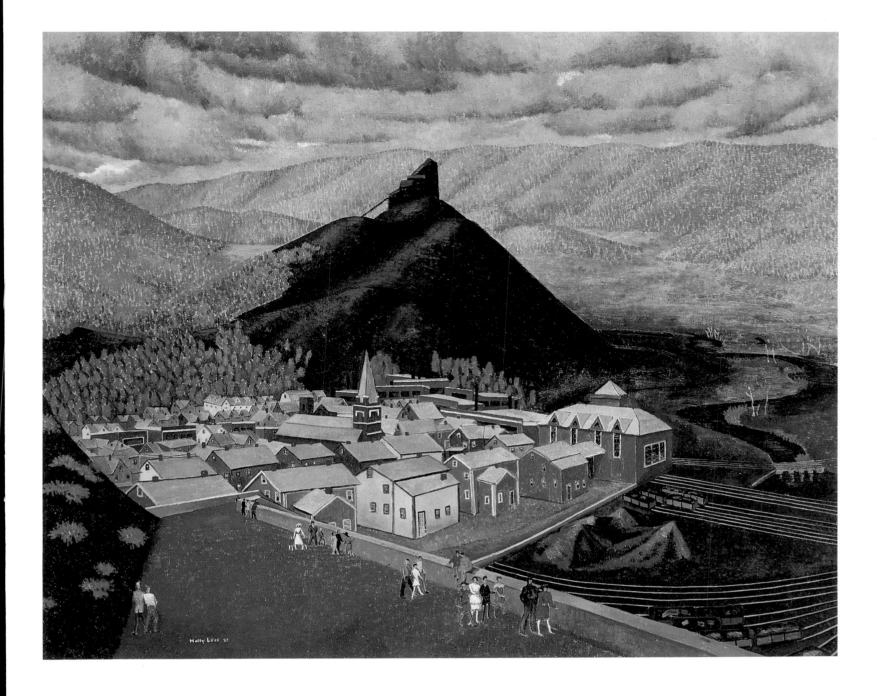

78

Constance Coleman Richardson (b. 1905)
Street Light 1930
Oil on canvas, 28 × 36 in.
Indianapolis Museum of Art, Gift of Mrs. James W. Fesler

Unheralded today but recognized during four decades in the middle of this century, Constance Richardson once exhibited her landscapes with regularity in New York City, receiving favorable reviews and seeing her paintings acquired by major museums. The daughter of a history professor at Butler College, she grew up in Indianapolis and attended Vassar. From 1925 to 1928 she studied at the Pennsylvania Academy of the Fine Arts, where she met Edgar P. Richardson, a fellow painting student who later became an art historian and her husband. After working in Indianapolis from 1928 to 1930, she moved to Detroit with her husband in 1931 and lived there for more than thirty years while he served as editor of *The Art Quarterly* and as director of the Detroit Institute of Arts.

Richardson's first landscapes were painted during the summers she spent with her husband in the hills of Vermont and New York state. When they were based in the Midwest, she painted along the Great Lakes. Then she discovered the West, and many subsequent vacations were spent in Wyoming, where she worked outdoors making oil sketches that she would later convert to finished oil paintings on gesso-ground masonite. Often her husband served as the model for the sole figure inhabiting her paintings of the western expanse. Her own words elucidate her artistic intentions: "... it interests me to look at nature, which I find much more remarkable than anything anyone can make up; and to try to say something about light and space and air and how wonderful the world is if you really look at it; and to say it with clarity, serenity and objectivity."[1]

Richardson's paintings were included in exhibitions on both coasts and in the Midwest in the 1930s, receiving coveted prizes. And in addition to her exhibitions at the MacBeth Gallery in New York in the 1940s and 1950s, she was given an exhibition at the DeYoung Museum in San Francisco in 1947, she was in the Pennsylvania Academy and Detroit biennial exhibitions of 1957 and 1959, and her paintings were shown at the Kennedy Galleries in New York in the 1960s and in 1970.

According to her husband's 1985 obituary in *The New York Times*, Constance Richardson was living in Philadelphia at the time.

One of the discoveries of this exhibition is Richardson's magical view of a summer evening in Indianapolis, when familiar objects are transformed in the nocturnal light. A mother accompanied by her daughter seems to call across the street to a younger child, while a man sits with a lighted cigarette on the steps of his house on the other side of the street. Shafts of light emanating from the street lamp shine through the tree leaves, illuminating the walk and the four individuals in the pervasively blue evening. In addition to the clearly established crepuscular mood, the painter constructs a well-defined space in generalized geometric planes. The powerful impact achieved through volumetric simplification has a parallel in Edward Hopper's urban scenes; and the poetic evening setting punctuated by the hypnotic focal point of the glowing cigarette recalls images by René Magritte.

[1] *Paintings by Constance Richardson* (MacBeth Gallery, New York, 1944), [2].

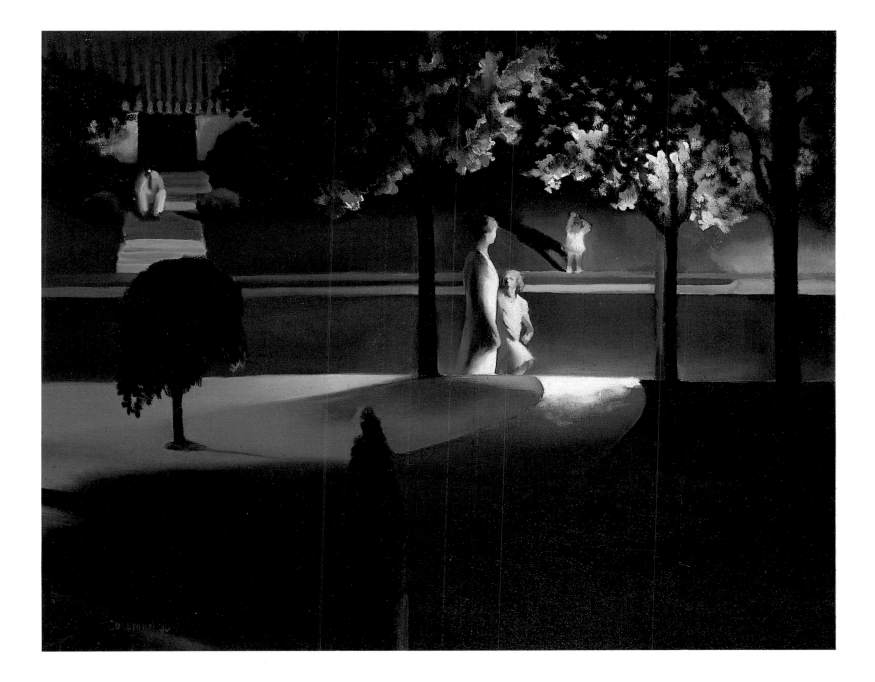

Doris Emrick Lee (1905–1983)
April Storm, Washington Square 1932
Oil on canvas, 24 × 34 in.
Museum of Art, Rhode Island School of Design,
Gift of Mrs. Murray S. Danforth

Doris Lee is a well-known realistic painter whose name is associated with the Woodstock art colony—she was president of the Woodstock Artists Association in 1952. Lee acquired early recognition as an artist in 1935 when she received first prize and the Logan Gold Medal in the American Artist Annual at the Art Institute of Chicago[1] and won two mural commissions in the first competition sponsored by the United States Treasury Department.

Born in Aledo, Illinois, in 1905, Doris Emrick attended Rockford College. Upon graduation in 1927 she did two momentous things: she married Russell Lee, an engineer who became an art photographer during their years together, and they departed for Europe. In 1928–29 she studied at the Kansas City Art Institute with Ernest Lawson, then returned to Paris to study with André L'Hote. But abstractions did not hold her attention long, and to shake herself of staleness, as she phrased it,[2] she enrolled at the California School of Fine Arts, where her teacher Arnold Blanch advised her to paint from nature. In 1931 she moved to Woodstock, New York, and painted in the company of Peggy Bacon, Alexander Brook, Leon Kroll, Yasuo Kuniyoshi, and Arnold Blanch, whom she married in 1939, having divorced Russell Lee (she and Blanch later divorced as well).

The painting that catapulted Lee into prominence was *Thanksgiving* (1935), not only because the painting won first prize at the Art Institute of Chicago but because Mrs. Josephine Logan, the benefactor's wife, called this kitchen scene, in which nine people scurry about preparing the Thanksgiving dinner, "atrocious," and a "Sanity in Art" campaign ensued. The Art Institute of Chicago rose to the challenge and acquired the painting for its permanent collection, and Lee later candidly wrote, "Through this fluke many people learned of my painting who probably never would have normally."[3]

In *Catastrophe* (1936), a painting bought by the Metropolitan Museum of Art, Lee displays the apocalyptic vision of a burning dirigible over New York City, with passengers descending by a parachute around the Statue of Liberty. Thus, in an uncanny way, she anticipated by one year the *Hindenburg* disaster.[4] *Life* magazine commissioned her in 1947 to travel and paint and then published four picture essays of her works: "Negroes of the American south, . . . North Africa, the Caribbean and Mexico, and Hollywood."[5]

In her paintings Lee draws heavily on her own rural beginnings in Illinois, reinforced by her later years of living in Woodstock in the Catskill Mountains. Her scenes of Americana are often populated by animated, gesturing individuals.[6] Occasionally one detects a caricaturish quality in her otherwise naturalistic paintings.

Doris Lee died at seventy-eight in Clearwater, Florida, and was survived by a brother, Edward Emrick, Jr., of Venice, Florida.

Doris Lee provides here a wonderful glimpse of the moment just before a sudden April shower in New York City's Washington Square. Figures involved in various activities begin to seek shelter, the sky darkens, and even the birds above are agitated. The red brick houses lining the square take on a warmer glow in the eerie light, and silhouetted against them are the big Washington Square arch, through which a Fifth Avenue double-decker bus passes, and at the left a small bandstand. Among the human-interest vignettes in the park are a woman tugging at her dog on a leash, a flower vendor, a mounted policeman, a roller skater, a would-be purse snatcher(?) at the left, an unescorted Scottish terrier, children forming a ring around a tree, a fight at the center, and parents trying to catch their running child at the right.

[1] Doris Lee, *Doris Lee* (American Artists Group, New York, 1946), [64].
[2] Ibid., [6].
[3] Ibid., [8].
[4] *7 American Women: The Depression Decade* (Vassar College Art Gallery, Poughkeepsie, N.Y., 1976), 33.
[5] Tram Combs, "Remembering Doris Lee," *Woodstock Times*, 25 October 1984, p. 18.
[6] See the post office murals illustrated in Karal Ann Marling, *Wall-to-Wall America* (Minneapolis, 1982), 59, 60.

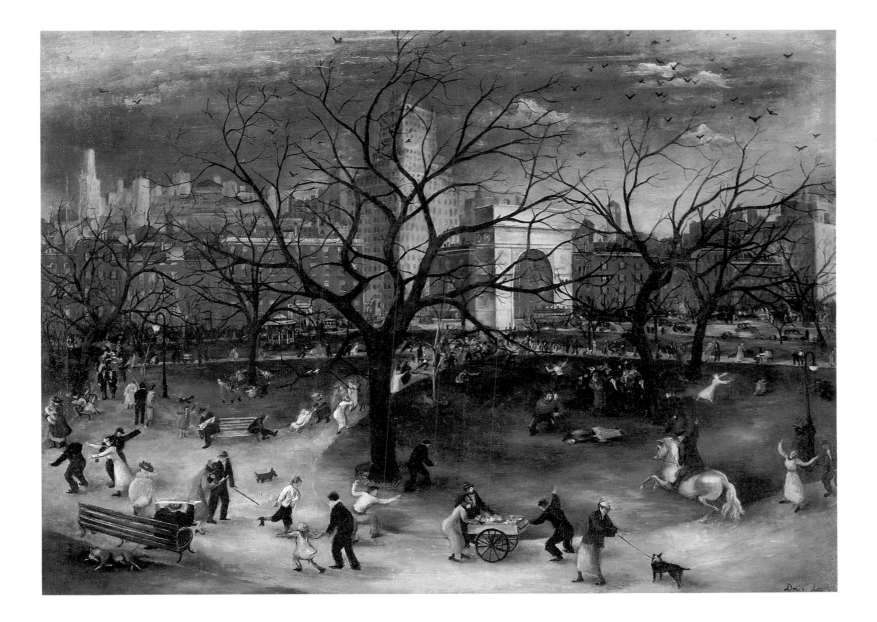

Agnes Pelton (1881–1961)
The Fountains 1926
Oil on canvas, 35 × 31¼ in.
Georgia Riley de Havenon

Pelton is a relatively unknown but unusually innovative artist who was an avant-garde abstractionist. Her pioneering modernism is especially evident in the 1926 painting in this exhibition and in the other paintings she showed in her 1929 one-woman exhibition in New York City, also in her *Orbits* (1934, Oakland Museum)[1] and in the twenty-seven symbolic paintings she exhibited at the Santa Barbara Museum of Art in 1943.

Born of American parents in Stuttgart, Agnes Pelton spent much of her childhood in France and Switzerland; her early education was acquired mostly in her home and emphasized music and art.[2] For formal artistic training she attended the Pratt Institute in Brooklyn, from which she graduated in 1900[3]. She then spent the next year in Italy, immersing herself in its art treasures. On returning to the United States, she studied with Arthur Wesley Dow, William Langson Lathrop, and Hamilton Easter Field. Two of her paintings were accepted for the International Exhibition of Modern Art in 1913, popularly known as the New York Armory Show. Also in that year she participated in an exhibition of "Imaginative Paintings" and began exhibiting at Ogunquit, Maine, during the summer. Her activities accelerated in 1915 when she participated in a Women's Suffrage Exhibition at Macbeth Galleries, had a one-person exhibition in New York, and received honorable mention for her entry *Philosophy* in Mrs. Harry Payne Whitney's contest for a mural decoration. In 1917 she was included in a group exhibition at the Knoedler Galleries in New York, and two years later she showed pastels of Taos at the Museum of New Mexico in Santa Fe.

A versatile painter, Pelton chose her subjects from a wide range of landscapes, portraits, and flowers. She spent a winter in the Hawaiian Islands painting from nature, and at a one-woman exhibition the next summer at Southampton on Long Island she dazzled the critics with her paintings of Hawaiian flowers.[4] Among the portraits in this exhibition was a pastel of Governor John G. Winant of New Hampshire.

From May to September 1926 Pelton visited the Near East, and her sitters included a Syrian girl and the daughters of Bayard Dodge, president of American University in Beirut. When she was back in America, she as usual had a Manhattan studio, but she also in these years maintained a studio in the Hay Ground Windmill on Long Island. Her painting of the windmill was accepted for an exhibition at the Brooklyn Museum along with *The Fountains*.[5] She was in California the winter of 1928–29 for her one-person shows in Pasadena and Los Angeles.

Pelton's turning away from figurative art can be marked by her exhibition "Abstractions" at the Montross Gallery in New York in 1929. The new paintings bore titles such as *Caves of the Mind*, *Incarnation*, *Ecstasy*, and *Sleep*. Two paintings from this exhibition, *The Fountains* and *Being*, were accepted for the 1930 Annual Exhibition of the Pennsylvania Academy of the Fine Arts. The next year the Argent Galleries in New York showed her abstract paintings. Dane Rudhyar, a composer and philosopher who in his youth was secretary to Rodin, had seen Pelton's paintings in the 1929 exhibition and wrote as an introduction to the 1931 exhibition, "I do not mean by abstractions the results of intellectual analysis and reconstruction (as exemplified in cubism), but forms having both actual being as entities of a semi-subjective world and universal significance as impersonal symbols of human experience."[6]

California became Pelton's adopted state in 1931. She settled in Cathedral City and continued her painting career in the West. Pelton and Rudhyar were founding members of the Transcendental Painting Group in New Mexico in 1938, and she invited him to write the introduction to the catalogue for her 1943 exhibition at the Santa Barbara Museum of Art. The flowering foliage in the desert never lost its appeal for Pelton, and

periodically through the 1930s and 1940s she showed her paintings at the Desert Inn Gallery in Palm Springs. Her last known catalogue is for her 1955 exhibition at the Palm Desert Art Gallery, illustrating an endearing motif of this aesthetic painter: *Smoke Tree in Bloom*.

We are fortunate to have on loan a painting from Pelton's first exhibition of "Abstractions."[7] The slim exhibition catalogue's short introduction, entitled "Abstractions in Color" and perhaps written by the artist herself, serves as the best accompaniment to this colorful painting of the spray emitted by a fountain:

> *These pictures are like little windows, opening to the view of a region not yet much visited consciously or by intention,—an inner realm, rather than an outer landscape. . . .*
>
> *Here color is like a voice, giving its message directly, without translation into the presentment of recognizable colored objects. Like music without an instrument, it acts on the perception which is sympathetically ready to receive it; but as the creative faculty acts in building forms, the colors active here, produce forms in space according to their nature and the quality of life and light which they represent.*
>
> *In so far as this creative activity is present, a concept appears to organize itself into what might be called a symbolic vision.*
>
> *As the fragrance of a flower fills the consciousness with the essence of its life without the necessity for seeing its material form, it seems that color will some day speak directly to us. . . .*[8]

[1] Illustrated in *Painting and Sculpture in California: The Modern Era* (San Francisco Museum of Modern Art, 1977), 99.

[2] "Agnes Pelton Art Exhibition at University of Redlands," *Redlands Daily Facts*, October 1951, Pelton file, library of National Museum of American Art. As always, Roberta Geier, the museum's librarian, was very helpful.

[3] Phil Kovinick, *The Woman Artist in the American West, 1860–1960* (Muckenthaler Cultural Center, Fullerton, Calif., 1976), 45.

[4] "Exhibition of Paintings at Memorial Hall," undated newspaper clipping, Pelton file, library of the National Museum of American Art.

[5] Annie Laurie Hopkins, from fragment of clipping ". . . Well Known Artist," Pelton file, National Museum of American Art.

[6] *Exhibition of Paintings by Agnes Pelton* (Argent Galleries, New York, 1931).

[7] I am grateful to Gail Levin for putting me in touch with the owner of this early abstraction.

[8] Georgia Riley de Havenon kindly sent me a photocopy of this catalogue.

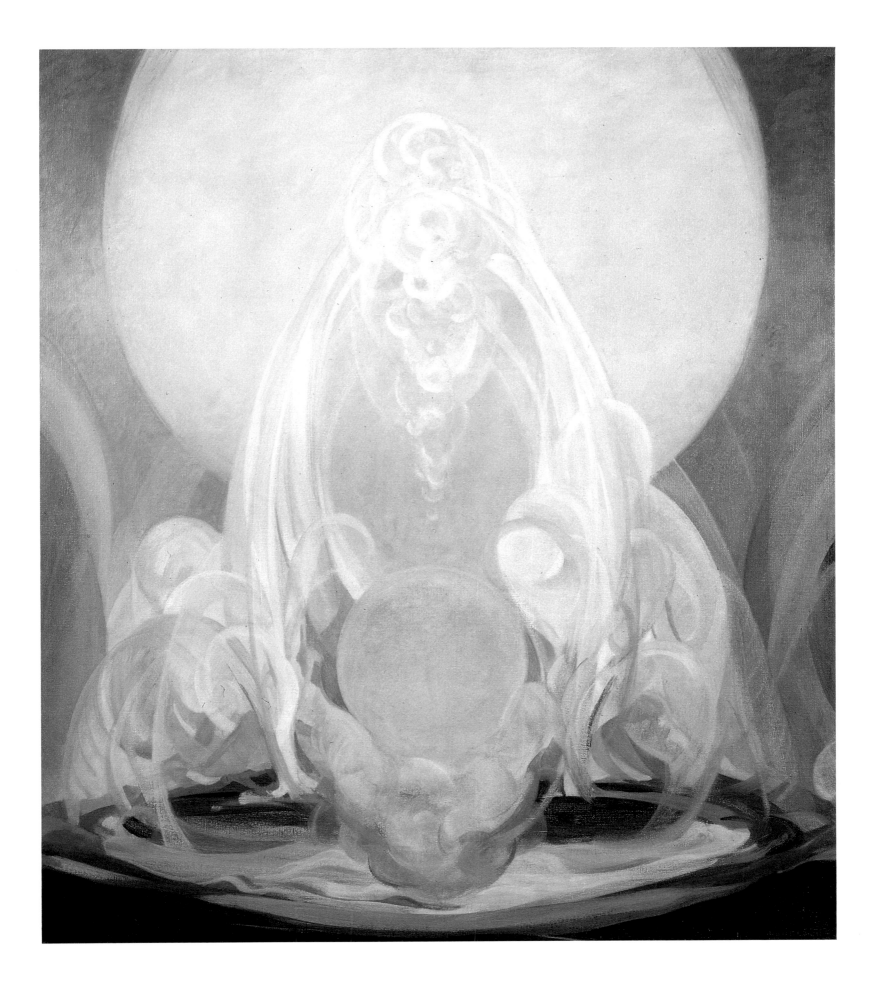

81
Georgia O'Keeffe (1887–1986)
Spring 1922
Oil on canvas, $35\frac{1}{2} \times 30\frac{3}{8}$ in.
Vassar College Art Gallery,
Bequest of Mrs. Arthur Shwab (Edna Bryner '07)

"Georgia O'Keeffe Dead at 98; Shaper of Modern Art in U.S." was the headline emblazoned on page 1 of *The New York Times* a year ago. Even if O'Keeffe had not lived for almost a century, her place in the development of modern art would still have been history-making, because in her ever-evolving style, she was a pace setter—in her awesome paintings of New York in the 1920s, like *Radiator Building*, in her discovery of the natural beauty of New Mexico, and in her magnified paintings of single flowers.

Born in Sun Prairie, Wisconsin, O'Keeffe displayed artistic talent early and undertook formal studies at the Art Institute of Chicago in 1905. Illness prevented her returning the next fall, and in the intervening year she decided to resume her training in New York at the Art Students League, where she studied in 1907–1908 with William Merritt Chase and others. In competition with the older students there, she won the top still-life prize of $100.[1] Because of financial difficulties, O'Keeffe worked the next two years as a commercial artist in Chicago. From 1912 to 1914 she taught art in the public schools of Amarillo, Texas, and during summers from 1913 to 1916 taught drawing at the University of Virginia. Her last go at education was to study with Arthur Wesley Dow at Teachers College, Columbia University, and her last stint of teaching was at West Texas State Normal College in Canyon, south of Amarillo in the Panhandle. She settled in New York to work as a professional artist in 1918.

O'Keeffe's exhibiting began in 1916 when Alfred Stieglitz showed the charcoal drawings of landscapes that she had mailed from the South to her New York friend Anita Pollitzer; Pollitzer on her own initiative took the batch to Stieglitz. O'Keeffe had written Pollitzer, whom she had befriended at Teachers College, "Do you like my music. . . . I didn't make it to music . . . it's just my own tune."[2] O'Keeffe previously had been dismayed to see the influences of her teachers on her art and was proud now of finding her own style in flower studies and landscapes.

Stieglitz gave O'Keeffe her first solo exhibition at his 291 Fifth Avenue gallery in April 1917. This was followed by an exhibition of one hundred paintings at the Anderson Galleries in New York in 1923. The next year, after Stieglitz divorced his first wife, he and O'Keeffe were married.

O'Keeffe's first glimpse of Santa Fe was in the summer of 1917, and starting in 1929 she began to make a habit of spending her summers in New Mexico. After Stieglitz's death in New York in 1946, her home in Abiquiu became her permanent residence. She took her first trip to Europe in 1953 when she was in her middle sixties. Travel to new places appealed to her, and she flew around the world in 1959, adding to her stone collection as she went. One of her favorite excursions in America was riding a raft down the Colorado River, which she did several times.

Six retrospective exhibitions of her paintings have been held: The Brooklyn Museum in 1927, the Art Institute of Chicago in 1943, the Museum of Modern Art in 1946, the Worcester Art Museum in 1960, the Amon Carter Museum in 1966, the Whitney Museum in 1970. The National Gallery of Art is now planning one more.

America's highest honors have been conferred on O'Keeffe: the Medal of Honor by President Gerald Ford in 1979, an honorary degree from Harvard in 1973, the M. Carey Thomas Award at Bryn Mawr 1971, the National Institute of Arts and Letters gold medal for painting 1970, Brandeis University's Creative Arts Award 1963, and election to both the American Academy of Arts and Letters and the American Academy of Arts and Sciences.

Lloyd Goodrich writes that O'Keeffe's work is a combination of abstraction and representation,[3] and this is certainly an apt description of her blown-up paintings of flower blossoms; they are recognizable yet they have been lyrically transformed by the painter's eye and brush. In her early work she, like fellow painters Arthur Dove and John Marin, started with natural images, which evolved into abstractions. As Susan Fillin Yeh writes, "O'Keeffe arrived at her images through distillation."[4] Her bone paintings, which began in 1931, exemplify this honing. Starting with *Cow's Skull: Red, White, and Blue* (1931, Metropolitan Museum), a realistic clarity of image is apparent, but over the years the bones became more abstract, graceful curvilinear forms at the hands of O'Keeffe. In the same way she had made careful selections from terrestrial nature, after her airplane travel in 1959, she chose a pattern of clouds as her subject matter in seemingly endless vistas.

In the last year of her life O'Keeffe—with the help of a young potter, Juan Hamilton, and a secretary—was cooperating with the National Gallery of Art on plans for its big retrospective of her paintings. She communicated this to me in a cordial letter of 5 August 1985, explaining why she could not lend any of the works in her own collection to the inaugural exhibition of The National Museum of Women in the Arts and graciously wishing us success in this venture. She died at St. Vincent Hospital in Santa Fe on 6 March 1986.

O'Keeffe marvelously evokes the spirit of spring in the joyous colors of this semi-abstract painting: radiant yellow foliage on a tree and two oversized fruits, perhaps apples, in the left foreground against the greens seen in nature, which imperceptibly blend with the blue and white of sky and clouds. O'Keeffe combines her amorphous forms with some stronger lines, such as the sinewy tree trunk and the architectonic diagonal, which may have been suggested by one of Manhattan's bridges or by her fourth floor window ledge in midtown New York. She seems to have been purposely ambiguous, delighting in the pulsations of forms without specifying what they are, and experimenting with a lyrical composition in the manner of Franz Marc and Wassily Kandinsky whose *On the Spritual in Art* impressed her enormously.

[1] Laurie Lisle, *Portrait of an Artist: A Biography of Georgia O'Keeffe* (New York, 1980), 50.
[2] Nancy Scott, "The O'Keeffe-Pollitzer Correspondence, 1915–1917," *Source*, III, no. 1 (Fall 1983), p. 36.
[3] Lloyd Goodrich and Doris Bry, *Georgia O'Keeffe* (New York, 1970), 15.
[4] Susan Fillin Yeh, "Innovative Moderns: Arthur G. Dove and Georgia O'Keeffe," *Arts Magazine* 56, no. 10 (June 1982), p. 70.

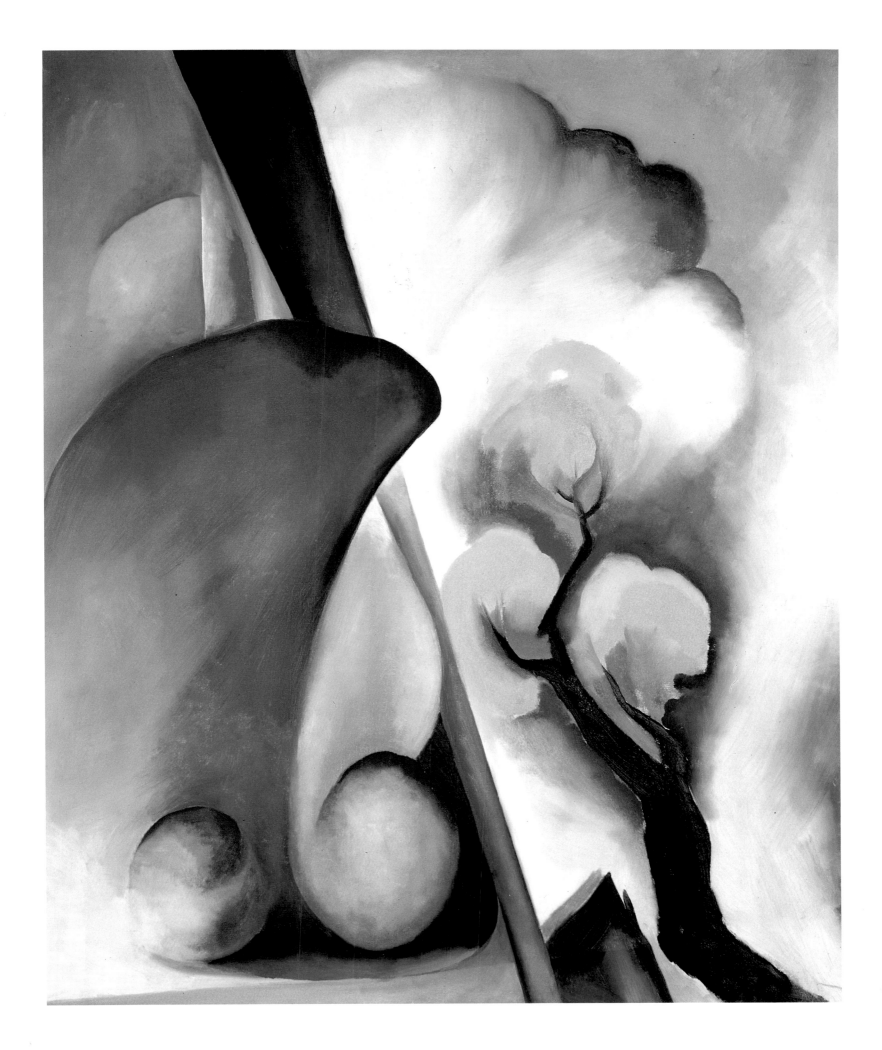

82
Georgia O'Keeffe (1887-1986)
City Night 1926
Oil on canvas, 48 × 30 in.
The Minneapolis Institute of Arts, Gift of the Regis Corporation,
John Driscoll, the Beim Foundation, the Larsen Fund,
and by Public Subscription

In 1925 O'Keeffe and Stieglitz moved into a top floor suite at the
Shelton Hotel in New York, and from this perch, thirty flights over
street level, O'Keeffe painted the monolithic skyscrapers, very often at
night as in this view. Squeezed between the towering buildings is an
incandescent moon. With the eyes of a modernist, she has simplified the
internal articulation of these behemoths, thus emphasizing their dark,
vertical silhouettes against the deep blue sky. Viewed obliquely on the
canvas and contrasted with the white building behind, these sleek
volumetric masses are both incisive and breathtaking.

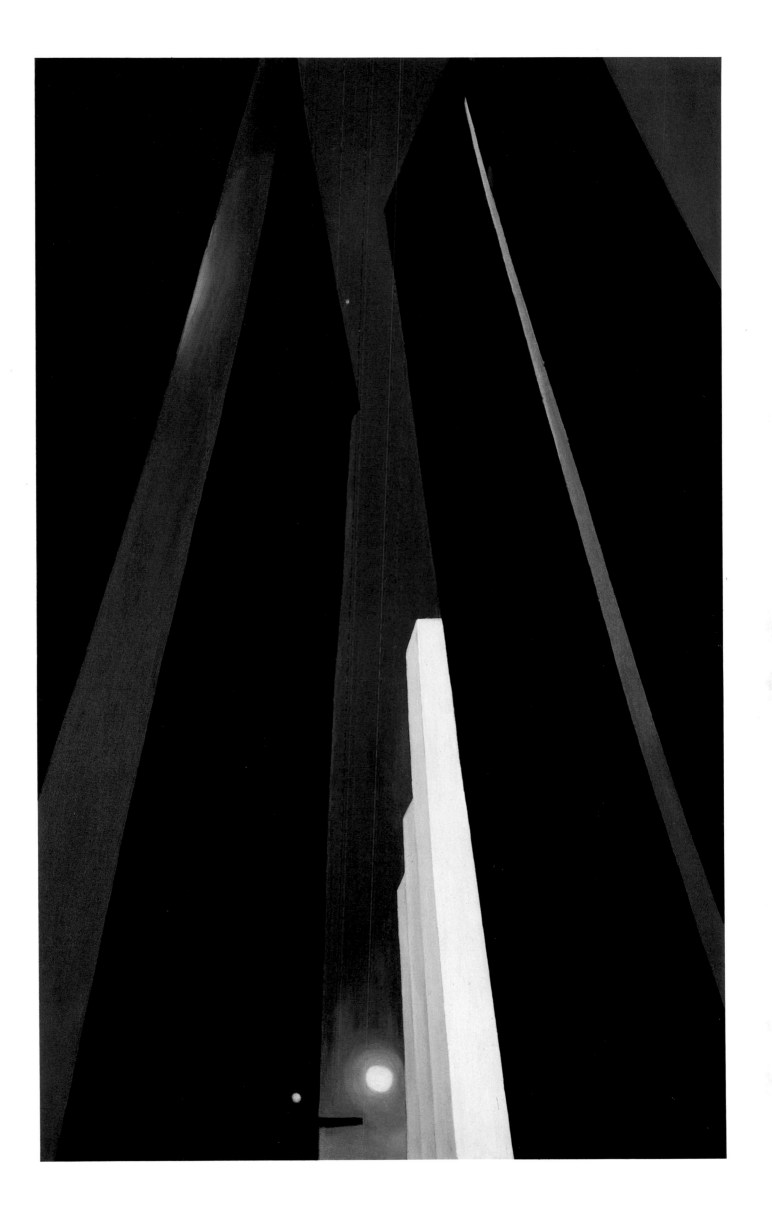

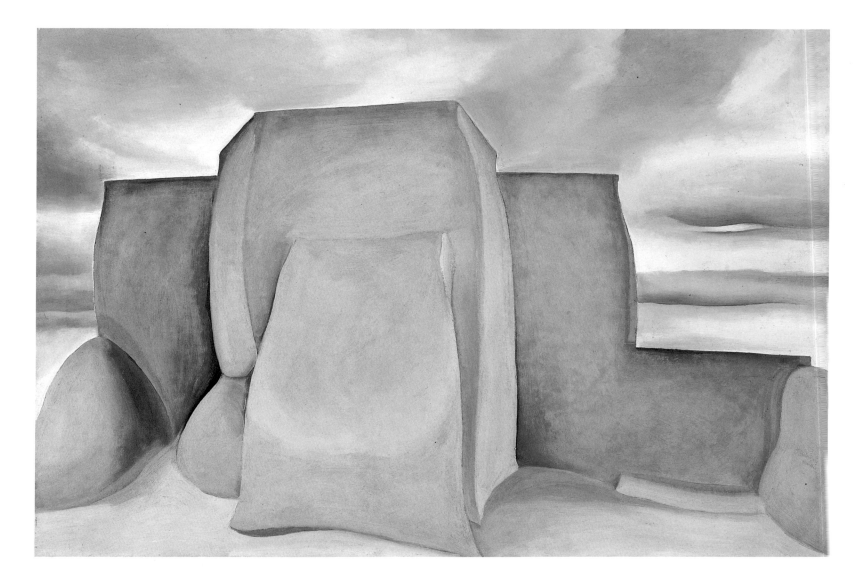

83
Georgia O'Keeffe
Ranchos Church—Taos 1930
Oil on canvas, 24 × 36 in.
Amon Carter Museum, Fort Worth, Texas

Before Georgia O'Keeffe visited Taos in the summer of 1929, she and her younger sister Claudia had seen only a portion of New Mexico on a vacation to Colorado in 1917. Among the new sights that excited O'Keeffe in the Sangre de Cristo Range where Taos is situated was the eighteenth-century Ranchos Church that still stands today. In typical O'Keeffe fashion, she depicted her new-found motif in a series of paintings. The version owned by the Amon Carter Museum differs from the others in its "wispy clouds in a gray-blue sky."[1] On the back of this canvas one can read the title "Ranch church—Grey Sky" in pencil and the signature "Georgia O'Keeffe—1930" in white paint. These paintings are important historically because they mark the beginning of O'Keeffe's mature career in depicting the desert beauty of New Mexico, which became synonymous with her name.

The essence of O'Keeffe's new style is seen here—her selectivity in painting from nature, her architectonic form expressed in the sun-baked adobe building, and the feeling of infinity behind her isolated motif. Her own words best describe her intentions:

The Ranchos de Taos Church is one of the most beautiful buildings left in the United States by the early Spaniards. Most artists who spend any time in Taos have to paint it, I suppose, just as they have to paint a self-portrait. I had to paint it—the back of it several times, the front once. I finally painted a part of the back thinking that with that piece of the back I said all I needed to say about the church.[2]

[O'Keeffe is also represented in this exhibition by *White Trumpet Flower*, 1932, cat. no. 99.]

[1] Katherine Hoffman, *An Enduring Spirit: The Art of Georgia O'Keeffe* (Metuchen, N.J., 1984), 109-110. Other versions are *Ranchos Church No. 1* (1929), in the Norton Gallery, West Palm Beach; and two paintings from 1930, one in the Phillips Collection, Washington, D.C., and another in the Metropolitan Museum of Art.
[2] Georgia O'Keeffe, *Georgia O'Keeffe* (New York, 1976), 63.

Still-Life

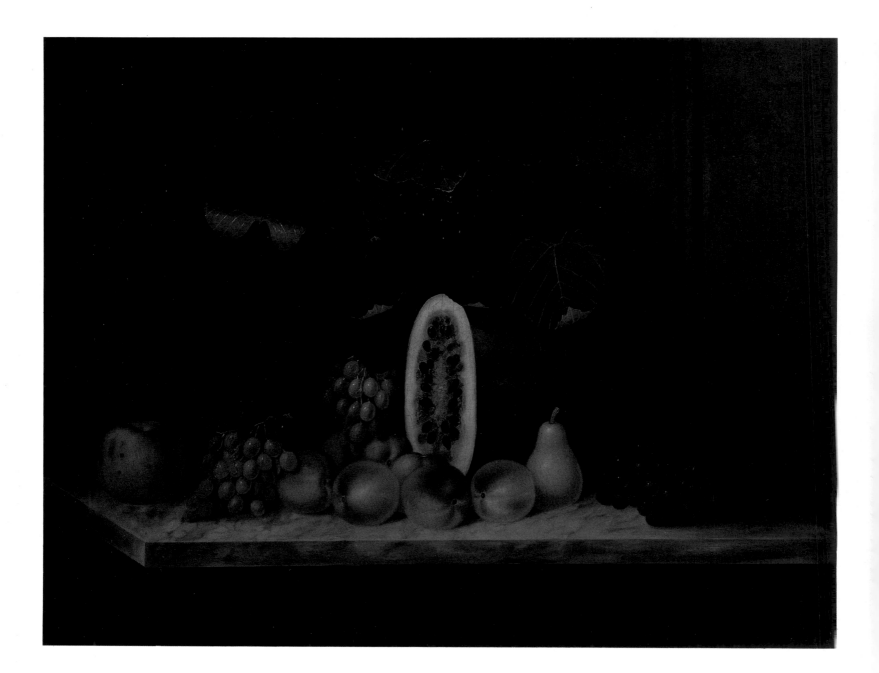

84
Anna Claypoole Peale (1791–1878)
Still Life between 1811 and 1819
Oil on canvas, 26½ × 34 in.
Mead Art Museum, Amherst College

Although Anna Claypoole Peale has left us a larger legacy of
miniatures, some sumptuous still lifes come from her earliest years as an
artist, and one of these is preserved today at the Mead Art Gallery,
thanks to a bequest of Professor Charles H. Morgan who has had a
distinguished career of teaching American art at Amherst College. In
1811 Anna Peale's "Fruit Piece (first attempt)" was accepted in the first
exhibition of the Pennsylvania Academy of the Fine Arts, and she
continued to exhibit regularly in the academy's annual shows until 1842.[1]

In this rare painting a variety of fruits is displayed on a marble table
top: an apple, grapes, peaches, a dominant watermelon, and a pear
placed upright. A large cluster of grape leaves fills the upper half of the
composition, providing vertical interest to the otherwise horizontal
format of the colorfully painted still life. One especially clever aspect is
the rendition of the underside of leaves, seen in the turned-up tips and in
the leaf that is folded over.

[For Peale's biography, see cat. no. 27.]

[1] Charles Coleman Sellers, "Anna Claypoole Peale," *Notable American Women*, vol. 3
 (Cambridge, Mass., 1971), 39.

85
Margaretta Angelica Peale (1795‑1882)
Strawberries and Cherries nineteenth century
Oil on canvas, 10 × 12 in.
Pennsylvania Academy of the Fine Arts, Gift of Mildred Carter

Although Margaretta Angelica Peale, the sixth‑born child of James and
Mary Peale of Philadelphia, did not strive for a professional career as her
sisters did, she exhibited at the Pennsylvania Academy of the Fine Arts
from 1828 to 1837, and she did develop a special expertise in still‑life
painting.

Margaretta Peale's bowl of strawberries is simply displayed on a bare
wooden table top, accompanied by further notes of red in the cherries
placed at the left, and all viewed against a neutral, warm brown back‑
ground. The fruits are defined in a sharp light that comes in from the
left, casting shadows that fall to the right. The artist achieves such
verisimilitude that the fruits look as if they could be plucked off the table.

 Other known still lifes by Margaretta Peale are of a succulent white
watermelon and dish of peaches at the Smith College Museum of Art
(signed and dated 1828 on the back) and a bountiful basket of
pomegranates and grapes at the Maryland Historical Society (of the same
decade). William Gerdts and Russell Burke report that other versions of
her *Strawberries and Cherries* exist, one of which is dated 1865.[1]

[1] William H. Gerdts and Russell Burke, *American Still‑Life Painting* (New York, 1971), 37.

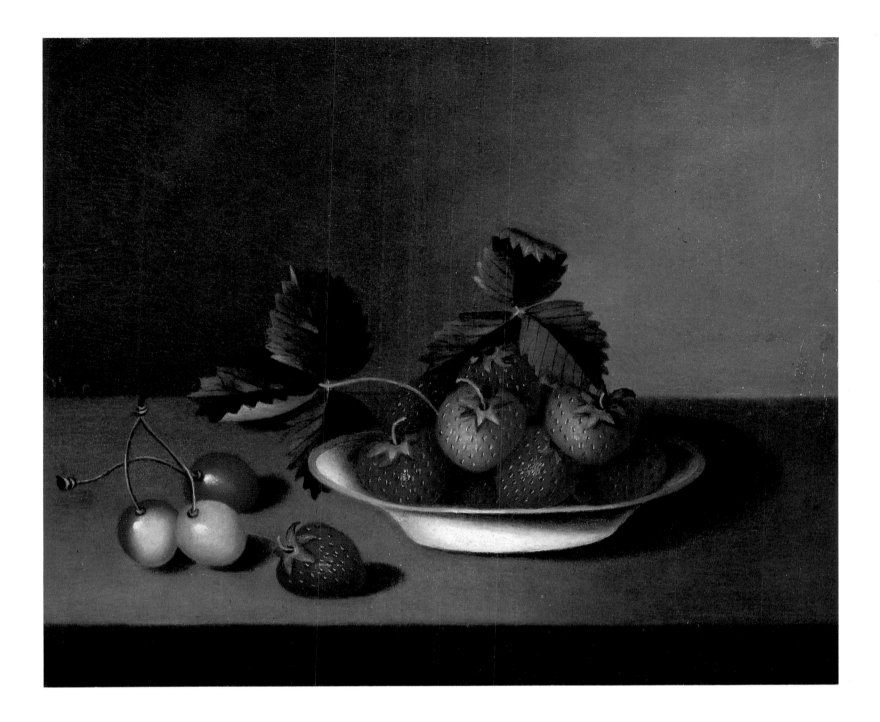

86
Mary Jane Peale (1827–1902)
Still Life nineteenth century
Oil on canvas, 18 × 24 in.
Mead Art Museum, Amherst College

Mary Jane Peale, granddaughter of Charles Willson Peale, had the distinction of knowing that she wanted to be a painter before her father, Rubens Peale, decided to turn to painting. Thus she became her father's teacher during the last decade of his life. Born in New York in 1827, Mary Jane Peale studied painting with her uncle, Rembrandt Peale, and with Thomas Sully. Her work consisted of still lifes and portraits. One of her portraits, *Rubens Peale* from 1860, shows her father with white hair and wearing hexagonal steel-rimmed glasses; the portrait is now owned by Southern Alleghenies Museum of Art (formerly in the collection of Mr. and Mrs. James Titelman). Probably the most memorable portrait of Rubens is by his older brother Rembrandt and shows him with a geranium; this painting was recently acquired by the National Gallery of Art. Mary Jane Peale died in Pottsville, Pennsylvania, on a farm to which her father had retired.

Mary Jane Peale's still lifes are of the most ambitious type undertaken by artists in her family—rich profusions of fruits spread compactly across the top of a table, as seen here in this luscious array of fruits and brightly colored leaves, with raspberries spilling from a tiny basket and a branch of cherries extending over the front edge of the table. Despite the diversity, a complex design knits all the differently textured elements together into one coherent whole.

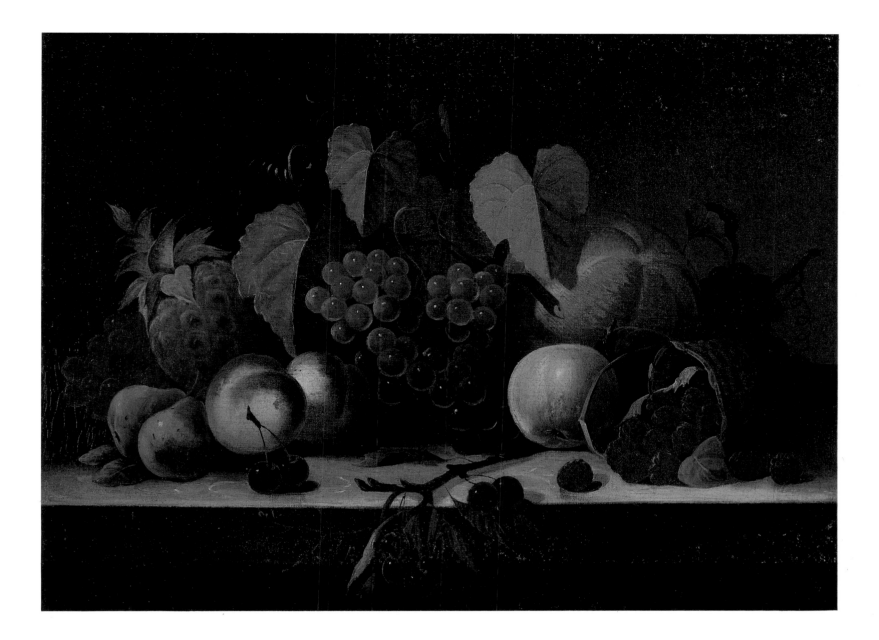

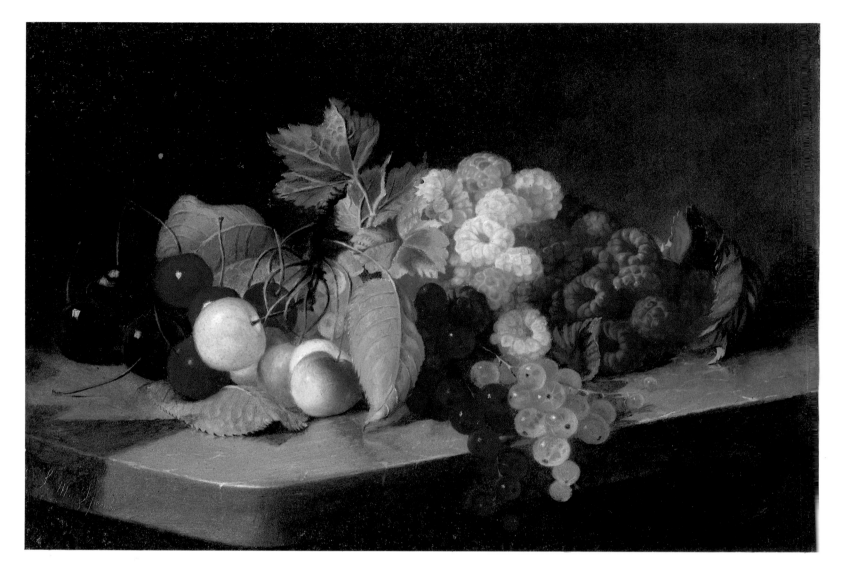

87

Lilly Martin Spencer (1822–1902)
Still Life with Berries and Currants c. 1859–1860, signed
Oil on panel, 8 × 12 in.
Courtesy of Ira Spanierman Gallery, New York

Still lifes appear intermittently among the exhibition and sales records for Lilly Martin Spencer, starting with two still lifes of fruit that were included in the eight paintings she exhibited at the Western Art Union in Cincinnati as early as 1847. A painting entitled *Currants* was one of three "fruit pieces" exhibited at William Schaus's gallery in 1859, and in this same year and in the next Spencer painted at least three more still lifes that she entitled *Raspberries.*[1]

In this magnificent array of contrasting fruits, color and lusciousness reign. Dark cherries and red cherries, red currants and yellow currants, and the delicacy called "white" raspberries, along with the usual red ones, are all grouped at the corner of a table that juts forward, bringing these attractive fruits close to the viewer. The shiny gray table reflects a red and yellow cherry at the left center and a raspberry at the right. There is little definition of space behind, but the color is differentiated: beige in the background and a more opaque brown under the table. A dark leafy stem contrasts with a lighter stem, rising to an apex on this small panel.

When the retrospective exhibition of Spencer was organized in 1973, evidence of the artist's ability to paint fruits was abundantly clear in the genre paintings: the well-stocked kitchens of *Shake Hands?* and *Peeling Onions*, and especially the many baskets, bowls, and pans full of fruits in *Kiss Me and You'll Kiss the 'Lasses*, as well as the overladen table in *Fruit of Temptation*. But no still lifes could be found for that exhibition. We are pleased to be able to show two still lifes in the present exhibition; another, *Still Life with Watermelons, Pears, and Grapes*, is in the Holladay Collection of The National Museum of Women in the Arts.

[For Spencer's biography, see cat. no. 36; see also cat. nos. 37 and 88.]

[1] Robin Bolton-Smith and William H. Truettner. *Lilly Martin Spencer: The Joys of Sentiment* (Washington, D.C., 1973), 183 and 198.

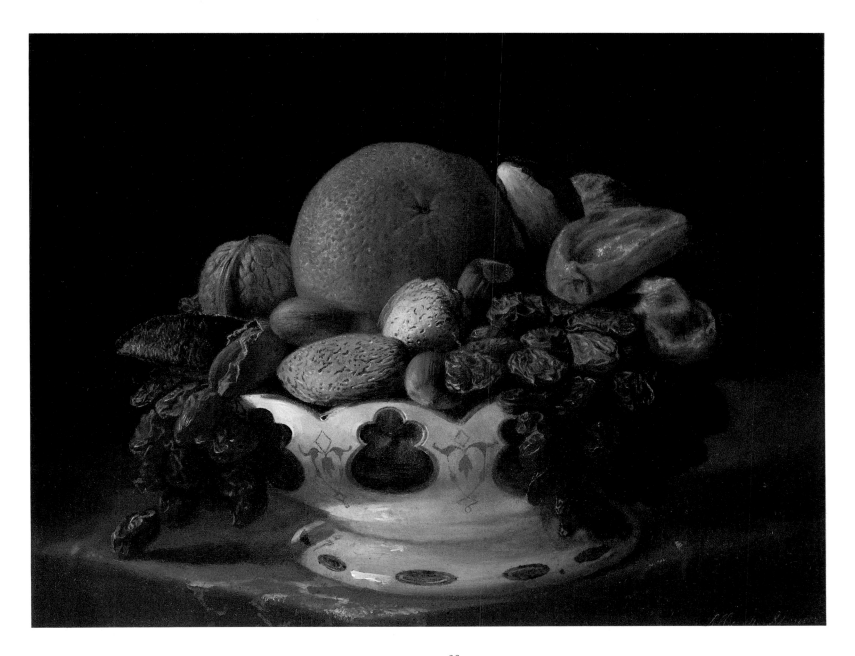

88
Lilly Martin Spencer (1822–1902)
Fruit with Walnuts early 1860s
Oil on panel, $9\frac{9}{16} \times 12\frac{7}{8}$ in.
Private collection

An orange dominates the variety of foods (several kinds of nuts, raisins, and some dried fruit) filling a porcelain bowl to overflowing in this painting. Again these objects of delectation have been tantalizingly placed forward on the projecting corner of the table—in a position to establish a feeling of immediacy for the viewer.

Spencer exhibited a painting entitled *Dried Fruit* (c. 1867) at the Leeds Art Galleries in New York on 27 March 1867, and this small panel painting may possibly be that missing work. Several "Fruit Still Lifes" were exhibited and sold by both Leeds and the New York dealer E.A. Doll in 1859 and in the early 1860s. A date of the early 1860s might be proposed for this painting.

89

Helen Searle (Pattison) (1830–1884)
Still Life with Fruit and Champagne signed and dated Düsseldorf 1869
Oil on canvas, $11\frac{1}{8} \times 13\frac{3}{8}$ in.
National Museum of American Art, Smithsonian Institution

The daughter of an architect, Helen Searle was born in Burlington, Vermont, in 1830 and grew up in Rochester, New York, where her father's work had taken the family. In her youth she taught art at a school in Batavia, New York. Then in the 1860s she traveled to Europe and persuaded the Düsseldorf still-life painter Johann Wilhelm Preyer to take her on as a pupil. Preyer, a dwarf, who had taught only his daughter Emilie and normally did not accept students, made an exception for Searle.

In 1876 Searle married the painter James William Pattison, and they lived for several years at Ecouen, near Paris, in a small artists' colony that also attracted the American sculptor Anne Whitney (cat. nos. 109–113) in the summer of 1875. The Pattisons returned to the United States in 1882 and in 1884 settled in Jacksonville, Michigan, where he became director of the School of Fine Arts and where she died in November of that year.

Today her *Still Life: Plums, Peach, and Grapes* of 1868 is in the Ganz Collection in Los Angeles and her *Still Life of Pomegranates* (with a date that might be read '70) is in the Probasco Collection in Chattanooga, Tennessee. Works that she exhibited at the National Academy of Design are *Partridges*; *Study of Violets*; *Bartlett Pears*; *Fruit*; and *A Roemer of Rhine Wine with Fruit*. In 1872 when she exhibited the latter, she gave her address as Washington, D.C. The title describes a painting closely resembling the still life borrowed for this exhibition.

This *Still Life* is a sophisticated composition in the European tradition, with a bee on the edge of the marble table top, a drop of juice on the purple plum at the right, a transparent glass that captures a window reflection, and two kinds of grapes. The decorative devices of the seventeenth-century Flemish and Dutch still-life painters have been filtered through her teacher Johann Wilhelm Preyer. Also evident in this painting is the implication of outside forces—beyond the straightforward presentation of realistic fruit—in the broken nut shell, the dehiscent green plum, and the torn leaf in the right foreground.

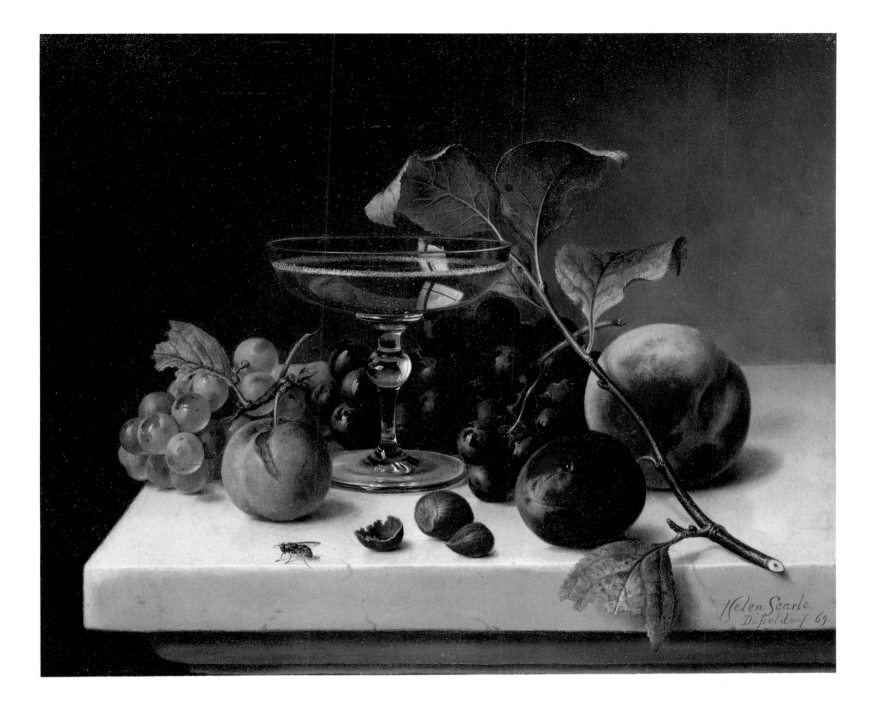

90
Ellen Robbins (1828–1905)
Peonies signed and dated 1887
Watercolor, 24 × 36¼ in.
The Watertown Free Public Library

Ellen Robbins has fortunately left an autobiography that recounts the story of her thwarted early desire for art instruction in her hometown of Watertown, Massachusetts, her first venture in teaching herself to paint wildflowers, and her year of study at the School of Design in Boston.[1] She next spent a year at Merrimac Printworks being taught "sketch making," but still no instruction in watercolor was available to her. Finally, she seized the initiative herself and painted her first watercolor of violets at the Forest Hills Cemetery. She then conceived the idea of painting in albums and sold a volume of twenty watercolors for $25.00. Before long she had created a vogue for her albums of autumn leaves. Theodore Parker, the famous Unitarian minister, ordered one that he sent abroad to a naturalist, and when the sculptor Harriet Hosmer (cat. nos. 100–103) returned home to Watertown from Rome for a visit, she commissioned a book for $50. Robbins recalls seeing her childhood friend Hosmer again: "It was early in the autumn, and each afternoon she drove up in her chaise to take me to the woods. Poison ivy was freely handled by me, and the dogwood's brilliant leaves made a striking page. Those days were delightful. As I painted, she read aloud to us Carlyle's 'Frederic the Great;' and when the book of leaves was finished and elegantly bound, she expressed the greatest satisfaction at my work."[2]

Robbins realized as a self-taught watercolorist that there was a niche she could fill. Her first teaching resulted in a class of seven students, and she soon moved from an amateur status to professional, supporting herself comfortably between her proliferating classes and the sale of her paintings at Doll and Richards Gallery. At the outset she traveled by trolley car from Watertown (where she lived on Pleasant Street, facing the Charles River) to Boston, but in the later years she moved into Boston. A perusal of the Boston papers from that time reveals regular advertisements for Miss Robbins's "Flower and Autumn Leaf Painting" classes as well as many enthusiastic reviews of her exhibitions of watercolors.

As early as 1850 Robbins began spending summers on the Isles of Shoals off the New Hampshire coast. The poet Celia Thaxter maintained both a literary salon and a special garden there,[4] which provided endless subject matter for visiting artists. Robbins, handicapped by a lame leg since birth, was not prevented from traveling, and in 1873 she and her sister Martha sailed for Europe to see both art and flowers.

Robbins's paintings of flowers are awesome for both their beauty and for their size: her *Peonies* of 1887, for example, is especially large for a watercolor, measuring 24 × 36¼". In addition to these monumental still lifes, many of which are in private collections today, Robbins painted black panels of flowers. She writes, "I earned a good deal of money painting them. The furore for ebonized panels in oils came some years after the autumn leaves in water colors. . . ."[3] She also painted a long frieze of flowers for the Browning Room at Wellesley College, but it was destroyed in a fire and is known today only in a few photographs. Robbins appears to have continued painting until close to her death at seventy-seven.

[1] Ellen Robbins, "Reminiscences of a Flower Painter," *New England Magazine* 14, no. 4 (June 1896), pp. 440–51, and no. 5 (July 1986), pp. 532–45.
[2] Ibid., 447.
[3] Ibid., 532.
[4] If I may be allowed a personal note, in the twentieth century when there was a great interest in reconstituting Thaxter's garden, my mother supervised the planting of the various species on Star Island.

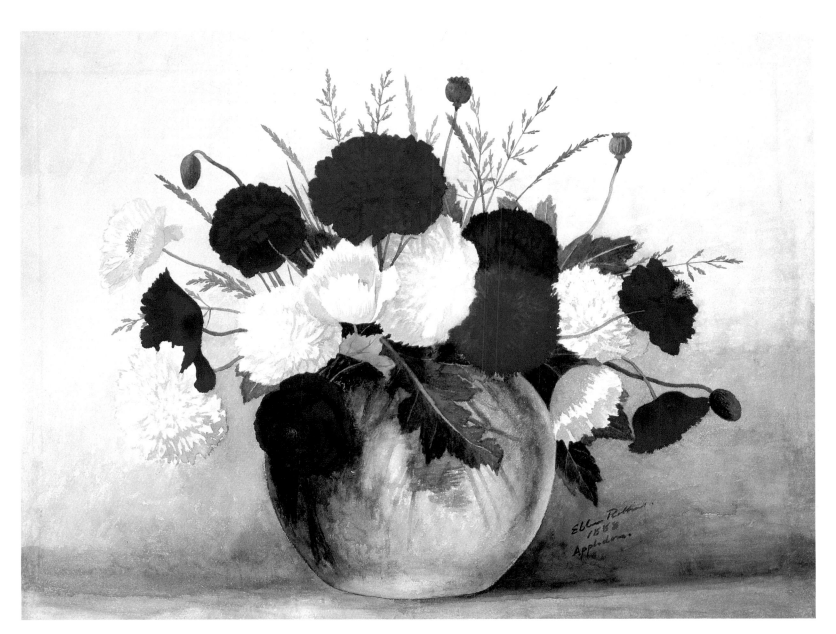

One impressive aspect of Ellen Robbins's flower compositions is that they are large for watercolor paintings. In the still life on the facing page, devoted solely to peonies of the white variety indigenous to New England, a fan-like arrangement of flowers appears above a great bowl. A few of the blossoms are open to the viewer, exhibiting their characteristic center of golden yellow stamens and providing a contrast to the peonies' abundant slender green stems. The bowl offers another contrast with its blue and white design of houses and foliage. Robbins, as always, has elevated her isolated segment of nature to a level of grandeur.

91

Ellen Robbins (1828-1905)
Carnations and Poppies signed and dated 1888 Appledore
Watercolor and gouache over graphite, 19 × 26 in.
Worcester Art Museum, Gift of Mrs. Gertrude Thaxter

One of the bonds between Ellen Robbins and the poet Celia Thaxter was a love of flowers. Although the painter grew up in a Boston suburb and the poet on the smallest island of the Isles of Shoals off Portsmouth, New Hampshire, they met when Celia Laighton married Robbins's cousin, Levi Thaxter of Watertown. The magnetic Celia Thaxter created an hospitable climate for writers at her home on Appledore (the largest of the islands and the one on which the hotel stood), and among her guests were James Russell Lowell, John Greenleaf Whittier, Nathaniel Hawthorne, Sarah Orne Jewett, James and Annie Fields. Artists also came—Childe Hassam painted the memorable picture of Thaxter standing amidst her tall flowers, the painter William Morris Hunt died mysteriously there, Robbins was a frequent summer visitor.

The islands are particularly conducive to the growing of flowers, and Celia Thaxter took great delight in planning her garden, as well as watching each month to see which species would bloom. Her guests always remarked on the cut flowers arranged within Mrs. Thaxter's cottage. Needless to say, this was a paradise for Robbins. In this rich composition she has painted red and white carnations interspersed with poppies. The green stems of the flowers can be seen in the translucency of the spherical green vase. In recent exhibitions two of Robbins's paintings of flowers on the edge of the woods have been shown, and again one is struck by the explosion of color on the paper and the impact of seeing these large blossoms filling the entire surface.

Anna Lownes (active 1884–1905)
Study of Apples before 1890, signed
Oil on canvas, 25 × 30 in.
Collection of Sandra and Bram Dijkstra

Little is known about this Pennsylvania painter of still lifes. According to the *American Art Annual* of 1905–1906, Lownes studied at the Philadelphia School of Design for Women and at the Delecluse Academy in Paris. The annual exhibition catalogues for the Pennsylvania Academy of the Fine Arts state that she had been a pupil of Milne Ramsey; this is further substantiated by the handwritten label attached to the stretcher of her *Study of Apples* from 1890, which bears the inscription: "Return to Haseltines' Galleries,[1] A. Lownes c/o Milne Ramsey 1523 Chestnut Street." Ramsey (1847–1915) had studied in the late 1870s in Paris and was a Philadelphia painter primarily of still lifes (although he had also painted genre subjects while in France). Among the titles of Lownes's works exhibited at the Pennsylvania Academy starting in 1884 and ending in 1890 are *Still Life*, *Yellow Roses*, *A Study : 'Perchance a thing o'er which the raven flaps its funeral wing'*, *An Interior*, *Carnations*, *A Cup of Tea*, and *Study of Wild Azalea*. For the years from 1885 to 1887, the Pennsylvania Academy catalogues and the National Academy of Design give Lownes's address as Media, Delaware County, Pennsylvania, but in the successive years they list 1708 Chestnut Street, Philadelphia.

Her painting *The Raven* was exhibited in the Palace of the Fine Arts at the World's Columbian Exposition of 1893 in Chicago,[2] and a still life hung in the Board Room of the Woman's Building.[3]

Study of Apples was one of two paintings by Lownes accepted for the Sixtieth Annual Exhibition at the Pennsylvania Academy in 1890. The study consists of only three components: apples, an overturned brass kettle, and a small gray-glazed pitcher decorated with a blue-leaf motif. The tactilely depicted objects are arranged on a plane parallel to the picture surface and are strewn across a white tablecloth on which the artist has signed her name at the lower right. The roundness of the forms is sharply articulated through the use of chiaroscuro: light is caught on the lip of the pitcher and on the round edge of the kettle, and all of the elements are illuminated against a dark background; a shadow is cast on the tablecloth by the handle of the kettle. A tour de force of a painting is achieved here with rather simple subject matter.

[1] One famous event at the Haseltine Galleries on Chestnut Street was the showing of Thomas Eakins's *The Gross Clinic* in 1876.
[2] *Catalogue of the Exhibits of the State of Pennsylvania and of Pennsylvanians at The World's Columbian Exposition* (State Printer of Pennsylvania, 1893), 118.
[3] Ibid., 159.

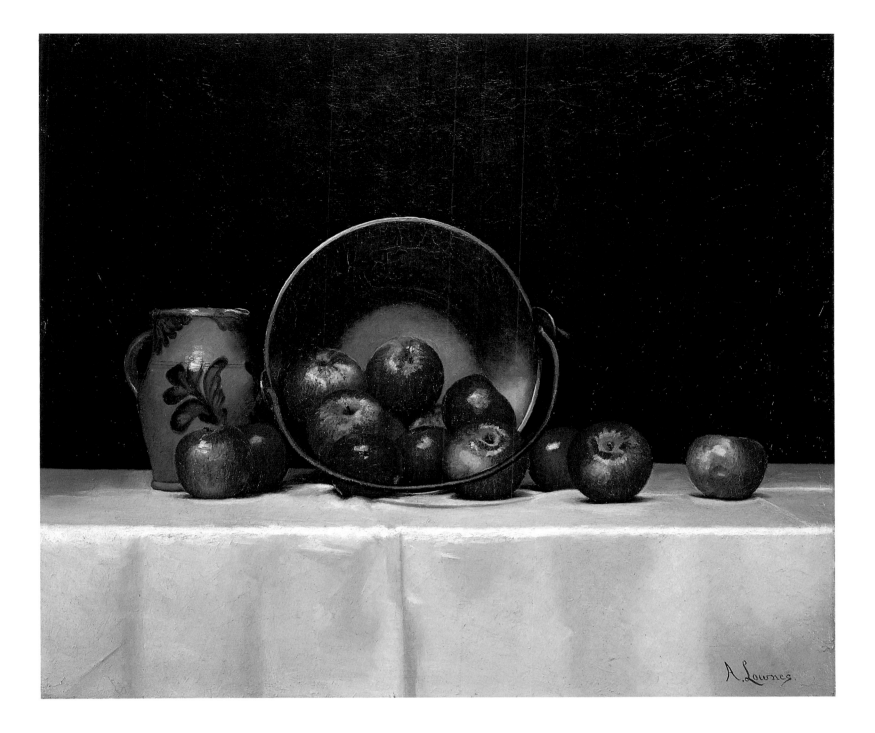

93
Henrietta Augusta Granbery
Peonies in an Oriental Vase 1891
Oil on canvas, $39\frac{1}{2} \times 26\frac{1}{2}$ in.
Marge and Leslie Greenbaum

Henrietta Granbery and her younger sister Virginia, who were born in
Norfolk, studied painting in New York City while teaching in Brooklyn:
Henrietta at West's Seminary and Virginia at Packer Institute. Virginia, a
still-life painter who lived ninety years, had the distinction of having more
of her fruit paintings reproduced by Louis A. Prang lithographers than
any other artist. Henrietta lived even longer, and her subject matter
consisted of landscapes as well as still lifes. She exhibited annually at the
National Academy of Design in New York from 1861 through 1890, and
among the works she showed there were *Autumn Leaves, Near Elizabeth,
New Jersey, Near the Mill, The Catskills, Geraniums, View in Central Park,
Bird-nest and Arbutus,* and *On the Delaware River.* The record of the
exhibition catalogues at the Pennsylvania Academy of the Fine Arts lists
some of the subjects she exhibited there: *Garden Flowers, Cherries, Azaleas,
Gladiolus, Sweet Peas, Moss Roses, Roses in the Finger Bowl, Fruit,* and *Pears.*

This decorative painting is in contrast to the earlier, starker still lifes of
the Peales. The flowers, with their subtle colors, fill the picture surface —
from the few blossoms scattered on the tablecloth in the lower left
through the vertical build-up at the center. The ornate vase has such an
intricate design, including the figure of an oriental man, that it makes
one curious to see what further motifs are on the other side.

Claude Raguet Hirst (1855-1942)
Still Life with Books 1890
Watercolor on paper, 10 × 14 in.
Chris Petteys

Named for her grandmother, who in turn had been named for an aunt in France,[1] Claudine Raguet Hirst submitted her paintings to art juries under the name Claude R. Hirst in order to conceal her sex. This artist, who grew up in Cincinnati's posh northern suburb of Clifton, studied from 1874 to 1878 at the Cincinnati School of Design before moving to New York, where she took lessons from Agnes D. Abbott, George Smillie, and Charles Curran. The first dated record of her appearance in a New York exhibition is in the year 1882, when two of her flower paintings were accepted for the National Academy of Design's annual show. Her entries in the next four consecutive years continued to be still lifes of flowers. But in 1890 a change occurred: the three titles were *A Bachelor's Solace*, *Crumbs of Comfort*, and *Ye Ancient Tale*. These titles describe Hirst's new subject matter of pipes and books. A *New York Times* article entitled "A Pipe That Brought Fame" (4 June 1922) begins:

> *A fine old meerschaum and a disorderly man were responsible for the fame of Claude Raguet Hirst, the painter, who, fellow-artists say, is unexcelled in the work in which she has found her métier. This métier is painting old books and old pipes. And its discovery was made quite by accident.*
>
> *Many years ago Miss Hirst loaned her studio to a fellow-painter who was waiting for his to be completed. Says Miss Hirst, "He was like me, he was not very orderly. His tobacco things were always around: and one day I noticed what an attractive group they made. He had a meerschaum pipe that was a glorious color. It was like old ivory. I had always liked old books and old engravings, so I put the pipe with some of my old books and painted them. It came out very well, and I sent it to the Academy, which was then in an old building on Twenty-third Street. It sold immediately. H.O. Havemeyer bought it."*
>
> *Since the sale of that first little picture Miss Hirst has painted nothing but old books, and always on an 8 by 10 canvas. As an artist says, "Her pictures are of an intimate kind that people like to get near." In fact, at exhibitions they are apt to be hanging crooked, as it is said, people take them down so many times to hold them and look at them. Two years after the sale of her first painting of the meerschaum pipe she married the owner of the pipe, W. C. Fitler, the landscape artist.[2]*

The marriage of Hirst and William C. Fitler (1857-1911) took place on 18 June 1901 in New York.[3]

Another event that may have affected Hirst's painting was the return to New York from Europe of William M. Harnett, who in 1886 took a studio on East 14th Street next to Hirst's studio; certainly one notes a similar *trompe l'oeil* quality to the realistic, sharply delineated still-life objects painted by these two artists. The major difference is that Hirst almost invariably, and always astonishingly, achieved her effect through the medium of watercolor.

Hirst was a long-standing member of the National Association of Women Artists, which was formed in 1889 and continues to function today. She often exhibited in the association's annual juried shows. In 1922 and 1927 her work won honorable mention, and in 1931 her oil *The Title Page* received the painting prize. Her 1936 entry was entitled *Ode to Superstition*.

Hirst, after living thirty years at 65 West 11th Street in New York City, died in 1942, surviving her husband by eleven years, and they are buried side by side in Woodlawn Cemetery in Queens.

According to the 1922 article in *The New York Times* mentioned above, one of the artist's favorite books, which she used in many of her paintings, was a small volume of *Paul and Virginia* in an English translation published in London on 24 May 1796. On the left page of the book opened in the foreground of this painting, the artist has distinctly copied the words "Publish'd by Vernor & Hood, May 24, 1796," and at the top of the right page we see the letters "PAUL AND VIR" (a tobacco pouch covers the rest of the name). In this romantic French novel, written by Bernardin de St. Pierre (1788), Paul and Virginia, the latter a daughter of a widow, Mme de la Tour, grow up as childhood playmates who fall hopelessly in love with each other. After a separation, Virginia tries to return by ship to Paul, but a hurricane breaks up the ship, and the dead body of the heroine is dashed upon the shore. Mme de la Tour's name is legibly painted on the right-hand page and a ship is visible in the illustration on the left. One of Hirst's paintings in the 1891 exhibition at the National Academy of Design was listed as *Paul and Virginia* (1890), for $200.00. Again in 1897 she exhibited a painting of the same subject.

Hirst's own words as quoted in the 1922 interview explain her method of working: "I always paint small things that I can paint the actual size; my books are small books, and I never use a magnifying glass to work with. I can't do it. I get things too large. I only use a glass to see if the little faces in the engravings I have painted are right. Some women like to sew to calm their nerves, but I paint books."

[1] I am indebted to Marge Greenbaum's genealogical research for the clarification of this name. As early as 1872, when the painter was seventeen, she exhibited at the Cincinnati Industrial Exhibition a marine painting (today in the collection of Dr. and Mrs. Leslie Greenbaum) that is signed "Claude R. Hirst."
[2] Chris Petteys's research located this article.
[3] Marge Greenbaum kindly provided this date, which she learned from finding the marriage certificate.

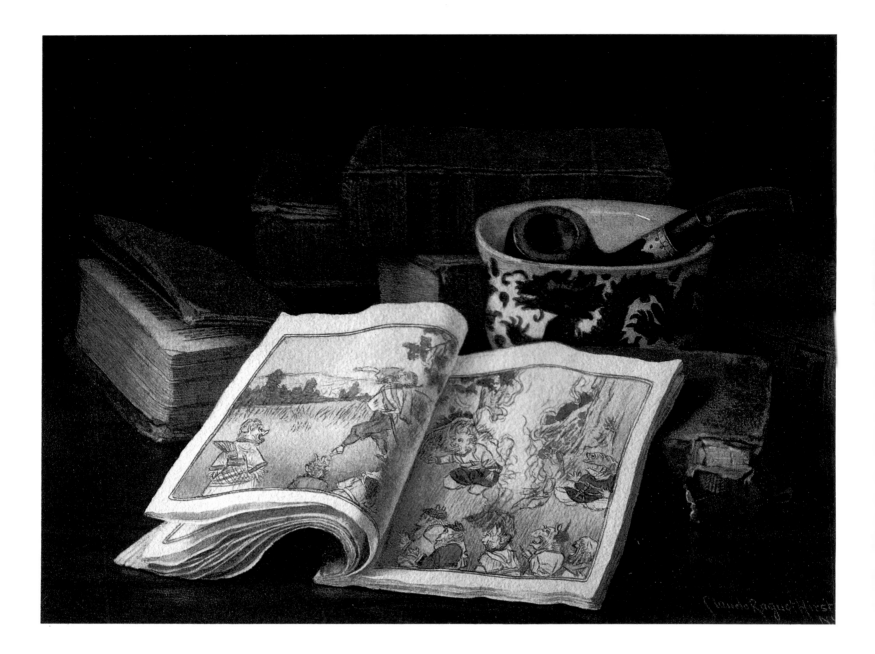

95
Claude Raguet Hirst (1855-1942)
Still Life with Japanese Children's Book c. 1890s(?)
Watercolor on paper, $10\frac{1}{8} \times 13\frac{1}{4}$ in.
Chris Petteys

In this painting Hirst has again combined old books, a pipe, and a bowl
with a decorative pattern. The objects are contiguously placed, leading
the viewer's eye back and around through the whole composition. The
emphasis here is on the charming, animated illustration of the open book.

Chris Petteys has learned from Shojo Honda of the Library of
Congress that the title of the book is *The Old Man and the Devils*
(Japanese fairy tale series, no. 7), and it is a translation by James Curtis
Hepburn from an old Japanese fairy tale, *Kobutori*, published by
Takejiro Hasegawa in 1886 in Tokyo. In the copy owned by the
Library of Congress one sees the lettering "but for fear you might not
come you must give us a pledge that you will," which Hirst did not
include in her pictorial rendition.

Hirst has again signed her still life in the lower right: Claude Raguet
Hirst, N.Y.

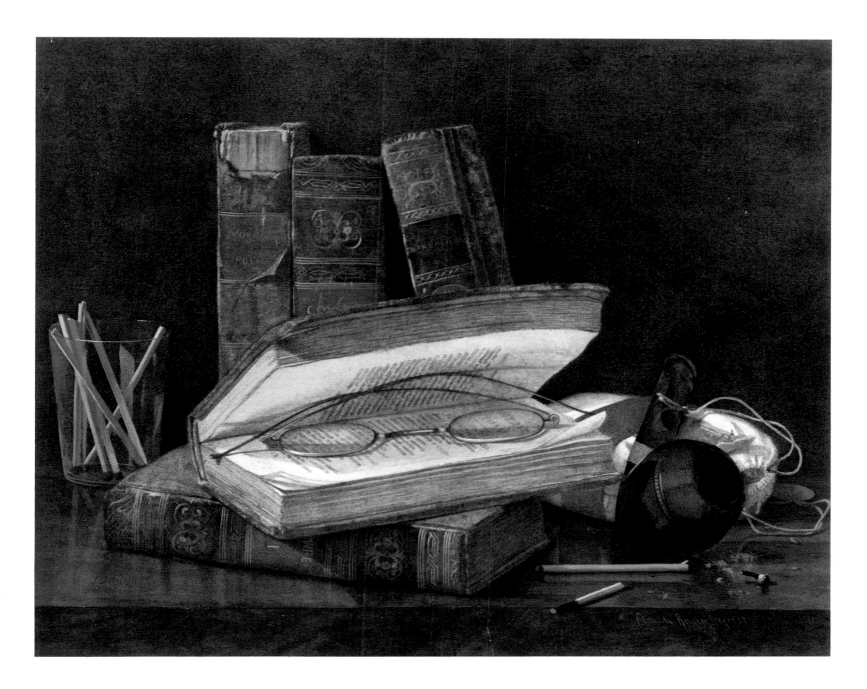

96
Claude Raguet Hirst (1855–1942)
Still Life with Books and Spectacles c. 1890s(?)
Watercolor on paper, $8\frac{9}{16} \times 11\frac{9}{16}$ in.
Marge and Leslie Greenbaum

In yet another of Hirst's arrangements of books and a pipe, letters in the book can be seen through the eyeglasses, which also serve the purpose of helpfully propping open the old text. Matches standing in a transparent container at the left are in contrast to a used match at the right, which extends forward over the front edge of the table, close to the artist's signature. A full tobacco pouch is shown behind, with two books standing together (one suffering some damage to its binding) and a third leaning against them. The stark white and the warm red colors highlight the objects, making them stand out against the opaque background.

97

Kathleen McEnery (Cunningham) (1888–1971)
Breakfast Still Life c. 1914
Oil on canvas, 30 × 24 in.
Joan Cunningham Williams

In letters that Kathleen McEnery wrote from Europe, where she had her
first exposure in 1906 to painting outdoors, she waxed enthusiastic about
the pleasure of sunlight: for example, from Segovia, "The square looked
fine—lots of blue sky with beautiful white clouds. I surprised myself by
going right along and painting sheep, hills, etc., things I never thought
of doing before. I really painted a mighty good little sunlightly thing."[1]
After McEnery married Francis E. Cunningham in 1914 and moved to
Rochester, New York, she painted many still lifes that are now in private
collections. In this one, the breakfast table is suffused with sunlight. The
eggs, the yellow-bordered plates, the orange, and the silver pitchers all are
modeled three-dimensionally through the use of light and shadow. The
viewpoint is from above, looking down on all the rounded forms. Then
filling the background are the graceful arcs of the irises and of the chair.

[For McEnery's biography, see cat. no. 55.]

[1] Letter preserved by Mrs. Joan Cunningham Williams.

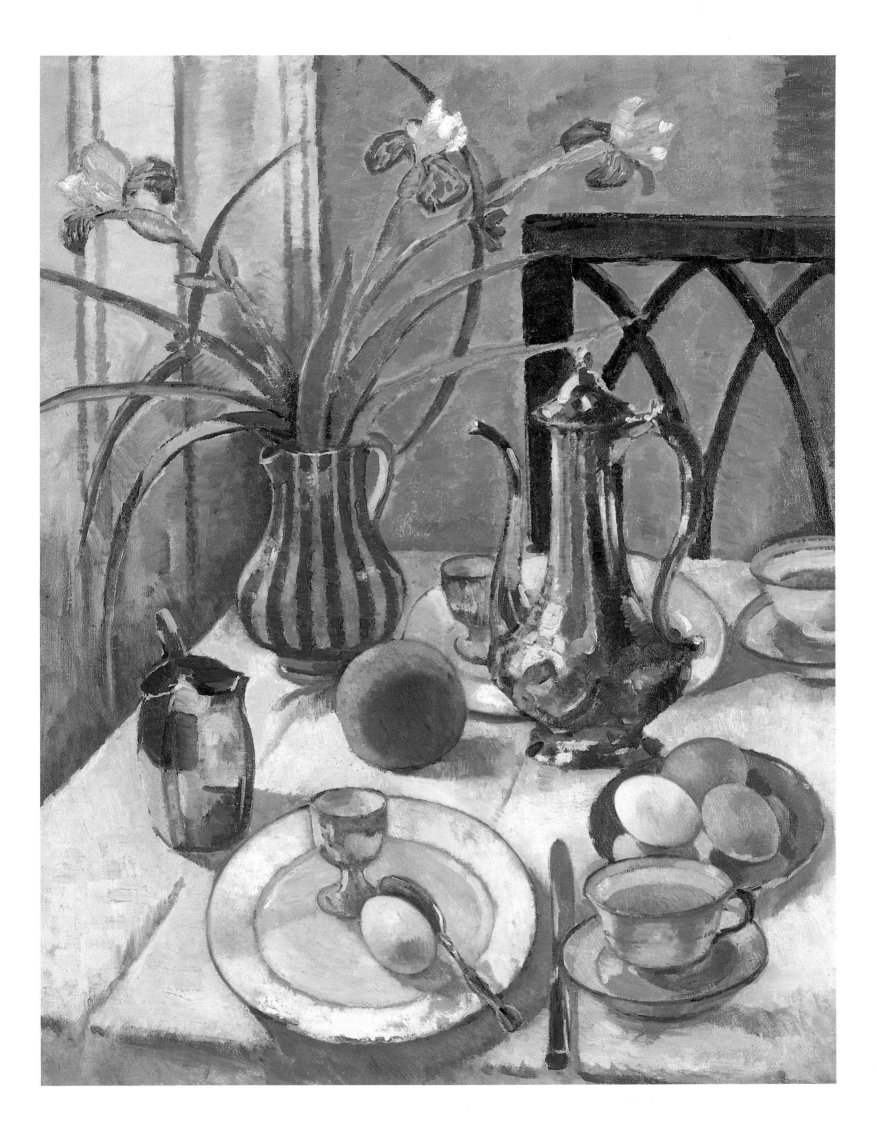

98

Louise Herreshoff (1876-1967)
Poppies c. 1920
Oil on canvas, 20 × 16 in.
The Reeves Collection, Washington and Lee University

The paintings of the turn-of-the-century artist Louise Herreshoff were
brought to the attention of the public in 1976 when Washington and Lee
University and the Corcoran Gallery of Art co-sponsored an exhibition of
the works found in the attic of the deceased artist's home.[1] Herreshoff was
born on 29 November 1876 in Brooklyn, New York, the only child of a
prominent Rhode Island family. Her mother died when she was only four,
so Louise was raised by her aunts in Providence. She attended the Lincoln
School there and took art classes at the studio of Mary C. Wheeler, starting
at the age of six and continuing until she graduated from the Lincoln
School in 1890. Wheeler was a progressive educator, and her students
painted from live models as well as conventionally drawing from casts.
Wheeler was also a painter who had spent many years in Europe, and was
becoming famous for taking her students there. For the next five summers
Herreshoff joined these classes, which were devoted both to visiting
musuems and to learning French. In 1895 at Fontenay-aux-Roses south of
Paris she met Raphael Collin, a leader in plein-air painting, and she
returned the next two summers to study with him. During these early years
she excelled in portraiture.

In 1898 Herreshoff moved to France to study with Collin and took the
opportunity to visit Holland, Italy, Switzerland, and the British Isles,
sketching and painting as she traveled. Upon her return to Paris in 1899
she enrolled in the Académie Julian, where she was a pupil of Jean-Paul
Laurens, the history painter with whom Ella Pell (cat. no. 45) had studied
earlier; his use of vivid colors had a strong impact on Herreshoff's later art.
In 1900 Herreshoff's *Le Repos* (1899), a three-quarter-length impressionist
portrait of a woman, typical of her early work, was accepted into the Paris
Salon exhibition. Her painting of *An Interior,* showing a woman seated in
front of a window, was exhibited at the National Academy of Design in
New York in the same year.

In 1903 Herreshoff returned to the United States as a mature artist,
bringing with her a love of color that was evident in the paintings she
exhibited that year at the Rhode Island School of Design. From 1903 to
1910 Herreshoff lived and painted in Providence and New York, making
annual summer trips along the coast of New England. It was during this
period that she began concentrating on still lifes, landscapes, and seascapes,
using brilliant pigments and heavily applied paint. She married Charles
Eaton in 1910 and lived briefly in Schenectady, New York, where he was
employed at General Electric Company, but they separated after three
months, and she returned to Providence to live with her Aunt Lizzie, who
had been her surrogate mother (Elizabeth Dyer, her mother's sister).

Between 1921 and 1925 Herreshoff exhibited at a variety of places: the
Pennsylvania Academy of the Fine Arts, the Philadelphia Watercolor
Club, the North Shore Art Association (Gloucester), and the Providence
Art Club. Then in 1927 with the death of her beloved aunt, Herreshoff
stopped painting and exhibiting altogether and stored her three decades
worth of work in the attic and basement of her home in Providence. She
spent the last forty years of her life collecting fine porcelain and other art
objects. In 1941, at sixty-six, she married the thirty-eight-year-old Euchlin
D. Reeves, a graduate of the School of Law at Washington and Lee
University, and they had twenty-six years together before he died in
January 1967. She died in Providence four months later in her ninety-first
year, bequeathing her collection to Washington and Lee University.

Louise Herreshoff has captured in this painting the full brilliance of not
only the familiar red poppy but also the yellow and orange. She probably
painted these summer flowers outdoors. The entire canvas is covered in a
thick and heavily applied paint, which gives the poppies and the
surrounding foliage an added weight. Quick, circular brush strokes have
been used for the flowers, while short, broad brush strokes have rendered
the leaves and stalks. The bright colors and powerful forms are reminis-
cent of the vigorously defined dishes and flowers in Mary Wheeler's late
paintings, for example, the *Still Life* illustrated in her biography.[2]
Herreshoff's *Poppies* has a Fauve-like appearance in the explosion of
color: vivid crimson plus shades of green ranging from deep forest green
to viridian. Herreshoff shows a strength in this fresh and vibrant work
that is characteristic of her paintings in the final decade of her artistic
activity.

[1] *Louise Herreshoff: An American Artist Discovered* (Washington and Lee University,
Lexington, Va., 1976).
[2] Blanche E. Wheeler Williams, *Mary C. Wheeler: Leader in Art and Education* (Boston,
1934), 238.

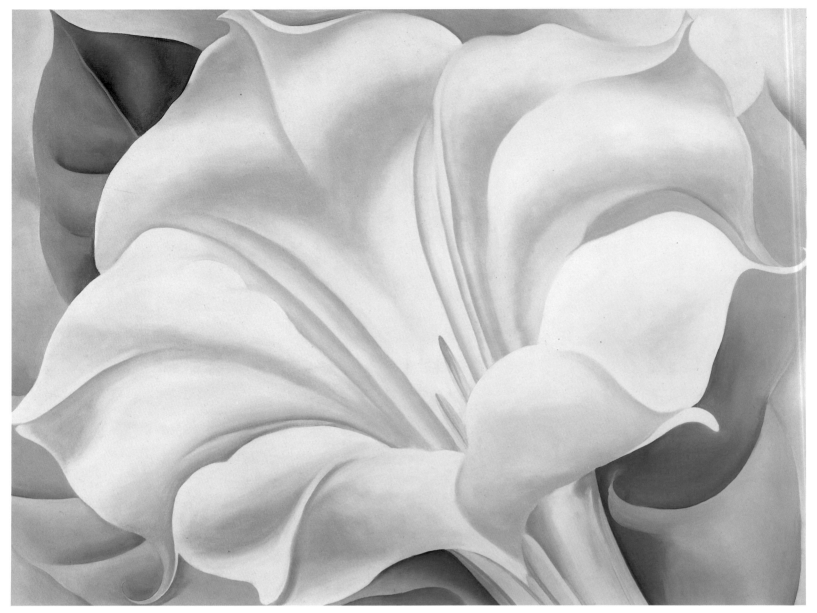

99
Georgia O'Keeffe (1887–1986)
White Trumpet Flower 1932
Oil on canvas, 30 × 40 in.
San Diego Museum of Art, Gift of Mrs. Inez Grant in memory of
Earle W. Grant

A horticulturist has identified this blossom as the flower of the datura, a
popular plant in America until the 1950s.[1] It was frequently chosen for
summer gardens because of its trumpet-shaped flowers and its large size
(the plant grows to about 3 feet by 3 feet). The datura, which has green
leaves and a yellow corolla tube, is described as having a "huge, fragrant,
snowy, trumpet-like flower."[2] It seems likely that Georgia O'Keeffe,
who stayed with her husband Alfred Stieglitz at Lake George (New York)
during the summer of 1932, making only one trip away to Montreal
and the Gaspé Peninsula in Canada, would have painted the datura
common to New York and the surrounding region, rather than the
trumpet vine known for its red flowers and indigenous to the Southeast.[3]

This work is characteristic of O'Keeffe's modernistic flower
paintings: an isolated blossom magnified and simplified on the canvas.
Her modernism may have been accelerated by the impact of
photography—both her husband's and their friend Paul Strand's. The
focus here is on the open white flower with a very simplified definition of
the anthers (only two); there is a generous splaying outward of the spiky
petals against the pale green leaves. The exuberant presentation of the
blossom is so capacious that the yellow-edged corolla and the green
leaves continue beyond the confines of the large canvas.

[For O'Keeffe's biography, see cat. no. 81; see also cat. nos. 82 and 83.]

[1] Kenneth C. Tufts of George J. Ball, Inc., confirmed by Barney Lipscomb, curator of
the Herbarium at Southern Methodist University.
[2] *Ball Seed Catalogue* (West Chicago, Ill., 1957), 27.
[3] *Datura meteloides*, a species described as "white tinged with rose or violet," is native to
"Texas to California and New Mexico" (Liberty Hyde Bailey and Ethel Zoe Bailey,
Hortus [New York, 1935], 202). Another aspect of the datura is its history as a
narcotic. A scholarly book from 1812 reports that the root was smoked in pipes and
that it was a cure for "paroxysms of asthma" (*Curtis's Botanical Magazine; or Flower-
Garden Displayed* . . . 35 [London, 1812], no. 1440).

Sculpture

100
Harriet Hosmer (1830–1908)
Clasped Hands of Elizabeth and Robert Browning 1853
Bronze, $3\frac{1}{4} \times 8\frac{1}{4} \times 4\frac{1}{2}$ in.
Armstrong Browning Library of Baylor University, Waco, Texas

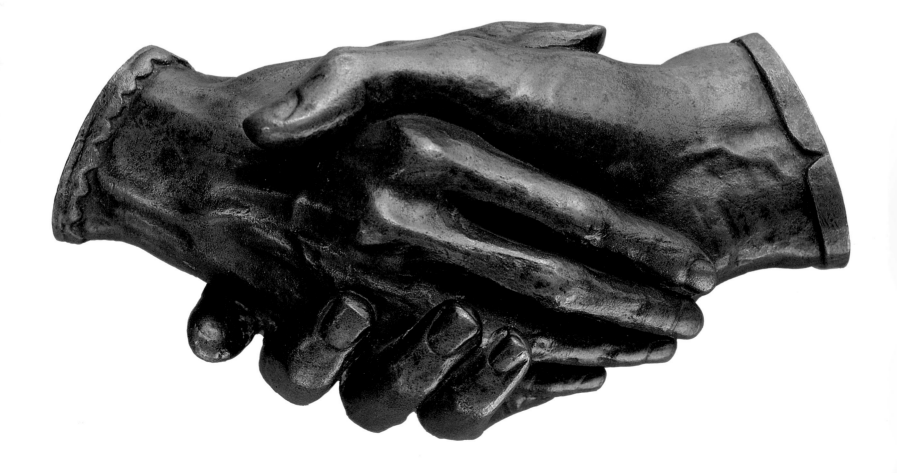

The first of the American nineteenth-century women sculptors to move to Rome, Harriet Hosmer had displayed such pioneering instincts earlier in her life as well. After completing Mrs. Sedgwick's school at Lenox in 1849, Hosmer returned home to Watertown, Massachusetts, and created a studio for herself on the family property, which abutted the Charles River. Dr. Hiram Hosmer, her father, encouraged her studies with the sculptor Peter Stephenson (contemporary biographers say that "Hatty" walked the fourteen miles to his Boston studio). When no medical school in the East would admit a woman, Harriet visited a classmate in St. Louis in 1850 and made arrangements to study anatomy at the Missouri Medical College. She thus became the first woman to study anatomy at what is now the Washington University School of Medicine.[1] Upon receiving her certificate of accomplishment from Dr. Joseph McDowell,[2] Hosmer embarked upon some regional sightseeing. First she took the steamboat down the Mississippi to New Orleans, and later in the spring of 1851 she took another boat north to Minnesota. During the trip some young male travelers proposed a race to climb a tall bluff along the river. The challenge appealed to the adventurous Hosmer, who entered the race and won. Her competitors named the four-hundred-foot bluff (near the present town of Lansing, Iowa) "Mount Hosmer" in her honor.[3]

In 1852 Hosmer arrived in Rome in the company of the internationally known American actress Charlotte Cushman and was able to persuade John Gibson, the English sculptor, to take her as his first and only pupil by showing him daguerreotypes of her idealized sculpture of *Hesper* (today in her hometown library). Her next two marble busts, *Daphne* and *Medusa*, were exhibited in Boston in 1853. Her life-size figure of *Oenone* (based on Tennyson's poem) followed in 1855, and two years later *Puck* was exhibited at the Boston Athenaeum. Commissions came from St. Louis for a sculpture of *Beatrice Cenci* and, in 1860, for her first public monument, a ten-foot bronze statue of *Senator Thomas Hart Benton*, which still stands today in Lafayette Park. During these years in Rome she modeled portrait busts, the statue of Zenobia, and sculptures of fauns. And Hosmer was the first American to be given a commission for a work in a Roman church: the tomb of Judith Falconnet in S. Andrea della Fratte (1857; one of the few tomb sculptures in Italy by a woman).[4]

Many fountains and chimney pieces were also requested of Hosmer during the 1860s and 1870s, especially by English tourists who then invited her to their country estates, where the witty, creative American amused them in the evenings with her improvisations and poetry, while by day she sketched their dogs, making studies for their more lasting preservation as sturdy sculptures. One of Hosmer's last commissions was a statue of *Queen Isabella* of Spain, commissioned by the city of San Francisco and unveiled in 1894. This popular artist died of pneumonia in Watertown at age seventy-seven and is buried in the family plot at Mount Auburn Cemetery in Cambridge.

The Brownings used to escape the cold winters of Florence by spending the season in Rome. Of her second winter in Rome, Hosmer wrote, "It was rendered memorable by my introduction to the Brownings, and as time went on and acquaintance ripened into friendship and intimacy, how often did I climb the cold, cheerless stairway which led to their modest apartment on the third floor of 42 Bocca di Leone. Nothing cold or cheerless, however, when their door was gained. There was ever the warm and affectionate welcome. . . ."[5] Elizabeth Barrett Browning, for her part, wrote to a friend in 1854 from Rome, "I should mention, too, Miss Hosmer . . . the young American sculptress, who is a great pet of mine and of Robert's, and who emancipates the eccentric life of a perfectly 'emancipated female' from all shadow of blame by the purity of hers. She lives here all alone (at twenty-two); dines and breakfasts at the *cafés* precisely as a young man would; works from six o'clock in the morning till night, as a great artist must, and this with an absence of pretension and simplicity of manners which accord rather with the childish dimples in her rosy cheeks than with her broad forehead and high aims."[6] The Brownings and other literati—for instance, William Thackeray and Henry James, who boarded at the Hotel Inghilterra on Bocca di Leone during their respective visits—along with Hosmer and the other American sculptors all lived in close proximity to each other in the neighborhood of the Spanish Steps.

Hosmer's simple representation of the two joined right hands of the Brownings, one hand clasped by the other, makes a permanent and indelible impression of the union of these two poets who had eloped to Italy seven years earlier. Only a difference in the two cuffs and a minuscule difference in the measurements of the hands distinguishes one from the other. The lacy cuff and slender fingers of the hand on the left belong to Mrs. Browning, whereas the more tailored cuff and slightly larger size of the hand on the right, which encompasses hers, indicate Mr. Browning. The wrists are also a little different in measurement: hers is $2\frac{1}{4}$ inches around and his $2\frac{5}{8}$.

The original plaster model by Hosmer is preserved today at the Schlesinger Library at Radcliffe College. Mrs. Browning consented to Hosmer's idea of sculpting their hands only on the condition that Hosmer do the casting herself. Hosmer explained in a speech that she intended to give in Chicago in 1910, "these hands are exactly as they came from the mould as I have wished to preserve at the expense of finish all their characteristics of texture."[7]

[1] Dorothy Brockhoff, "Harriet Hosmer: Nineteenth-Century Free Spirit," *Washington University Magazine* (Fall 1976), 15.

[2] Robert J. Terry, "Recalling a Famous Pupil of McDowell's Medical College: Harriet Hosmer, Sculptor," *Washington University Medical Alumni Quarterly* (January 1944), 62.

[3] Cornelia Carr, ed., *Harriet Hosmer, Letters and Memories* (London, 1913), 11; and Dolly Sherwood, "Harriet Hosmer's Sojourn in St. Louis," *Gateway Heritage* 5, no. 3 (Winter 1984-1985), p. 48.

[4] Barbara S. Groseclose, "Harriet Hosmer's Tomb to Judith Falconnet: Death and the Maiden," *The American Art Journal* 12, no. 2 (Spring 1980), p. 78.

[5] Carr, *Harriet Hosmer Letters*, 48.

[6] Frederic G. Kenyon, ed., *The Letters of Elizabeth Barrett Browning*, vol. 2 (London, 1897), 166.

[7] Hosmer's notes for the projected speech are preserved in the Schlesinger Library, Radcliffe College.

101
Harriet Hosmer (1830–1908)
Puck 1856
Marble, 30 × 15 × 20 in.
Wadsworth Atheneum, Hartford, Connecticut,
Gift of A.C. and S.G. Dunham

In letters of 1856 Hosmer wrote about having photographs taken of her son and daughter, meaning *Puck* and *Oenone*, and about the visit of the young prince of Wales to her studio, when the prince was so taken with her *Puck* that he bought it instantly, using his own pocket money.[1] The crown princess of Germany also saw the sculpture in Hosmer's studio, exclaiming, "Oh, Miss Hosmer, you have such talent for toes!"[2] With this winsome sculpture Hosmer created a veritable salary for herself. Orders for replicas flooded in—from Charlotte Cushman, a Mr. Clift of New York, Lord Lyons for his rooms at Oxford, from Chicago, Australia, the West Indies (today in the Barbados Senate Chamber). Eventually about fifty were sold at $1,000 each.

Puck is depicted here sitting on a large toadstool under which grow acanthus leaves and a number of mushrooms. In his upraised right hand he holds a big beetle, while with his left he presses down on a lizard whose tail coils up over his forearm. A scallop shell is clamped on Puck's head, forcing curls to tumble down over his forehead. His wings curiously resemble a bat's. Roman copies of Hellenistic sculpture, such as the *Child Hercules with Snake*, *Boy with a Goose*, and *Boy with Mask* in the Capitoline Museum, may have inspired Hosmer to create her impish nude boy.

[1] Carr, *Harriet Hosmer Letters*, 76 and 344.
[2] Ibid., 79.

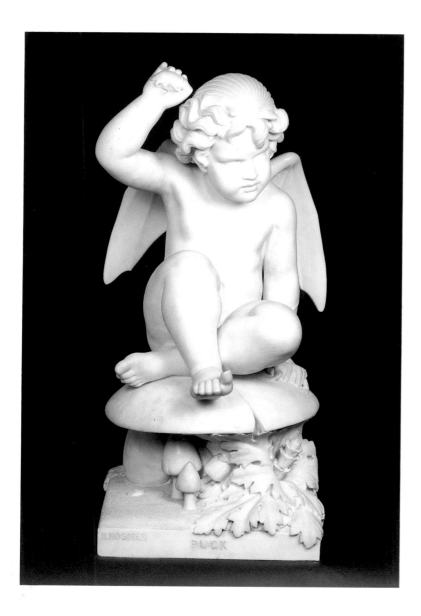

102
Harriet Hosmer (1830–1908)
Zenobia in Chains 1859
Marble, 49 × 16 × 21 in.
Wadsworth Atheneum, Hartford, Connecticut,
Gift of Mrs. Josephine M.J. Dodge

The heroine Zenobia probably appealed to Hosmer as a subject in the same way the virtuous martyr Beatrice Cenci had interested her earlier, and in the same way that Judith, Susanna, Mary Magdalene, Esther, and Bathsheba had interested the seventeenth-century Italian painter Artemisia Gentileschi. William Ware's *Zenobia*, published in 1837, had also been well received,[1] and readers knew about the third-century Palmyran queen, whom the Roman emperors found invincible until 272 when Aurelian defeated her and brought her captive to Rome. She was paraded through the streets in chains, and this is the episode represented by Hosmer in her white marble statue. Hosmer began a seven-foot *Zenobia* in 1858 and in a letter wrote, "When I was in Florence, I searched in the Pitti and the Magliabecchian Libraries for costume and hints, but found nothing at all satisfactory."[2] She went on to describe a useful mosaic in San Marco, which showed the Madonna in an oriental regal costume, and explained that now she was awaiting the cast of a coin. Hawthorne wrote as follows about his visit to Hosmer's studio to see her *Zenobia* on 15 March 1859:

> Zenobia stood in the centre of the room, as yet unfinished in the clay, but a very noble and remarkable statue indeed, full of dignity and beauty. It is wonderful that so brisk a woman could have achieved a work so quietly impressive. . . . The idea of motion is attained with great success. . . . I have seldom been more impressed by a piece of modern sculpture.[3]

Bonfigli in his 1860 *Guide to the Studios in Rome* gives the address of Hosmer's studio at this time as 5 Via Margutta. According to the *Boston Daily Evening Transcript* of 18 April 1862 (p. 2), her Via Margutta studio was "open to visitors on Tuesday only and then is so thronged that those who expect more than a few words from her will be disappointed."

The completed sculpture of *Zenobia* was shown at the International Exhibition of 1862 in London, and two years later it went on tour in America. Advertisements were taken in the newspapers announcing the visiting hours and the admission price, reviews in periodicals were extremely laudatory, and the public swarmed to see the colossus (30,000 people during four months in Boston[4]—after it was on view in New York for eight weeks and before it was exhibited in Chicago and Milwaukee[5]). Other advertisements in nineteenth-century newspapers inform us that the popularity of Hosmer's statue resulted in the republication of Ware's *Zenobia*.

Hosmer's queen is stately and serene in her captivity. Her slightly bowed head[6] and the chain are the only proof of her capitulation. She is still crowned, and she seems to step slowly and majestically. Her dress is belted with a Medusa medallion, and a rosette holds the crossed bands together between her breasts. The dress falls in classical, catenary folds similar to those on the *Minerva Giustinani* that Hosmer might have seen in the Vatican collection. Both her crown and her sandals are decorated with curvilinear designs. In addition to the crown over her wavy hair, she wears a band with a star pattern to hold up her long hair in the back.

After the now-lost seven-foot-high *Zenobia* was exhibited in London, skeptics questioned the ability of the petite Hosmer to execute such an imposing sculpture. In her rebuttal in *The Art-Journal* of 1 January 1864 Hosmer relates that she first did a small model, four feet high, and that she then worked with her "own hands upon the full-sized clay model during a period of eight months." The marble version in this exhibition corresponds to that original model of four feet, of which she made replicas for several interested clients, such as the prince of Wales, Mrs. Potter Palmer of Chicago, and Robert Emmons of Boston.

1 Lucy Larcom, in describing her days as a mill worker in mid-nineteenth-century Lowell before she became a poet and teacher, wrote, "One book . . . had a wide popularity in those days. It is a pity that it should be unfamiliar to modern girlhood— Ware's 'Zenobia.' The Queen of Palmyra walked among us and held a lofty place among our ideals of heroic womanhood, never yet obliterated from admiring remembrance." (Lucy Larcom, *A New England Girlhood* [Boston and New York, 1889], 244).

2 Carr, *Harriet Hosmer Letters*, 120.

3 Nathaniel Hawthorne, *Passages from the French and Italian Note-books of Nathaniel Hawthorne* (Boston, 1883), 494.

4 *Boston Daily Evening Transcript*, 27 April 1863, p. 2.

5 Hosmer's *Zenobia* was the only piece of sculpture in Milwaukee's first public art exhibition of 1865 (Porter Butts, *Art in Wisconsin* [Madison, 1936], 126 and 129).

6 Hosmer seems to reflect Ware's description: "Her gaze was fixed on vacancy, or else cast toward the ground" (William Ware, *Zenobia*, vol 2 [New York, n.d.], 192).

103
Harriet Hosmer (1830–1908)
Sleeping Faun 1865
Marble, 50 × 62 × 26 in.
The Forbes Magazine Collection, New York

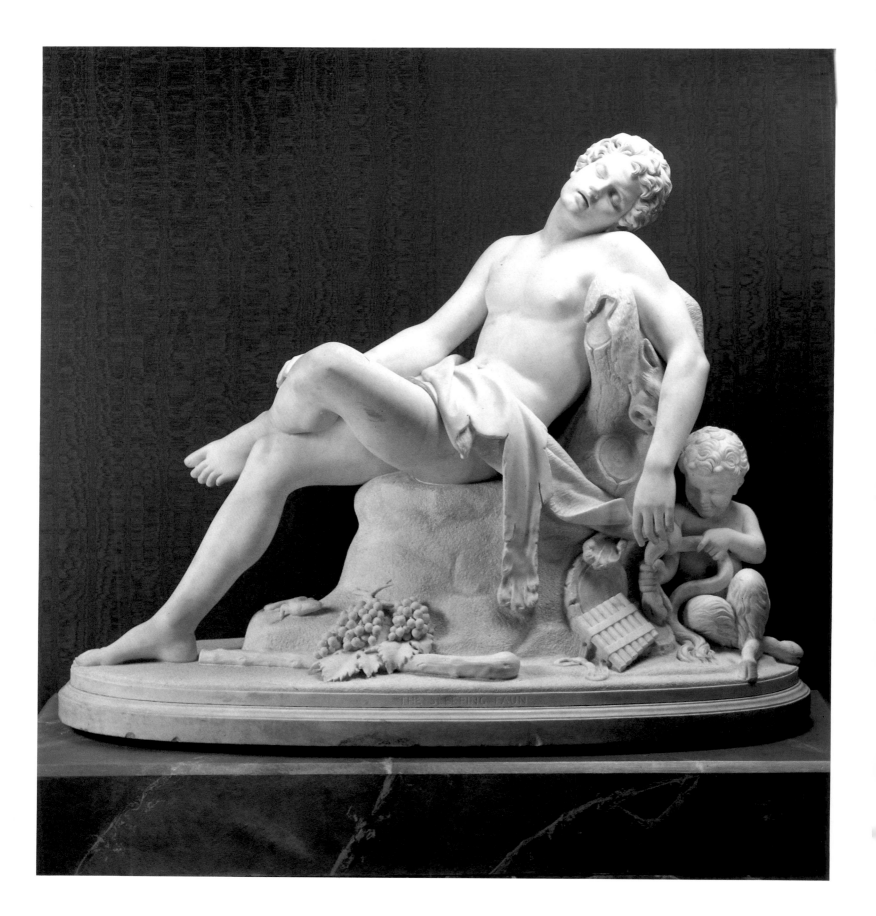

As noted above, a close colony of American artists and writers lived in Rome in the mid-nineteenth century—among them Hosmer, the Salem-born Louisa Lander, and Nathaniel Hawthorne. Hosmer and Lander thus became the inspiration for Hawthorne's two female artists working in Rome in *The Marble Faun* (1860). Hawthorne's writings make clear his specific fascination with the copy of Praxiteles's *Faun* in the Capitoline Museum and the one in the Villa Borghese, just across the street from where he lived. The tangential development is that Hosmer then created neo-classical fauns, which were enthusiastically received. When her life-size marble *Sleeping Faun* was exhibited at the Dublin Exhibition of 1865, it was purchased the first day for the city of Dublin by Sir Benjamin Guinness for $5,000.[1] Hosmer's *Sleeping Faun* (borrowed from Dublin) and her *Waking Faun* were two of the seven sculptures chosen by the United States Selection Committee for the Exposition Universelle in Paris in 1867.[2] Sir Charles Eastlake, director of the National Gallery, London, observed, "If the *Sleeping Faun* had been discovered among the ruins of Rome or Pompeii, it would have been pronounced one of the best Grecian statues."[3] Indeed, Cornelius C. Vermeule believes that the Greco-Roman *Dionysos or Satyr on a Donkey*, which was in Rome in the nineteenth century (today in the Minneapolis Institute of Arts), may have served as a source for Hosmer.[4]

The languid, muscular figure reclines against a tree stump, which serves as a chair. The faun is nude except for an animal skin that extends across the lower part of his torso. His head rests on his left shoulder as he sleeps with his lips slightly parted. His musical pipes have dropped to the ground. Meanwhile a satyr child plays with the tail of the hide. Further realistic details on the base are a lizard, a rustic cane befitting the woodland faun, and a branch of grapes appropriate to these followers of Dionysos.

Hosmer's sculptures went not only into genuine art collections but into fictional collections as well. When Theodore Dreiser in 1927 wished to evoke a prosperous home with choice works of art in *The Financier*, he wrote, ". . . some bronzes of Hosmer and Powers . . ."; and three pages later, "there were then the two famous American sculptors, Powers and Hosmer, of whose work he had examples"; and two pages further, ". . . statues by Powers, Hosmer, and Thorwaldsen."

The *Sleeping Faun* in this exhibition belonged to Lady Marian Alford, one of Hosmer's most ardent patrons. Elizabeth Barrett Browning related how in 1860 this daughter of the marquis of Northampton knelt down before Harriet and "placed on her finger the most splendid ring you can imagine, a ruby in the form of a heart, surrounded and crowned with diamonds."[5] Hosmer used to divide her vacation time in England between visits with Lady Marian at Castle Ashby and visits with Lady Louisa Ashburton at Melchet Court. It was, in fact, at Lady Marian's suggestion that the latter made her first call at Hosmer's studio in 1867 and immediately ordered not only a *Sleeping Faun* for herself but also a *Puck*, a *Will-o'-the-Wisp*, two *Putti upon Dolphins*, a marble chimney piece, and the *Waking Faun* as well.[6]

[1] James Parton et al., *Eminent Women of the Age* (Hartford, Conn., 1869), 584.
[2] Eighty-two paintings and seven sculptures were chosen. See Carol Troyen, "Innocents Abroad: American Painters at the 1867 Exposition Universelle, Paris," *The American Art Journal* (Autumn 1984), 3-26.
[3] Wayne Craven, *Sculpture in America* (New York, 1968), 329.
[4] Cornelius C. Vermeule, "Neoclassic sculpture in America: Greco-Roman sources and their results," *Antiques* (November 1975), 972-31.
[5] Kenyon, *Letters of Elizabeth Barrett Browning*, 392.
[6] Virginia Surtees, *The Ludovisi Goddess, The Life of Louisa Lady Ashburton* (London, 1984), 131.

Margaret Foley (1827–1877)

Bust of Jenny Lind signed and dated M.F. FOLEY. ROMA. 1865. SC.

Marble, 16½ × 16½ × 3 in.

The David and Alfred Smart Gallery, The University of Chicago, Gift of Dr. and Mrs. Isadore Isoe

Margaret Foley, like Harriet Hosmer and Edmonia Lewis, realized her career as a sculptor in Rome, where she worked for seventeen years. In her youth she taught school in Vergennes, Vermont, but along with many other Yankee women at this time she was lured in the 1840s to Lowell, Massachusetts, by its thriving mills, its lending library, and the Lyceum lectures and concerts. The "female operatives" began their workday at 5 A.M., ended at 7 P.M., and then flocked to the evening Lyceum lectures to hear such speakers as John Quincy Adams and Ralph Waldo Emerson.[1] One of the lecturers, Andrew Preston Peabody (a Unitarian minister and later a Harvard professor), was impressed to find on arriving at the lecture hall in Lowell that "every girl had a book in her hand and was reading intently; as he rose to speak the books were laid aside and the note taking began. Peabody claimed he had never seen such assiduous note taking— 'No, not even in a college class—as in that assembly of young women, laboring for their subsistence.'"[2] Lucy Larcum, who was a friend of Foley's and later a published poet, had gone to work in the mills at the age of eleven.[3] In her memoirs she described the classes that the mill women organized in German literature, botany, and ethics.[4]

While working in the spinning rooms of the Lowell mills, Foley made carvings from wooden bobbins and, heartened by her success, moved to Boston to become an artist. By 1848 she had established herself as a cameo portraitist and eventually graduated to life-size portraiture. She saved enough money to move to Rome in 1860 and take a studio at 53 Via Margutta in the same four-story palazzo inhabited by such American artists as Elihu Vedder, Randolph Rogers, Florence Freeman, and Chauncey Ives. Foley supported herself by making profile portraits of tourists on marble medallions, thus many such portraits exist today in the United States and England, signed "M.F. Foley, Sc. Roma".[5] Several of her medallions were accepted at the Dublin Exhibition of 1865, at the Exposition Universelle in Paris in 1867, and at the Royal Academy of Arts in London in the 1870s. Correspondents to American newspapers in their articles on the artists in Rome invariably mentioned Foley's studio, and one learns of her earning sufficient money from her medallions to make a fountain of three life-size children playing under an umbrella-like acanthus. The fountain was commissioned for Chicago and was to be cast in bronze, but after the great fire of 1871, Foley released the donors from their obligation and adjusted to the idea of making an indoor marble piece for the Centennial in Philadelphia. The heavy eight-foot-wide fountain was shipped to Philadelphia and installed in the center of Horticultural Hall, amidst begonias and ferns. Today it is a working fountain in the new Horticulture Center of Philadelphia's West Fairmount Park.

During these years in Rome, Foley became a close friend of the English writers Mary and William Howitt, and naturally the likenesses of the Howitts were immortalized in marble medallions by the artist. In June 1871 the Howitts and Foley found their ideal summer home in the Tyrol. In the village of Dietenheim they discovered a rambling old mansion that was only partially occupied by a peasant family. It had plenty of room for Mr. and Mrs. Howitt, their daughter Margaret, and "Peggy" Foley. The view of the Dolomite range may have evoked memories of the Green Mountains for the Vermont-raised sculptor.

The last known work by Foley was a marble bust of the dynamic theologian Theodore Parker, signed and dated 1877 (collection of Mr. Lee Anderson). Foley had listened to the Unitarian Parker preach when they both lived in Boston and had possibly seen him again when he visited Rome after tuberculosis forced him into an early retirement (he died in Florence in 1860). According to a dispatch from Rome to the *Boston Daily Evening Transcript* of 18 April 1862, one bust of Theodore Parker was by this date already on view in Foley's studio "in this gallery of celebrities."[6] Foley herself endured neurological pain that forced her to spend the winter of 1877 with the Howitts at Merano, a health spa, rather than to attempt the long trip back to Rome after their summer in the Tyrol. Foley died there in December "from a chronic brain disease"[7] and was buried in the Protestant Cemetery along the Passirio River.

This marble medallion of the Swedish soprano Jenny Lind (1820–1887) is typical of the innumerable profile portraits sculpted by Foley: the profile is of the left side,[8] the sitter wears jewelry, and special attention has been lavished on defining the hair. By the time Foley made this portrait, Jenny Lind had retired from the opera, had already concertized in America under the aegis of P.T. Barnum (who was an impressario before becoming the circus partner of Bailey's), and was still touring the Continent giving concerts. A man who attended her first concert in America described her as follows: "She is not what some would call handsome but when she smiles, her sweet face lights up to almost positive beauty. Her complexion is beautiful, and her eyes large blue of the sweetish expression. . . . She has light, wavy, auburn hair."[9]

Foley successfully conveys the singer's sweetness. The profile may be a little idealized, but her lips are quite individualized, and the eyelid is finely delineated. Lind wears a necklace with "Roma" inscribed on a six-pointed pendant and an elaborate earring that is like a dangling miniature triglyph. The diadem encircling her head is perhaps inspired by the fillet seen on classical heads of Minerva in Roman collections.

105
Margaret Foley (1827–1877)
Bust of William Cullen Bryant signed and dated Roma 1867
Marble, $18\frac{3}{4} \times 18\frac{3}{4} \times 2\frac{1}{2}$ in.
Mead Art Museum, Amherst College, Anonymous donor

William Cullen Bryant (1794–1878) may be chiefly known today as the writer of the nature poem "Thanatopsis," but in his day he was equally famous as editor of the New York *Evening Post*, a position he held for almost fifty years. He was also one of the founders of the Republican Party. When he died at his home on 16th Street in New York, flags were lowered to half-mast in the city. He was commemorated by his friend Asher B. Durand in the painting *Kindred Spirits* (New York Public Library), which recalls the trip that Bryant took through the Catskills with landscape painter Thomas Cole in 1841.

Bryant made his sixth trip to Europe, visiting as always France, Spain, Italy, and Germany; and in March 1867, when he was revisiting Rome, he may have sat for this portrait by Margaret Foley. Certainly Bryant's appearance corresponds with his age at this time: recently turned seventy-two, he had a balding pate, a heaviness in his cheek, crow's feet around his eyes, grooves in his forehead, and a vein at his temple that seems to pulsate in this portrait. The artist differentiated between the long wavy locks of hair that fold under at the nape of the poet's neck and the short curlicues of his beard, and these are in fine contrast to the brief staccato lines of the bushy eyebrows.

Among other famous sitters whose portraits Foley sculpted were Henry Wadsworth Longfellow; Mrs. Julia Ward Howe, remembered best for writing "The Battle Hymn of the Republic"; Senator Charles Sumner from Massachusetts; Henry Farnam, the philanthropist who gave Farnam Hall to Yale University; and the English writers Mr. and Mrs. Samuel C. Hall, who lent their marble portraits to the Exhibition of the Society of Female Artists in 1871, resulting in the following published tribute: ". . . Miss Foley is an American lady, resident at Rome; in her own country and in Italy she has obtained large and merited celebrity: she is, indeed, one of the many sculptors of whom the New World may be justly proud."[1]

[1] "Exhibition of the Society of Female Artists," *The Art Journal* 10 (1871), 91.

[1] Lucy Larcom, *A New England Girlhood* (Boston, 1889), 253.
[2] Claudia L. Bushman, *'A Good Poor Man's Wife' Being a Chronicle of Harriet Hanson Robinson and Her Family in Nineteenth-Century New England* (Hanover, N.H., 1981), 41.
[3] Larcum, *New England Childhood*, 153.
[4] Ibid., 241-42. Larcum at the time was a steady contributor to *Operatives' Magazine* and *The Lowell Offering*, the mill girls' literary magazines. After she left Lowell, she became well known as a poet and a teacher of English literature at Wheaton Seminary.
[5] Eleanor Tufts, "Margaret Foley's Metamorphosis: A Merrimack 'Female Operative' in Neo-Classical Rome," *Arts Magazine* 56, no. 5 (January 1982), pp. 88-95.
[6] This article of 1862 is so informative that it deserves to be quoted further: "This bust of Theodore Parker fitly joins this gracious company. It is one of the most successful portraits of that large-hearted man, and having been widely copied in plaster it holds a place in many a negro cabin in America, a fact which pleased the man of whose features it is so faithful a copy. Many ideal heads made by Miss Foley have gained a wide popularity; in fact, she is a well known and honored exhibitor in most of the art galleries of Europe—perhaps her Cleopatra and her Albanese girls have been the most extensively copied and most generally admired of her ideal medallions. The most important work which Miss Foley has ever undertaken is, however, her studies of the Prophet Jeremiah, of whom she intends to make a life-size statue one of these days."
[7] Entry in the death register of the Protestant Parish of Merano, vol. 2, p. 22, no. 58.
[8] An exception is the portrait of Margaret Dawes Eliot in the Wellesley College Museum (also seen in the circular medallion of her, signed and dated "Roma 1864" in the Washington University Art Gallery) and a granddaughter of Lucretia Mott (known through a nineteenth-century photograph today).
[9] W. Porter Ware and Thaddeus C. Lockard, Jr., *P. T. Barnum Presents Jenny Lind, The American Tour of the Swedish Nightingale* (Baton Rouge, La., 1980), 24.

106
Margaret Foley (1827-1877)
Cleopatra signed and dated Roma 1876
Marble, $23\frac{3}{4} \times 19\frac{5}{8} \times 11\frac{7}{8}$
National Museum of American Art, Smithsonian Institution,
Gift of Paul William Garber and Philip C. Garber in memory Sarah R. Garber

Occasionally Foley tried her hand at ideal or historical subjects. Various newspaper accounts mention her medallion of the *Prophet Jeremiah* and her bust of *Jeremiah* as well as designs for a life-size, seated statue of this Hebrew prophet. Other endeavors of hers in this realm were the Magoun tombstone of the Mother and Child wearing thin Greek chitons (late 1860s, Mt. Auburn Cemetery, Cambridge); *Joshua*, exhibited at the National Academy of Design in 1871; *Boy with Kid*, "which found a home in England";[1] and *Egeria*, accepted at the Seventh San Francisco Art Association exhibition of 1875. Precedents in Rome were such works as Randolph Roger's *Nydia, the Blind Girl of Pompeii*, William Wetmore Story's *Cleopatra* and *Libyian Sibyl*, Harriet Hosmer's *Oenone* and *Zenobic*, Louisa Lander's *Virginia Dare*, and Florence Freeman's two ideal works inspired by Longfellow: *Chibiados* (from *Hiawatha*) and *Sandalphon*.

It is not surprising, then, that one of Foley's last works would be the queen of Egypt who ruled in the last half of the first century B.C. Foley's American contemporary in Rome, Edmonia Lewis, also created a *Cleopatra*, and both of these artists sent their marble queens to the Philadelphia Centennial Exhibition of 1876.

Foley's *Cleopatra* is a cool, serene Egyptian with thin eyebrows, small ears, and a delicate mouth. She wears a crown (from which nine points are missing today) whose symmetrical design consists of two snakes coming together, and she wears a grooved bracelet on her right arm and a bracelet in the form of an asp on the other. Her classical chiton is fastened over her right shoulder, and her hair falls in two parallel, vertical plaits to her bare shoulders. The back of the sculpture is inscribed MARGARET FOLEY SCOLPI. ROMA 1876.

[1] M.H., "Art in Rome, 1872," *The Art-Journal* (1872), 132.

Edmonia Lewis (1844–c. 1911)
Old Arrow Maker and His Daughter 1872
Marble, $21\frac{1}{2} \times 13\frac{5}{8} \times 13\frac{3}{8}$ in.
National Museum of American Art, Smithsonian Institution,
Gift of Mr. and Mrs. Norman B. Robbins

Half American Indian and half American Black, Wildfire Lewis was raised by her mother's tribe, the Chippewa Indians. The exact dates of her birth and death have been difficult to determine because of varying anecdotal accounts, but in a sworn document the artist stated that she was born near Albany, New York, in 1844.[1] She described her parents and nomadic childhood with simplicity: "My mother was a wild Indian, and was born in Albany, of copper colour, and with straight, black hair. There she made and sold moccasins. My father, who was a negro, and a gentleman's servant, saw her and married her. . . . Mother often left her home and wandered with her people, whose habits she could not forget, and thus we her children were brought up in the same wild manner. Until I was twelve years old I led this wandering life, fishing and swimming . . . and making moccasins."[2]

Orphaned early, Wildfire was given new direction by her older brother, Sunrise. A California gold miner, he financed her schooling near Albany[3] and helped her in 1859 to attend Oberlin College, where she completed high school courses and enrolled in the college's liberal arts program. At this time she also changed her name from Wildfire to Edmonia. Among her courses were drawing and painting, and Oberlin today owns one of her drawings done after an engraving of *The Muse, Urania* (1862).[4]

Boston, the center of liberal thought in the nineteenth century, attracted Lewis, and with a letter of introduction to the anti-slavery advocate William Lloyd Garrison, she traveled there in 1863 in hopes of pursuing a musical career. Once there, she was fascinated by the sculptured busts that she saw in the State House and with the monuments that decorated the city in honor of early American patriots. Garrison, when he became aware of her new interest, introduced Lewis to the neo-classical sculptor Edward Brackett, who became her teacher. Her first sculpture was a portrait medallion in memory of John Brown, the abolitionist martyr. In 1864 and 1865 Lewis had a studio in the same building on Tremont Street as Anne Whitney and asked Whitney to give her sculpture lessons.[5]

At the Soldier's Relief Fair of 1864 Lewis exhibited a portrait bust of Colonel Robert Gould Shaw, the Bostonian who had been killed leading the first Black regiment in the Civil War, and it became such a popular work that one hundred plaster replicas of it were sold, providing Lewis with enough money to buy a boat ticket to Europe. Today the bust of Shaw on loan from the Afro-American History Museum to the Boston Athenaeum, signed and dated Rome 1867, is a marble version made by Lewis after she moved to Italy. It shows a noble head rising above bare shoulders—in the style of Brackett's *Washington Allston* (1844, Metropolitan Museum); Shaw is depicted with a mustache and a narrow goatee, and a far-off gaze is conveyed through the incised eyes. Lewis visited England and France before settling in Rome, where she became a member of the American colony, taking a succession of studios in the area around the Spanish Steps. One of her most impressive works is *Forever Free* (signed "Fecit a Roma 1867," Howard University Art Gallery), composed of two former slaves who have broken their chains of bondage. The robust, muscular male figure stands looking heavenward in gratitude, the broken manacle hanging from his upraised left arm; and the accompanying female kneels beside him, her hands clasped in prayer.

After this emancipation work Lewis turned to her other ethnic interest and made a number of sculptures based upon *The Song of Hiawatha* by Henry Wadsworth Longfellow. She even tried to sculpt Longfellow's portrait simply by stalking him as he strolled along the streets of Rome in 1868. When his brother Samuel saw the reasonable likeness in Lewis's studio, he suggested that the poet sit for the artist so that she might perfect her portrait. The marble bust, which belongs to Harvard, rests on a tall bookcase in the Sarah Whitman room of Radcliffe's Schlesinger Library. Lewis did other portraits of eminent Americans, among them Senator Charles Sumner; William Lloyd Garrison; Wendell Phillips, president of the Anti-Slavery Society in America; Charlotte Cushman, the actress; and Maria Weston Chapman, head of the Boston Female Anti-Slavery Society. She also, like other artists in Rome, developed a lucrative business of copying important sculptures for travelers who wanted souvenirs of their Grand Tour. The biography of Elizabeth Buffum Chace relates that Lewis's "marble copy of the Young Augustus, which Mrs. Chace purchased, seemed to all of us the best reproduction of the original then offered by any artist in Rome."[6] Called the *Young Octavian* today, this sculpture and Lewis's copy of *Moses* (after Michelangelo) (1875) are in the National Museum of American Art and were included in Lynda Roscoe Hartigan's recent exhibition "Sharing Traditions, Five Black Artists in Nineteenth-Century America."

Lewis made some full-length statues of mythological and historical personages: for example, *Death of Cleopatra*, which created a sensation at the Philadelphia Centennial Exhibition because of its startling realism; *Hagar*, the pathetic Old Testament woman cast out into the wilderness by Abraham, about whom Lewis commented, "I have a strong sympathy for all women who have struggled and suffered";[7] and *Hygeia*, goddess of health. *Hygeia* appropriately stands on the tomb of a woman physician and reformer, Dr. Harriot Kezia Hunt (Mt. Auburn Cemetery, Cambridge); the right hand of the classically draped figure once held Hygeia's symbol: a cup from which a serpent drinks.

In 1873 Lewis visited the United States because five of her sculptures were being exhibited at the San Francisco Art Association. Two pieces, *Poor Cupid* and *Hiawatha's Marriage*, were sold there, and Lewis then took the remaining three works to nearby San Jose for an exhibition. Newspaper accounts report that over 1,600 visitors saw her work, and the San Jose Library canvassed for subscriptions to purchase her *Bust of Lincoln*.[8] The other two sculptures, *Awake* and *Asleep* (each composed of two infants), were privately bought but can now be found with *Lincoln* at the San Jose Library.

Lewis returned to Rome and was last noted there in 1911. The circumstances and date of her death are unknown.

[1] Marilyn Richardson, "Edmonia Lewis," *Harvard Magazine* 88, no. 4 (March/April 1986), p. 40. Some of the confusion has arisen from conflicting remarks made by the artist herself. In one interview in Rome, Lewis was quoted as saying "I was born at Greenhigh, in Ohio" (H. W., "A Negro Sculptress," *The Athenaeum* 39, no. 2001 [3 March 1866], p. 302).

[2] Ibid.

[3] Lynda Roscoe Hartigan, *Sharing Traditions, Five Black Artists in Nineteenth-Century America* (National Museum of American Art, Washington, D.C., 1985), 87.

[4] Marcia Goldberg, "A Drawing by Edmonia Lewis," *The American Art Journal* 9, no. 2 (November 1977), p. 104.

[5] Anne Whitney letter of 9 August 1864 to Adeline Manning, Whitney Archive, Wellesley College Library.

[6] L.B. Wyman, *Elizabeth Buffum Chace* (Boston, 1914), 37–38.

[7] "Edmonia Lewis," *The Revolution* 7, no. 6 (20 April 1871), p. 8.

[8] Interview with Lewis during her 1873 visit recorded in the *San Francisco Chronicle*. Philip M. Montesano, "The Mystery of the San Jose Statues," *Urban West* (March/April 1968), 25.

[9] "Edmonia Lewis," *The Revolution*.

[10] Joseph Leach, *Bright Particular Star: The Life and Times of Charlotte Cushman* (New Haven, 1970), 335.

[11] Ibid., 364.

[12] Cynthia D. Nickerson suggests that the small deer represents the one that Hiawatha slew on his way through the woods, and that by the inclusion of this attribute, Hiawatha's presence in the sculpture is implied (Nickerson, "Artistic Interpretations of Henry Wadsworth Longfellow's *The Song of Hiawatha*, 1855–1900," *The American Art Journal* 16, no. 3 [Summer 1984], p. 64).

The Song of Hiawatha by Longfellow was written in 1855 while Lewis was living among the Chippewa Indians, and the poem later inspired Lewis to make several related sculptures. A newspaper item in *The Revolution*, datelined Rome, 21 March 1871, describes a visit to her studio: "Her first *Hiawatha's Wooing* represents Minnehaha seated making a pair of moccasins and Hiawatha by her side with a world of love and longing in his eyes. . . . In *The Marriage* they stand side by side with clasped hands. In both, the Indian type of features is carefully preserved and every detail of dress, etc., is true to nature; the sentiment is equal to the execution."[9] *Hiawatha's Wooing* impressed Charlotte Cushman so much that she and a group of other Americans bought it and presented it to the Boston YMCA.[10] When Cushman was back on tour in the United States, she was delighted to read in the New Orleans *Picayune* of 7 January 1873 that "Edmonia Lewis had snared two 5000 dollar commissions."[11] Lewis also made marble busts of *Minnehaha* and *Hiawatha* (1868), which have reappeared in recent times at a 1972 exhibition at the Kennedy Galleries in New York. Now they are at Howard University.

The lines in Longfellow's poem relevant to the sculpture in this exhibition are:

In Lewis's sculpture the old arrow maker sits half-clad, with only a necklace of animal teeth over his upper torso; in his hands he holds flint and a stone. His daughter Minnehaha sits at his side holding in her lap the mat she is plaiting. Both father and daughter wear moccasins, and a small deer lies at their feet.[12] The relationship of the two figures is physically quite similar to Lewis's sculpture *Forever Free*: the male is placed higher in the composition, and the female appears a bit diminutive at his side. The two figures are pliably modeled. The eyes have not been drilled, thus the two personages seem like generic symbols for their literary prototypes. In fact, the head of *Minnehaha* at Howard University (c. 1867) has been replicated by Lewis in this 1872 sculpture. Another example of the *Old Arrow Maker* belongs to the National Museum of American Art, and a third is at the Tuskegee Institute in Alabama.

William Gerdts proposes that the marriage of Minnehaha and Hiawatha, who came from two previously warring tribes, had a special meaning in the aftermath of the Civil War because the theme reflected the hope for the resolution of America's North-South difference.

At the doorway of his wigwam
Sat the ancient Arrow-maker,
In the land of the Dacotahs,
Making arrow-heads of jasper,
Arrow-heads of chalcedony.
At his side, in all her beauty,
Sat the lovely Minnehaha,
Sat his daughter, Laughing Water,
Plaiting mats of flags and rushes;
Of the past the old man's thoughts were,
And the maiden's of the future.

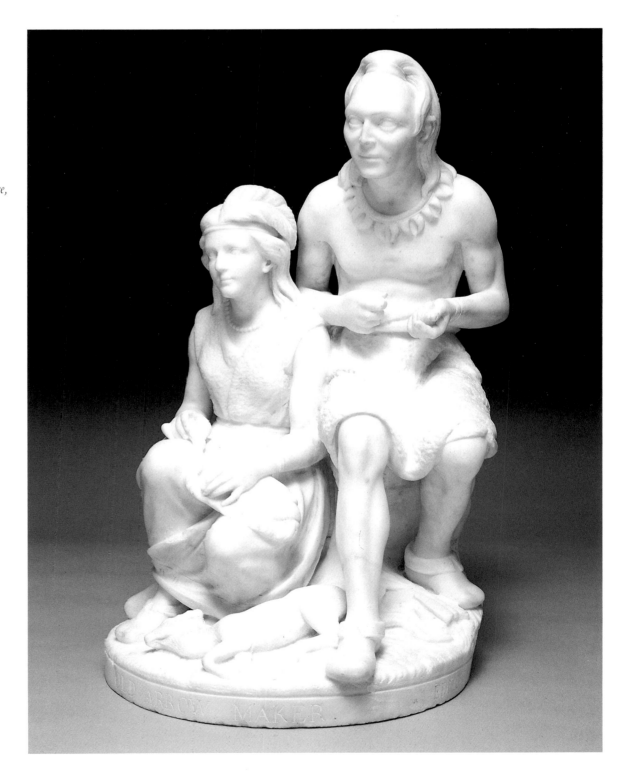

108
Vinnie Ream (Hoxie) (1847–1914)
Sappho 1865–1870
Marble, $66\frac{3}{8} \times 23\frac{7}{8} \times 21$ in.
National Museum of American Art, Smithsonian Institution,
Gift of General Richard L. Hoxie

The post office worker who sculpted the marble statue of Abraham Lincoln for the place of honor in the Rotunda of the United States Capitol had to be represented in this exhibition. This Wisconsin-born artist was the last person to take the likeness of Lincoln on that fateful day in 1865 when he attended Ford's Theater. She had asked the president to sit for her, and although he was too busy for formal sittings, he permitted her to come to his office in the early mornings to model him in clay as he worked at his desk. The sessions lasted one half-hour every day for six months. After Lincoln's assassination, a competition for a statue was announced, and the model that Vinnie Ream submitted was selected, making her the first female artist to receive a government commission ($10,000). Once her six-foot eleven-inch plaster cast was ready for transference to marble, she traveled to Italy, accompanied by her parents, to select the Carrara marble and supervise the stone cutters. While a post office clerk, she had studied with the sculptor Clark Mills; she studied in Paris with Léon J.F. Bonnat, en route to Italy, and then in Rome with Luigi Majoli, whom she called "the greatest sculptor in Rome."[1] Ream took a studio at 45 Via di San Basilio and remained for six months. In addition to her statue of *Lincoln*, she modeled from life the composer Franz Liszt and Cardinal Antonelli[2] and created at least two ideal works of semi-nude females: *Passion Flower* and *Spirit of the Carnival*.[3]

On her triumphal return to Washington, Ream received a second government commission at double the money—$20,000—for a statue of Admiral Farragut (completed 1881), which can be seen today in Washington, D.C., at K Street between 16th and 17th St., N.W. She worked on this ten-foot statue for six years, the last two of which were spent in the Washington Navy Yard, where the bronze from the propellors of the admiral's flagship, *Hartford*, were melted down to be used for the casting of the statue. While working on the Farragut Memorial, Ream married Lt. Richard L. Hoxie on 28 May 1878. Ream then devoted herself to her husband and son, temporarily giving up sculpture.

At the time of the World's Columbian Exposition in Chicago, Vinnie Ream Hoxie, like Anne Whitney, did not want to be segregated in the Woman's Building and thought her work should be shown in one of the state exhibitions. But as it turned out, her two large neo-classical marble statues *were* included in the Woman's Building: an allegorical figure of *The West* (1866–1868), with stalks of wheat and ears of corn, which had received first prize at the St. Louis Fair;[4] and *Miriam's Song of Triumph*, in which the Old Testament prophetess, dancing to her raised timbrel, leads the women across the Red Sea.

When Ream resumed sculpting, she accepted two commissions for bronze statues to be placed in the United States Capitol: one from Iowa of *Governor Samuel Kirkwood* (1913), and one from Oklahoma of *Sequoya* (1912), the Cherokee leader. In the statue of Kirkwood, which is over seven feet tall, the governor stands in a classic contrapposto pose, gesturing as if to make a point. Ream had a full-blooded Sioux pose in her studio for the sculpture of Sequoya. Her husband related, "It is perhaps not generally known that Mrs. Hoxie commenced the study of the life of this famous Indian nearly 40 years ago, when her first bust of Sequoya was made. Since signing the contract for the statue, April 29, 1912, she has devoted much study and labor to the evolution of the model and at last she was satisfied."[5] Ream died in Washington at sixty-seven before casting *Sequoya*.

Ream proves her ability as a neo-classical sculptor with her life-size marble statue of the Greek poet Sappho. With a downward tilt of the head, the idealized Sappho looks lost in her thoughts. Her right hand holds the stylus with which to write, and her left contains the scroll. Below at her feet is a lyre. She stands in the classic contrapposto, and her Grecian drapery, fastened at her left shoulder, falls loosely over her semi-exposed breasts. The American Edward Bartholomew created an equally tall marble Sappho earlier in Rome (c. 1856, Wadsworth Atheneum) that is more conservatively draped and inscribed simply SAPPHO on the base, whereas Ream in a sophisticated way has given the name in authentic Greek lettering.

The tomb of General and Mrs. Hoxie in Arlington National Cemetery is majestically marked by a copy of Ream's *Sappho*, and the sculptor's epitaph reads: "Words that would praise thee are impotent."

[1] Vinnie Ream letter to William Henry Holmes, 24 October 1879 (microfilm roll 2227, Archives of American Art).
[2] Richard L. Hoxie, *Vinnie Ream* (Washington, D.C., 1908), plates 8 and 10.
[3] *The White, Marmorean Flock: Nineteenth-Century American Women Neoclassical Sculptors* (Vassar College Art Gallery, Poughkeepsie, 1972), nos. 29 and 30.
[4] Vinnie Ream letter to Leonard Myers, 7 September 1875 (Archives of American Art).
[5] Letter from Richard L. Hoxie to Senator Gore, 22 December 1914 (National Museum of American Art library).

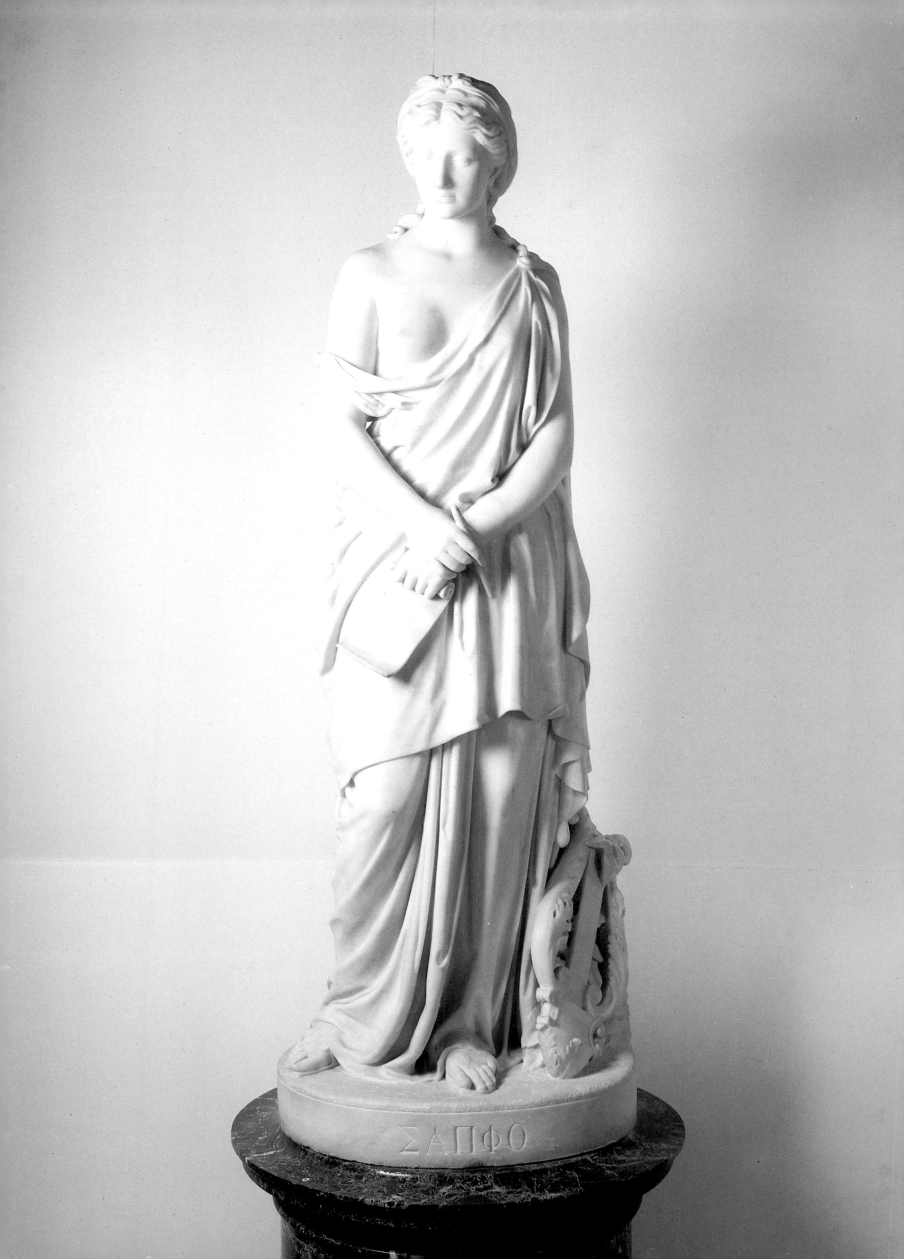
ΣΑΠΦΟ

109
Anne Whitney (1821–1915)
Bust of Laura Brown 1859
Marble, 12⅝ × 11 × 6 in.
National Museum of American Art, Smithsonian Institution, Given in
memory of Charles Downing Lay and Laura Gill Lay by their children

Watertown, Massachusetts, whose Unitarian Church was attended by both the Hosmers and the Whitneys, produced another free spirit in Anne Whitney. As usual in the nineteenth century, at least one son in the Whitney family went to Harvard while the daughters, Anne and her older sister Sarah, were tutored at home—except for the one year of 1834/35 that Anne studied at a private girls' school in Bucksport, Maine, the town in northern Maine where the watercolorist and mother of Winslow Homer, Henrietta Benson, was born. After teaching school in Salem, Massachusetts, from 1847 to 1849, Anne Whitney traveled by boat to New Orleans via Cuba (December 1850 to May 1851) to visit cousins. During these years she was writing poetry, and in 1859 a book of her collected poems was published. Her interests then shifted to sculpture, and she spent 1859/60 in New York and Philadelphia: studying anatomy at a hospital in Brooklyn, attending lectures by William Trost Richards in Philadelphia, and drawing at the Pennsylvania Academy. Her earliest known extant sculpture is the *Bust of Laura Brown* in this exhibition, and her earliest full-length life-size work is a marble of *Lady Godiva* (now in a private collection in Dallas). In her correspondence with William Trost Richards regarding *Godiva*, she was advised by the older artist in true Victorian tones to depict *Lady Godiva* clothed since Godiva had been a virtuous woman; the motif of the horse appears only in the border of Godiva's dress. Whitney began her modeling in a shed called the "Shanty" on the family property in Belmont. To put her Godiva in stone, she paid $500 for a block of imported marble.

In 1862 Whitney took a studio on Tremont Street in Boston next to that of sculptor William Rimmer, who gave her private instruction. Although she was tempted by the mecca of Rome, her abolitionist concerns prevailed and she waited until the Civil War was over. Her colossal sculpture of *Africa*, created during these years, and her *Godiva* were exhibited in Boston and New York to high acclaim. Finally in 1867 Whitney traveled to Rome, where she remained for four years, living near the top of the Spanish Steps and working in a studio closeby. Two neo-classical works from this period are her *Lotus Eater* (Newark Museum) and *Chaldean Shepherd* (Smith College Museum of Art). In a more polemic and realistic vein was a sculpture of the Haitian liberator, *Toussaint L'Ouverture*, a work now lost. The story of this black martyr, who was jailed and starved to death in Paris by Napoleon, was often cited in the North during the Civil War. Whitney depicted the hero chained in his dungeon, pointing to letters inscribed on the floor, "Dieu se charge." She traveled during the summers: to Munich's famous foundry in 1868, for example, where she learned about casting in bronze, the medium she would later choose for her *Roma*, the most famous sculpture from her Italian sojourn.

After returning to Boston and locating a studio, Whitney was accorded a commission in 1873 from the state of Massachusetts for a marble statue of Samuel Adams for the United States Capitol. When the plaster cast was finished, it was shipped to Florence for transference into marble. Whitney went to Florence in 1875 to select the Carrara marble and to supervise the job of carving the stone at Thomas Ball's studio. She used this opportunity to spend the summer and fall at the artists' colony in Ecouen, north of Paris. With the bronze sculpture *Le Modèle* of an Ecouen peasant who kept falling asleep while she sat as a model, Whitney again veered away from the neo-classicism so popular with the American male artists of this period. She was also innovative with her subject matter: a realistic, rustic peasant rather than an idealized, imagined figure. Five years later Whitney's Governor Samuel Adams was cast in bronze and erected downtown in Boston, in a square renamed for Adams in front of Faneuil Hall.

A momentous event occurred in 1875: Whitney won an anonymous competition in Massachusetts to execute a statue of famed senator Charles Sumner. Her prize-winning model has been lent to this exhibition by her hometown library. In 1876 as many as three of her sculptures were solicited for the Philadelphia Centennial Exhibition, including the new *Summer*. That fall she bought a four-story house on Beacon Hill at 92 Mt. Vernon Street, in which she lived and worked for nearly two decades, creating such important pieces as portraits of the abolitionist leader William Lloyd Garrison (he liked it better than those by other artists), President James Walker of Harvard (the marble today is in the Faculty Room and the bronze is in the narthex of Memorial Hall at Harvard), President Alice Freeman Palmer of Wellesley College, Harriet Beecher Stowe, an eight-foot-high seated figure of the English writer Harriet Martineau, and many others. Among the public monuments were the colossal statue of *Leif Ericson*, which stands today on Commonwealth Avenue in Boston, and a fountain of a putto, which was exhibited at the World's Columbian Exposition of 1893 and can be seen in a bronze replica at the intersection of Chestnut and Highland Streets in West Newton, Massachusetts.

Wellesley College engaged Whitney to teach modeling in the spring semester of 1885. She commuted by train to the college and made some lasting friendships with faculty members, which resulted ultimately in her papers' being deposited in the college library. She was famous enough that, when first volume of *Who's Who in America* was published in 1899, she was included.

Whitney, who lived to be ninety-three, spent her last years in the penthouse apartment of the new Charlesgate Hotel on Beacon Street, overlooking the Charles River, which flows down from her native Watertown and empties into the Atlantic Ocean, which she had thrice crossed in quest of training and of precious Carrara marble.

During the two years that Anne Whitney ran a girls' school in Salem, Massachusetts, she became friends with the family of William Augustus Brown, a Quaker ship-owner. In 1854 Brown moved his family to Brooklyn, where he became a prosperous wholesale produce dealer. Whitney, who had begun sculpting in her thirties by first making portraits of her parents, yearned for some formal artistic training, and because two of her brothers, John and James, were merchants in Brooklyn, she knew she had a base from which to pursue her studies. Also at this time her friend the young painter Fidelia Bridges from Salem was working as governess in the Browns' home. Whitney was, therefore, visiting several old friends when she called at the Brown household in 1859 and was commissioned by Mr. Brown to model a bust portrait of his youngest daughter, Laura, who was born in 1856. The sculptor worked in the very home we see depicted in Bridges's painting of *Laura Brown in a Wing Chair* in this exhibition (see cat. no. 38). When Laura died prematurely at twenty, this marble portrait passed into an elder sister's hands and remained in the family until it was given in 1968 to the National Museum of American Art.

"Bee-Bee," as Whitney called Baby Brown, is portrayed in a pure classical way—nude upper torso and pupils not incised. The artist has caught a pleasant expression with the beginning of a smile and the hint of a little plumpness. Long locks of hair fall to the sitter's shoulders and form corkscrew curls at her back. The profile view shows the cute snub nose of the child. Whitney's letter of 15 May 1859 to her sister tells of her struggle to capture Laura's facial expression: "The likeness is good and the modelling I think the best by far I have done. It has been a great labor. The perpetually ranging curves of a child's face, the impossibility of getting a half moment's fixed look, and this child's xpression [sic] being the most mobile and protean I ever saw, made altogether the work for sometime almost a despair. In this I have followed Mr. Brown's advice, religiously to copy nature and learn the alphabet before attempting to make the ode."[1] This sculpture, included in the annual exhibition at the National Academy of Design in 1860, was the first of many of Whitney's works to be accepted in major national and international shows.

[1] Whitney Archive, Wellesley College Library.

Anne Whitney (1821–1915)
Senator Charles Sumner 1875
Plaster, $29\frac{1}{2} \times 14 \times 20\frac{1}{4}$ in.
The Watertown Free Public Library

In 1874, upon the death of Charles Sumner, the Massachusetts senator who was caned on the Senate floor for his strong abolitionist stand, a competition was announced for a statue of the famous statesman to be placed in the Boston Garden. The plaster model in this exhibition was Anne Whitney's entry, and it won the competition. Nevertheless, the Boston Arts Committee felt it would be improper for a woman to sculpt a man, and therefore Whitney was simply given the $500 award, while the commission was handed over to Thomas Ball. This prejudice must have rankled Whitney, but twenty-five years later vindication came when friends raised the money for her to execute a statue of Sumner in bronze for Harvard Square. This life-size statue can be seen today in a little park in front of the gates to Harvard University. One addition to the bronze version is a book in the senator's right hand.

Sumner was respected not only as an advocate for the emancipation of slaves but as a man of culture who had traveled to Europe to learn languages and to study art and literature. Whitney knew him personally because he had been a Harvard classmate of her brother Alexander's, and the two men had remained friends during law school. Photographs of Sumner attest to the prominent sideburns with which Whitney frames his face. She shows him in the prime of life—with an attractive physiognomy and in a relaxed, seated pose. He wears a bow tie, and his jacket is pulled across his chest, held by only one fastened button. A special elongated chair in the Longfellow House in Cambridge was reserved for the six-foot-tall Sumner when he visited the poet, and the side view of Whitney's sculpture shows the senator's lankiness.

Wendell Phillips, who had been president of the Anti-Slavery Society, wrote to Whitney on 18 June 1876: "But you've outdone Samuel [Adams]. Your Sumner is marvelous—just perfect—leaves your competition out of sight behind you. I was not in favor of a sitting position—but if I saw your model twice more I fear I should be converted. You make me forget the chair, we don't see it—clothes are so easy one does not notice them—pose just the thing, whole expression just faultless. How one longs to be a great man to be so immortalized!"[1]

A plaster cast of *Sumner* was exhibited with Whitney's marble *Roma* and her bronze *Modèle* at the Philadelphia Centennial Exhibition of 1876; and in 1879 *Sumner* was exhibited at the Union League Club House in New York. Whitney had a second plaster version available for exhibition, and it is preserved today in the Tufts Library, Weymouth, Massachusetts, along with Whitney's bust of *George Chapman* and Edmonia Lewis's portrait bust of *Maria Weston Chapman*. The original model of *Senator Charles Sumner*, the pride of the Watertown Free Public Library, is usually prominently displayed within a plexiglass case opposite the main desk, and it is extraordinary for it to be on loan, but the trustees of the library wished to share this sculpture with the rest of America.

[1] Letter in Whitney Archive, Wellesley College Library.

III
Anne Whitney (1821–1915)
Leif Ericson 1889
Plaster, bronzed, 102 × 54½ × 27 in.
National Museum of American Art, Smithsonian Institution,
Gift of Anne Whitney

Ole Bull, the Norwegian violinist, his wife and other members of the Scandinavian community in the United States, raised money to commission a colossal statue of Leif Ericson for Boston. There was great interest in the Norseman at this time, impelled by the scholarship of Professor Eben Horsford, who believed that he had uncovered the fortifications of an early Icelandic settlement on the Charles River in Cambridge, further corroborating the claim that Leif Ericson had discovered America. Whitney carefully researched her subject in order to be as authentic as possible in depicting the Norse attire.[1] She found a virile young man to serve as her model and began work on the statue in her studio in 1880. The huge bronze statue was unveiled on the Commonwealth Avenue mall on 29 October 1887. The following is inscribed in Runic letters on the pedestal: "Leif, the discoverer, son of Erik, who sailed from Iceland and landed on this Continent, A.D. 1000." On the north and south sides of the tall pedestal are bronze reliefs. One shows the Norsemen debarking and climbing a cliff on which Ericson stands at the top looking off into the distance with his left arm raised to shield his eyes. He is standing in the same pose as he is on a magnified scale in the free-standing bronze statue above. The other is an interior scene showing Ericson reporting back to his father, the king, who is seated on a throne; a horn cup, much like the one in Ericson's right hand in the above statue is shown on the table, and Norse arms decorate the wall. The whole red sandstone pedestal is set like a boat within a wide granite basin, and the front of the pedestal is shaped like a projecting, pointed prow of a galley, complete with the head of a dragonlike creature.

After the successful reception of the statue in Boston, Mrs. J.T. Gilbert of Milwaukee commissioned a second bronze statue for installation in Milwaukee's Juneau Park, including the same tall pedestal with the Runic lettering. Melzar H. Mosman, Whitney's foundry man from Chicopee, Massachusetts, accompanied the sculpture to Milwaukee (he charged Whitney $33.65 for his train fare), and he related that he had had to turn the statue slightly to meet the requirements of Mrs. Gilbert, who wanted Ericson to be seen down the long avenue that leads to the park, with Lake Michigan behind him so that he had the appearance of having just climbed the bluff at his back and of reconnoitering the territory before him.[2]

At the time of the World's Columbian Exposition in 1893 Anne Whitney did not want to exhibit in the Woman's Building because she thought women's art should not be segregated. The dynamic Mrs. Potter Palmer did not easily accept "no" for an answer and countered with an invitation for Whitney to send her statue of *Leif Ericson.* The artist could not resist this opportunity, and the statue shown in this exhibition in Washington is the plaster version that Whitney bronzed for the exposition in Chicago, which she afterwards gave to the Smithsonian Institution. The tall and muscular hero stands in a self-confident contrapposto pose, wearing a shirt of mail with two circular breastplates and a studded belt from which hangs a knife in an ornamented sheath. His long hair falls from under a casque to his shoulders, and leather straps criss-cross over his shins. Did Anne Whitney find it amusingly ironic that her *Leif Ericson* stood grandly in an exhibition honoring the four hundredth anniversary of Columbus's discovery of America?

[1] Whitney's interest in Leif Ericson continued after the completion of the statue: I found in her library at her summer home in Shelburne, New Hampshire, fifteen volumes of *The Heimskringla: A History of the Norse Kings* by Snorre Sturlason, in English from Icelandic, 1906, inscribed "A.W. 1907."
[2] Mosman letter to Whitney, 22 November 1887, Whitney Archive, Wellesley College Library.

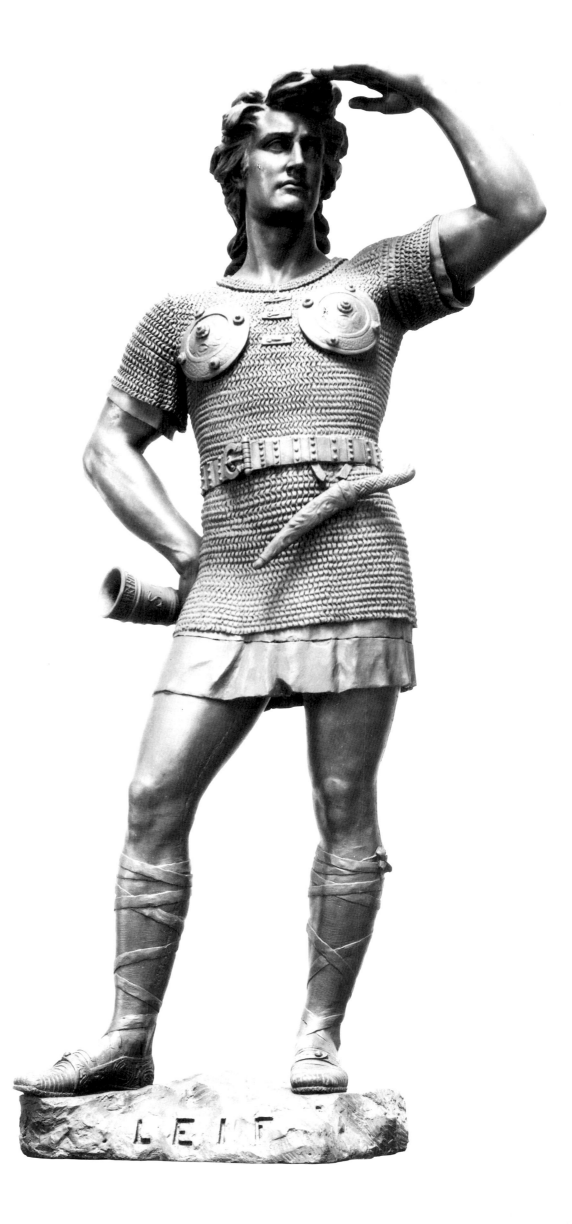

Anne Whitney (1821–1915)
Roma 1890
Bronze, 27 × 15½ × 20 in.
Wellesley College Museum, Gift of Class of 1886

In a letter dated as early as 1 December 1867 Whitney wrote to her family about the beggars in Rome: ". . . Poor old beggar women sit in the chill mornings in the sun with their hands folded round the friendly *scaldino* [foot warmer] under their rags. . . ."[1] Many who situated themselves on the Spanish Steps were licensed beggars, but Whitney found them in St. Peter's too, and she was mystified that in the Pope's city there should be indigent, uncared-for people. She was so moved that in 1869 she modeled a seated old woman, bent over with weariness, holding two coins in her right hand, her face creased from hours of sitting in the sun. By creating this realistic work, Whitney displayed an iconographic innovation in neo-classical Rome. She also seems to have caused a disturbance with her didactic image entitled *Roma*, as if saying that an impoverished woman symbolized the city. As a result Whitney had to slip the sculpture out of the city much like contraband and hide it with the American minister in Florence. It re-emerged in 1871 at the International Exposition in London. A marble version was included in the Centennial Exhibition in Philadelphia in 1876, and in 1890 Professor Eben Norton Horsford commissioned the casting of the work in bronze for Wellesley College.[2] This bronze version was unveiled by Horsford in 1891 as the gift of the Class of 1886 to Wellesley's new art building in celebration of its fifth reunion.

A noticeable change appears in the border of the beggar's dress in the later casting. In the first plaster model the hem of the dress was more ragged, and the symbols of Rome appeared within triangles. In this final bronze version the following sculptures from Rome are reproduced in miniature within medallions connected by a curvilinear vine: the *Laocoön*, the *Apollo Belvedere*, the *Dying Gaul*, and a *Hercules*. The disk that dangles from *Roma*'s left hand bears the words "Quest Vante in Roma," which can be translated, "This is what goes in Rome." Apparently the artist could not resist appending her own comment.

Whitney made a *Roma* of heroic dimensions for the Columbian Exposition of 1893, and in her diary she recorded, "The mould is safely lowered"[3] (that is, from a window of her studio on the top floor of 92 Mt. Vernon Street, where we can still see today the great expanse of glass windows that Whitney installed).

[1] Whitney Archive, Wellesley College Library.
[2] Horsford, who had left his position as professor of applied science at Harvard in 1863, used his chemical talents to invent Rumford Baking Powder and other products, which made him a millionaire. Whitney's bust portrait of Horsford (dated 1890) is in the Wellesley College Library today.
[3] Whitney Archive, Wellesley College Library.

Prior to the World's Columbian Exposition of 1893 Whitney was busy with commissions for portraits of four prominent American women: Harriet Beecher Stowe, Lucy Stone, Frances E. Willard, and Mary Livermore. These were to be installed in the exposition's Woman's Building, which Whitney later visited in Chicago, inspecting as well her *Putto with Calla Lily Fountain* at the center of the Hall of Honor and nearby her statue of *Leif Ericson*.

Whitney's letters describe her train trips to Hartford during the cold winter months of December 1891 and January 1892 to take the likeness of the author of *Uncle Tom's Cabin*. Unfortunately, at eighty, Stowe had turned senile, but her alert sister Isabella B. Hooker and the Connecticut Committee for the Exposition wanted the portrait, which today can be seen in the Stowe House in Hartford. Lucy Stone, abolitionist and suffragist, who kept her maiden name after marrying Henry Blackwell, is famous for convening the first national Woman's Rights convention in 1850 at Worcester, Massachusetts. She sat seven times for her portrait at Whitney's studio, beginning in March 1892, and the bust was finished in April. Today it is on top of a bookcase in the reading room of the Boston Public Library. Perhaps the least known of the four is Mary Livermore, a prolific writer and a tireless lecturer, who unflaggingly traveled across the country carrying the message for women's rights (she gave eight hundred lectures in twenty-five years). Mary and her husband, a Universalist minister, had been guests at Whitney's farm in New Hampshire before and thus were invited to Shelburne for sittings during the summer of 1892. A plaster cast of this portrait is preserved in the Public Library, Melrose, Massachusetts, where Livermore died in 1905.

Frances E. Willard (1839-1898) is famous as the national president of the Woman's Christian Temperance Union and founder of the world's WCTU.[1] Previously she had served as president of Evanston College for Ladies and as the first dean of women at Northwestern University. In the nineteenth century many of the suffragists, like Anne Whitney and Mary Livermore, also supported the work of the WCTU because they observed that when a husband's wages were consumed by alcohol, the rest of the family suffered. Willard was Whitney's houseguest in April 1892 and stayed until the thirtieth for her sittings. Whitney's letters resound with her enthusiasm for Willard, whose spirit she greatly admired. Undoubtedly this explains why the strongest characterization among these four marble portraits appears in the face of Willard: a wonderful sensitivity in the eyes, which have clearly articulated pupils and irises; a genial, yet resolute, expression on her face; and three lines around the mouth and eyes of this woman in her fifty-third year. Pinned to her dress are the white ribbon of the WCTU and the white rose of the suffragist movement. The clothes are also well rendered: the double collar, the puffed sleeves of the jacket, and the rippling lines of the blouse. Tendrils of hair are modeled at the nape of her neck under the bun. Whitney has a special ability for conveying subtle lines of folds in clothes, as one sees on Lady Godiva's chemise and here on the sitter's back above the signature "Anne Whitney Sc 1892."

This sculpture, preserved in a place of honor at the Willard House, a National Historic Landmark in Evanston, Illinois, is a permanent part of the WCTU museum, but the national officers have generously agreed to lend their treasure to this historic exhibition. Anne Whitney and Frances E. Willard would probably applaud their decision.

113
Anne Whitney (1821-1915)
Frances E. Willard 1892
Marble, $22 \times 18 \times 9\frac{3}{4}$ in.
National Woman's Christian Temperence Union

Elisabet Ney (1833–1907)
King Ludwig II 1869
Plaster, 29 × 20 × 12 in.
On loan from the Elisabet Ney Museum, University of Texas at Austin,
Harry Ransom Humanities Research Center

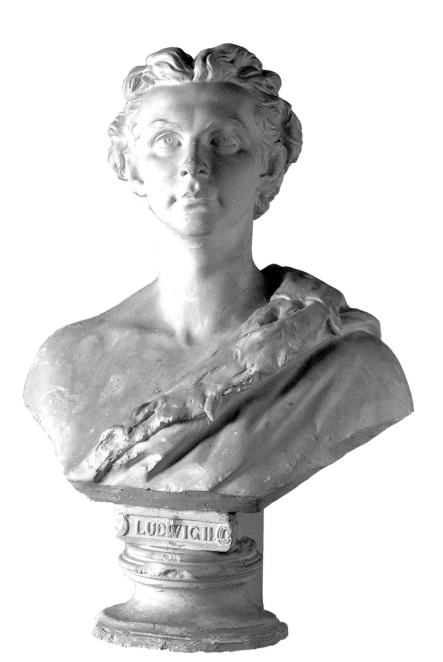

In America the name Elisabet Ney is associated with Texas—the pioneer state to which the German-born sculptor migrated in 1873. Generations of Austin schoolchildren have visited the stone studio where she worked in the last sixteen years of her life, today preserved as the Elisabet Ney Museum. But the museum's collection of her bronze and marble busts and plaster casts vividly reminds the modern-day visitor of Ney's earlier European heritage and of the extraordinary career she pursued, modeling the heads of some of the most prominent personalities in the Old World, one of whom—King Ludwig II of Bavaria—is represented in th s present exhibition.

The daughter of a Münster stonemason, Ney persuaded the art academies first in Munich (1852–54) and then in Berlin (1854–57) to admit her as a sculpture student. In Berlin, where the abundant public statuary of Gottfried Schadow still cast a neo-classical shadow, Ney studied with Schadow's protegé, Christian Daniel Rauch, then seventy-seven years old and considered Europe's greatest living sculptor (Canova had died in 1822; Thorvaldsen in 1844). Imitating the social acumen as well as the restrained classical style of her master, Ney soon made her way into "high society" and charmingly cultivated the acquaintances of luminaries such as Jacob Grimm, Alexander von Humboldt, Cosima and Hans von Bülow, and Joseph Joachim, most of whom sat for medallion or bust portraits by Ney. By 1859 she had added Arthur Schopenhauer and King George V of Hanover to her roster of sculpted likenesses. In 1865 she modeled the heroic features of Italy's Giuseppe Garibaldi (the marble bust today is in the Fort Worth Art Museum), and in 1867 she was commissioned by King Wilhelm I of Prussia to portray his political compass, Prince Otto von Bismarck. From late in 1867 through 1870, on the enthusiastic recommendation of Bismarck, she served as young King Ludwig's personal sculptor in Munich, and only upon the outbreak of the Franco-Prussian War of 1870–71 did Ney's European star begin to dim. She was suspected of being a Bismarck plant in the Bavarian court (which indeed she was, in a sense, having naively agreed to pass on to her royal sitter the political "philosophy" regularly dictated to her by the resident Prussian ambassador), and realized that her damaged relationship to the sensitive monarch could never be repaired.

Abruptly turning her back on Germany and the nightmarish web of political intrigue that had entangled her, Ney took a ship to America on 14 January 1871 with her "best friend," Dr. Edmund Montgomery (whom she had married on the island of Madeira in 1864). She first flirted with the utopian life promised by a German-founded Georgia commune, then, after giving birth to two sons, moved her family to Texas and settled into the unrewarding life of trying to make a success of a huge derelict cotton plantation near Hempstead in Waller County. Her sculptural expertise was called upon in 1890 when a group of Austin lawmakers and their "ladies" began to plan for the Texas exhibit that would be sent to the 1893 World's Columbian Exposition in Chicago. The proud Texans realized that effigies of their greatest heroes were in order, and Ney was given the challenging—and gratifying—task of creating standing statues of Stephen F. Austin and Sam Houston. She conceived of them both as youthful, in historical ("frontier") costume, but also did an ideal bust of Houston as an older man, which is represented in the present exhibition. In the last decade of her life she made up for the previous years of forced inactivity and sculpted the portraits of many prominent living Texans. Her final major work, executed in marble that she had personally selected in Italy, was the dramatic figure of *Lady Macbeth* (National Museum of American Art), completed in 1905. Ney died of a heart attack in 1907, and her life companion (to whom she had never admitted being married) Dr. Montgomery followed her in 1911.

[1] Marjory Goar, *Marble Dust, The Life of Elisabet Ney: An Interpretation* (Austin, Tex., 1984), 121.

Bismarck was so pleased with *his* portrait by Ney that he recommended her as a sculptor to the Bavarian King Ludwig II (1845–1886); and Ney, who had enjoyed Munich in her student days, was delighted to return as a court sculptor. Ludwig had ascended the throne on 10 March 1864 while still eighteen, and one of his first acts was to invite his favorite composer Richard Wagner to his court. When Ney arrived late in 1867, she was given commissions for a bust of Ludwig plus statues of Iris and Mercury and the busts of two chemists to decorate the new Polytechnic Institute. Ludwig was consumed during 1868 with his plans for Neuschwanstein Castle and did not sit for his portrait until 1869. Then Ney was given the splendid Odysseus Room in the Royal Palace for her studio, and in the mornings the young king posed for her.

When Ney once saw the king wearing the attire of the Order of the Knights of St. Hubert, she observed that he seemed more at ease than in his customary clothes and she hastily sketched him, proposing that she make a full-length statue of him in the gold embroidered robe with the sword at his side. The idea appealed to the theatrically minded king, but he found the sittings tedious and requested that literature be read to him. In order to keep him involved with this project, Ney dressed in a Grecian white robe one day and recited Goethe's *Iphigeneia in Taurus*.[1] Ludwig, patron of the arts, was enchanted and mollified. And today the large marble sculpture stands awesomely in Ludwig's castle on the island of Herrenchimsee.

In terms of the monarch's visionary look, the portrait bust in this exhibition is very close to the full-length statue. The clothes are more informal in the bust, however, which is the intermediate version between Ney's first clay model and the final marble sculpture that is preserved today at Castle Hohenschwangau.

Ney was in America when she learned that Ludwig had been declared insane for his reckless spending and had presumably committed suicide by walking into Lake Starnberg at Neuschwanstein just before his forty-first birthday. Once Ney was settled in Austin, Texas, in a studio that she called "Formosa" (Portuguese for "beautiful"), she had this plaster bust, modeled in happier days, shipped to her, as well as the full-length plaster statue of Ludwig, which was exhibited en route at the Columbian Exposition in Chicago.

115
Elisabet Ney (1833–1907)
Sam Houston 1899
Bronze, 31 × 23 × 15 in.
On loan from the Elisabet Ney Museum, University of Texas at Austin, Harry Ransom Humanities Research Center

When the Texas committee for the World's Columbian Exposition commissioned Ney to sculpt statues of Sam Houston and Stephen F. Austin, her first inclination was to model them in their old age in recognition of their years of accomplishments. This bronze bust was Ney's first idea for the portrait of Houston (1793–1863), the lawyer who served as governor of Tennessee before moving to Texas. Houston has the distinction of having been the first president of the Republic of Texas and serving for twenty-five years both as United States senator and as governor. Given Houston's legal training and political offices, it is understandable that Ney would clothe him in timeless classical robes and imbue him with the patriarchal air of a Roman senator. Her final decision was to depict Houston and Austin at a more youthful stage, as virile, far-seeing, buckskin-clothed pioneers. Today Ney's marble full-length sculptures of the two Texas leaders are in the United States Capitol in Washington, D.C., and in the foyer of the main entrance to the Texas capitol in Austin.

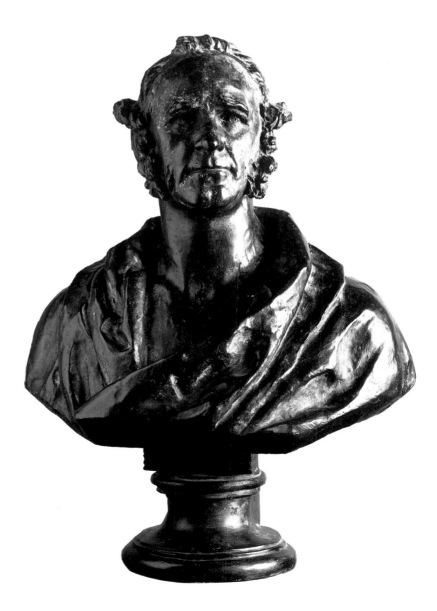

Evelyn Beatrice Longman (1874–1954)
Victory 1903
Bronze, 28 × 8¼ × 7¼ in.
The Metropolitan Museum of Art,
Gift of Edward D. Adams, 1912

Evelyn Longman is best known today for her statue *Genius of Electricity*, which for sixty-four years stood atop the twenty-six-story American Telephone and Telegraph Building at 195 Broadway in New York City, and which was again in the news in 1981 when it traveled uptown to be installed in the lobby of the new AT&T building designed by Philip Johnson and John Burgee at 550 Madison Avenue. Renamed *The Spirit of Communications*, and more popularly called "Golden Boy," this twenty-two-foot-tall gilded bronze nude, holding symbolic bolts of electricity over his head with coils of cable wound around his torso, was initially installed 434 feet above street level in 1916 and became a familiar figure over the years by its continued appearance on the cover of telephone books.

Born in a cabin in Winchester, Ohio, into a family of six children, Longman took a job at fourteen in a wholesale house in Chicago while attending evening classes at the Art Institute of Chicago. She saved enough money to enroll at Olivet College in Michigan, but after a year and a half there, she realized that what she really wanted was training in sculpture with Lorado Taft. She therefore returned full-time to the Art Institute of Chicago, serving as Taft's studio assistant during the summers of 1898 and 1899. She accelerated her program of studies in order to finish within two years and graduated with highest honors. In 1900 Longman went to New York, where she assisted Hermon A. MacNeil and Isidore Konti on the decorations for the Pan-American Exposition of 1901. She also met Daniel Chester French at this time and subsequently worked for him for three years. She was the only woman ever admitted as an assistant in French's studio. Mrs. French recalls, "She was young, and I remember the first day she came to our house. She wore a grey hat with a curling feather down over her ear which with the dark eyes beneath, took Mr. French's eye, quite as much as the reputation she had already acquired as to talent."[1] It was during this period that Longman modeled the head of the Frenches' daughter Peggy (1899–1973, who later became a sculptor), a vivacious, smiling young girl with grape leaves in her hair, and cast it in bronze.

Meanwhile Longman also opened her own studio and was chosen to create a *Victory* statue for the St. Louis Exposition of 1904. In 1906 she entered the competition for the bronze doors of the chapel at the United States Naval Academy in Annapolis and won the $20,000 commission over thirty-three other sculptors. The success of these reliefs resulted in a second commission for doors, this time on the library at Wellesley College (1911). Among the many bust portraits she made was one of educator Alice Freeman Palmer, Wellesley's second president, for the Hall of Fame. When Longman and the architect Henry Bacon collaborated on the *Fountain of Ceres* for the Panama-Pacific Exposition of 1915, they received an award for their work; they collaborated again on the Illinois Centennial Monument for Logan Square, Chicago, in 1918. In both instances Longman created allegorical figures in a classical style. She also did much of the decorative work on Daniel Chester French's Lincoln Memorial in Washington, D.C.[2]

Longman lived in New York City until her marriage on 28 June 1920 to Nathaniel H. Batchelder, headmaster of the Loomis School in Windsor, Connecticut. She then moved her studio to Windsor and thereafter took on commissions for many monuments in Connecticut: war memorials in Naugatuck and Windsor; the Spanish War Memorial of Victory on a ship's prow for Bushnell Park, Hartford (1927); and a decorative frieze for the Post Office and Federal Building in Hartford (1933). Longman's most famous portrait was done in this period: a six-foot bust of Thomas A. Edison, the only one for which he sat. She spent two weeks at Edison Laboratories in Fort Myers, Florida, shortly before the inventor's death in 1931, taking measurements of her subject. According to *Art Digest*, her bust of Edison was among the portraits to be seen at Longman's exhibition at the Grand Central Galleries in 1932.[3]

Longman was the first woman sculptor elected to full membership in the National Academy of Design.[4] Among the many awards bestowed on her were the W.M.R. French Gold Medal at the Art Institute of Chicago in 1920, the Widener Gold Medal at the Pennsylvania Academy of the Fine Arts in 1921, and the Watrous Gold Medal at the National Academy in 1923. She died after a long illness at seventy-nine in Osterville, Massachusetts, and was survived by her husband.[5]

Evelyn Longman was chosen to provide a *Victory* statue for the Varied Industries Building at the St. Louis Exposition of 1904. But her sculpture was so well received that instead of placing it on this building, it was put on the dome of Festival Hall, the centerpiece of the entire exposition, and the sculptor was awarded a silver medal.[6] A small-size replica was later used as a trophy awarded in athletic competitions by the Atlantic Fleet of the United States Navy.

Longman's youth stands on tiptoes on a globe, shouting victory—with his mouth open and his arms upraised, holding aloft a laurel wreath and an oak spray. He wears a short tunic, greaves, and a mantle that blows around his body. The twenty-eight-inch bronze statue shown here is a reduction of the original.

[1] Mrs. Mary Adams French, *Memories of a Sculptor's Wife* (Boston and New York, 1928), 188.
[2] Ibid., 259.
[3] "A Longman Show," *Art Digest* 6, no. 8 (15 January 1932), p. 13.
[4] Beatrice Gilman Proske, *Brookgreen Gardens Sculpture* (Brookgreen, S.C., 1943), 138.
[5] "Evelyn Longman Sculptor, 79, Dies," *The New York Times*, 11 March 1954, p. 34.
[6] Jonathan A. Rawson, Jr., "Evelyn Beatrice Longman: Feminine Sculptor," *International Studio* 45 (February 1912), 101.

117

Janet Scudder (1869–1940)
Frog Fountain 1903
Bronze, $37\frac{1}{2} \times 25\frac{1}{2} \times 19$ in.
The Metropolitan Museum of Art, Rogers Fund, 1906

After the first great wave of American sculptors—male and female—went to Rome in the nineteenth century to be near the source of Italian marble and have access to experienced stonecutters, a second wave of American sculptors went to Paris at the turn of the century. Janet Scudder was among these new sculptors, who became famous for their garden sculpture, and she remained in Paris for forty-five years. Despite her prolonged foreign residency, Scudder modeled statues for fountains that were as popular with American clients as those by her contemporaries in the National Sculptors' Society, such as Brenda Putnam (1890–1975), Harriet Frishmuth (1880–1980), and Anna Coleman Ladd (1878–1939).

One possible vanity of Scudder's was to be vague about the year of her birth. In her autobiography she loosely mentioned that she was born in the 1870s,[1] but Lewis W. Williams II checked with the Indiana State Library, which supplied the date 27 October 1869 from Vigo County birth records.[2] Scudder was the fifth child born into this Terre Haute family. Her mother died when she was only five, and she was raised by her father and a stepmother. At eighteen she entered the Cincinnati Academy of Art for its three-year program and studied sculpture with Louis Rebisso. Upon graduation in 1891 she moved to Chicago, where she was hired as one of the female assistants in Lorado Taft's studio, known as "White Rabbits," working with Taft on his sculptural projects for the World's Columbian Exposition. With the money she earned, Scudder departed for Paris in 1893 with Zulime Taft (Lorado's sister). Because Scudder had admired Frederick MacMonnies's sculpture at the Columbian Exposition, she insisted upon studying with him in Paris, and within a year she became one of his assistants. When her money ran out, she returned to New York and secured enough commissions for portrait medallions to move back to Paris in 1896. She was the first American woman to have her portrait medallions accepted by the Musée du Luxembourg.

A trip to Italy introduced Scudder to the youthful nude figures of Roman and Renaissance art, and back in Paris she modeled *Frog Fountain*, which resulted in new commissions from American art patrons for garden statues. She bought a marvelous villa on the edge of Paris at St. Cloud and was able to experiment in her own garden with new sculptural ideas.

At the time of World War I, Scudder helped to organize the Lafayette Fund for war relief, and upon America's entry into the war, she served overseas with the YMCA and the Red Cross. She even turned her house over to the YMCA. In 1925 the French Government recognized her humanitarian aid by making her a chevalier of the Legion of Honor.

Success came to her early in the twentieth century when the architect Stanford White bought the *Frog Fountain*. The Art Institute of Chicago acquired *Fighting Boys Fountain*, and *Young Diana* received honorable mention at the Paris Salon of 1911. She won a silver medal at the Panama-Pacific Exposition of 1915 and was selected an associate member of the National Academy in 1920. Further prizes were the Olympiad Medal at Amsterdam in 1928 and a silver medal at the Paris Exposition of 1937.

In the fall of 1939 Scudder returned to New York, taking up residence at 38 West 9th Street. The next summer she rented a cottage in Rockport, Massachusetts, hoping to recuperate from pneumonia, but she died suddenly on 10 June at seventy years of age. *The New York Times* ran a photograph with her column-long obituary, calling her one of the world's foremost women sculptors and sub-headlining that her works were shown in fourteen museums.[3]

All writers hail Scudder's *Frog Fountain* as her most famous garden statue. When the American architect Stanford White acquired the first one she made, he recommended that she make four more.

Scudder devotes a chapter in her autobiography to this sculpture and relates how a four-year-old street urchin posed in her Paris studio: "In that moment a finished work flashed before me. I saw a little boy dancing, laughing, chuckling all to himself while a spray of water dashed over him. The idea of my Frog Fountain was born."[4] The animated little nude boy, balancing himself on one foot by stretching out his arms, peers downward at the three frogs through whose open mouths spray is emitted. Water lilies are appropriately entwined in the hair of this playful little sprite.

[1] Janet Scudder, *Modelling My Life* (New York, 1925), 3.
[2] Lewis W. Williams II, "Janet Scudder," *Notable American Women*, vol. 3 (Cambridge, Mass., 1971), 252–53.
[3] Obituary, *The New York Times*, 11 June 1940, p. 25.
[4] Scudder, *Modelling My Life*, 172.

118
Abastenia St. Leger Eberle (1878–1942)
Roller Skating 1906
Bronze, 13 × 11¾ × 6¼ in.
Whitney Museum of American Art,
Gift of Gertrude Vanderbilt Whitney

The work of Abastenia Eberle was the sculptural counterpart of the Ashcan School of painting early in the twentieth century in New York City. Eberle was, in fact, so taken with the naturalism of life on the Lower East Side of New York amid the recently arrived immigrants that she rented two rooms under the Manhattan Bridge, using one as a studio and the other as a playroom with toys for the tenement children who posed for her. *Playing Jacks*, *Yetta and the Cat Wake Up*, and *On Avenue A* (also called *Dance of the Ghetto Children*) were among her sculptures of this period.

Eberle was born to Canadian parents living in Webster City, Iowa. She grew up in Canton, Ohio, where she had her first art training with a local sculptor who was a patient of her physician-father's. In 1899 she began the three-year program at the Art Students League in New York City, studying with C.Y. Harvey, George Grey Barnard, and Kenyon Cox, and was able to pay her way through school with prizes and scholarships. Eberle received her first public recognition in 1904 when a large sculpture *Men and Bull*, made jointly with Anna Vaughan Hyatt (see cat. no. 120), was highly praised by Augustus Saint-Gaudens in the exhibition of the Society of American Artists and recommended for the St. Louis Exposition, where it won a bronze medal.[1]

Eberle's realistic renditions of New York street scenes began with *Roller Skating* in 1906, followed by *Girls Dancing* (also called *Ragtime*) in 1907. Her first trip abroad was in 1907, when she went to Naples in order to cast her works in bronze more cheaply than she could in New York. She caused a bit of a sensation because the Neapolitans had never seen a woman at work in a foundry before. On her return to New York she took a studio in Greenwich Village and resumed working on such urban subjects as *Woman Picking up Coal* (1907) and *Ragpicker* (1911). Two of her sculptures were exhibited in the Armory Show of 1913: *Girls Wading* (1913, Corcoran Gallery of Art) and *White Slave* (1913, private collection, Westport, Connecticut). During this period Eberle exhibited regularly at the Macbeth Gallery in New York, the National Academy of Design, and the Pennsylvania Academy of the Fine Arts. Her work was included in three international exhibitions: Venice, 1909, Rome, 1911, and Paris, 1913. She was also active in the suffrage movement, leading the section of sculptors in a Fifth Avenue parade in 1911 and contributing to an exhibition for the benefit of woman's suffrage at the Macbeth Gallery in 1915.

In 1920 the National Academy elected Eberle an associate member, but a heart condition was beginning to sap her energy, and she failed to meet the requirement of participating in two successive annual exhibitions to achieve full membership.[2] She won the Garden Club of America prize for her fountain *Boy Teasing Fish* in 1929, and two years later the Allied Artists of America awarded her the Lindsey Morris Memorial Prize for a small bronze sculpture.[3]

Eberle bought an old barn in Westport, Connecticut, which she converted into a studio in 1931 for summer use and eventually expanded and winterized for year-round living. Her last sculpture, *Madam Pharazan*, was shown at the National Sculpture Society exhibition at the Whitney Museum of American Art in 1940. She died in New York City at the home of a longtime friend and former pupil just two months before her sixty-fourth birthday. After services at the Episcopal Church of the Incarnation on Madison Avenue, she was buried in Fairfield, Connecticut.

Roller Skating was Eberle's first study of New York street children. A cast of this work, which has become very popular, was purchased by the Metropolitan Museum in 1909, making Eberle the youngest sculptor represented in the museum at that time.[4] In this small bronze Eberle has caught the motion and vivacity of a youngster—with one foot on the ground and her arms outstretched. The idea of rapid forward movement is conveyed by the blowing backward of the girl's hair and skirt. The child's face vividly expresses her youthful excitement at self-propulsion.

[1] Louise R. Noun, *Abastenia St. Leger Eberle, Sculptor* (Des Moines Art Center, Des Moines, Iowa, 1980), 4.
[2] Ibid., 16.
[3] Beatrice Gilman Proske, *Brookgreen Gardens Sculpture* (Brookgreen, S.C., 1943), 158.
[4] Noun, *Abastenia St. Leger Eberle*, 5.

Abastenia St. Leger Eberle (1878–1942)
The Windy Doorstep signed and dated 1910
Bronze, $13\frac{5}{8} \times 9\frac{5}{8} \times 6\frac{3}{8}$ in.
Worcester Art Museum, Worcester, Massachusetts

Eberle is represented in this exhibition by two of her most celebrated works. *The Windy Doorstep* received the prize for the best piece of sculpture by an artist under thirty-five at the National Academy in 1910 and a bronze medal at the Panama-Pacific Exposition of 1915. The sight of a farm woman sweeping her door stoop in Woodstock, New York, inspired Eberle to sculpt this figure. Again, the artist succinctly conveys motion in the skirt and apron that are blown to the side, combining it this time with a sense of determination as the lowered head (bound in a kerchief) concentrates on the task.

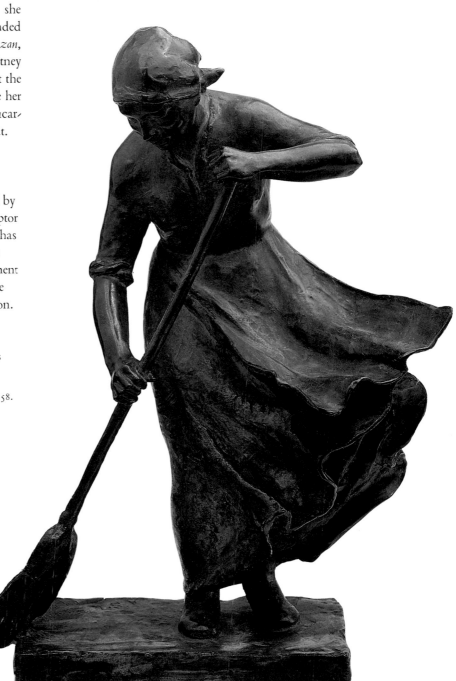

120
Anna Hyatt Huntington (1876–1973)
Joan of Arc 1915
(photographed without replaced quillon
during restoration)
Bronze, marked Gorham Co. Founders,
$49\frac{7}{8} \times 32 \times 13\frac{1}{2}$ in.
Dallas Museum of Art, Kiest Memorial Fund

A giant among artists, Anna Hyatt Huntington lived to be ninety-seven and capped her seventy-year career as a sculptor with the last of her seven heroic equestrian monuments, *General Israel Putnam*, completed when she was ninety.

Born in Cambridge, Massachusetts, where her father, Alpheus Hyatt, was a professor of paleontology at the Massachusetts Institute of Technology, and her mother, Audella, painted landscapes and sketched diagrams for her husband's books, Anna was encouraged, along with her elder sister Harriet, to pursue sculpture classes with Henry Hudson Kitson in the 1890s. For Anna's first exhibition in 1900 at the Boston Arts Club she already had forty animal sculptures to display. She then moved to New York City to further her studies at the Art Students League with Hermon MacNeil and to obtain criticism from Gutzon Borglum. She also spent much time at the Bronx Zoo studying the wild animals and often carried two or three models with her on the subway so that she could work on several different poses at once.[1] The *Men and Bull* sculpture on which she and Abastenia St. Leger Eberle collaborated received a bronze medal at the Louisiana Purchase Exposition of 1904.

The marriage of Anna Hyatt to Archer Milton Huntington took place in 1923 in the studio that she shared with sculptor Brenda Putnam on 12th Street in New York. Among the massive sculptures she subsequently modeled were *El Cid Campeador*, erected in Seville in 1927,[2] and many Spanish subjects for the terrace of The Hispanic Society of America, founded by Mr. Huntington in New York in 1904. The Spanish government was moved to decorate her with the Grand Cross of Alfonso the Twelfth in 1929. When the Huntingtons were returning home by boat from Spain, they noticed an advertisement for the Brookgreen plantation in South Carolina. Mr. Huntington, the adopted son of the railroad magnate Collis Potter Huntington, bought the 10,000 acres, and in 1932 the outdoor museum at Brookgreen Gardens was opened. Not only did this enable Anna Huntington to show her work but she and her husband commissioned works of other sculptors during these lean years of the Depression. The American Academy of Arts and Letters awarded Huntington the Gold Medal for Distinction in 1930 and six years later organized a retrospective exhibition of 171 of her works.

A true lover of animals since her childhood, the sculptor did not enjoy the city life of New York, so in 1940 the couple settled at Stanerigg, an estate in Redding Ridge, Connecticut. In her specially built studio she developed huge works such as *Fighting Stallions*; *Lincoln*, which she gave to New Salem, Illinois; and the energetic equestrian statue of *José Martí*, the Cuban patriot, for Central Park in New York City.

In addition to her bronze sculptures, some of her works were cast in aluminium, and she was thus one of the first American sculptors to use this lightweight metal in her work. Her dynamic sculptures are located today in more than two hundred museums and parks around the world. One of the pieces recently in the news was her *Young Diana* of 1924 (Boston Museum of Fine Arts), for which Bette Davis recalls posing in the nude during her teens. One of Huntington's last philanthropic deeds was her gift of a fire truck to the town of Redding, where she peaceably lived her last years among her Scottish deerhounds and many species of birds protected in a special sanctuary.

When Anna Hyatt was living in France, she became so inspired by the story of Joan of Arc that she created an equestrian statue of the heroine. It received honorable mention when it was exhibited at the Paris Salon of 1910, even though the judges could scarcely believe that a woman had done it. This success resulted in Hyatt's being chosen as sculptor for a monument to the Maid of Orleans for Riverside Drive in New York. The committee that commissioned this sculpture wanted to celebrate the five hundredth anniversary of Joan of Arc's birth, and it spent two years looking at the statues in France and studying the submitted designs before awarding the coveted commission to Hyatt.

Marion Allen in her portrait of Hyatt (see cat. no. 21) has captured the moment when the sculptor was creating a maquette for this commission in which the French heroine holds aloft a straight sword. Of the five full-size castings of this statue—in New York City; Blois, France; Gloucester, Massachusetts; the Plains of Abraham in Quebec; and the California Palace of the Legion of Honor—the sword is bent in the New York version. But proof of the way it was modeled by the artist is given in Allen's portrait as well as in the 1915 photographs of the completed work. Of course, the sword raised high turns out to be a fragile part of the sculpture. Of the medium-sized models, like the one on loan to our exhibition, the example in the Munson-Williams-Proctor Museum recently suffered damage to the sword in transit from the museum to which it had been lent, and the one at the Archer M. Huntington Gallery at the University of Texas has a reconstructed sword.[3] The circular quillon on the version in Dallas is different from Hyatt's first conception as she described the sculpture in an interview: "I thought of her there before her first battle, speaking to her saints, holding up the ancient sword. Her wrist is sharply back, to show them the hilt, which is in the form of a cross."[4] Her original conception can be seen today in the *Joan of Arc* on permanent display at the Brookgreen Gardens. Since Hyatt made these middle-sized versions as preliminary models, Beatrice Gilman Proske and Ronald Christ[5] believe that this variation of the circular hilt would have been made by Hyatt because she had found an authentic French prototype. The fact that Hyatt carefully researched the historical accuracy of Gothic armor for this sculpture in consultation with Bashford Dean, then curator of armor at the Metropolitan Museum, has been confirmed in more than one contemporary account.[6]

As Hyatt has modeled her, an inspired Joan stands up in her saddle with her weight on the stirrups, ready to lead her French troops in battle against the English and Burgundians. She is astride a vigorous Norman horse, which is depicted in motion. Several contemporary critics wrote about this unusual commission because it was the first time a woman had ever attempted a large equestrian statue, and Hyatt had to build the large armature herself for the sculpture. When questioned about the difference between her conception of Joan as a frail girl rather than the rustic peasant of Jules Bastien-Lepage's painting[7] or the "robust peasant, with an opulent bosom beneath the cuirass," of Emmanuel Frémiet's sculpture,[8] Hyatt answered that she believed her heroine was a person of the highest spiritual aspirations and therefore, instead of brandishing her sword, she carried it as a "sword of spirit," looking heavenward for guidance to lead her troops.

The completed bronze statue on a granite base (with some stone included from Joan's Rouen dungeon)[9] was unveiled on Riverside Drive at 93rd Street on 6 December 1915. The French government honored Hyatt by naming her a chevalier of the Legion of Honor in 1922, the year that a casting of Joan was erected in Blois.

[1] Beatrice Gilman Proske, "Anna Hyatt Huntington," *Brookgreen Bulletin* (Fall 1973), 5.
[2] Bronze replicas of her *El Cid* were placed at The Hispanic Society of America in New York; in Balboa Park, San Diego; at the California Palace of the Legion of Honor, San Francisco; and in Buenos Aires.
[3] I am grateful to Dr. Andrea S. Norris, chief curator at the Archer M. Huntington Gallery, University of Texas, who conveyed to me the opinion of Ronald Christ.
[4] Grace Humphries, "Anna Vaughn Hyatt's Statue," *The International Studio* 57, no. 226 (December 1915), p. XLVIII.
[5] Beatrice Gilman Proske, curator emerita of sculpture at The Hispanic Society of America, and Ronald Christ are collaborating on a joint publication of Anna Hyatt Huntington's life and letters.
[6] Humphries, "Anna Vaughn Hyatt's Statue," 50; and Charles H. Caffin, "Miss Hyatt's Statue of Joan of Arc," *The Century* 92, no. 2 (June 1916), p. 311.
[7] Frank Owen Payne, "Noted American Sculptors at Work," *Art and Archaeology* 21, no. 1 (March 1926), p. 124. Payne is referring to the *Joan of Arc* painting in the Metropolitan Museum.
[8] Caffin, "Miss Hyatt's Statue of Joan of Arc," 310.
[9] Humphries, "Anna Vaughn Hyatt's Statue," 50.

Bessie Potter Vonnoh (1872–1955)
Allegresse 1921
Bronze, $25\frac{1}{2} \times 23\frac{1}{2} \times 12\frac{1}{2}$ in.
Detroit Institute of Arts, City of Detroit Purchase

Success came early to the St. Louis-born Bessie Potter, who at twenty-two already had her own studio in Chicago. Her family had moved to Chicago in 1874, and at eighteen she enrolled at the Art Institute of Chicago for sculpture classes with Lorado Taft. She became one of the female assistants, nicknamed "the White Rabbits," in Taft's studio, working on sculpture for the Columbian Exposition of 1893, and she modeled the figure *Art* for the Illinois State Building. Taft relates that it was at this exposition that Potter saw the small bronzes by Paul Troubetskoy that influenced her to experiment with bronze figurines,[1] and today most museums in America have at least one of her small bronzes: *The Young Mother* (1896), *Girl Dancing* (1897), *Daydreams* (1903), the group entitled *Motherhood* (1903), or *The Fan* (c. 1910). Her fame soon spread beyond Chicago, and she exhibited several pieces at the Tennessee Centennial of 1897. More remarkably, she was commissioned by the Fairmount Park Art Association in Philadelphia to model a colossal portrait bust of Major-General S.W. Crawford as part of a Civil War memorial. This was followed by a similar commission to sculpt a marble bust of Vice President James S. Sherman in 1911 for the United States Senate Building.

Bessie Potter met Rodin on a trip to Paris in 1895 and made a trip to Florence before getting married in 1899 to Robert Vonnoh, a painter whom she had met in Lorado Taft's studio. They made their home in New York City and later in the artists' colony in Lyme, Connecticut. Meanwhile she began to be awarded prizes: a bronze medal for *The Young Mother* at the Paris Exposition of 1900, an honorable mention at the Pan-American Exposition (1901) in Buffalo, a gold medal at the St. Louis Exposition (1904), the Shaw Prize at the National Academy in New York for *Enthroned* (1904), and a silver medal at the Panama-Pacific Exposition in San Francisco (1915). In 1913 the Brooklyn Museum gave her an exhibition, and she had work accepted into the Armory Show. During the 1920s and 1930s she turned to life-size statues: a bird fountain for Ormand Beach Park, Florida; a bird bath of two children for the Audubon Society's bird sanctuary near Theodore Roosevelt's grave at Oyster Bay, Long Island (1925); and a group of children for the fountain memorializing Frances Hodgson Burnett (author of *Little Lord Fauntleroy*) in the Children's Garden, Central Park (1937).

In 1906 she became an associate member of the National Academy of Design, and she received its Gold Medal in 1921. Bessie and Robert Vonnoh had several two-person exhibitions in New York galleries in the second and third decades of this century. They were living on the French Riviera at Nice when he died in 1933 at age seventy-five. Bessie Vonnoh returned to New York, but she tapered off in her work. In 1948 she married Dr. Edward Keyes, who passed away nine months later. She died at her home (33 West 67th Street) on 8 March 1955,[2] five months before her eighty-third birthday.

In 1921 the National Academy bestowed its Watrous Gold Medal on Bessie Vonnoh's *Allegresse*. This group sculpture is typical of Vonnoh's work and displays several of her strengths. She was extremely successful at combining figures, emphasizing their intrinsic links, in much the way Käthe Kollwitz was at the same time modeling integral family units. But in addition, Vonnoh—under more auspicious political conditions—created joyous works: for instance, *The Minuet* (1897, Sheldon Art Gallery in Lincoln, Nebraska), and *Sea Sprite*, a fountain of a happy nude girl standing on a fish (exhibited in San Francisco, 1929).[3] Vonnoh was adept at modeling both the nude and the clothed figure, in the latter case favoring Grecian drapery (see, for example, *The Fan* [c. 1910], Holladay Collection, The National Museum of Women in the Arts, and *In Grecian Draperies* [c. 1928], Fort Worth Art Museum). Although her figurines are usually static, and sometimes affectionate groupings, when she sculpts her dance pieces, they are quite naturally lively and exceedingly graceful works. Another cast of *Allegresse* is in the Museo de Arte in Ponce, Puerto Rico.

[1] Lorado Taft, *The History of American Sculpture* (reprint, New York, 1969), 449.
[2] Obituary, "Bessie P. Vonnoh, Sculptor, Was 82," *The New York Times*, 9 March 1955, p. 27.
[3] Illustrated in *Contemporary American Sculpture* (The California Palace of the Legion of Honor, San Francisco, 1929), 321.

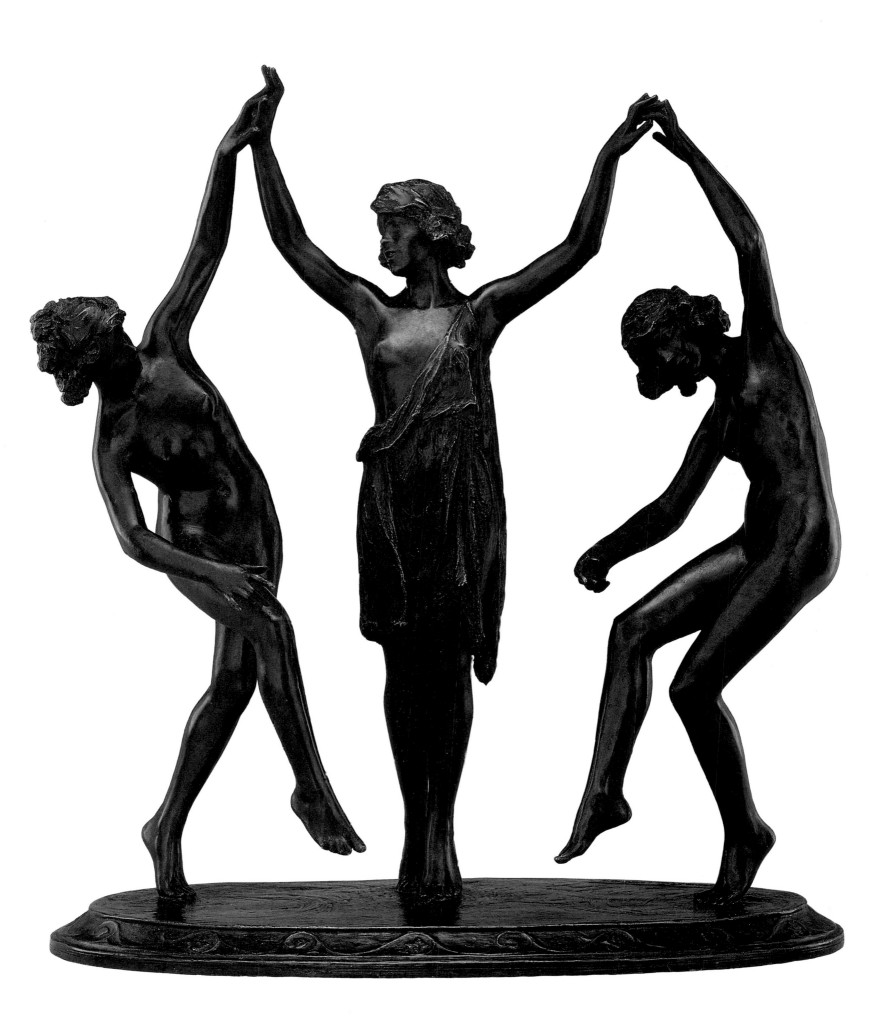

Malvina Hoffman (1885–1966)
Nijinsky in "L'Après-midi d'un faune" 1912
Bronze, 8⅝ × 16½ × 4¼ in.
The Malvina Hoffman Estate, Courtesy of Berry-Hill Galleries,
New York

Malvina Hoffman, who in life traveled with celebrities, in death shared the front page of the 11 July 1966 *New York Times* with Martin Luther King and Mayor John Lindsay. A photograph of the sculptor accompanied her obituary, and a photograph of her *Mongolian Archer* was reproduced on an inside page.

Hoffman was born in a brownstone house on West 43rd Street in New York, the youngest daughter of an English pianist who at eighteen was accompanist to Jenny Lind on her first American concert tour.[1] While attending the Brearley School, Hoffman also studied at the Women's School of Applied Design and at the Art Students League. Later at the Veltin School she took painting with John Alexander and modeling with Herbert Adams and George Grey Barnard. When Gutzon Borglum, the sculptor of Mount Rushmore, saw her clay portrait of her father, he encouraged her to carve it in marble. The finished work was exhibited in 1910 at the National Academy of Design.[2] This same year her bust of Samuel B. Grimson received an honorable mention at the Paris Salon.

In 1910 she went to Europe, first to Italy and then to Paris, where she took a studio at 72 rue Notre-Dame des Champs, the same building in which Elizabeth Nourse (cat. no. 49) had lived eighteen years earlier and still the neighborhood of Elizabeth Gardner Bouguereau (cat. no. 46). Her first commission there was the portrait of the American ambassador, Robert Bacon.[3] Armed with a letter of introduction, she tried five times to meet Rodin before finally gaining admission to his studio. Then she easily ingratiated herself by finishing a Musset poem in French when the aging sculptor's memory faltered. She studied with Rodin for sixteen months, until the $1,000 supporting her European stay ran out. On her return to New York she followed Rodin's advice and studied dissection and anatomy at Columbia University College of Physicians and Surgeons before returning to work with Rodin for two more summers. She learned bronze casting, chasing, and finishing at foundries, while at the same time developing a wide circle of artistic friends: Pavlova, Nijinsky, Diaghilev's ballet corps, Matisse, Brancusi, and Mabel Dodge. Janet Scudder (see cat. no. 117) took her to her first soirée at Gertrude Stein's. As Hoffman wrote, "These were the days of Jean Cocteau and d'Annunzio, of Maeterlinck, and Mary Garden's great performance in *Pelléas et Mélisande*; of Romaine Brooks, the painter. . . ."[4] Hoffman strove to capture the new freedom in the dance in her sculpture and won first honorable mention for *Russian*

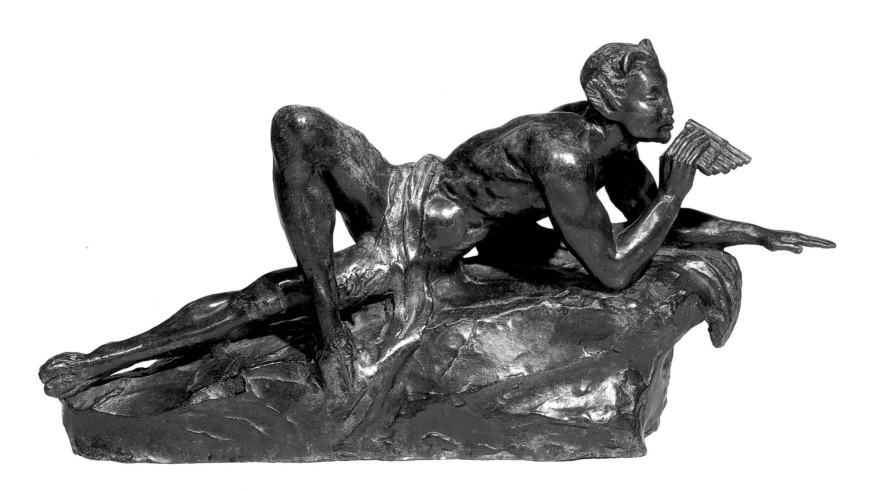

Dancers at the Paris Salon in 1911 and the Shaw Prize at the National Academy in 1917 for *Bacchanale Russe*, which represents Anna Pavlova and Mikhail Mordkin. A six-foot cast of the latter was bought by a group of French critics and museum representatives to be placed in the Luxembourg Gardens.

Hoffman worked for forty-five years in the studio that she found over a florist's shop at 15 East 35th Street in New York City. Among her large commissions in the 1920s were: *The Sacrifice*, a war memorial of an armored knight being held by a grieving woman, which was given by Mrs. Martha Bacon to the chapel at Harvard University, and her monumental, heroic figures of England and America entitled *To the Friendship of the English-Speaking Peoples*. In 1925, when the sculpture was installed, the dauntless sculptor mounted the porch ninety feet above street level in London with her mallet and chisel "to deepen many of the accents on the faces and shields."[5]

An exhibition of Hoffman's work was held at the Grand Central Art Gallery in New York in 1929. It included 105 pieces of sculpture and traveled to museums around the country for five years. Also in 1929 she was given her largest commission—over one hundred sculptures for the *Races of Mankind* exhibition at the Field Museum of Natural History in Chicago. For this project she traveled around the world for two years to study people in their native environments. Her husband, Samuel Grimson, the violinist, whom she had married in 1924, traveled with her and handled the photography (they later divorced in 1936).

In 1948 the United States Fine Arts Commission asked Hoffman to make bas-reliefs for the American War Memorial Building in Epinal, France, and this was followed by a second commission for bas-reliefs for Joslin Hospital in Boston in 1956. Hoffman's realism made her a popular portraitist, and she counted among her sitters Henry C. Frick, founder of the Frick Museum (portrait completed posthumously in 1920); Ignace Paderewski (four busts in 1922); Ivan Meštrović, the Yugoslav sculptor (1925); Wendell L. Willkie (1944); Felix M. Warburg (1935); Teilhard de Chardin (1948); Katharine Cornell (1961); and Marguerite Yourcenar (1961).

Hoffman was the recipient of many awards, including the National Sculpture Society's Gold Medal of Honor (1964), and five honorary degrees. She was promoted to full membership in the National Academy of Design in 1931 and was made chevalier of the Legion of Honor in 1951. At eighty-one, Hoffman died of a heart attack in her sleep at her studio. Among her longtime friends who participated in the Episcopal funeral service at the Church of the Incarnation were the poet Marianne Moore and the organist Virgil Fox. With her accomplishments, Hoffman had gained an international reputation.

Malvina Hoffman saw Vaslav Nijinsky (1890-1950) dance in Paris in 1912 and based two sculptures on his famous role in *The Afternoon of a Faun*. Just three years earlier the Polish-born Russian dancer had made his Paris debut with Diaghilev's Ballet Russe, and now in 1912 he was introducing the ballet choreographed to Claude Debussy's tone poem *L'Après-midi d'un faune*.

In her realistic style Hoffman depicts the lithesome, artfully draped, almost nude figure, reclining on the ground and playing musical pipes. The only apparent make-up for Nijinsky were the pointed ears and the hoofs of a goat to authenticate him as a faun. The bronze figurine, the second of two lifetime castings, has a warm dark brown patina.

[1] Malvina Hoffman, *Heads and Tales* (New York, 1936), 19.
[2] Myrna Garvey Eden, "Malvina Cornell Hoffman," *Notable American Women, The Modern Period* (Cambridge, Mass., 1980), 343.
[3] Malvina Hoffman, *Yesterday is Tomorrow* (New York, 1965), p. 111.
[4] Hoffman, *Heads and Tales*, 52.
[5] Hoffman, *Yesterday is Tomorrow*, 217.

Malvina Hoffman (1885-1966)
Pavlova in "La Gavotte" 1915
Bronze, 14 × 8 × 5 in.
The Malvina Hoffman Estate, Courtesy of Berry-Hill Galleries, New York

Hoffman made many representations of the prima ballerina Anna Pavlova (1885-1931) in the course of her career. She had never forgotten the electricity of the first time she saw Pavlova dance with Mikhail Mordkin in Glazunov's *Autumn Bacchanale* in London in 1910, when she had returned to further performances to make sketches.[1] Later in Paris, when she was studying with Rodin and wished to liven up her work, her memory of the Russian dancers was so vivid that the sculptures she made of them were able to capture their joyous, energetic movements. [*continued on next page*]

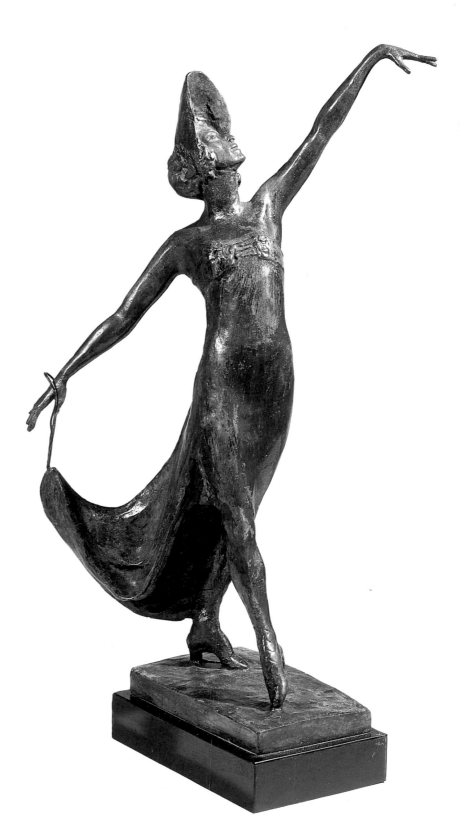

When Pavlova danced in New York in 1913, Hoffman again attended the performances, which included *La Gavotte*. On Pavlova's return with the Ballet Russe to the Metropolitan Opera House in April 1914, Hoffman at last had the opportunity to meet the dancer and to show her the sculptures she had made. Pavlova, touched by the young artist's enthusiasm, gave her a permanent pass to the wings, where she could make drawings in closer proximity to the stage.[2] From this vantage point Hoffman made her first sketch of *La Gavotte*. Pavlova liked the sketch so much, which showed her head thrown back as her body moved forward, that she suggested to her managers that it be used for a poster. It developed, in fact, into a series of posters promoting the Ballet Russe.

Hoffman has described the modeling of *La Gavotte* in her studio and the specific attire worn by Pavlova for posing: "short tights, long-heeled golden slippers, the famous yellow poke bonnet with long streamers. . . . The diaphanous clinging yellow satin dress, which I added as drapery after the nude figure was completed, served to accentuate the grace and rhythmic silhouette of her figure. . . . The *Gavotte* is small. Often, in looking at it, I think that many things that are done small have a more direct response to the emotion that went into them. Sometimes they are later enlarged. I've never done this with the *Gavotte*, liking it as it was."[3] Hoffman made the statuette of *La Gavotte* in colored wax and later in 1915 in bronze. Both versions received prizes: the wax *Gavotte* was awarded the Watrous Medal from the National Academy of Design, and the bronze an honorable mention at the Panama-Pacific Exposition in San Francisco in 1915.

In the meantime a bigger project had seized the sculptor's imagination, and when she stopped in London in August 1914, she proposed to Pavlova that she depict the entire ballet *Bacchanale* in the form of bas-relief. Pavlova agreed then and there to begin the posing. Fortunately, the Ballet Russe went on tour in America 1914-15, and the artist and dancer continued their sessions together in New York. Pavlova even arranged for Hoffman to take lessons with her assistant dance partner, Pavley, in order to experience first-hand the movements. Then Hoffman and Pavley performed for Pavlova herself. From one hundred drawings came the final sculpture of twenty-six clay low-relief panels.[4]

In 1924 Pavlova sat for her portrait, which Hoffman made into both a marble bust and a tinted wax head, marvelous depictions of the ballerina's sensitive face. Hoffman and Pavlova met for the last time in Paris in January 1931, a few days before the dancer died at forty-nine in The Hague where she was on tour.

124
Malvina Hoffman (1885-1966)
Tamil Climbing a Palm Tree 1933
Bronze, 85 × 24 × 42 in.
Field Museum of Natural History

More than one writer has stated that Malvina Hoffman was given the largest commission ever granted any sculptor—110 bronze studies for the *Races of Mankind* exhibition at the Field Museum of Natural History in Chicago.[1] Hoffman traveled to remote parts of Asia, the Pacific Islands, Africa, Europe, and North America, departing from San Francisco in 1931 with twenty-seven pieces of luggage that contained drawing materials, cameras, moving-picture equipment, and medical supplies to combat poisonous insects. She was accompanied by her husband, a secretary, and an assistant who cast her clay models into plaster. She relates their adventures in her autobiography *Heads and Tales*, describing their transportation, which consisted of more than forty types of ships, including South Sea outriggers and Chinese junks, and their overnight accommodations, which ranged from a castle to seaweed mattresses.

The full title of this sculpture from South India is *Tamil Climbing a Palm Tree to Collect Toddy for Wine*. Hoffman recalls driving out of Madras to find some toddy wine collectors: "These agile tree-climbers performed their feats going up the tall palm-trees with their heels held together by a raffia loop about fifteen inches long, and a great rope of raffia lashed around their bodies and around the trees."[2]

In this work, as in so many others, Hoffman creates a whole environment: the strong Tamil, the palm tree, the container attached to his waist to catch the sap, and the bucket at the bottom of the tree. In the *Pygmy Family from N.E. Congo* (1931) she has composed a mother and child with a father who beats a drum that is tied between two poles. All of her sculptures are ethnologically interesting and correct, but many are visually exciting as well, for instance, the *Hawaiian Surfboard Rider* and the *Sara Dancing Girl* from Lake Chad.

[1] Hoffman, *Yesterday is Tomorrow*, 108.
[2] Ibid., 138.
[3] Ibid., 144-46.
[4] Janis C. Conner, curator of the Estate of Malvina Hoffman, arranged a recent exhibition of the Bacchanale Frieze. See Janis C. Conner, *A Dancer in Relief, Works by Malvina Hoffman* (Hudson River Museum, Yonkers, N.Y., 1984).

[1] Obituary, "Malvina Hoffman Dead At Age of 81," *The New York Times*, 11 July 1966, p. 1; and James L. Riedy, *Chicago Sculpture* (Urbana, Ill., 1981), 129.
[2] Hoffman, *Heads and Tales*, 322.

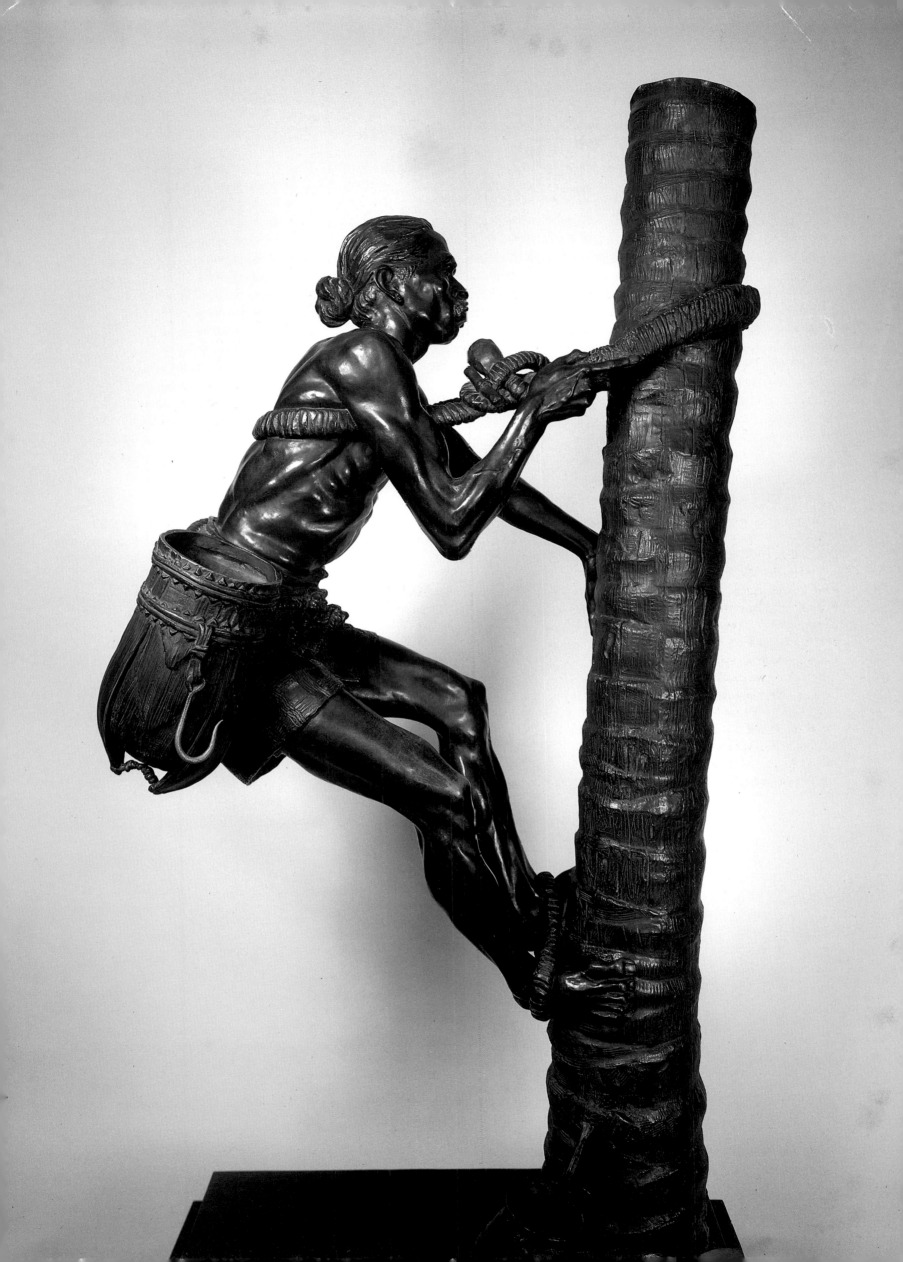

Select Bibliography

Beaux, Cecilia. *Background with Figures*. Boston: Houghton Mifflin, 1930.

Breeskin, Adelyn Dohme. *Mary Cassatt: A Catalogue Raisonné of the Oils, Pastels, Watercolors, and Drawings*. Washington, D.C.: Smithsonian Institution Press, 1970.

Burke, Mary Alice Heekin. *Elizabeth Nourse, 1859-1938, A Salon Career*. Washington, D.C.: Smithsonian Institution Press, 1983.

Casteras, Susan P., and Seymour Adelman. *Susan Macdowell Eakins, 1851-1938*. Philadelphia: Pennsylvania Academy of the Fine Arts, 1973.

Carr, Cornelia. *Harriet Hosmer, Letters and Memories*. New York: Moffat, Yard & Co., 1912.

Cummings, Hildegard. *Good Company, Portraits by Ellen Emmet Rand*. Storrs: William Benton Museum of Art, University of Connecticut, 1984.

Gerdts, William H. *The White, Marmorean Flock*. Poughkeepsie: Vassar College Art Gallery, 1972.

————. *Women Artists of America 1707-1964*. Newark: The Newark Museum, 1965.

————, and Russell Burke. *American Still-Life Painting*. New York: Praeger, 1971.

Goodyear, Frank H., Jr., and Elizabeth Bailey. *Cecilia Beaux: Portrait of an Artist*. Philadelphia: Pennsylvania Academy of the Fine Arts, 1974.

Harris, Ann Sutherland, and Linda Nochlin. *Women Artists: 1550-1950*. Los Angeles: Los Angeles County Museum, 1976.

Hoffman, Malvina. *Yesterday is Tomorrow*. New York: Crown Publishers, 1965.

Hoppin, Martha J. *The Emmets: A Family of Women Painters*. Pittsfield, Mass.: The Berkshire Museum, 1982.

Huber, Christine Jones. *The Pennsylvania Academy and Its Women*. Philadelphia: Pennsylvania Academy of the Fine Arts, 1974.

Noun, Louise R. *Abastenia St. Leger Eberle, Sculptor*. Des Moines: Des Moines Art Center, 1980.

Petteys, Chris. *Dictionary of Women Artists*. Boston: G.K. Hall & Co., 1985.

Rubinstein, Charlotte Streifer. *American Women Artists from Early Indian Times to the Present*. Boston: G.K. Hall & Co., 1982.

Tarbell, Roberta. *Marguerite Zorach: The Early Years, 1908-1920*. Washington, D.C.: Smithsonian Institution Press, 1973.

Index of Artists

Photographic credits

Bill Finney *cat. nos. 8 and 19*
Rick Stafford *cat. no. 10*
Allan Finkelman Studio *cat. nos. 31, 32, and 35*
Joseph Freeman *cat. no. 49*
Douglas Baz *cat. no. 81*
Jerry Kobylecky *cat. no. 104*

Photographs of other objects in the exhibition have been provided
by the individual lenders.